ART SCHOOL

The MIT Press Cambridge, Massachusetts London, England

ART
SCHOOL

(PROPOSITIONS FOR THE 21ST CENTURY)

edited and with an introduction by Steven Henry Madoff

Publication of this book has been supported by the Anaphiel Foundation and by a grant from the National Endowment for the Arts.

MIT Press books may be purchased at special quantity discounts for business or sales promotional use. For information, please e-mail special_sales@mitpress.mit.edu or write to Special Sales Department, The MIT Press, 55 Hayward Street, Cambridge, MA 02142.

This book was set in Scala and Gotham by the MIT Press. Printed and bound in Canada.

Library of Congress Cataloging-in-Publication Data

Art school : (propositions for the 21st century) / edited by Steven Henry Madoff.
 p. cm.
Includes bibliographical references and index.
ISBN 978-0-262-13493-4 (pbk : alk. paper)
1. Art—Study and teaching—History—21st century. I. Madoff, Steven Henry.
N90.W49 2009
707.1—dc22

 2008053209

10 9 8 7 6 5 4 3

CONTENTS

Acknowledgments **vii**

Introduction
Steven Henry Madoff **ix**

1 On the Ground: Practical Observations for Regenerating Art Education
 Ernesto Pujol **1**
2 An Ethics: Putting Aesthetic Transmission in Its Proper Place in the Art World
 Thierry de Duve **15**
3 Education by Infection
 Boris Groys **25**
4 Aesthetic Platforms
 Brendan D. Moran **33**
 Project 1: École des Beaux-Arts **38**
5 Conversation: John Baldessari and Michael Craig-Martin **41**
6 Dear Colleague
 Robert Storr **53**
 Project 2: Bauhaus Building **68**
7 How to Be an Artist by Night
 Raqs Media Collective **71**
 Project 3: Black Mountain College **82**
8 The Thing Seen: Reimagining Arts Education for Now
 Ann Lauterbach **85**
 Project 4: Institute for Design **98**
9 Include Me Out: Preparing Artists to Undo the Art World
 Charles Esche **101**
 Project 5: Yale Art and Architecture Building **114**
10 Roaming, Prelusive, Permeable: Future Academy
 Clémentine Deliss **117**
11 Artereality (Rethinking Craft in a Knowledge Economy)
 Jeffrey T. Schnapp and Michael Shanks **141**
12 Undesigning the New Art School
 Charles Renfro **159**

13 Conversation: Marina Abramović and Tania Bruguera **177**

14 From Exhibition to School: Notes from Unitednationsplaza
 Anton Vidokle **189**

15 In Latin America: Art Education Between Colonialism and Revolution
 Luis Camnitzer **201**
 Project 6: Marfa Complex **216**

16 Under Pressure
 Ute Meta Bauer **219**
 Project 7: Art Center College of Design **228**

17 Teaching Art: Adorno and the Devil
 Daniel Birnbaum **231**

18 Nobody Asked You to Do Nothing/A Potential School
 Liam Gillick and students **247**
 Project 8: Generator Project **254**

19 Conversation: Dennis Adams, Saskia Bos, and Hans Haacke **257**

20 States of Exception
 Steven Henry Madoff **271**
 Project 9: Le Fresnoy **286**

21 Questionnaires
 Brian Sholis, Ann Hamilton, Dana Schutz, Fred Wilson, Guillermo Kuitca,
 Jeremy Gilbert-Rolfe, Matthew Higgs, Mike Kelley, Paul Chan, Paul
 Ramírez-Jonas, Piero Golia, Shirin Neshat, Thomas Bayrle **289**

22 Dear Steven
 Ken Lum **329**
 Project 10: Zollverein School of Management and Design **340**

Contributors **343**

Notes **353**

Index **365**

This book would not have been possible without the generous support of the Anaphiel Foundation in Miami, dedicated to the support and awareness of creative expression and to the role of art in everyday life. Special thanks to the foundation's founder, Craig Robins; its board members: John Baldessari, Bonnie Clearwater, Samuel Keller, and David A. Ross; and its director, Lisa Versaci. Additional funding has been provided by a grant from the National Endowment for the Arts.

I would also like to thank all of the participants in the symposia sponsored by the Anaphiel Foundation, on whose thinking and guidance this book has drawn; and to Bruce Ferguson; Elizabeth Plater-Zyberk, dean of the School of Architecture, University of Miami; Sheena Wagstaff, chief curator, Tate Modern; and to the engagement in the project, in partnership with the Anaphiel Foundation, of Donna E. Shalala, president of the University of Miami; Michael R. Halleran, dean of the College of Arts and Sciences, University of Miami; and the University of Miami staff and community.

Finally, a word of thanks to my editors at the MIT Press, Roger Conover, for his vision, and Sandra Minkkinen for her care, and to the book's designer, Emily Gutheinz.

Steven Henry Madoff

No school is a school without an idea. Every school embodies an inheritance at least and at most is an invention rising out of its inheritance. By inheritance and invention, I mean the transmission and transformation of a creed, of a technique that animates the hand, of a thought about the consecration of knowledge as it individuates the self and enhances a community, a network, many communities and many networks. An ethics of knowledge is the foundation of any school in its essential definition as a gathering place, but the complexity of what that knowledge should be, how its production is configured and unfolds, who translates it across the bridges of generations and time, whether its structure is rigid or limpid in its willingness to change, whether it is resistant to external mandates or longs for the imprimatur of an outside authority, and what status and success signify for its teachers and graduates—all of these define the place of gathering, its ethical complexion, its reasons for being, and what learning means there.

Art School (Propositions for the 21st Century) is an outgrowth of my deep curiosity about what a particular kind of school—an art school—might and will be in this new century. The climate and landscape of contemporary art haven't been as eruptive as the great upheavals of the previous century—at least not yet. Of course, in the past twenty-five years, the inventory of cultural production has expanded far beyond anything before in the history of art. The topography of making has been flattened: no one discipline, style, genre, or artist dominates. But there has been one unstoppable influence, particularly after the 1960s: the juggernaut of Marcel Duchamp as the tutelary spirit hovering above the notion of art as the outward sign of an idea manifested through any sensorial means, using any object from any precinct of production as its instrument, with its concept claiming priority over the making or appropriation of the optical thing, of the sign itself.

From the 1980s on, the influence of conceptualism has affected art schools all over the world. Many schools have erased the boundaries between disciplines, as the supremacy of the expression of a concept in this post-Duchampian epoch rides across all material means—photography, video, painting, drawing, sculpture, or any of them and more joined in an installation. Somewhere between philosophy, research, manual training, technological training,

and marketing, an evolved profile of contemporary artistic practice has pressed the art school as a pedagogical concept itself to address what an artist is now and what the critical criteria and physical requirements are for educating one— or should I say educating tens of thousands, as the complexities of capital markets worldwide have fostered an industry of producing artists for the primary purpose (though not an exclusive purpose—the cultural desires of humanism remain a need of intellectual, social, and spiritual health) of circulating objects tied to the speculative exchange of money. The economy and ecology of images and thought-encrusted objects are only burgeoning, nurtured by technologies that are in fact eruptive, pervasive, and increasingly accessible.

And what does this abundance of art objects and activities do for and to culture and portend? Of course, on one elemental level, it means the proliferation and distribution of *ideas*, and the only matter of final consequence is the quality of the ideas (certainly as much as the quality of the objects, as contested as that may be in some quarters). It's a commonplace to reiterate the fact that an artwork is anything now—a parade, a meal, a painting, a discussion, a hole in the earth filled with the thought embedded in the work's title—and it is now more than obvious that preparing young artists to live in a landscape of infinitely elastic production will demand some new requirements that, as I say, have already begun to be negotiated over the past few decades. The factory of ideas, objects, practices, and pedagogies that constitute an art school today, as they will tomorrow, seems particularly restless, wanting more porosity, irritated by bureaucratic weight, impatient for new shapes, even for an ephemeral life.

This very potency of the Zeitgeist's appetite for hybridity has driven the questions and propositions in this book. The writers are largely artists who also invest their creativity in teaching, and their essays range over continents, histories, traditions, experiments, and fantasies of education, as well as the realities of inertia and success. The same holds true for the conversations and questionnaires that I've included. The conversations mean to offer a record of the thoughts of some great artists who have also been great teachers. The questionnaires are a way of asking other artists of note what their own experiences were as art students—and the range of opinion is considerable. But that can be said about this book in general, in considering the viability and use of art schools as they exist today. As Thierry de Duve observes, there's no certainty about the efficacy of art education or whether art schools are a necessity at all and will remain a fixture of the world, just as they haven't always been required in the past. In South America, a vital tradition continues of artists training other artists in their studios—a far more autonomous means of transmitting knowledge than the bulkiness of institutional learning. Across the globe, there

are any number of small, nomadic, peculiar, and useful "academies" that have sprung up over the past decade, whether in bars, as the framework of biennial exhibitions or as residencies and fly-by-night research initiatives. Naturally they are reactions to the stolid weight of fixed institutions, with their rules, their acquiescence to the Bologna Process in the European Union or to the hegemonic regulation of M.F.A. programs in the United States. In the meantime, what the immense and persistent reach of the art market will mean to art school pedagogy as the century progresses is beyond knowing, but not beyond the speculations of the contributors here.

Even this issue may simply be a moment in time, becoming a nonissue, a feature of the landscape that once seemed a challenging promontory that was climbed, tunneled through, acclimated to. But the questions remain concerning the most appropriate, inventive means by which the transmission of knowledge can be accomplished and with what outcomes—which can never, in fact, be guaranteed.

My curiosity has had the benefaction of a five-year project underwritten by the Anaphiel Foundation in Miami in its aim to create a new model for art education to benefit its own creative community. The foundation's interest allowed nearly one hundred important artists, educators, architects, writers, technologists, and administrators to meet in more than half a dozen symposia in London, New York, and Miami to share their practices and experiences, to wonder aloud, and to vent and predict. Many of these crucial participants and their concerns roam the pages of this book, whose simple and large ambition is to ask what art education is and what it should be in the twenty-first century.

New contentions seem to emerge every day, and there's no end to the symposia, online discussions, and impromptu conversations at exhibitions, art fairs, and of course in classrooms and studios in which the topic boils and erupts. At the time of this writing, a global recession is in progress, and its impact on the art world will no doubt bring changes of some duration to art education, whether in enrollment, funding, or in a less visible way the attitude that faculty and students have toward the commercial status of the art work as it filters down to the adaptation of styles and strategies. What's clear in this book and in the ongoing consideration of the institutional and informal transmission of art knowledge is that something has happened in the accumulation of cultural habits that now seems to have quickened with impatience for new ideas and new means. I plead guilty to the impulse. Every author and every editor wants to think of what they've published as a gauntlet thrown down. That's what I hope this book will be for readers—a gauntlet and perhaps in some ways a series of alternative blueprints. There is much to be done.

ON THE GROUND

Practical Observations for Regenerating Art Education

Ernesto Pujol

As a contemporary artist who sees no difference between my studio and my teaching practice (they form a seamless legacy), I write from the ground up, from a hands-on perspective as an artist instructor seeking to regenerate the studio as classroom. Although art education is a site-specific process and cultural product, I share my field notes, which I have organized into three specific categories: the curriculum, the faculty, and the community.

At the dawn of the twenty-first century, American middle-class students now enter art school with eight evolving tools including: (1) cable, satellite, and Web-accessible televisions; (2) laptop computers; (3) cell phones, and particularly smart phones; (4) DVDs and game players, portable and stationary; (5) MP3 devices and iPods; (6) credit cards and ATM cards; (7) digital cameras, integrated and standalones; and (8) scanners. All generate instant information, communication, and currency to goods, and several include image capture. A pivotal historical perceptual change is taking place among us, making the abyss between past and present modes of perception greater than ever before in terms of attention, translation, forms, aesthetics, and production. The future of art education will be based on the notion of universal immediate access.

Many of our old curriculum structures, fiercely protected by entrenched bureaucracies to the point of paralysis, make change extremely slow and even close to impossible, discouraging many young faculty members who are ready and clamoring for it. The temptation for administrators is to let things fall by their own weight: asking young faculty for patience while hoping that they do not burn out, give up, and leave during long transition processes; quietly buying out old faculty by offering early retirement, or passively waiting for them to retire or die with their boots on out of respect or political fear. In the meantime, current and new students, at least throughout schools in the United States, are paying fortunes for inadequate art educations and getting into bank-loan debt, which is a huge disservice to them. Therefore, we must not be lazy or afraid of triggering change, no matter how painful, and ultimately we must rely on the growing numbers of our art students who connect the dots on their own and end up with a multidisciplinary education in spite of the institution, not because of it.

So what does this all mean for foundation curriculum development? It means that art schools stand at the threshold of multidisciplinary art research and intradisciplinary art production—not as one more theoretical seminar or "multimedia" studio among stubbornly traditional course offerings, or one more state-of-the-arts degree, but as the next wave of cultural production. The artists of the twenty-first century may become in some sense Renaissance folk, deploying a panoply of disciplines and mediums for their work. But we must seek to understand these new patterns of creativity fully in order to ensure our nation of historical memory and true experimentation beyond Internet shopping for global materials and fabrication technicians.

Industrialism triggered the end of craft and divided makers from thinkers. Photography relieved painting and sculpture from the burden of documenting reality. And modernism allowed art decades of important psychological self-regard that affirmed the individual but unfortunately created a hermeticism that disconnected art from middle America, making it suspect and irrelevant. Conceptualism brought in a class system that turned artists into producers who hired shop technicians. We dismissed middle America as cattle and their artists as nostalgic artisans of the landscape. In turn, they responded by electing politicians who dismantled our nation's cultural life, and worse. The art world retrenched, thinking itself superior and believing it could survive through the benefaction of the private sector. Yet our recurring incestuousness, evidencing the decadence of empire and globalism, has finally crumbled our walls.

Contemporary art is evolving not only beyond traditional tools and techniques (the paint-stained academic studio, the macho foundry shop, and the cavelike photo laboratory) but also beyond the upper-middle-class, white-encoded traits of modernism's Puritan roots, as all art is generated by a specific people in a specific place; as whiteness is a color. Its art-for-art's-sake stance, historically important as a chapter devoted to process in the twentieth century, has generated a fear of narrative content, particularly the political, that is not serving us well in the twenty-first century. Modernism defined universalism purely through form, devoid of social content, but this has become a repetitive formula, an armor without a body, ultimately decorative. In the meantime, the rest of the world has caught up, and it is telling its stories unapologetically. Globalism is a network of intimacies. It finds profound traits of the human condition in common, despite site-specific differences. It bears no relation to a fascism of exported style.

What does this mean for foundation programs in our art schools, which are increasingly outdated and are the refuge of surviving but isolated and frustrated American modernists? It does not mean substituting Photoshop and crappy recycling for painting and sculpture. Historic means of production can be informed by conceptual and multidisciplinary methods that can save them from becoming the stuff of hobbyists, a visual macramé. Students should receive training in the basic tools of Conceptualism, such as scholarly research and literary writing, as applied to traditional painting, sculpture, printmaking, glass, ceramics, and photographic processes, making muscled and poetic gestures more conscious and articulate and balancing craft with thought, while also gazing selectively at other disciplines.

Students should have to develop fully thought-out written proposals before, during, and after painting and sculpting. I don't mean that they should do this simply to defend an image or object during individual and group critiques, as students have always done, but to learn how to justify that creation intellectually, beyond the subjective, in our visually dense and materially cluttered world. If they don't want to do this, they have no business being professional contemporary artists. They should be doctors and lawyers who paint on Sunday, or they should be the fine two-dimensional technicians who paint for Jeff Koons. We are all creative; creativity is part of the human condition. However, not everyone is a cultural producer. Our art schools' counseling departments should be sharper in vocational counseling.

If you live in New York City, it looks as if all of the art created now is conceptual. However, if you visit cities and towns across our tired empire, most students are painting in some form or another. Painting remains the most populated major in art schools. Therefore, how do we marry Conceptualism and painting? Contrary to the predictable notion that painting alone needs to change, we need to begin to define Conceptualism beyond its by-now rigid academic classicism, its oxygen-lacking formalism, beyond the dictatorial notions of purity that all hegemonic styles inevitably acquire. Conceptualism was born in the 1960s as a movement in which the originating tangible and intangible ideas for works of art and their manufacture took precedence over the appreciation of final products (other than documentation). Yet Conceptualism has evolved to the point that artists now practice it, for better or for worse, as an aesthetic, if not a style (packaging); as a production methodology that can be applied to the most traditional of mediums; and as new hybrid forms that combine elements from many mediums and disciplines.

Art students need access to training in other disciplines, combining what we may identify as the very best of historical and contemporary drawing, painting, sculpture, photography, and installation art with conservation, ecological, and environmental efforts; ethics; cultural anthropology; urban sociology; behavioral psychology; global political science and economics; robotics; and media theory, among other fields. Nevertheless, the challenge is not just to open old boxed-up departments and bring in this challenging and refreshing intellectual diversity; it is also to not set this in stone.

It is time to call for a new flexibility in curriculum development, implementation, and evaluation, followed by even more change. Combinations of old and new mediums and disciplines will have to be revised every few years.

The structure will have to run against the traditional academic model: a revolving door that may not be very friendly to notions of tenure, even as schools will have to commit fully to a temporary or part-time faculty, unlike the current situation of low pay and no benefits for adjuncts.

This multidisciplinary foundation curriculum could be followed by more advanced junior and senior individualized learning, as soon as the individual art student is focused enough, project driven enough, with the curatorial guidance of theoretical and studio advisors. A multidisciplinary degree should be regarded as the beginning of a lifelong intellectual journey, not the end of it. This is about generating public intellectuals, visual scholars, and artist citizens: active cultural workers who participate in global society. I would institute a five-year B.F.A. and do away with undergraduate majors, even while disciplines and mediums would be studied with as much depth as possible. The loss of majors does not mean the loss of disciplined, rigorous training. Disciplines and mediums should be like languages that we engage with according to project needs.

There is no question that conceptually based multidisciplinary training turns foundation and advanced studio classes into reading-and-writing classes, as well as demanding more comprehensive courses in craft and technique. Thus, studio professors (who are normally paid less than art history and theory professors because administrators think that they have to prepare less) should have their pay increased. In addition, one of the issues that needs to be reconsidered is precisely the traditional separation of art history, art theory, and studio courses. *Conceptually based, multidisciplinary studios are hybrid learning environments.* Materially this means that either instructors need to have access to both messy studios and clean, wired classroom spaces, or there need to be coteaching teams. Instructors who are not able to implement conceptual processes and creative methodologies should be paired with scholars who not only give the usual lectures but also assign research and writing about the work in the studio and review it. At the faculty level alone, this academic conversation among peers should ideally reenergize these professionals.

THE FACULTY

Most multidisciplinary artists came to their complex practices during the twentieth century in a self-directed manner, particularly those who chose mostly

nonprofit, community-based initiatives that engaged in public art. They constructed these practices through force of vision and character. They didn't receive a packaged template; they created the road on the map, though they looked back to earlier practices too.

Many schools are still struggling with artists who found a niche on their faculties during the 1970s and '80s and then stopped growing—an unexpected perversion of tenure, which was meant to secure and promote radical thinking. They have become an old guard that holds on to the power fantasy of the New York painting school as an eternal and universal evaluation standard, by way of Abstract Expressionism and what critics called "Hard-Edge Abstraction," dismissing everything that has since come their way. They perceive everything as a question of turf. Therefore, they're threatened by new and visiting faculty, women faculty (though some of them are women who took on the ways of bully masculinity in order to succeed in a world of men), gay and lesbian faculty, faculty of color, and combinations thereof. This faculty does a lot of harm to students because rather than educating them, they have a dying agenda; they seek followers of tradition regardless of students' true needs.

I want to point out, as the extreme opposite to this, that we also do not need any more art world celebrities who do not take teaching seriously. We do not need famous artists in the classroom who do not teach with the same intensity with which they practice their art making, accepting teaching invitations merely out of vanity. They do not give enough time to students, depending too much on teaching assistants. When they finally show up in the classroom between exhibitions and trips, they talk about themselves more than they talk to the students about their work. And of course they recruit students as studio assistants, giving them the impression that this is a Hollywoodesque career—which is sometimes, but on the whole rarely, true.

We need a professionally active faculty committed to both teaching and pursuing its own extracurricular projects. We also need to stop hiring faculty artists who have no field experience—artists who have jumped from their B.F.A. to their M.F.A. without blinking and have very little to offer students other than textbook ideas and textbook art. This sort of oxygen-lacking wheel is killing contemporary American art in and out of academia. I believe that teaching should come after the fire of extensive field experience. Therefore, this means a curriculum that goes beyond exhibiting in faculty shows within college and university galleries, being awarded more than just faculty development grants and university-sponsored residencies abroad. This in-house system unfortunately serves to enshrine and promote mediocrity.

According to College Art Association statistics, although we are graduating more M.F.A.s than ever before, they are leaving school in such financial debt that they cannot afford to go into communities and take chances as artist-citizens. Perhaps this is a uniquely American problem, and European countries that support their artists face other challenges. In the United States, we are not graduating artists; we are graduating teachers right and left, and we should finally admit it. We are generating institutionalized artists and institutional art, and this runs the risk of collapsing over the next few decades, whether multidisciplinary or not. We need more fellowships for our students, and schools need to stop their grandiose expansion plans, consider their appropriate scale, and charge less for the education they provide as a civil act of cultural disobedience.

Because graduate art programs are mostly producing teachers, they should consider providing seminars in pedagogical theory—not just art theory seminars. Education is a discipline with many differing theories and practices, and we should respect it more seriously. I pursued graduate work in both education and psychology at the beginning of my career, and it made a huge difference in my understanding of the creative and learning processes in the studio as classroom.

THE COMMUNITY

Art has a socially critical role to play in the survival and evolution of the American democratic experiment, currently weakened by unrestrained capitalism and the threat of terrorism. Art schools need to rethink their relationships with art market representatives. I live in the real world, so I want my young multidisciplinary artists to pay their rent through their art projects as funded by foundation grants, museum commissions, teaching, lecturing, and gallery sales. I want our labor to result in the commoditization of multidisciplinary practice as a new means of expression that seems, unfortunately, to be increasingly devoid of social impact at the same time that it is swallowed whole by the voracious art market.

Conceptual practices and process-documentation-as-art are already commoditized. Multidisciplinary practice is just spreading across the pedagogical landscape; it is just about to be institutionalized. And what usually follows this new credibility is money, resulting in eventual bulk adoption by the gallery

world. The question is what can we do at the art school level to try to protect the potential of a socially powerful art practice (and we haven't had one of those since early feminist and AIDS activist queer art) from this all-too-quick commoditization? How do we slow this down just a little?

Considering a new system of checks and balances, the politically challenging times we live in, and no desire to return to the 1960s, it is absolutely crucial that art schools consider their institutional role in the support of democracy. The history of creative expression is linked to the history of freedom. There is a connection between the state of artistic expression and the state of democracy. When was the last time we thought about possessing and exercising moral authority as art schools, in the U.S. and everywhere else in the world, as players in the national and international context—and how can this come about in our young century?

I would like to put forward the notion that *art schools should be the conscience of the art world*, becoming far more involved in it, which is fundamentally different from what has taken place in the past, when art schools dismissed the art world under the guise of purity. All this, once again, worked for a while, but the art market has gotten so big that even critical attention from the art world requires market credibility.

Art schools should not only consider finding a strong and clear moral core from which to educate but should achieve a moral presence in the art market. They should educate young artists about shop and business ethics; counsel them about the challenges of early success, in terms of the rigid branding expectations that are publicly set; dare to address those art dealers and collectors who walk through their M.F.A. shows; and host more than ever before the experimental and political art that has not yet found exhibition venues. Otherwise their alumni are going to be vulnerable to both art market pressures and conservative political climates. In the end, art theory alone—whether feminist, queer, or postmodern—does not constitute a lasting moral core for art schools. Actions must follow. These positions, if not exercised in the real world, end up as ultimately disempowered liberal talk. There need to be truly embodied practical gestures of institutional citizenship. In the U.S., art schools should also claim the role of lobbying Washington for more arts funding.

People roll their eyes when someone suggests that art students perform some volunteer service as part of their formation. But I cannot tell you how challenging and ultimately formative it was for me to work as a reader to blind college students during my undergraduate studies. I remember spending all morning in the drawing and painting studios and then switching gears and

spending many afternoons with intelligent people my age who could not see the images I was creating; I had to describe these images to them. That experience made me not only more articulate about my work but much more mindful of and generous with audiences.

Carol Becker, the current dean of Columbia University's School of the Arts, in a 1993 essay, "The Education of Young Artists and the Issue of Audience," wrote the following, which I paraphrase.[1] The issue of audience is not raised enough while looking at student work in art schools. Therefore, by omission, it is usually assumed that the work is being made for a gallery context, and this assumption becomes self-fulfilling. Educators should guide artists to help viewers through their work's complexity. That is what art students find most difficult to actualize. They themselves do not always know how they arrived at their own images, so they are unsure of what information is necessary to give people. And yet the amount of "information" revealed by a work of art is the measure of how much power an artist gives to an audience.

How can art schools transcend the critical and commercial tastes dictated by a handful of urban centers like New York, Los Angeles, London, São Paulo, and Berlin? The answer may lie in having some portion of the conceptual and technical art training anchored in struggling communities and in violated natural landscapes, as cultural supports for their sustainable human development and ecological restoration. There is much talk among the airport-living art world elite about postnationalism (although ethnic violence and even genocide seem alive and well in Africa, the Middle East, and Eastern Europe). However, such talk is still mostly circumstantial, even as we slowly evolve toward that postnationalist future.

Culturally serving needy and isolated populations, black, brown, yellow, red, and white, poor and rich, is an important factor in the formation of a visual scholar. Community-based pedagogical experiences, whether they complement a curriculum as encouraged extracurricular work or as studio workshops, should not be relegated to the experimental or public art corner of a department, but should be integrated into everything else. We cannot be prescriptive of what experiences in cultural services an art school may make available to its art students. Art schools need to look around and find what is right for them. Art schools need to act as site-specific entities. When I was a visiting professor at Bezalel Academy of Arts and Design, first in Jerusalem and later in Tel Aviv, I experienced an art program that attempted to mix Jewish and Arab students in the same classes. The effort was challenging and painful, but necessary. Otherwise it would have been a morally bankrupt school. I do not

think that they have succeeded in attracting numbers, but they hold a moral ground for trying.

Moreover, for some art schools, it may not be about providing some community experience. It may be about accessing a region. I have often spoken with curator Saralyn Reece Hardy, former head of the Museums and Visual Arts Program of the National Endowment for the Arts and now director of the Spencer Museum of Art in Kansas, about the need for a new regionalism. I think that American art schools need to visit their own country, particularly the Midwest—that unknown area between New York and Los Angeles. They are still making the mistake that the pioneers made: they think it empty, barren. It would be much more revolutionary for a Northeast or West Coast art school to have an outpost in Kansas than in London, reconsidering the prairie, the westward expansion, the notion of the endless (political) boundary that we just expanded to the Middle East.

This is the kind of curriculum reality check that also leads me to say that if American art schools are in the business of mirroring culture, they need to stop dismissing religion as an anti-intellectual subject and conversation. Walking through art schools right now, it is hard to tell that we are a country at war. Cultural critic Michael Brenson, during a lecture delivered some years ago at the New School for Social Research in New York City, argued that museums that have embraced globalism will sooner or later have to address the social, political, and economic forces that triggered global art: grassroots narratives about colonialism, racism, poverty, civil war, rape, fundamentalist religion, and terrorism, among many others.[2] Otherwise museums were going to end up doing a terrible disservice by decontextualizing and ultimately castrating global art, robbing it of its power by regarding it only through its formal qualities. The same could be said of art schools. Art schools need to embrace the narratives of their international professors and students, or they will betray them by colonizing them once again through whiteness.

Nevertheless, art schools cannot simply use communities as one-time laboratories for new trends in art making. There is no universal community access—no passport to all communities. Working successfully in one specific community does not mean that the same methodology can be used elsewhere or have the same resulting experience. Schools should enter into long-term partnerships with communities whose leaders and members are willing to participate in the education of artists, the way they might take on the education of doctors by allowing the establishment of a public clinic. In addition, there is a need to improve the mental health services that art schools offer to students

who are facing dyslexia, attention deficit and compulsive disorders, addictions, and depression. Art schools need to help students through these personal challenges before giving them the responsibility to work with communities.

Community interaction is not just about making art as the site for social change; it is about possible new materials found outside the studio and the computer lab. It is about the ethics of collaboration, about issues of authorship and profit sharing. Who takes home the cash if it can be sold in the art market? Do the ethics of place dictate that a product be ephemeral or permanent? Should it be about process and experience rather than about an object at all? Moreover, should there be two products that satisfy different needs: social needs and career needs? Community-based art places its emphasis on issues, on problem solving through culture, rather than on the purity of mediums. I also want to point out that what I have stated here about community could be said of the environment. As artist Frances Whitehead is fond of saying, the history of humanity is overrated. As a Zen Buddhist, I do not even believe in the human concept: there are no humans; there is only nature.

CONCLUSION: WHAT IS THE MEASURE OF OUR SUCCESS?

What constitutes success for the graduating student? Success is a tricky term. Some artists achieve great critical success but no commercial success, or vice versa. There are plenty of commercial artists with showy assets who are dismissed as clowns and impersonators fooling the gullible masses by the critics, whose notion of art is still very traditional. In addition, some artists feel that they are never successful enough, no matter how great their curatorial and financial accomplishments. The fact is that in America's culture of entertainment, few visual artists are household names. Any television celebrity elicits more name recognition than any biennial star.

Nevertheless, in the short term, art schools are successful if they guide young artists into the right artistic production processes for them: this match between talent (creative intelligence and skills) and old and new mediums is what gradually helps them to achieve their unique voice. This match also inserts the young artist into visual history, into the right ancestral inheritance line through which to locate, understand, and articulate their work both to the art world that receives them and in the greater social context. Recognizing a social context helps to liberate young artists from the modernist anxiety

concerning originality, which is turned into spectacle by celebrity culture. If an art school were able to achieve this for its students, it would be an enviable institutional accomplishment. For an art student to acquire so much intellectual and technical maturity would be admirable.

In the long term, I believe that artistic success should be defined as the ability to sustain art making for a lifetime, whether within the profit or non-profit sectors, remaining part of the conversation about the destiny of the country, the culture, and global citizenship. Artistic success should be about continuing to grow and produce, constructively critiquing and regenerating, because no one should be blindly tied to tools that become obsolete, to mediums that cease to be relevant to people's lives, to theories that no longer explain who we have become as a people, both mirroring the culture and providing alternatives for the culture. I have often been hard on modernism in the United States because, just as religious architecture, imagery, and materials (stained glass) were the language of the Middle Ages, modernism was the language of the twentieth century. But to continue upholding it feels like the decadence of empire. Perhaps environmentalism will be the consciousness shaping art in the twenty-first century, but regardless, schools must be free to entertain visions of the future.

As an artist, I sometimes feel no urgency to make more art because I am surrounded by throwaway images, piles of inexpensive objects, and lots of noise. Nevertheless, I am still driven to continue to help students find the right artistic processes for them—with some small epiphanies and breakthroughs along the way, I hope—so that they in turn provide society with critical thinking tools that help to uphold a creative democracy.

AN ETHICS

Putting Aesthetic Transmission
in Its Proper Place in the Art World

Thierry de Duve

How is art in a given society transmitted from one generation of artists to another? Art schools have not always existed, and nothing says that they must always exist. In a way, they already no longer exist. Their proliferation is perhaps a trompe l'oeil, masking the fact that the transmission of art today from artist to artist is very far from occurring directly in schools. On the contrary, it travels through extremely complex channels that end up

implicating the collective as a whole. In fact, we are living in a society (1) where the profession of the artist (unlike that of the architect) is not protected, and anyone can try to become known as an artist without necessarily having attended an institution that grants a diploma; (2) where museums—public institutions not reserved for professionals—are the principal tools of the transmission of the patrimony and direct the way the public will be exposed to art; (3) where the diffusion of living art is shared in more or less equal parts between museums and centers of contemporary art in the public sector, along with art galleries and foundations that are products of the private sector but make art accessible to all; (4) where viewing contemporary art with any frequency requires a specialized, sophisticated, and highly intellectual background; (5) where an enormous part of this art culture is transmitted (with varying degrees of vulgarization) through specialized journals, catalogues, books, and mediums in general, which come from the private sector for the most part, with relatively little transmitted through educational institutions; and (6) where the technical aspect of the artistic apprenticeship is minimized in relation to the intellectual, historical, and cultural aspects conveyed by these mediums, while the aesthetic aspects have been taken over by museums, art centers, and galleries.

For some time now, students who wish to devote themselves to the practice of art no longer become apprentices to a master, inscribed in a chain of direct kinship. As I have already noted, school is far from the only place where transmission occurs. We might even say that art schools are secondary in relation to the system of museums and contemporary art centers, commercial galleries and public and private collectors, reviews and catalogues, and institutions of cultural mediation. We are living in a paradoxical situation, where an increasingly specialized art culture is transmitted by the most general channels and circulates in places where all publics, including the "general public," are blended. It is from within this heterogeneous public that what we call the *artworld* (written as a single word) emerges; an expression that flourished after it served as the title to Arthur Danto's influential article of 1964.[1] And it is at the heart of this milieu, this scene and its institutions, that art schools exist today. The art schools best suited to the current world—and, no doubt, the best schools—are those that deliberately underscore that they consider themselves part of the *artworld* establishment. And so in the late 1970s, there was NSCAD (Nova Scotia College of Art and Design) in Halifax; in the 1980s, CalArts (California Institute of the Arts) in Valencia, near Los Angeles, and Goldsmiths College in London; in the 1990s, the Jan Van Eyck Academie in Maastricht and the Villa Arson in Nice.

This last example is an excellent indicator of current tendencies. Just like the Städelschule in Frankfurt, which is joined with the Portikus gallery, or the Chelsea College of Art in London, which built a spacious gallery (the Triangle Space) a stone's throw from Tate Britain, Villa Arson brings together an art school and an exhibition center, as well as a program of artist residencies. The Villa Arson is the only school in France that has a real art center, or perhaps I should say that it is the only art center that has a school—and it is this potential inversion that seems to me to be indicative of a tendency that merits analysis.[2] The name changes to which the Villa Arson were subjected in the course of its history are already very significant. These are changes not only in terms of the plural and singular of the word *art* but also in terms of the epithets "national" and "international," along with the use of words like *research* and *contemporary*. But there is something still more instructive. In 1994, the idea was raised to cancel the first phase of the Villa's life (the initial three years were to be under the aegis of a municipal school that had yet to be created) and to transform it into a National Institute of Artistic and Pedagogical Research, with a Department of Artistic Productions and Exhibitions (the art center and artist residencies), a Research Department, and a Training Department. It is interesting to note that in this project, which was not carried out, the set of activities designated as "critical discourse, classes, seminars, colloquia, library" (which I would call *instruction*) came under the Research Department and not the Training Department, and the latter dealt only with practical activities (which I would call *apprenticeship*).[3] It is no less interesting to note that the Training Department was concerned with *dissemination* to a number of potential *publics*, listed here in order: "artists in residence; researchers; a permanent teaching staff; teachers from other schools (visiting instructors); fourth- and fifth-year students at the Villa Arson; fourth- and fifth-year students from other schools; instructors in continuing education; young artists in advanced graduate programs (grant recipients); cultural decision-makers and elected officials (sensitization to contemporary art)."[4]

Without even wondering if this list established an order of priorities, I must say that in this project, the assimilation of training to *dissemination;* the confusion between users and actors at the Villa; the strange use of the word *public* to speak of teachers, artists, or researchers; the emphasis placed on the plurality of publics; the porousness that places the "public" of students alongside that of cultural decision makers and elected officials—all of this is symptomatic of a tendency that has been accentuated pretty much everywhere since 1994, even though it was not actually put into effect at Villa Arson.

It is not absurd to use the word *public,* indeed *publics* in the plural, to refer to the population at the Villa, since at its heart it is the art center that should be the center of operations. Nevertheless, is it right to put it there? Is it right to drown the specificity of the art school in the din of the art center, putting them on equal footing? I doubt it. It is as if, on the same level but in separate compartments, the permanent teaching staff had to address students; the researchers-theoreticians had to address their potential readers; the curator of an exhibition had to address the contemporary art world; "instructors of instructors" had to address instructors in continuing education; artists-in-residence had to address young artists in graduate programs; and the director of the establishment had to address the cultural decision makers. It is as if, to the plurality of publics, a plurality of addresses had to correspond. This project contained a core of truth that was important to recognize, but it also contained a great risk of resignation before the task that in my view is still a priority for art education—that of the *transmission* of the torch from artist to artist— which is a completely different thing from *dissemination* to various publics.

Long ago, the torch passed from artist to artist by transiting through the "public"—that is the essential truth of this project. I've said it already, and I can't say it enough: At the Salon des Refusés, it was the anonymous crowd that Manet asked to legitimize him, a legitimization that was not accorded without delay by the crowd, but came to him finally by way of the painters who came after him and who showed in their work that *Déjeuner sur l'herbe* had made its case. To cite only one artist: Cézanne, who earned his stripes at the École Gratuite de Dessin in Aix-en-Provence, who twice failed the entrance exam of the École des Beaux-Arts, and who fell back on the Académie Suisse before finally pursuing his métier as an autodidact, copying the masters at the Louvre. In short, these were the painters who attended the "school" of the salon and the museum, spectators among the crowd of spectators. I also can't repeat enough the "message" of which Duchamp was the provocative messenger, which is that from now on the true artist is the one who emerges from the crowd when he receives its blessing "with every delay," not the one who comes out of an École des Beaux-Arts equipped with a diploma. Under these conditions, anyone can be an artist and anything can be art, which is not without consequence regarding the knowledge we must have of the *artworld*, in which the best art schools play an explicit part. 1964, the year Danto "invented" the *artworld* after his "revelation" regarding Warhol's *Brillo Box* (so he tells us in book after book), was also the year Arturo Schwartz produced replicas of Duchamp's readymades in the wake of his 1963 retrospective in Pasadena, which would propel dear Marcel to

the rank of artist of the century in record time, more influential than Picasso. This date should make us prick up our ears because it was during this time that the readymade's "message," though "mailed" in 1917 (date of the famous urinal), arrived at its destination. Danto was the first to acknowledge receipt of the message as a philosopher. In the wake of his article, various institutional theories of art saw the light of day (though it should be said in passing that Danto's is not one of them), all supposedly made necessary by extreme cases like Duchamp's readymades or Warhol's Brillo boxes.[5]

An "art world" has always existed, with its own sociology, which Danto's expression *artworld* referred to in the '60s. But it is a much more specific world, a "contemporary art world" that is a very particular segment of the world and the art world, which we are now speaking of. This is an art world often characterized as post-Duchampian because it has taken note of the readymade's "message," but that, to my mind, commits the classic error of interpretation by making the messenger responsible for the (good or bad) news that he is merely delivering. The only art considered authentically contemporary in the eyes of this art world are practices that identify art with art-in-general—a category of art created by Duchamp's readymades that consummated the divorce of art and the traditional artist's métier, with its specialized skills and artisan habits (major symptom: the rejection of painting as part of this critique, which sees a paradigm shift in conceptual art). That which is a condition of conceptual practice becomes, by this critique, a normative criterion for art making. The result is that today we hear expressions like "the art scene" and "the contemporary art scene" employed interchangeably, as if the realities that they referred to were congruent and, worse, as if it were taken for granted that the only art that counted was art that interpreted the "message" of the readymade as a radical break, of which Duchamp would be the author.

We no longer believe in these tabulae rasae prophesized by the artists of the historical avant-gardes, but we still believe firmly in the one tabula rasa that claims that the concept of art itself changed irretrievably after Duchamp. The entire false debate around the "crisis" in contemporary art, with which we have been beaten about the ears in France for the past fifteen years, comes from this notion. Some, whose tastes are not necessarily reactionary but who refuse to recognize themselves in the conceptual critique supposedly issued by Duchamp, are forced to declare their refusal of contemporary art because the others, who are not necessarily enthusiasts of this purely institutional posterity, identify contemporary art and post-Duchampian art by making the messenger responsible for the news he delivered. And the art schools most aware

of the situation deliberately take their place in this *artworld*, defined as post-Duchampian, which means that they have unconsciously placed themselves in the position of only being able to transmit a tradition that is willingly cut off from everything that preceded Duchamp. Given this, it should not come as a surprise that I have had such a difficult time salvaging the notion of tradition as transmission.

The idea of opening Villa Arson's educational functions to a variety of different publics translates the indeterminacy of the channels of transmission of art since Manet and duly notes it. Yet the omission of the "general public" from the potential publics of the Villa is, in my opinion, an unfortunate and very significant oversight, perhaps this project's most outstanding lapse, because it is the result of a restricted conception of the *artworld*. What is at stake in this oversight is not the sociological definition of the contemporary art public, what is at stake is the ethical dimension of art. When the government invests money of the taxpayer in cultural institutions such as an art center, whether attached to a school or not—even when the polls indicate that these programs interest only a small part of the population—it gives credit to the fact that art rightfully addresses everyone as far as the state is concerned. And that includes the Other with a capital O. This is the fundamental reason for which artists are not simply "art professionals," and we are right to draw a distinction between creators and "creative types." And when the state finances an art school, whether attached to an art center or not, it finances an educational apparatus that must certainly train professionals, but it is also maintaining a means of transmission that must pass this ethical dimension of art from one generation of artists to another.

I have less objection to institutions conceived of as tandem art school/art centers when they take note of the indeterminacy of a situation (1) in which art schools form an integral part of the *artworld*, provided that the *artworld* rightfully extends to everyone and anyone; (2) in which the profession of art is neither protected nor circumscribed to specific technical gestures transmissible solely by the people in the field; and (3) in which the culture that is necessary to acquire the métier is difficult to distinguish from the culture that is necessary simply to appreciate contemporary art. Since this is the situation, I can easily imagine that the task of sensitizing elected officials and cultural decision makers to contemporary art would fall to an institution in which artists also happen to be trained; that the instruction practiced there could possibly end up training art critics and curators as well as practitioners; that it is a privileged place where intellectuals, philosophers, and scholars in the social sciences

come to familiarize themselves with the specific problems that contemporary art presents to their disciplines, and where artists in residence work within a community that shares the same passion; and finally, that such a community constitutes the ideal terrain for the blossoming of young talent.

The simplest way to create this terrain would be to say loud and clear that an institution such as this is a school of art. That is to say, it is a school where the goal is to train artists; a school where artistic tradition is transmitted from one generation of artists to another; and not a center for the diffusion of contemporary art that adapts a message that is identical, perhaps, to that of other publics and their various demands. A school such as this is a professional school in a very paradoxical sense, since it specifically addresses the young men and women whose vocation destines them to address everyone. The question of the public, or publics, is in fact *a question of address*; envisaged sociologically, this is a false problem. (It is this question of address that sometimes makes the cohabitation in art schools of art, communication, and design departments difficult because only the first of these—art—aims for this very specific transfer of universal address.) Addressing the Other is what distinguishes a work of art (especially if it is a readymade) from some unspecified object, from a piece of merchandise (including when it is placed on the market), or from a product whose purpose is some sort of communication (even when it uses technical and aesthetic means borrowed from advertising).

To define the school as an art school is to make the question of address a specific theme, a subject for attention, which does not mean preaching on a daily basis that art should address everyone, but instead—and again this is where we find the paradox of a professional school that does not train professionals—that the entire school is organized in terms of the transmission from artist to artist. Now, as I have emphasized, this transmission is no longer direct. There is no use in regretting it: What is at stake is not a transfer from transmitter to receiver but from addressor to addressee. By transmission from artist to artist, I do not mean a mode of communication but a mode of address. The more we privilege one mode of address, the more it relays and restarts all the others (precisely by virtue of the paradox, specifically directed at young people, that their vocation—I did not say their function—is supposed to address everyone). This mode of address says that the address is the same for everyone and at the same time that it is not in the same place, depending on the "public" to which one belongs. Concretely: the artist puts it on the envelope, in a way; the general public receives it or does not receive it; the artist/professor transfers it to his or her students; the professor of aesthetics talks about it and theorizes

it; the art critic judges it; the art lover feels it was intended for him personally; the cultural decision maker relays it; the budding young artist acknowledges receipt and responds. An art school functions well when everyone is assigned his or her rightful place in relation to the address, provided, of course, that this place is not static. (The sensitized cultural decision maker is also an art lover; the visual artist/professor is an art critic when he critiques his students' work, an artist when he does his own work, and so on.) But if the question of address is not made a theme in the school, everyone is majoring in communication. There are no longer addresses in the plural; publics are targeted; information is disseminated; pedagogy itself becomes a kind of strategy.

Allow me to play devil's advocate for a moment: Let's imagine that art schools are done away with. Their resources are used to gather researchers and artists who have no obligation to transmit what they do (as at Villa Médicis). A center for conferences and colloquia is created; sensitization training for cultural decision makers is organized; a school for curatorial practice, like the Magasin in Grenoble, is built alongside the art center—there are a lot of interesting things that could be done. But then we should not claim to train artists there, lest we create a confusion between art and communication, between the practice of art and the way artistic practice is transferred to mass media. The advantage of the opposite solution is immediately apparent: once the question of address is brought to the fore as a theme, nothing forbids inviting scholars and artists in residence or organizing colloquia and sensitivity workshops; nothing forbids opening these activities to the school's students who are focusing on making art. I have never claimed that this cultural mix was useless in the formation of future artists. Quite the contrary. It is a matter of untangling the confusion I consider dangerous on the level of principles, not on the empirical level. In order to simplify, I will sum things up by saying that the dominant tendency, it seems to me, can be reduced to a slogan: "Everything that is good for the art world is also good for future artists," which contains a portion of truth and a great risk of ethical resignation. Personally, slogan for slogan, I would be glad to reverse it: "Everything that is good for future artists is also good for the art world." In this way, we can conceive not of publics in the sociological sense but of the address to publics that arises from the sociological.

Let's finish by going beyond the slogan. Consider this analogy: I remember endless conversations with an art critic friend at the newspaper *Libération*, who, article after article, tried in a very didactic and intelligent way to explain contemporary art to his public, a public he reasonably judged to be the "general public," which could not be assumed a priori to have the requisite cultural

expertise. In contrast to his pedagogical approach, I thought of *Libération*'s rock music page, deliberately written as if it addressed only rock fans and ignored the rest of the public. And I remarked to my friend that I, who know nothing about rock culture, always read the rock page passionately because by addressing me as if I were an expert, it made me want to become one. The analogy is an analogy in more ways than one. If, in order to sensitize elected officials and cultural decision makers, these people were addressed *as if* they were already passionate lovers of contemporary art and not children who had to be introduced to it, I am sure a lot of resistance would fall away and we would create allies more easily. If exhibitions were conceived and mounted as if the "general public" expected nothing less, instead of making it feel that no one can enter contemporary art without a password, then the public would more easily get the sense of being part of the "scene." If we speak to an auditorium of cultural mediators *as if* they invested the same stakes in art as the artists, we would give them the justified sense of being a link in the chain of transmission—a feeling that we nip in the bud when we do the opposite and speak to artists as if they were cultural mediators.

I am not being particularly idealistic in saying this. I practice communication and strategy myself, of course. By addressing everyone as if each person were a lover of art, indeed, an artist, we liberate desire and enthusiasm. If only because a school populated by impassioned people is a more vibrant school, and nothing guarantees the maintenance of passion more than the annual arrival of young men and women consumed by the passion to make art, I want to plead here for the maintenance of art schools conceived as crucibles in which technical *apprenticeship*, theoretical *instruction*, and the *formation* of judgment are brought together to create a unique question of address. But I have not forgotten that art schools have not always existed, that they are fragile at the moment, and that there is no reason to think that they will always exist. We should ask ourselves why Beuys had up to six hundred students lapping up his words at the Düsseldorf Academy. He spoke to them only when he held public discussions at documenta. Perhaps the art school of the future will not necessarily be an institution made of bricks and run by an appointed team of professionals, but nothing more or less than a mode of transmission of art addressed to everyone as if they were all artists. The day this school that is no longer one comes into existence, I will personally feel no nostalgia for CalArts, Goldsmiths, or Villa Arson any more than I feel nostalgia for the Bauhaus or the old École des Beaux-Arts.

EDUCATION BY INFECTION

Boris Groys

The goal of education—any kind of education, but especially a humanistic education—is traditionally understood as being twofold. First, the students are supposed to acquire a certain knowledge, certain practical skills, and a certain professionalism in the field in which they are being educated. Second, the students are supposed to be changed as human beings, formed anew by their education—to become different, more accomplished, even

a better exampleof humanity. The same is true of the traditional art education that has a goal of producing a "true" artist. Yet in the case of contemporary art education, both traditional goals of education lose their plausibility. The tradition of modern art rejects all the established criteria of artistic professionalism. Since its beginnings, the artistic avant-garde called for abolishing the art system, of art as a specific professional activity—in fact, of art per se. Contemporary art, of course, is the heir of the historical avant-garde.

Inevitably, at least some, if not all, of the things taught in any art school will immediately and automatically be perceived by students as obsolete, outmoded, uncool, and irrelevant—a remnant of the dead past. Students immediately begin to look for something alternative, something necessarily outside the school, something that still remains out of reach for the existing art system because it operates on a frequency still unheard, still forming, emanating from the perceptions and instincts of another generation. The same can be said about the second traditional goal of art education: to create a "true artist" endowed by the "true artistic ethos." Long ago, the figure of the true artist began to be regarded as a perfect manifestation of kitsch.

Today art education has no definite goal, no method, no particular content that can be taught, no tradition that can be transmitted to a new generation—which is to say, it has too many. Just as art after Duchamp can be anything, so can art education be anything. Art education is an education that functions more as an idea of education, as education per se, because art education is finally unspecific. But there is one characteristic of traditional education that has remained unchanged throughout the history of art and, generally, throughout the cultural revolutions of modernity. Now, as ever before, education suspends the student in an environment that is meant to isolate him or her, to be exclusively a site of learning and analysis, of experimentation exempted from the urgencies of the outside world. Paradoxically, the goal of this isolation is precisely to prepare students for life outside the school, for "real life." Yet this paradox nonetheless is perhaps the most practical thing about contemporary art education. It is an education without rules. But so-called real life, where we are subject to an endless variety of improvisations, suggestions, confusions, and catastrophes, is also finally without any rules. Ultimately, teaching art means teaching life.

This notion of life is central to modern and contemporary art, to their histories and theorizations. Academic, museographed, codified dead art is traditionally rejected within art schools by students whose own nascent practices find the work of the past to be inadequate as an introduction to life as it takes

place here and now. Modern and contemporary art understands life as being ever changing, as a flow, as a process to which the individual should be permanently adjusted because this process is dangerous to anyone unprepared for change. Education sees the psychology of the student as analogous to a computer whose software should be continually updated to function inside contemporary information networks, to survive all possible virus attacks from the outside world, to incorporate the viruses coming from the outside into his or her own software, and—in the best sense of modernism's subversive ambition—even to start a hacker attack against the software of the others.

Life understood as a permanent source of infection that endangers the health of students' nervous systems was articulated early in the twentieth century by Kazimir Malevich in "An Introduction to the Theory of the Additional Element in Painting," which concerned itself with the problems of art education.[1] Malevich describes a range of art styles—"Cézannism," Cubism, and Suprematism, among them—as effects of different aesthetic infections metabolized in the artist by bacilli of one aesthetic kind or another. That is to say, they were triggered by new visual forms and impressions produced by modern life. So Malevich compares the straight lines of Suprematism (which he introduced into painting, according to his own view) to the bacillus of tuberculosis, whose organic form is also rectilinear.[2] Just as a bacillus modifies the body, so too are the sensibility and nervous system of the artist modified by novel visual elements introduced into the world by new technical and social developments. The artist "catches" them—with the same sense of risk and danger. Of course, when somebody becomes ill, you call a doctor. But Malevich thinks that the role of the artist is different from the doctor's role or the technician's, trained as they are to remove deficiencies and malfunctions, to restore the integrity of the failing body or a failing machine. Instead, Malevich's model for artists and for the teaching of art follows the trope of biological evolution: Artists need to modify the immune system of their art in order to incorporate new aesthetic bacilli, to survive them and find a new inner balance, a new definition of health.

If artists try to resist, the effects are obviously disastrous. They fall to the side, prematurely aged; the quality of their works suffers; the works become irrelevant for the world they are living in. Malevich sees the art school as the best defense against this artistic degradation. The closed world of the art school keeps bacilli permanently circulating and students permanently infected and sick. And most important: Precisely because the art school is closed and isolated, the individual bacilli can be identified, analyzed, and bred—as is also the

case with isolated, sterile medical laboratories. The isolation of the art school can be an attack on the health of students, but it offers the best conditions for breeding the bacilli of art.

In his influential text "The Sublime and the Avant-Garde," Jean-François Lyotard writes that modernist art reflects an extreme state of insecurity, which is a consequence of artists rejecting the help that art schools can offer—all the programs, methods, and techniques that could allow the artist to work professionally—and remaining alone.[3] For Lyotard life is within the artist, and it is this inner life that begins to manifest itself after all the external conventions of art are removed. But the conviction that the artist rejects school to become sincere, to be able to manifest his or her inner self, is one of the oldest myths of modernism: the myth in which avant-garde art is an authentic creation in opposition to the mere reproduction of the past, of the given. Art is proclaimed to be an expression of the artist's true identity, or at least as a deconstruction of this identity.

Yet Malevich makes a different claim that has proven far more in keeping with contemporary art: "Only dull and powerless artists defend their art by reference to sincerity."[4] And Marcel Broodthaers declared that he became an artist in an attempt to become insincere. To be sincere means precisely to remain repetitive, to reproduce one's own already existing taste, to deal with one's own already existing identity. Instead, radical modern art proposed that artists get themselves infected with exteriority, become sick through the contagions of the outside world, and become an outsider to oneself. Malevich believed that the artist should become infected through technique. Broodthaers let himself become infected by the economics of the art market and the modalities of the art museum.

Modernism is a history of infections—by political movements; mass culture and consumerism; the Internet, information technology, and interactivity. Additionally, our world has become a place in which theoretical discourses increasingly proliferate and circulate. In the time of the Cold War, artists, like everyone else, were confronted with a relatively simple choice between Communism and bourgeois democracy. Today old and new ideas multiply and diversify themselves. Especially since the astonishing public success of French philosophy from the 1960s and '70s, waves of intellectual fashions have rolled over the cultural world and artistic production, including over every "advanced" art school in the 1980s and afterward. Some philosophical authors became international stars. Some of these new ideas produced agitations for politically and ideologically motivated violence on a global scale.

Today's art students are attacked from all the sides by religious, philo-sophical, ideological, and political discourses of different kinds. Most of these discourses are critical, most of them proclaim their deep discontent with the state of the world, and most of them want to provoke a change in attitudes and in the actions of society. It would seem that an enormous amount of art is specifically concerned with social praxis, with using "critical theories" of different provenance to address not only social issues but the practice of art making itself.

The times are over in which a teacher could imagine his or her role as being an exceptional individual bringing the critical, theoretically trained, sophisticated mind into the world of habit and tradition. Students now are well informed about critical theory, and they are infected by it just as students were infected by modern technique in Malevich's time. So the question arises, how should students deal with new infections? Two immediate solutions of-fer themselves. The first is to overcome them, suppress them, ignore them, especially by turning to teachers who do the same; the second is, by logical extension, to leave art and go out into communities to heal the world. Both solutions betray the initial modernist project to live through one's infections without sanitizing either oneself or the world. And just as obvious, neither has led to the advancement of artistic practice or of its teaching.

Art practice itself is always already infected by politics. Every art activity consists primarily in policing the public, organizing public space, building a community of visitors and spectators, and structuring this community around certain priorities and goals. Of course, contemporary art is overwhelmingly tied to the art market, which means that artworks are seen primarily as commodi-ties. Works of art, however, are not just commodities but also statements made in the public space, where the majority of people see them not as buyers but as consumers of meaning. The number of big exhibitions, biennials, triennials, and so on is growing constantly. These exhibitions, in which so much money and energy are invested, are of course created for visitors who will probably never purchase an artwork. Even art fairs, which are primarily there for buyers, are slowly transforming into events that go beyond material acquisition; they include curated exhibitions, seminars, and lectures. In other words, they are becoming community activities in designated places that have the potential to transmit meaning in the social sphere.

The concept of the school, then, is entering into a reciprocal relationship, infecting the world as much as the world infects it. At the same time, the art system is well on its way to becoming part of the mass culture that for so long

it wanted to observe and analyze from a distance. It is becoming part of mass culture not simply as the production of individual objects that are traded on the art market but as an exhibition praxis that combines with architecture, design, and fashion—just as the guiding intellectual figures of the avant-garde, such as the artists from the Bauhaus, Vkhutemas, and others, had predicted as early as the 1920s and '30s. This is even more pressing now, when students are often invited by galleries and curators to show their works to the consuming public while they are still in school. Indeed, this very tendency to incorporate the art school actively into the demands of capitalist markets for ever new products indicates that the contemporary art audience more than ever before is part of mass culture, which can also be called entertainment culture.

Mass culture comprises transitory communities: people tasting pop culture through movies or music, who don't know one another, who don't know where the other came from or is going, who are assembled only briefly and then disperse—and yet they undoubtedly form communities of interest; of demographic, statistical numeration; and thus of data that are mined for significance, which inevitably leads to political as well as commercial interests. To put it another way, these are radically contemporary communities in their simultaneous heterogeneity and homogeneity, and they are much more contemporary than older ideas of religious communities, political communities, or labor collectives. All of those traditional communities emerged historically and presume that their members are linked to one another from the outset by something that derives from their shared past, whether a shared language, a shared faith, a shared political history, or a shared education that enables them to do certain jobs. Such communities always have specific boundaries, and traditionally they close themselves off from all those with whom they have no shared past.

But the entertainment culture that now must be seen to include art audiences is not closed off and is growing exponentially, while the art that is being made tends increasingly toward addressing issues of community, of social organization, of politics and the market. It is not surprising, then, that this is the atmosphere within the academy today. Unless students willfully choose to limit themselves to the historical transmission of traditions and techniques, they are equally infected by entertainment culture, the pervasiveness of the market, the social orientation of culture toward the mass and toward community, and thus, as I have already said, toward exteriority. The art school, at least on the graduate level, may harbor a transitory community of students and visiting teachers who change every few years, yet it has its own particular kind

of viral incubation that spreads outward beyond the academy's walls, which is the perpetual creation of its own network. Students form a community of colleagues that often lasts a lifetime, infecting one another through ongoing dialogues, studio visits, exchanges of work, collaborative projects, exhibitions, publications, and so on.

The openness to exteriority and its infections is an essential characteristic of another feature of the art school's modernist inheritance, and that is the inheritance to reveal the Other within oneself, to become Other, to become infected by Otherness. From Flaubert, Baudelaire, and Dostoyevsky, by way of Kierkegaard and Nietzsche, to Bataille, Foucault, and Deleuze, modern artistic thought has acknowledged as a manifestation of the human much of what was previously considered evil, cruel, and inhuman. Just as in the case of art, these authors and many others have not only accepted as human what reveals itself as human but also what reveals itself as inhuman. The point for them was not to incorporate, integrate or assimilate the alien into their own world but, conversely, to enter into the alien and become alien to their own tradition. They manifest an inner solidarity with the Other, with the alien, even with the threatening and cruel, and this takes us much further than a simple concept of tolerance. Over the course of modern art, all of the criteria that could clearly distinguish the work of art from other things were called into question. Sometimes a thing was conceived from the outset as a work of art; sometimes it was considered art only by its introduction into the gallery or museum. It is the case of contemporary art and its teaching that the concept of art per se cannot be reduced and cannot be taught within former limitations, as it has been so pervasively influenced by the will to Otherness.

The triple infection of the market, politics, and globalization, as they enter art practice and art education now, are joined together by this fundamental modernist viral strain. Indeed, this is not so much a strategy of tolerance and inclusion as a strategy of self-exclusion—of presenting oneself as infected and infectious, as being the embodiment of the dangerous or the intolerant. While so much contemporary art today that is socially based would seem to be just the opposite of this notion of self-exclusion in its focus on the agency of community, in fact the dissolution of the artist's self in the crowd is precisely this act of self-infection by the bacilli of the social. And so this infection of the market and politics, of what was once conceived as intolerable to the rules of art's identity, is unavoidable and the artist's body undergoes within the academy all the stages of the bacilli's intrusion: shock to the system, weakness, resistance, adaptation, renewal. This self-infection by art education must go on if we do not want to let the bacilli of art die.

AESTHETIC
PLATFORMS

Brendan D. Moran

Producing a contemporary building for the practical pursuit of art education is a tricky task. After all, in giving form to a social institution, it seems logical to avoid precluding potentially positive directions for change. Yet any specificity in a design that means to give form to a particular teaching philosophy is bound over time to fail, rendering a chokehold on change in place of being its enabler. Still, what choice does a designer have? Examining

the recent history of art school designs reveals that more often than not, ad hoc solutions have trumped lofty ambitions: art can be taught almost anywhere, and long has been. In principle, retrofitting existing structures and sites, if done intelligently and with a nimble touch, has proven to be no less restrictive or expressive than imagining new forms.

The challenge of designing art school environments has less to do with any existing need for iconic structures than with instituting flexibly configured structures—or platforms—in which creative production will take place.[1] Such a tactic may still involve studios with high ceilings and northern light, lightless subterranean spaces for photography or digital production, or a surfeit of social spaces for discussion and contemplation, but it also involves spaces with less specifically definable parameters. Since it is accepted that media specificity is not the only means to extend traditions, a higher premium is generally placed on nurturing creative experimentation as a normative value than on mastering techniques. In short, framing platforms for action reframes the circumspect educational challenges of *what* to do and *how* to do it. The history of architecture suggests that by allowing these questions to be distinguished from the more complex problem of *why*, socially expansive and interdisciplinary intellectual environments have been shaped throughout the twentieth century, with their layering of means, goals, and significance.[2]

Since the early years of the twentieth century, the architecture of training environments for artists has taken on the character of a "platform" in two distinct ways, both brought on by processes of democratization in cultural production and consumption. Like an oil rig, the art school has been conceived primarily as a mechanized interface between the harvesting and distribution of its resource, registering on its surface the rituals of productive exchange and leaving other aspects of the business securely concealed elsewhere. Less an atelier than a switching station or a valve, art schools in this sense constitute a variety of warehouse floors on which instructors, students, and administrators pull their respective weight toward the goal not only of the production of objects but of *movement*, of generational flows—and not just of art but of artists as well.

At the same time, the educational arena is increasingly comparable to the hardware components within computing, which must not only multitask in support of myriad software applications but that we want to house both efficiently and attractively, within a variety of *other* contexts. Allowing for infinite possible plug-ins, the seamlessly productive platform of the factory, as in Andy Warhol's exhibitionistic one, facilitates the types of recordings, recodings, and

transcodings that generate new textures and practices of art production, distribution, consumption, appreciation, and ultimately education for any and all interested comers.[3] The expansive locus of contemporary art education, like any good operating system, needs to provide a flexibility of connections between the arts and, perhaps more important, between art and nonart—especially since the most inventive contemporary work questions assumptions about the clarity of such distinctions.

Art instruction generally entails inculcating the ability to make informed choices from within a heterogeneous array of skills and techniques (some not even primarily involving the aesthetic), while simultaneously imparting a sense of how to ask socially relevant questions.[4] The emergence of this situation accompanied increased efforts to re-envision the milieus available for making both art and artists, and this was less the result of architecture culture imagining a new standard form for the art school than a side effect of the codification of the twentieth-century research university, a predominantly postwar American occurrence.[5] Between approximately 1940 and the late 1960s, dramatic shifts in culture and economics engendered the image of the artist as a free agent loosely tied to institutional patronage, a role typically taken on by colleges and universities.

Furthermore, with the gradual demise of determinate educational regimes that accompanied the general turmoil in art and society in the late 1960s, training largely based on medium specificity gave way to the wholesale reconfiguring of the interface of various art forms. Distinct mediums increasingly were linked together under larger categories of intermedia, interdisciplinary, environment, and even design, which hardly suggested a return to a unified *Gesamtkunstwerk*, the total work of art. Instead it presupposed a kit bag of techniques and artistic methods capable of being pilfered separately or in tandem by artists of any and all stripes. In fact, this was largely a reaction *against* American education's privileging of specialization over breadth or synthesis. As media-specific instruction in effect *supported* such specialization, its demise was oddly contradictory: While a diversity of practices ballooned, their ensuing standardization produced a higher degree of professionalization.

Ultimately, the result of integrating art education into the research university was a demotion of technique and a corresponding elevation of theory. This was true despite the fact that research into theory or theoretical innovation was typically *not* the apparent career goal of artists, even of those trained in this intellectualized environment—although in more recent years, it has been for some. The academic space of the postacademy studio became a laboratory of

sorts for experimenting with, among other things, the application of thought (theory) to the social complexities of art. This gave primacy to the studio as a space analogous to the computer "desktop" *avant la lettre*, or maybe more clearly the ubiquitous MySpace page. As part of what Mark Jarzombek has called the psychologizing of modernism, such spatialization has been increasingly private and noncommunal, constituted most effectively by one room for one student, replete with a door—and a lock.[6]

The emergence of multiple little "studio" cubicles for individual production, in lieu of common art studios for training in technique, corresponded to the total atomization of the public realm within institutional spaces. A prominent example of this is the now-ubiquitous "crit," which dates back to the 1950s for both artists and architects. The crit is a public revealing of a private activity, conferring a hybrid status on the closed space and intimate production of the individual studio. With all of these changes, one constant seems to be indefatigable: no matter what model for the housing of artistic training is evaluated, they are all found wanting by one analyst or another. And while the models have certainly diversified over the twentieth century, and now the twenty-first—among them, some seminal and still-potent examples—there has yet to be any new paradigm as momentous as the École des Beaux-Arts or the Dessau Bauhaus.

Ten "Projects" are distributed throughout the pages of this book. They comprise illustrations accompanied by brief descriptions that highlight some of these great paradigms, as well as hinge experiments and a variety of new buildings either realized or proposed, mostly since the 1970s. Many of the projects featured here have earned significance through their refusal to organize needed spaces in such a way that the forces of life and living are rigidly disciplined, made to fit into either predetermined arrangements or mind-sets, and in this way secure the ability to continue to generate new frontiers for art, education, and the design of art education.

PROJECT 1

**ÉCOLE DES BEAUX-ARTS, EARLY NINETEENTH CENTURY, FELIX DUBAN,
PARIS, FRANCE**

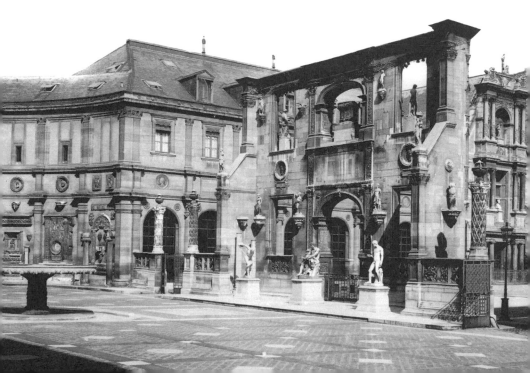

The Parisian École des Beaux-Arts was arguably Western Europe's premiere school of art in the nineteenth century, encompassing painting, sculpture, and architecture—the last segregated from the other two. Yet its status as the paradigmatic academic setting for training artists and architects, distinct from other environments of professionalization, such as guilds or workshops, extends back even a century and a half earlier. Repeated efforts were made to establish a distinct urban enclave for instruction following the first emergence of autonomous institutions in 1663, principally on the site of and within some of the buildings of a former monastery. By 1791, the Musée des Monuments Français was also housed within the same buildings, but it was not until some forty years later that the construction of an entirely new structure was achieved, the Palace of Studies. Designed by Felix Duban, the building accomplished an idealized image of the school's inner workings and public authority.

Instruction in both art and architecture at the École was sequential, with hierarchical stages traversed before the student could emerge as a productive professional. Early instruction was through mimetic exercise, conducted en masse in large halls, first by observing plaster casts and later through studying the live human form. More advanced levels depended on students becoming affiliated with ateliers, traditionally located beyond the campus within the city at large. Yet this stage also depended on the salon system, which pulled students out of anonymity through commissions and prizes into full-fledged artist status.

At the palace's center was a formal double-height hall, holding architectural and sculptural casts, and various rooms en suite around them for instruction and other activities. The complex of buildings that constituted the school after Duban's building was realized in effect encompassed many aspects of the public performance of making artists, among them the presentation of lectures, the housing of artifacts and texts, and various public interactions—as opposed to more private, atelier-based ones—between academy members, professors, studio instructors (masters, who were not professors but artists), and students.

In short, the academic environment devoted to art production, not yet a part of the national university system (this would happen only after the student protests of 1968), was instituted through a split between the professional interactions of artists—entailing not just schools but also museums, government agencies, and the more rarefied aspects of social life—and places for the production of art objects. Despite a myriad changes regarding education and the environment in which it took place, this basic split—though not often expressed or openly admitted—has remained relatively constant right up to the present.

CONVERSATION

John Baldessari and Michael Craig-Martin

MICHAEL CRAIG-MARTIN: It seems to me the most important thing about an art school is that it's the creation of a sympathetic ambience in which people feel comfortable and free to act according to their own instincts. You have to make a place where people feel at ease to be who they are and bring what they have, naturally, in themselves to bear.

I think that's true of the people teaching: the more students are put into a similar situation where they're at ease, the more successful the experience can be. You can't make it successful, but you can create circumstances where these things can happen.

JOHN BALDESSARI: I totally agree. You have to set up a situation. You can't teach art, that's my premise. You know, when CalArts [California Institute of the Arts] started—I don't know how it was at Goldsmiths—we just eliminated grades. We had pass/fail. You can't use grades as a punishment—you know, to attend class or do this or do that.

The students are there of their own free will. We also had no curriculum. In other words, you chose from a menu and made up your own dishes.

One thing I worked very hard on at CalArts was to try to provide a sort of aesthetic ambience that wasn't already present in Los Angeles. So I purposely avoided inviting any L.A. artists to join us. The faculty were all pretty much from New York. And I started a very active visitors' program of mostly European artists coming in. They would do shows or work with the students or whatever.

But basically, you're acting like Cupid, trying to make relationships between the artists. I tried to set up things where something might happen. You know, like I assigned David Salle to drive Daniel Buren around. It might just be dead in the water, but then again sometimes something happens. It's certainly not just about us as teachers.

MCM: That's what I say—you put something together. I mean, you build a school on the social circumstances that exist at any one time, and schools change in response to what the situation is. Goldsmiths is really a school of the sixties that's invented in the seventies.

And it's very interesting, John, what you're saying about the unstructuring of CalArts. These were all the things that we did at Goldsmiths too. We didn't even have classes, and students weren't attached to anybody in particular. They were attached to groups of people.

JB: Yeah, comparable to that, we had one guy teaching the equivalent of critical studies, and class was in session whenever you met him on campus. (Laughter) Which I thought was really very good.

MCM: The golden period of Goldsmiths was when the people who became so successful there just had a chemistry between them. The school, for a very short time, was in a particular building in which you had the art library, all the studios, all the workshops, the bar, and the canteen. And I could come in in the morning, check in here, check in there, go up through the studios—and in fifteen minutes, I'd seen everything that every student had done in the school since the last time I was there. That was unbelievably useful, this kind of powerhouse of a place where everybody was rubbing up against everybody else. And that seemed to generate a certain kind of companionability.

JB: I assume it was open twenty-four hours too.

MCM: Yes. You could go there anytime at all.

JB: Right. We winked at students living in the studios. They weren't supposed to, but it was a way to supplement their meager existence.

And one thing, too, I think we should look at more is that period of the late '60s and the '70s you mentioned—that's when everything seemed possible. Social change, I mean, and art was exciting.

MCM: It was the collapse of authority, of a sense of received ideas, when everything was under question. So naturally art education was part of that questioning. It became possible in Britain to do certain things in education because all the conventional constraints were put in doubt. And so if you wanted to just ignore them or undo them, you could.

You can't do that now. I mean, I don't know about America. The situation in Britain today would make the kind of school that Goldsmiths was in the '70s unthinkable. It would never get off the table. Somebody would announce the plan, but when everybody stopped laughing, they'd throw you out.

JB: In the United States at that time, there was one new college a month being opened, and students would just like be nomadic. They would go from one school to another. And because we were the hot new school, they all showed up at CalArts. I had this great idea that when you enrolled in a college program, you'd just get something like a credit card, and you'd get it punched for each school you went to. And then, when it's all punched, you'd get your degree.

MCM: But as you also implied, it's who's teaching that's an important part of this. And I've always thought that it's not what you teach the students; but a principal part of the function is to attract the students to come, to bring those people together. If you have people teaching there, they're bringing in some kid here and some kid there who is being attracted by one of these people. You get a different mix. That's what creates the school. It's not just that these are great teachers, because sometimes really interesting artists are not the greatest teachers. But if they feel comfortable and there are people attracted to meeting with them, working with them in some kind of way, that's where a school can shine.

JB: Well, right or wrong, I would say that you can't teach art, but it might be a good idea to have artists teaching. You know, so at least you have people who profess to be doing something we call art, and it might be interesting to hear what they have to say about it.

MCM: Yes, it's very important to have people whose central world is not the world of education. The great thing about having artists teaching in an art school is that they bring their experience of what it is to be an artist in the world. And so this thing you can't teach, you're teaching by example. You're teaching by your presence. You're teaching because you're sitting at lunch with

kids, and they're learning as much at lunch, if not more, than they are when you're talking to them in the studio.

JB: Well, you're demystifying the idea of an artist. They're not somebody who's in a book or magazine or museum. You know, they're ordinary people. Now and then they'll do something good—most of the time they don't.

MCM: And they're trying to figure out how to get by.

JB: Yeah, exactly. And you learn that art is not orderly: You don't go A, B, C, D and end up with art.

MCM: Which is why you can't have a proper curriculum. There are no basic things. What's basic for one artist is not basic for another artist. And so you can't have basics; you can't build it in the normal curriculum way. The amazing thing about young people is they can jump in at a very sophisticated level without actually understanding what they're doing. Somehow that innocence also allows them access to something. And so a part of teaching is helping them to realize what it is that they've stumbled on.

JB: Art schools are unlikely bedmates with universities. The university is a home to a physicist or some kind of biotech lab, but it's not a home for an artist. It's a very uneasy alliance. And people on the faculty can never understand why you don't have a Ph.D. They just don't get it.

MCM: I couldn't agree more. When I went to Britain, I was absolutely amazed because there was a whole set of universities and then there was a whole set of art schools. An art school was something in Britain. If you said to an ordinary person on the street, "Oh, he goes to art school," they didn't know what an art school was. But everybody knew there were things called art schools. It was part of the social fabric of Britain. And they ran parallel to each other. We didn't do the same thing as the kind of education in a university. We had some other form of higher education. So you had these two streams of higher education. It was absolutely a brilliant structure.

Then, in 1987, Mrs. Thatcher thought, *I'll upgrade all of these pathetic little places that are not universities and make every college in Britain a university.* And all of the structures of the university, which were irrelevant and harmful to art education, were put in place. There are hundreds of kids in Britain doing

Ph.D.s—*Ph.D.s!*—in fine art. And the terrible thing is, where does a Ph.D. have meaning? In the art world? No. It has meaning in one place.

JB: Teaching.

MCM: Now what's going to happen is we're going to end up with schools that are entirely run by people with Ph.D.s, who have no experience of the art world at all. It could not be a worse situation.

JB: When I was at the University of California, San Diego, I was on this ad hoc committee to advance somebody in the art department. And, I don't know, somebody from physics or whatever asked why weren't we considering Paul Klee to teach. And I gently reminded him that Klee was dead. (Laughter) And then they said, "Well, what about de Kooning?" And I said that he could probably get more money in one painting than you could pay him for a whole year.

MCM: I suggested at Goldsmiths, with the Ph.D. program, that what they should do is to call about ten really interesting major artists around the world and say, "Would you like to get a Ph.D. from Goldsmiths? Come back in five years and tell us what you've been doing." (Laughs) Because you are doing the highest-level research in the world. If you want the highest-level research, you need to go to Jeff Wall or whomever. You need people who are out there, in the world, doing what it is that an artist does. That is the equivalent of being a Nobel Prize–winning physicist. Conversely, of course, the minute an artist feels a constraint from an institution, they're out.

JB: Exactly, exactly. And part of what we're talking about, too, assuming that one might want to get artists to teach, is that you can't impose a kind of construct on them of a semester and a quarter and these hours and this number of classes. You just figure out, you know, what they could adjust to and then try to make it work for them.

MCM: Oh, there's no doubt that people who are happy in what they're doing perform much better than people who feel constrained. And the minute an artist feels a constraint, if they have any option at all, they're out.

JB: Yes. The only way I got Sol LeWitt to teach was he wouldn't go on campus—you'd meet off-campus. We just hung out in a bar, and that worked. You

know, it's like all the planets surrounding you have to line up in the right way: the right students, the right time, the right faculty, the right city. Everything just aligns for a few moments.

MCM: And if you're one of the kids who's in that group, you get an advantage that just as good a student doesn't have three years earlier or three years later. And it's the breaks. There are these strange moments when things can happen.

JB: And you don't know about it until after the fact. An art school will have an incredible reputation for things that happened about five years ago, but you didn't know it back then. Then you look back and say, "Wow, those were the golden years," as you said.

MCM: Absolutely. And then it's changed. Everybody wants to go there, and of course by the time they want to go, what it was is gone for the very reason that the people who began to come to the school are going there for different reasons, with different criteria, because they think that it's going to lead automatically to something. Of course, as we said, schools don't guarantee success. It's pretty much over by the time you read about it in the newspaper.

But it's always changing. I mean, when I first went to London, the art schools *were* the art world. Of course, there were artists, and, of course, there were very good artists, and there were many different things going on. But the art schools were the art world, and it mattered where you taught because that signified what your team was, who you were really interested in. There were six major art schools in London. One was very conservative, one was very radical, one was interested in this, one was interested in that. And people who taught in these places were drawn to these things. Now in London we have a very big art world—and the schools have become less important.

JB: It's almost the reverse in L.A. An art school called Chouinard became CalArts. There was a second art school called Otis Art Institute, and that became . . . Otis Art Institute. (Laughter) But different. There's UCLA; there's the University of Southern California. Pasadena College of Art and Design was strictly design, and yet to emerge. And was there any hot art school to go to? Probably it was Chouinard. When you look back, that's where the good artists had gone to school.

But the difference at that time was that the good artists were not teaching. That's something you did when you had to make a living. And the same thing obtained in New York—that you taught if you couldn't make enough money off of your work. I would have a lot of arguments with my colleagues in New York about why I taught. And then things began to change. You got very good artists teaching, and this continues. Does Charlie Ray need to make money? Paul McCarthy, Mike Kelley? No, they don't need to make money, but they are teaching. And because of that, it creates a certain kind of energy, I think.

MCM: Initially, I was teaching entirely in order to make a living, and it never occurred to me that I'd spend so much of my life doing it. But then I think that both you and I were people who, once we were doing it, had to make it interesting and enjoyable for ourselves, and so we got engaged in the question of what it was that we were doing.

JB: Well, we had to support ourselves. I tried other jobs, and they were pretty boring. I wanted something that was related to art. I started out as a public school teacher, and slowly, as I went on, I thought, *If I'm not going to have to commit suicide, I'm going to have to make teaching like art.* Or somehow a form of art. And if I could think of it that way—and art is about invention—then how could I make art interesting for myself and not go out of my bloody skull? So I just tried crazy things with the students.

I can remember one class when I just put up a map of L.A. on the wall, and some student would throw a dart at it and we would just go there for the day with some cameras and just fuck around.

Conversely, I learned a lot about art by teaching. You know, you don't teach by lecturing. You try to communicate, and that's not lecturing. You know you made a point when you see the light in a student's eyes—"Oh, yeah, I see." But you don't just tell him and walk away. It's a flirting game.

MCM: No, I agree completely. I certainly found one of the reasons why I had to stop doing it was because, to me, teaching is something that has to be done over a long term. I don't know how to do it in one go. I sometimes said to students, "You know, I could tell you everything I know, everything I could think of saying to you, in a day or two. But it wouldn't make any difference because you'd understand all the words, you'd write it all down, it would all make sense, and it would be absolutely useless to you. The thing you have to do is *you* have to act it out. I say the things, *you* act the things out. Over two or

three, four years you say, "Ah, now I know what you meant." They have to find that moment.

JB: I've always been kind of painfully aware that when I'm teaching, I'm not. And when I don't think I'm teaching, I am. Students are watching you. You're teaching all the time, when you don't know it.

Roy Lichtenstein made a beautiful point once. He said: "You can be in a museum, looking at the best painting in the world, a beautiful woman walks in—what are you going to look at?" (Laughter) But that's very profound. And if you're lecturing in a class and there's a car crash outside, you better bring that car crash into what you're saying or you've lost them.

MCM: Yes, I don't know how to do something unless I get engaged in it like that. I'm either in or I'm out. I ended up being in for much longer than I ever intended.

One of the issues that's different from when we started teaching is that there are artists these days who become financially independent much younger, without ever having had the experience of teaching. And I find that those people are very reluctant to become engaged in teaching later on because they have no experience of it. It scares them a little bit, and they think, *Why would I bother doing it?* And even if they are slightly interested, when they get there, they're a bit intimidated because they don't have the experience—the kind of grassroots experience—that people of our generation had.

JB: Well, it's about being terrified too. CalArts has such a reputation; a lot of artists wouldn't come there because the students would just tear them apart.

MCM: And they would too. I stopped teaching about seven years ago. I found that I was no longer comfortable in the situation that art education in England presented me with.

Also, my own situation had become distorted because I had become known outside of the school as somebody who taught. My relationship with students changed, from the generation of people like Damien Hirst and Liam Gillick and those people when I had been just another person in the school, had changed. Afterwards, when it became a thing that I'd somehow been involved in the success of that group, it changed everything. And I felt very uneasy about it. The question of the market is so far from our original experience.

JB: Yeah. Well, I could see a sea change happening right about the early '80s. Once a year I would invite like an art dealer to come to CalArts. I invited Paula Cooper to come, and she was very upset afterwards. And why? Because the students didn't want to know about the artists—they wanted to know about how much money the art was selling for in the marketplace. From then on it was changed. And listen, when parents read about the success of art in the *Financial Times* and the *Wall Street Journal*, kids are no longer going to have a fight with their parents about going to art school, you know? They'll have a fight about becoming a doctor or a lawyer maybe. (Laughter)

MCM: Yeah. "Why don't you go into something safer, like art?"

JB: Yeah, "like art." (Laughter) So I think the reasons for going to art school have changed now. It's so you can hook into a network. It's a huge marketplace.

MCM: You know, in Britain, when Damien curated "Freeze," he was in his second year at Goldsmiths. The kids had no idea about money. They weren't thinking about it. There was no money in the art world. It wasn't part of Damien's ambition any more than it was anybody else's. But what there was was an ambition to make work and get it seen quickly: "We're not waiting around for people to come and validate us. We want to engage." What happened was that that attracted commercial interests quickly.

JB: I don't know. I'm still an idealist. I do think that if you can get a group of really interesting people together, you're going to attract good students. And it'll be sort of like the Frankfurt School in New York, you know? Something might come out of it.

MCM: I think, in all of these changes, at some fundamental level, there's good, authentic art and nongood, inauthentic art. And this has always been the case. There have always been artists who made fortunes who were of zero interest as artists. So the question of there being money in it is a distraction. When somebody can spend a million dollars making something, it's hard not to take it with some degree of seriousness because of how much has been thrown at it. But it's just like the movie industry: they spend a fortune on films that flop. It's not a guarantee. Nothing's ever a guarantee.

JB: I think what is omnipresent is always this cloud over a student's head: "I don't want to suffer to be an artist. I want a family, a home. I want to go out to restaurants. If I can do that, I'll be an artist." The idea of sacrificing to do art, it's not there anymore.

MCM: It didn't even occur to us that it was a problem. You did one thing in order to enable the other thing that you wanted.

JB: But you don't find that now—very rarely anyway. Nobody wants to lead that kind of life.

MCM: We used to think in terms of "radical" or "not radical." This is an irrelevant issue now. The question is: How do you come up with something that is identifiable as yours? It's logo-ing. It's branding.

But one of the things that's interesting about art is that it doesn't necessarily follow the obvious, endless trajectory in one straight path. Some kid finds a way of refusing that is so interesting that it undermines all of this other thing.

JB: Exactly, exactly. Because there are going to be people who don't want to deal with it. They want to change it.

MCM: You know, everything at Goldsmiths was made out of a piece of paper, a bit of string, and a bit of old . . . something. And everybody made work because there wasn't anything else. There was no budget. There was no money. We were in this dump at the end of the line. We didn't know what we were doing, and we had incredible freedom. But you can't have radical without orthodox. And if there's no orthodoxy, if there's nothing that's the status quo, what do you resist?

JB: Our job, if you can get the kid to talk about this crazy idea in their mind, is to encourage them or say, "That's kind of tired," and see what kind of reaction you get. Or you can lay out to them the whole history of that idea that they think is so terrific, and say, "Okay, if you can go somewhere with that, then do it."

I always thought of myself as a facilitator. I might point out to them that they're reinventing the wheel. And they might get to where they want to go faster if I can fill in some information for them.

At CalArts I had a teaching assistant in '70 who had a rubber stamp made that said: "Nice idea, but it's already been done by," and there was a line and you just filled it in. (Laughter)

MCM: You can definitely speed things up. You can bring so much to bear. It would be very difficult to find all of this out if one were out in the world on one's own. An art school is essentially a shortcut. It's a condensing of a certain kind of experience. But a school, certificate or not, cannot authorize someone to be an artist. It's not like going to law school, and the day before you weren't a lawyer and then you get your certificate and you're a lawyer.

JB: Well, I think there are some hard lessons we've learned. Certainly, a school is not about real estate. It's about faculty. It's about getting together a group of core people who might be exciting to young artists, so they might want to find out what's afoot. And then you put all that stuff in the pot and see what comes out, and you have no idea what's going to.

MCM: A lot of young people have very sensitive antennae for... I would call it "authenticity" in the person that they're talking to. And when they're presented with somebody who they sense has authenticity, it has a lot of impact on them. Part of a good art school is to pull in those people—and a lot of it's to do with example.

I think we took a criterion that was in us about our idea about art, and we created an education that reflected the values that we were seeking in our art. And other people now need to come along with other ideas, the things that are deepest in them about their art. And *they* are the ones who should form the schools of the future, not us.

JB: I don't think any potential M.F.A.s would necessarily be interested in creating a school, but they'd like to be around some artists who were thinking about doing really great art. And if you could be in that situation, then what do you have but an art school? Or you can call it something else. But it's a bunch of people, like some older artists and some younger artists, saying: "Well, let's see. Can't we kind of fuck things up? What can we do?" (Claps hands once.) And there you are.

DEAR COLLEAGUE

Robert Storr

Genius needs no education. It is sui generis and self-sufficient, effortlessly assimilating what it needs to know of the world and the expressive means it requires. Accordingly, genius is not the problem of art schools. Indeed, but for melancholia and social ostracism, which are traditionally its hallmarks, genius is not a problem at all, except for those who possess or are possessed by it—though the fact that lesser mortals cannot fathom its demands

and torments adds mesmerizing shadows to its luster. For the rest, genius goes its own way and achieves its own ends with abundant rewards in the here and now. Freud listed them as fame, fortune, and the love of women, or at any rate guaranteed posthumous honors, though Leonardo da Vinci's imputed homosexuality perplexed the good doctor while opening the prospects to a wider span of human desire.

Once the battle for modern art was won against the forces of the academy, whose conservative training and principles were held up by the avant-garde as the antithesis of unfettered creativity, the godlike qualities that cloaked da Vinci were bestowed on Pablo Picasso. In retrospect, the necessary refitting was less dramatic than it may originally have seemed, as in both cases, the archetypical genius was personified by supremely confident, supremely capable men of the world whose prodigious talents as draftsmen and painters were apparent from their early youth. As to those who filled the bill in three dimensions, there was the saturnine polymath Michelangelo and the virtuosic modeler and carver Auguste Rodin, each in his own way comparably sure of his powers and preeminence.

By the same token, the classification uneasily fits the more awkward exemplars of all-but-inexplicable artistic innovation and achievement, such as Vincent van Gogh, Jackson Pollock, and David Smith. Their ambiguous status directs attention to a paradox at the heart of the concept of genius, when it bumps up against the paradigm-changing imperatives of modernism. For none of these three artists showed any natural gift for drawing in the traditional manner, which is widely assumed to be the litmus test of innate talent. To the contrary, their basic inadequacies in this domain do much to explain their fierce pursuit of alternate formal modes.

Today, of course, the very category of genius is under relentless assault from postmodernist thinkers. They question everything about it, but especially its implicit or explicit disregard for all of the contingent social, cultural, and political factors embedded in the goals and methods of individual artists. They are just as skeptical about the supposedly transcendent standard of quality by which genius's accomplishments are judged. These critics argue that in lieu of such a contextual appreciation of art's genesis and reception, we are left with yet another version of the Great Man theory of art history. The only matters of dispute are who belongs in the pantheon and which values determine the place that they are assigned in that hierarchy, where instead we should be debating the ways in which individuals act as agents of history. Why history as a teleological entity (or capitalized periods within it, such as Late Capitalism) should

replace the Great Man as a metafictional protagonist is a subject worth looking into—but not here.

BIG PROBLEMS AND SOME (OTHER) HISTORY

At the advent of the women's movement in the 1970s, when Linda Nochlin asked the rhetorical question, "Why have there been no great women artists?"— thereby riling feminist colleagues eager to correct the perennial imbalance between male and female "old masters" by tipping the scale in favor of unfairly neglected, but rarely unquestionable, candidates for laurels—part of the answer she offered focused precisely on their absence from or severely restricted acceptance by the very academy that modernism had ostensibly overthrown. In the nineteenth century, when the genres of paintings were still ranked with history painting at the top and still life at the bottom, women lucky enough to gain admittance to an academy were confined to still life or, in ascending importance, to landscape and portraiture. However, history painting required the undraped life study of models of both sexes, and such classes were not considered the proper place for a lady—a restriction that women of earlier generations, such as Artemisia Gentileschi, had not necessarily suffered. Eventually Thomas Eakins and others broke that taboo, and today few schools accord much importance to the nude. Moreover, virtually none concern themselves with its morality, except where "the gaze" remains stigmatized by puritanical strains of feminism as essentially male and heterosexual, an attitude as anachronistic as earlier forms of prudery.

Reminding the reader of women's struggle for full recognition in and full access to the academy is not intended to fight old battles to forgone, though still only partially achieved, victories. (Let us not forget that in the majority of art schools, male faculty members still outnumber their female counterparts even as female students frequently outnumber males.) Instead, the point is to demonstrate the contradictions at the heart of the modernist myth, contradictions still deeply ingrained in the postmodernist myths that have supplanted them. More specific, the point is to underscore the pivotal role that art schools have played in modern art's development, not as a symbolic foil for genius and a brake on progress but as a potential or actual engine of positive change. Nochlin made plain that reaching gender parity in visual culture would not come about by hagiographically rewriting history based on the miraculous discovery

of previously unsung female geniuses who matched the men comprising the male canon. Instead, what was needed was the removal of the impediments that had long prevented women from getting the same high level of formal education that men held a monopoly on.

It should go without saying that the same obstacles and more have confronted artists of color—with the same statistical consequences until very recently. Exceptions to a general lack of educational opportunity thus account for the scarcity of black artists in or under consideration for the canon. But the embrace of the academy—no matter how limited or halfhearted—has much to do with the relatively high standing of those who have belatedly found their niche in textbooks and museum collections. Notables in this regard are Osawa Tanner (a student of Eakins at the Pennsylvania Academy of Fine Arts); Romare Bearden (a student of George Grosz at the Arts Students League, where the comparably poor and far more provincial Pollock was mentored by Thomas Hart Benton); Augusta Savage (who attended Cooper Union, a wholly scholarship-based institution in which the arts were fostered alongside engineering and other "practical" disciplines); and Elizabeth Catlett (the product of the George Washington Carver High School in Harlem, where her teachers included Norman Lewis and Charles White). That all of them followed artistic paths in which elements of their academic training were retained partially explains why modernists of the mid-twentieth-century formalist stripe have been so reluctant to accept them as part of the broader modern movement. They are routinely consigned to marginal status—if any attention is devoted to them at all—thereby perpetuating institutional racism on "aesthetic" principles.

As an educational matrix, the academy is defined not only by the elite visual arts conservatories but also by the lower echelons of the same instructional system and the more forward-looking secondary schools that prepare young people for it. Nevertheless, taking these examples of ignored and marginalized artists and multiplying them across generations, communities, countries, and cultures, the academy functioned as a ladder of social mobility. In the United States, the GI Bill subsidized veterans of World War II, the Korean War, and more recent conflicts who sought accredited artistic instruction that they would otherwise have been denied. (Paradoxically, this has made military service a base of support for the arts of arguably longer-lasting and more far-reaching importance than the Works Progress Administration or the National Endowment for the Arts.) Meanwhile, the incorporation or expansion of art departments in colleges and universities throughout the nation, especially in low-cost state schools, provided previously nonexistent venues for veterans to

make use of that financial resource while opening doors for others who were similarly inclined and often similarly hard-pressed, but who were able to make the jump with the aid of affordable student loans. Without the combination of these factors, we might never have heard of Ellsworth Kelly or Leon Golub. Nevertheless, academic pursuit has not been without its own ambivalences. David Smith bluntly declared that the artist should not be, indeed could not be, "well rounded" and remain true to his or her nature or vocation. His compellingly adversarial example, coupled with the skepticism that so many modernists have felt toward social integration and supposedly cerebral pursuits, remains deeply embedded in the educational model we have inherited.

This ambivalence abides, despite the myriad counterexamples that one could point to before arriving at postmodernity. For instance, both Smith's near contemporary, Ad Reinhardt, and his junior, Philip Pearlstein, worked toward degrees in art history at the Institute of Fine Arts before consecrating themselves entirely to their own work. Moreover, Donald Judd and Allan Kaprow both attended Meyer Shapiro's lectures at Columbia University. That scholarly apprenticeship manifested itself in Kaprow's open challenge to Bohemia in his 1964 *Art News* article, "The Artist as a Man of the World?"[1] in which he flatly, defiantly stated that rather than being outcasts "suicided by society," as Antonin Artaud had described Van Gogh, most artists of the postwar, post–abstract expressionist generation were college graduates seeking reasonable economic security as a reward for the rigorous advancement of their artistic ideas and for their pragmatic striving after professional recognition.

ACADEMIES AND ACADEMICS OLD AND NEW

In light of these developments, the gathering emphasis that they place on concept in relation to craft, and the relation of all of this to what is taught and how it is taught in art schools today, it is pertinent to double back and recall the pressures that brought about the creation of the original artist-engendered academies of the Renaissance—crucially that of the Carracci family—on which the state-mandated Academy of Louis XIV and its many offshoots were premised. The Renaissance saw a diversification and expansion of demands made on artists by aristocratic, ecclesiastical, and moneyed private patrons. These demands put increasing strain on the medieval methods of transmitting aesthetic tradition from master to apprentice within the old workshop structure.

Ambitious artists who saw their interests mirrored in the new intellectual and practical disciplines that emerged with the rediscovery of antiquity began to aspire to a higher status in society than that of skilled artisans.

As humanism flourished during the Renaissance in rhythm with fitful relaxations of religious dogma and political constraint under "philosopher princes," science and the liberal arts were born. Da Vinci epitomized the visual artist as a central figure in this constellation of learning. The need for an in-depth knowledge of rhetoric, literature, history (sacred and secular), mathematics, and the classics became imperatives for anyone hoping to find more than a subordinate place in the new system. For the first time in the West, artists—whether exalted or unexceptional, mad or bad—were expected to be educated men to some considerable extent. The partial alienation and eventual disenfranchisement of those who overcrowded that same system during the nineteenth century, or were simply excluded from it, gave rise to the bohemian who compensated for this loss by being, in part or in whole, an autodidact. Here van Gogh's restless self-instruction provided a template for maverick or renegade talents. (Contrary to the conventional image of van Gogh as a stammering intuitive, he was a great reader and a constant writer. His on-again, off-again relations with mentors, chief among them Camille Pissarro, also furthered his education.)

To this brief summary must be added the modernist academies of the twentieth century that were formed as alternatives to the nineteenth-century academy in crisis. Preeminent among them was the Bauhaus. It was created in 1919 by Walter Gropius out of the ruins of the old Weimar Academy and subsequently transformed and transplanted in Germany (from Weimar to Dessau, and finally to Berlin) by other leading lights of the avant-garde. The Nazis shut it down in 1933, and it was then taken into exile in America, where its principal reincarnations took shape at Black Mountain College under the guidance of Josef Albers (later the spark for the rejuvenation of the arts program at Yale, the oldest such university program in the U.S.) and at László Moholy-Nagy's New Bauhaus in Chicago, which ultimately became the Illinois Institute of Technology. Russian and Dutch undertakings along the same lines were equally important in the 1920s and early 1930s, though their impact has been less pervasive due to a variety of factors. The delayed effects of the Soviet constructivist model have been much greater, prompted by the more or less direct formal parallels to minimalism and by the active investigations of the postmodernist art historians into mid-twentieth-century modernism's antecedents. Common to all of these insurgent academies was the notion that teachable visual principles and

theoretical perspectives regarding art's place in society transcended all media and rendered obsolete their former separation from each other. Accordingly, their previous hierarchy (with painting at the pinnacle and crafts at the bottom) was dispensed with, and students' premature specialization in any of them was discouraged.

Against this background, three other experiments deserve to be cited that set the tone for arts education in the later decades of the twentieth century: the Kunstakademie in Düsseldorf, where in the early 1960s, Joseph Beuys and others turned an old-style academy inside out to fashion a free-form environment that fostered new media as well as old; the Nova Scotia College of Art as constituted in the 1970s, when it was a small, relatively isolated but nonetheless worldwide center for conceptual art; and the Disney-linked California Institute of the Arts, where vanguard figures ranging from John Baldessari to pioneering feminists such as Miriam Shapiro engaged in a process of pedagogical "détournement"—to borrow situationist nomenclature—and fundamentally restructured an institution established to feed the entertainment industry into one that radicalized the "culture industry" in the broadest, though not always purest, ideological sense in which Theodor Adorno intended the phrase.

AESTHETES AND ANTI-AESTHETES

Of course, the rise of "conceptual" practices is crucial to the shift that these three schools represent. It was Duchamp's condemnation of "retinal" art (i.e., painting) and of perceptual art in general, coupled with his elevation of ideas to the status of a primary medium, that set the conceptual dematerialization of art in motion. Ideas, inherently mental rather than physical as they are, were tangibly articulated by Duchamp in subordinate, often hybrid, sometimes ephemeral media. Duchamp, an accomplished painter with a chip on his shoulder about the traditions he was turning his back on, became a direct or indirect craftsman in a wide range of forms and processes and a connoisseur of paper; typography; printing technologies; book design and book binding; casting in bronze, lead, plaster, resins, and rubber; photography; lighting effects; as well as the vernacular objects that he selected and sometimes altered to realize his readymades and assisted readymades. This only attests to the exquisite degree of formal discernment and attention to facture that was intrinsic to a practice so supposedly indifferent to how things were made or how they looked, except

insofar as facture conveyed the anti-artist's all determining anti-art idea. His example spread. It became academic.

If I have added quotation marks to the term "conceptual," it is only to signal that its meaning as generally understood at present is nonetheless wide open to doubt, if not contestation. The eventual corrective to nineteenth-century aestheticism, as exemplified by Charles Baudelaire and Oscar Wilde, was Duchamp and anti-aestheticism. The conceptual and the anti-aesthetic also come in forms high and low, and so far as the eye can see, there is no end to the line of journeymen postmodernists who feel intellectually entitled—like their journeymen modernist predecessors—to a live-work space and a teaching job.

Since Duchamp, the pendulum has swung decisively toward what Gregory Battcock called "idea art" in his 1973 anthology of the same name, nudged further in that direction by the steady legitimization of contracted fabrication, often coupled with a "machine age" aesthetic and, at least nominally, "workerist" politics. Already in 1922, Bauhaus master Moholy-Nagy was literally phoning his paintings in to an enameling factory that produced them to his specifications, and in 1962 Tony Smith did much the same to have one of his first minimalist sculptures made. Considering his employment of draftsmen and technicians, Sol LeWitt's dictum that "an idea is a machine to make art" emblematizes this fusion of concept and delegated facture. However, LeWitt did not believe that a work could exist only as an idea, but that it must be physically realized, differing in this conviction with Lawrence Weiner. Still, LeWitt opted out of making his own work on the grounds that his assistants could do it better, which is to say not more pleasingly but more articulately, even as he maintained that "banal ideas cannot be rescued by beautiful execution"—words to the wise for contemporary artists who specialize in the expensive manufacture of conceptually specious products.

Needless to say, current academic and art world contests and standoffs do not for the most part focus on painting, except in opposition to it. This has put that medium on the defensive in relation to photography, film, installation, and various avowedly conceptual practices, even when artists critical of its potential and their own engagement have represented it in an institutional setting, as was the case when Gerhard Richter and Jörg Immendorff after him held professorships in painting at the Düsseldorf Academy during and after Beuys's anarchic, multimedia era.

In the best as well as the worst of ways, this shift has meant the academicization of the anti-aesthetic impulse in all its myriad manifestations from

agitprop text and photomechanical "pictures-type" art to antimonumental scatter or scatological plop art, most of it in one form or another captioned by "theory." Having pressed to give the art's pedagogical consolidation its due, I will insist that as apparently contradictory and as troublesome for traditionalists as this particular academic assimilation of an avant-garde tendency has been, it has also been necessary and dialectically fruitful. Nothing has done more to keep "old" media from depending for their future on artists in semiretirement than their having fallen into the hands of those who must substantially reconceive them in the fight to carve out a place for themselves in the world. Indeed, that was precisely Richter's dilemma when, as a painter with little idea of modernism and still less exposure to modernist work, he arrived in the Rhineland at the moment when neo-Dada took hold of the academy and the art world.

In fairness to the traditionalists, though, let me remind readers of the gist of Leo Steinberg's indispensable essay, "Contemporary Art and the Plight of Its Public."[3] In that 1962 text, Steinberg describes his own painful struggle to come to terms with his mounting fascination with Jasper Johns—then a dazzling and disorienting thirty-two-year-old upstart on Tenth Street—and his equally intense grasp of the consequences of that attraction. Everything that Johns seemed at the time to represent (formal and intellectual calculation and rigor) was theoretically, but also aesthetically and emotionally, antithetical to what Steinberg had come to value in Abstract Expressionism. To borrow from Roland Barthes' *A Lover's Discourse* as a way of describing Steinberg's predicament, he felt himself succumbing to a dangerously illicit love as it eclipsed another legitimate one, and so he experienced the exhilaration and anguish of temptation, infidelity, and alienated affection.[4] But as Steinberg examined the phenomena of his own discomfort, he took pains to explain how others who did not share his mounting excitement could quite reasonably experience such pangs without falling into the camp of hidebound reactionaries—or at least not respond with a single recoiling leap backward. After all, Steinberg argued, was it not the case throughout the history of early modernism that vanguards that carried the day and became established consistently rejected or belittled the challenge of those that followed in their traces?

Why all of this capsule history? Because the problems that currently bedevil art education in the United States, as well as in many other countries, issue directly from a long-standing tendency to reassert obsolete philosophical dichotomies (mind-body/intellect-intuition/creation-interpretation/aesthetics-criticality) and impose them on institutions of differing types in order to pit those institutions against one another or against noninstitutional or quasi-institutional forms of teaching and learning. The reassertion of these false antagonisms regarding human consciousness and creativity is the work of "radicals" as well as "traditionalists." In both camps, that reassertion usually comes with a disclaimer that states that the person or group forcing the distinction between one-half of a binary and its counterterm intends no such thing, but is simply "defending" the holism of their complex position against the oversimplification of their real or fantasized adversaries. Those adversaries, they hasten to say, are eager to reduce all understanding to one absolute principle.

Here I am compelled to remind readers that the glorious times of the past that traditionalists habitually refer to when condemning the current money-driven scene, where the artist is nothing but a brand-conscious entrepreneur, were ones in which studio labor frequently did the lion's share of the actual painting or sculpting that went into the works that the artist-as-idea-man-and-virtuoso-project-director sold to wealthy patrons. The differences between the "culture industry" of the Renaissance, baroque, and neoclassical eras and our own are considerable, but they do not hang on the opposition of things entirely created by the hand of the master and those created under his or her supervision. If there is a distinction to be made between the factory that Peter Paul Rubens ran and the one that churns out Jeff Koons's paintings today, it is in the standards maintained by the studio head; the talent of the workers under his direction (we may yet discover that a contemporary Anthony Van Dyck was in Koons's employ, but that does not elevate the averageness of the collective output); and the quality of the ideas that drive the enterprise.

The gap between Koons's "idea" of painting and the results he gets from his generally skillful crew points to a fundamental principle at the crux of the dilemmas now facing those who teach studio and poststudio art. For if LeWitt is right that "banal ideas cannot be rescued by beautiful execution,"[5] the banality of an idea may nevertheless have its origins in an artist's inability to discern and act on the qualities intrinsic to his or her medium. These are qualities learned by doing something deliberate with the medium, while remaining

vigilant to what the medium itself may be inclined to do and, in the process, what it may suggest to the maker, thereby complementing or altering his or her intention. Under these circumstances, facture is invention rather than execution. Making is thinking. Repeated experience of such physically engaged cognition and cogitation stimulates and stocks what the French art historian Henri Focillon called "the mind in the hand."[6] There is no substitute for that mind's knowledge or for its powers of imagination—and no fast track for realizing its potential.

To say this is not to recreate the cult of authenticity that is attached to the autograph work (primarily the concern of romantics and art dealers), but simply to assert that logos, the sign of reason and divinity, resides not just in the text but in the body and its phenomenological awareness of its own capacities and of the sensual world around it. On the latter score, I will conclude this part of my purposefully patched together thoughts on art education with an anecdote that stresses the objectivity even of verbal language, which is, after all, only one of art's languages. A frequent guest at the home of the great symbolist poet Stéphane Mallarmé, Edgar Degas, once asked his friend for advice, as he was having a hard time with his "violin d'Ingres"—that is, his aesthetic hobby—which was writing sonnets. "I have no ideas," Degas complained. To which Mallarmé replied with gentle exasperation, "But poems are not made of ideas, they are made of words." Of conceptual art modes, Bruce Nauman could not have said it better.

AXIOMS AND RULES

The outline of this essay is no outline at all, except insofar as a net woven in fits and starts can be said to have an overall plan or is the necessary result of an incremental technique and the dimension of its application. As with a net that is designed to catch something, but has the shape of the things it catches when thrown in this direction or in that, the only step to be taken when one decides that it is big enough for the anticipated prey is to tie off its loose ends and test it. I will leave testing it to another time and to the work of art schools to be observed and analyzed, but I'll tie off my loose ends by making a series of plain yet emphatic claims and statements—partial justification for which I hope to have provided in the preceding remarks. And so, with a nod to Ad

Reinhardt, I offer my own version of "Rules for a New Academy," accompanied by these introductory axioms.

Genius lacks nothing that it needs.

Art schools have nothing to teach geniuses.

Geniuses do not go to art schools.

Students who go to art schools aren't geniuses.

Students who go to art schools lack something.

Students go to art schools to get what they lack.

Students don't always know what they lack.

The purpose of art schools is to provide students with the things they know they lack and ways of finding the things they don't know they lack.

Schools that do not recognize what students lack should rethink what they are doing.

Schools that do not rethink what they are doing are the enemies of art and the enemies of anti-art. They should close.

All schools are academies.

Any student who goes to art school is an academic artist.

Nonacademic artists are generally fairly poor or fairly rich; academic artists tend to make do or make out.

Nonacademic artists are either exceptionally intelligent or exceptionally neurotic, and sometimes they are both; academic artists are for the most part smart, sane, and hard working.

Imagination is very unequally distributed among artists. Who has it and who lacks it has little to do with whether the artist is academic or nonacademic.

Nonacademic artists are not our problem. They are their own problem.

It is not right to say that making is secondary and thinking is primary.

It is not right to say that talk is cheap but doing taxes the soul.

It is not right to pretend that not knowing is more creative than knowing.

It is not right to pretend that knowing is creating.

It is not right to withhold pertinent information from a student on the grounds that it will be confusing since it will only be more confusing later when the student comes across it.

It is not right for a student to shy away from pertinent information out of the fear of being influenced, since anyone who is aware of what the student has shunned will think they were influenced anyway.

Ignorance is ignorance.

Bliss is bliss, just as presentness is grace when grace is present.

It is not right to say that reading is the same as writing that writing is the same as drawing that drawing is the same as taking a picture that taking a picture is the same as making a movie that making a movie is the same as going for a walk since nothing is the same as anything.

It is not smart to proclaim indifference to the medium you're using when indifference is the only reaction your work provokes.

It is not smart to change media when the trouble starts in the hope that another medium will be trouble free.

It is really not smart to become a multimedia artist when no medium yields or appeals to you.

It is not smart to make forms and hate formalism.

It is not right to teach formalism while pretending that no one notices your political, social, and cultural biases.

It is not right to read theory if you do not read the books that the theorist is theorizing—Barthes without Balzac, Benjamin without Baudelaire.

It is not right to discuss the Subject without identifying yourself as a subject.

It is not right to affirm your identity by caricaturing other identities.

It is not right to "deessentialize" yourself while "essentializing" everyone else.

It is not right to read prose without poetry, poetry without prose, art history without history, art history without artists' statements, criticism written for the classroom without criticism written for the newsroom.

It is not right to critique popular culture but never go bowling.

It is not right to go bowling and think that you are in touch with America.

It is not right to say to people your work is too personal to talk about when you talk to your friends all day long about personal things.

It is not right to discuss "aura" unless you are in front of an actual work of art.

It is not right to pretend that what interests you is what interests history.

It is not right to say that the mess you are making is only your concern when you are messing with history.

It is not right to withhold exceptions to the rules you proclaim when you know there are exceptions.

It is not right to confuse a dialogue with discourse so as to turn a discourse into a monologue.

There are other rules, but no exceptions to these rules.

PROJECT 2

BAUHAUS BUILDING, COMPLETED 1926, WALTER GROPIUS,
DESSAU, GERMANY

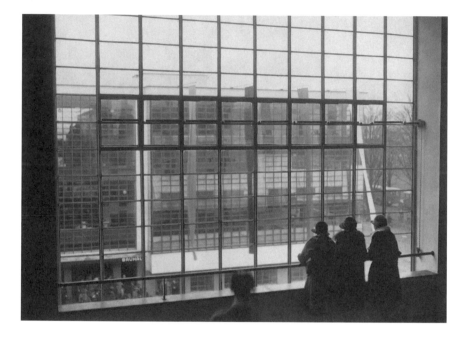

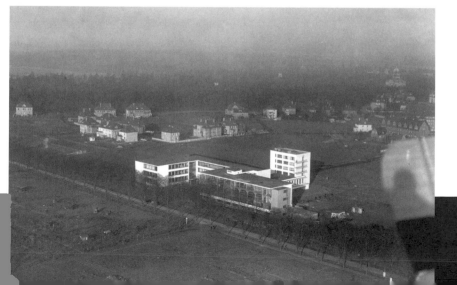

The Bauhaus was born as a self-conscious modernist manifesto, published in 1919 along with an image of the new synthesis of the arts it proposed, a woodcut by Lionel Feininger of a medieval cathedral with its spires topped by stars. The new entity was first realized, however, by adapting the city of Weimar's existing art school, whose doors had closed during World War I. It was also housed in an available building, the applied art institute of the influential Dutch Art Nouveau architect and teacher, Henry van de Velde. Only in 1926, with the Bauhaus's relocation to Dessau, was it finally housed in a building designed specifically for it by the school's founder and director, Walter Gropius. Yet even this was to be short-lived, as the Nazi regime railed against its "alien" values and forced the withdrawal of its funding. Under Mies van der Rohe, the Bauhaus's final iteration was narrowly conceived as a school of architecture in Berlin, where it spent four years in the makeshift quarters of a former telephone factory before closing for good in 1937. What has come to be known as the greatest pedagogical experiment of European modernism spent barely half of its existence in the architectural monument to its forward-looking, integrative attempt to link craft production with an ambitious aesthetico-cultural program.

Gropius's masterwork, like a cathedral, was a world unto itself. In early photographs, it appears forlorn on the periphery of Dessau—nothing but traditional farm buildings and villas encircling it from a distance. The building's aesthetic agenda produced particular effects of its own, though. Gropius's solution to the problem of studio space for art instruction split the space into collective workshops that emphasized material experimentation (displayed behind large glass grids that precariously hung off the volume of the building) and deemphasized classrooms and ancillary public spaces, constituting the building's three-wing, asymmetrical pinwheel form.[7]

What was arguably the primary innovation of the Bauhaus pedagogy, however, found no direct expression in the building's form and wasn't even part of the original vision. The famous Vorkurs (foundation course) was housed in nondescript existing studio classrooms, very much unlike the honorific workshop spaces. The school's revolutionary innovation related far more to a new sequencing of steps on the road to becoming a trained artist and far less to any concrete spatial determination of how such instruction occurred. The flexibility of Gropius's geometric plan may have mirrored the modularity of the Bauhaus pedagogy, but ironically, after the school's move to Berlin in 1933, the building was easily converted into a training center for Nazi party officials. While the building has come to signify a formidable aesthetic pedagogy, it was also far more susceptible to alteration than it might seem such a visionary endeavor could be—perhaps because Gropius's manifesto was at heart difficult to translate into a standardized built form.

(*Top*) View looking from stairs toward opposite stairs across street, with workshops to the right. (Photo credit: Bauhaus-Archiv Berlin)

(*Bottom*) Aerial view. (Photo credit: Bauhaus-Archiv Berlin)

HOW TO BE AN ARTIST BY NIGHT

Raqs Media Collective

The professional sphere of contemporary art subsists within a larger economy of the production of material and immaterial cultural goods. This includes the media and entertainment industries, publishing, and software and design, along with a network of globally active galleries and auction houses that trade in art (traditional, modern, and contemporary) and antiquities. It is not a matter of dispute that a large number of people who train in art academies finally end up

as wage workers (with regular or precarious employment) within the continually burgeoning culture industry. When art students graduate from their academies, they usually end up as "no-collar" workers in the industry by day and as artists by night in their dreams.

Contemporary art can also be a refuge from the relentless pressures of the culture industry. But it is the kind of refuge that makes no bones about the fact that it is also a secret internal exile. The young artist, who often begins professional life as an intern in the corporate setting of the culture industry, usually finds himself or herself in a simultaneous condition of internment within contemporary art.

All industrialization processes bring in their wake an enormous pressure for the new. The so-called creative industry is no exception to this rule. The logic of production itself is typically captured in the slogan, "Innovate or perish." A great deal that is valuable in cultural and artistic life becomes a casualty of this entrepreneurial acceleration. Tenure within this industrial milieu comes at a price. What is lost is the capacity to reflect, to take time, to be critical of the world and one's own practice. The no-collar worker by day is at war with the artist by night. The lives of contemporary art practitioners the world over are scarred by this battle.

Sometimes this double life can be traumatic. The fear of irrelevance, obsolescence, and marginality haunts many younger practitioners, and the pressure to exhibit as an artist is almost as lethal as the pressure to innovate as a cultural worker or entrepreneur. Coupled with this is the fact that the dissolution of a stable canon in the wake of the rapid global dispersal of contemporary art practice brings a certain disorientation to bear on the lives of most practitioners. No one quite knows what to do next to stay afloat in a swiftly changing world.

The question of what then constitutes an education that can adequately prepare a practitioner for a vocation in the contemporary arts is primarily a matter of identifying the means to cultivate an attitude of negotiation with and around this kind of pressure. Learning the ropes is learning to do what it takes to maintain a semblance of the life praxis of artistic autonomy. To think about the content of such an education requires us to return to some very basic questions.

A SOBER INTERLUDE AT SCHOOL

Education ordinarily presumes a retreat, or a period of waiting, so as not to burden the student with the distractions and demands of a professionally productive

life. The position of apprenticeship that education generally assigns to the student implies a withholding or a deferral of the fullness of practice, which is held out as a promise that can be redeemed once the student proves mastery over the rudiments of a calling. Being someone, and learning to be someone, are seen as two distinct moments, with the first following the successful completion of the second. While this may be true generally, it is difficult to sustain this understanding of art education as a phase that merely seeks its posthumous completion in the career of an artist.

Artists undertake to transform themselves continuously through their practices and throughout their working lives. For an artist, there can be no rigid separation between being someone and learning to become someone. The reason to continue to be an artist lies in an everyday rediscovery of what remains to be said or done. Being an artist is no different from learning to become an artist. This process of rediscovery of what it is that he or she needs to do transforms the artist on an everyday basis. The horizons of the artist's self continuously expand to take in the incremental unraveling of what the artist still desires to inscribe on his or her consciousness and the attention of the world.

The day that an artist realizes that his or her stock of things left to think about and to do has depleted to a point where it measures less than what has been done already, that artist might as well stop practicing. This means that in order to continue working, the artist learns to constantly prepare for the unknown, for what remains to be done. An artist's education is never finished. School is never out.

WHAT IS A SCHOOL?

Is school a place, an institution, a set of facilities, a situation, a circumstance, an attitude, or a constellation of relationships of the transfer of acquired, invented, and accumulated knowledge, experience, and insight from one generation to another? Perhaps a school or the idea of a school as a condition of learning, of being open to discourse and discovery, can also be seen as something that we might carry with us wherever we go, whatever we do.

Whenever we think of a school, it is useful to remind ourselves that the meaning of the word has undergone many transformations, and the root of the English word *school* can be found in the classical Greek term *Skholē'* (Σχολή), which denotes, first, "a pursuit or time of leisure" (taken from a withholding of, or vacation from, other kinds of more instrumentalized time) and only consequently shades off to mean "a forum for discussion" and "a place for learning."

It is necessary to dwell on this conflation of duration (time), gathering (a forum), and site (a place for learning). Of these, time is the most important, because a gathering that does not endure or a place that disallows the transformative, accumulative inscription of exchange and discourse cannot by itself, or even in combination, generate a context for learning. So it is time, and a particular kind and quality of time—time out, leisurely time, the kind of time that can be a vessel and receptacle for reflection—that is central to learning. The current reality of schools, and of all other institutions that produce the commodities known as technique and information, have strayed a great distance from the original sense of what schooling might have meant.

When it comes to the artist's education (which is by definition a continuing process of learning and preparation), this emphasis on a non-instrumental attitude to time introduces a certain tension between the imperative of having to be productive (in a professional sense, especially within the art industry) and a desire to vacate the pressures of production, output, and delivery in order to accumulate time to keep on entering situations conducive to learning. It means that while an aspirant has to create the conditions of living that require him or her to seek out and make room for non-instrumental time—time for reflection, for contemplation, for investigations that do not necessarily demand results—there is simultaneously a surfeit of obstacles (through constant demands to produce and perform) that hinder this search.

These demands may stem from the art world, from institutional contexts, from the market, from the need to stay in circulation, and most significant, from the artists' ongoing assessments of their own generative capacities. The paradox of an artist's life is that in order to prepare for production, the artist must engage with time in a non-instrumental way, while this engagement at all times can represent a fundamental distraction from production.

There are two possible ways out of this conundrum. One is to loop preparation and production, leisure and work, in a pattern of successive and alternating phases. The other, perhaps a more difficult and rewarding procedure,

is to insist on a mode of practice that is also reflective—that is, to insist on a mode of practice in which reflection is inseparable from practice. Here, making is thinking, and learning is what occurs at the instance of activity. Praxis is theory.

This second mode of intertwined practice/reflection, or praxis, is often difficult to sustain in the face of the current frugality and precariousness of institutional hospitality toward the non-instrumental activities of artists. That is why artists who choose this mode can often end up generating the contexts that make their work possible. For them, the work of art is not just about making art but also about making the conditions and initiating the networks of solidarity and sociality that enable the making of art. These conditions are not just the material and institutional circumstances that have to do with space, resources, and attention to the practical issues that underwrite the realization of artistic projects (though these are very important and require a great deal of energy). Most crucial, they are also about the diligent and enduring cultivation of the kind of intellectual ambience and the social matrix that allows the unfettering of artistic praxis and inquiry.

RIYAAZ

In Hindustani (north Indian classical) music traditions, *riyaaz*, or the everyday cultivation of one's musicality, is a repertoire of exercises to keep the voice or fingers or one's ability to play an instrument in good shape. But it is more than this. It is as much about the cultivation of a set of attitudes and sensibilities as it is about the honing of a skill. *Riyaaz* is an attempt to explore the boundaries of what one can do on a regular basis and of pushing these boundaries, again on a regular basis, so that the foundations of one's practice undergo a daily renewal, so that one keeps becoming an adept. *Riyaaz* is a practitioner's meditation on his or her practice.

What would constitute the *riyaaz* of the kinds of artists who busy themselves with the continuous generation of contexts for praxis? By way of an attempted response to this question, here are eight points for consideration that sketch a rudimentary set of contours for a hypothetical instance of an artist's *riyaaz*—just as the eight notes (CDEFGABC) of a scale provide scaffolding for the *riyaaz* of a musician. Articulating these "notes" through practice means filling them out, embodying them with the experiential specificity and particularity

contingent on different situations. The notes can be "sung" in any order and combination, with some repeated, some not, depending on the emphases that a particular situation may call for. No rules are mandated for their singing, other than that each note is given its due in a manner that the singer sees fit. No one instance of *riyaaz* can be identical to any other, and *riyaaz* constitutes a form of meditation, not a formula for practice.

(1) EMBEDDED CRITICALITY: The awareness that the cultivation of a critical relationship to one's situation is a privilege that has to be earned by an intimacy with it, not purchased by a distance from it. One has to know reality with the intimacy appropriate to a lover in order to appreciate its flaws and be awake to its beauty. This means that the practitioner's stance toward a reality cannot be compromised by an abdication of his or her entanglement with it. When the desire to create a new context for one's practice takes hold, the practitioner reflects on how that context and the inauguration of that practice can respond with curiosity and generosity toward what already exists in the practitioner's environment. This is also an acknowledgment of the corollary fact that the desired context cannot be built from materials other than those provided by the existing environment, given that the environment's boundaries are seen to be flexible and open to redefinition through the practice itself. While there may be no escape from what exists, entire worlds can also open themselves out or be prised open from the coordinates of a street corner or a cul-de-sac.

Like the first note on the scale, which anticipates the next octave even as it founds one, embedded criticality acts as a tonic, providing the engaged practitioner with impetus—the slope of a trajectory as well as a destination.

(2) UNINTENDED CONSEQUENCES: The willingness to be open to all the possibilities, including some that are neither anticipated nor intended. The capacity to experience the emergence of new desires of practice when confronted with new contextual possibilities. The education of intention in order to keep the will apace with changing circumstances, An abeyance of foreclosure. Recognition of the occasional unpredictability of the familiar and the patience necessary for surprises go hand in hand. With an openness to unintended consequences, the practitioner remains alert, even to the unimagined.

(3) RADICAL INCOMPLETENESS follows logically from an openness to unintended consequences. Learning to be comfortable with the idea that the circumference of a work is always larger than the boundedness of its nominated authorship. The work of art is never done, and so there is always room for another author. And then another. Contexts gather people.

(4) NON-(UN)EQUALITY OF PRACTICES: Generative contexts attract many different kinds of people and their different kinds of energy. Not everyone comes with the same history. Class, gender, culture, race, traditions, belief systems, even nutritional histories are always at the practitioner's back and shape the content of every interaction. The fact that some people have more knowledge or information or appear to have more or are able to present themselves as having more should not distract from the responsibility of having to live with and address those who do not display the same bounty.

Everyone is communicative and knowledgeable, or not, depending on the context they find themselves in. Loquaciousness and reticence go hand in hand, just as knowledge and uncertainty do. Unequal purchases on the understanding of the world are apportioned in roughly equal measures. Some people may know a lot, but everyone is equally ignorant. So no matter how much knowledge an instance of practice embodies, it still does not know as much as any other instance of practice. This means that different practices, even when they are not equal to each other in terms of their communicative or cognitive strengths, are at the same time not unequal either. Learning this modesty is essential for practitioners who desire a sense of their own strengths.

(5) MINOR MEDIA: The differences between different kinds of practice are chromatic. They are differences of character, not of quantum. There may be major and minor media, but the differences are not analogous to the differences between greater and lesser or higher and lower practices. What matters in the end is not scale or impact, but acuity, affect, dispersal, resonance, and endurance. This allows different people to enter the field of practice in a manner commensurate with their histories and capacities (which, as we have seen above, are neither identical nor unequal).

Minor media are practices in a minor key. They introduce tonal altera-
tions that rearrange the regularities made familiar by the repetition of major
practices. They alter the mood or setting or emotional tenor of a practice by
insisting on attention to irregular variations. They are ways of remembering,
imagining, and accounting for things that do not get remembered, imagined,
or accounted for in the ordinary course. At the same time, they are things that
can be done every day. Although *riyaaz* is not the same as the making of a
work of art, minor media are the practices that can be stitched into the folds of
everyday *riyaaz*—observation, recording, alteration, restoration, arrangement,
rearrangement, ordering, disordering—one step at a time.

Minor media are not masterstrokes and do not seek to produce master-
pieces, and they are not necessarily worked on by great masters. What they do
allow is a dense layering (by one person or by many over lengths of time) of the
work of art with a multitude of surfaces that produce a context, rhythm, and
texture of accumulative annotations. It is this accumulation that occasionally
yields the sharp significance that is the unique property of a work done in a
minor key.

(6) INCREMENTAL RECORD: Building an archive of works incrementally (wheth-
er they were done in a minor key or a major one) creates a record of the gen-
erative life of a practice even as it is in process. A history of the movement of
a practice gets inscribed into the very terms of its expression, making visible
all of its ideas—threadbare, discarded, extended, or transformed. This not only
allows others to enter into the making of a work (if the work is, say, an extended
collaborative process) but offers them the opportunity to become familiar with
what has been said already. Of course, it also allows practitioners to revisit
ground that they may have already covered in order to mine fresh insights
or remind them of something that might have eluded their memory. The re-
cord and trace of a work's incremental evolution is something that has to be
learned. It does not happen by itself.

(7) INTERLOCUTOR: The various kinds of accumulations that we have de-
scribed, produced by the actions made possible through *riyaaz*, can take the
form of complex assemblages. These assemblages demand mediation and

become arenas within which the artist acts as an interlocutor in order to fulfill his or her mediatory role. If the work is a boat, the artist-interlocutor is a sailor. An interlocutor is someone who speaks between different acts of speech by translating, annotating, mediating, criticizing, interpreting, and extending the contents of the different instances of articulation. The practitioner is not the owner or possessor of a work of art. Instead, the artist takes custody of what might have begun within his or her life, consciousness, and body, but the work is already on its way out into the world. The artist takes responsibility for the safety and integrity of the work during this voyage, making sure that it lands on some more or less secure promontory of meaning before embarking on other journeys.

(8) CONTINUOUS EXCHANGE: Neither the history of an idea nor the here and now of the moment of its iteration occupies a space of privilege. The net effect of the provenances, conversations, and the warp and woof of expressions and meanings woven into a work can only give rise to a space of a continuous exchange between memory, reflection, articulation, and action in which everyone concerned—practitioner, viewer, critic, curator, and enthusiast—contributes to the production and circulation of ideas and knowledge, which are based on a continuing encounter with the work of art. People learn from and with art, not simply from the speech of teachers but from the ongoing history of exchanges and conversations that embody the relationships and interactions that straddle the work of art over time. School may be an initiatory process of significance to some artists, though not to the development of others. Clearly, this process of continuous exchange is the transposed articulation in another key or the situation that we found ourselves embedded in critically at the beginning of this "octave."

CODA: THE WISHING TREE

It is said that on an unmapped island, sheltered in the curve of a hidden bay, there stood a speaking tree. It was one of its kind. Some called it the *waq-waq* tree, the tree of tongues; some called it the *kalpataru*, the tree of desires. If you stood under the leaves of the speaking tree and named your desires, the wind

rustling in the leaves of the tree would echo each utterance and the wishes that had names would come true.

The world is made as the things in it are named. Sometimes naming presumes knowledge; sometimes the name is a sign that we do not yet know what we name. We trust the name to make do while we hold our knowledge in abeyance. The creation of the world, the sustained and sustaining desire for the world, and the knowledge of the world—which is a tacit admission that we do not know and can never know all of the world—all end in the same set of consequences. The world and the things in it get reproduced by naming, knowing, not knowing, and desiring. This is what keeps things alive, and the world gets created anew with the expression of each desire. In this sense, an education for art is a school (a time set aside) for the production of desires, a space for the continuous generation of interpretive acts that also successfully constitute the world or a world among many.

The artist by night, in dreams, recovers what the no-collar worker lost by day.

PROJECT 3

BLACK MOUNTAIN COLLEGE, 1933–1957, ALFRED KOCHER, BLACK
MOUNTAIN, NORTH CAROLINA

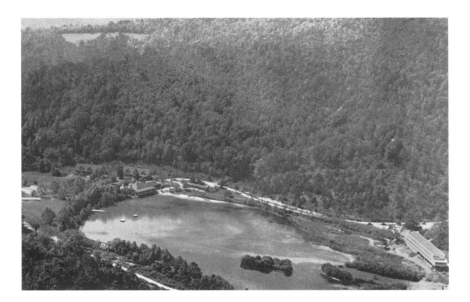

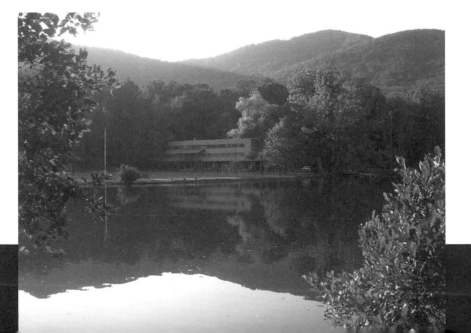

Black Mountain College constitutes an important hinge between the Bauhaus and American twentieth-century art education, with material necessity as the mother of its innovation. Largely through the presence of the former Bauhausler Josef Albers (who had taught and refined the *Vorkurs*), the institution thrived during the 1940s and 1950s and became an epicenter of a vein of American artistic and literary experimentation, with its influence helping to make art instruction a vital element of undergraduate curricula. As one of a number of important sites where overtly theoretical approaches to making decisions about formal artistic practice were first promoted in the United States, it uniquely brought to the fore certain aspects of the art colony model transposed to the system of American higher education.

Under its founder, John Andrew Rice, and a circle of faculty who left Rollins College in protest of his dismissal a year before, plans for a new institution were hatched at the height of the Great Depression. The scenic grounds of a boys' camp in North Carolina were chosen as a makeshift location for a small liberal arts college that placed art at the center of humanistic learning. Lacking any real forward-thinking instructors in the arts, Albers, who had fled Nazi Germany, was hired, along with his wife, Anni, in 1934. Subsequently, in an effort to definitively symbolize the institution's ambitions, the college bought the grounds of a summer camp in 1939 and hired arguably the highest-profile modernist architect associated with aesthetic education then available: Walter Gropius himself.

The economic troubles of the late 1930s stymied the building of Gropius's grand campus design and necessitated a compromise solution that capitalized on the summer camp's informal atmosphere. Whereas Gropius's unrealized project was a unified modernist complex comprising bulky bars on *piloti* projected over the waters of modest Lake Eden, the realized design of young American architect Alfred Kocher instead turned the project into a collage of old and new—just when the *Vorkurs* was being grafted onto American arts education. Kocher's new building was a long bar like Gropius's, which he sited across the lake from the existing residential and social spaces of the main facility. While fleshing out the lack of spaces for art production, Kocher atomized the institution—segregating studios (practice) and classrooms (theory)—a move at odds with Gropius's integrative plan and the interdisciplinary spirit that nurtured the school's beginnings.

While the achievement of a Black Mountain campus might be seen as an expression of a brilliant pedagogical philosophy, it seems important to also view it as a fortuitous and apocryphal compromise negotiated with unified architectural vision. The summer institute thrived in a way that school-year activity did not; the environment's art colony atmosphere proved intensely productive, resulting in compelling modernist explorations as well as emerging challenges to them. For example, five years before the demise of both the school and the institute in 1957—having lasted a decade longer than the Bauhaus—the first interdisciplinary "happening," John Cage's *Theater Piece No. 1*, was staged there, in improvised collaboration with Merce Cunningham, Robert Rauschenberg, Charles Olson, and David Tudor, among others.

(*Top*) Aerial view as it appeared in an institutional brochure from the 1950s. (Image courtesy Black Mountain College Museum and Arts Center)

(*Bottom*) Studies Building, 1940–41. Architect: Alfred Kocher

THE THING SEEN

Reimagining Arts Education for Now

The only thing that is different from one time to another is what is seen and what is seen depends upon how everybody is doing everything. This makes the thing we are looking at very different and this makes what those who describe it make of it, it makes a composition, it confuses, it shows, it is, it looks, it likes it as it is, and this makes what is seen as it is seen. Nothing changes from generation to generation except the thing seen and that makes a composition.
—Gertrude Stein, "Composition as Explanation"

Ann Lauterbach

1.

Stein's mantra, *nothing changes from generation to generation except the thing seen and that makes a composition*, has long resonated with me as a way for contemporary artists to think their present moment in relation to their subjects, materials, and forms. I have taken the phrase "the thing seen" in its widest possible construction: the way the world's variety comes into focus through myriad events and facts, near and far, in an artist's work; I call

this focus "pressure." How, I ask students, does *world* press on your consciousness? It is of course an abstraction, this *world*: it holds in its five letters both the inscrutable and the illimitable. But artists find ways to make *world*, through subject and material, scrutable and, through form, limited.

You cannot plan for the new, since by definition it arrives out of the conditions that give rise to it. *Now*, on the other hand, also arrives out of the conditions that give rise to it, but instead of these conditions being akin to the prow of a ship (the Great Ship New), they are more akin to the buoyant waters that hold the ship up, in which horizontal surface (space) and vertical depth (time) are in a mutable, ambient relation—the relation, we might say, of scale. Where your particular ship is on the waters of *Now* is what you need to discover when you are making a work of art.

Of course, *the thing seen* does not have to be composed only of what is in the foreground. This is the mistake of the new. In his seminal essay, "Tradition and the Individual Talent" (1919), T. S. Eliot talked about the incident of the contemporary "individual talent" in relation to the past, which he called tradition. He spoke quite powerfully about the notion that new art alters how we know the past: "The existing order is complete before the new work arrives; for order to persist after the supervention of novelty, the *whole* existing order must be, if ever so slightly, altered; and so the relations, proportions, values of each work of art toward the whole are readjusted; and this is conformity between the old and the new."[1]

The flaw in Eliot's argument is his insistence on the idea of an "existing order" as a "whole," a coherent trajectory that implies an accepted historical canon, whereas we now know that history is a plurality in which many traditions may be found. The social philosopher Jürgen Habermas (in conversation with Michael Haller) offers a compelling description of a more contemporary experience of time. Speaking about Derrida's notion of difference, Habermas says: "Derrida's . . . conception of difference [expresses] . . . the fantastic unbinding of cultures, forms of life, styles, and world perspectives that today no longer simply encounter each other, but mutually open up to one another, penetrate each other in the medium of mutual interpretation, mix with one another, enter into hybrid and creative relationships, and produce an overwhelming pluralism, a decentered, hence obscure multiplicity, indeed a chaos of linked but contingent, nearly undecipherable sounds and texts."[2]

Habermas's description of Derrida's difference is, I think, a vivid and apt characterization of our present age, with its vast global interconnectivity. Within this fluid matrix, this "unbinding," the object of Stein's singular *the thing*

seen becomes an almost phantom distillation. If we do indeed now live within "an overwhelming plurality," then what structures are needed to teach artists to respond to it? As a corollary, how are we to think about, or teach, "history" within an arts context?

When I was in college in the 1960s, I was confused by the way the study of literature was contracted around the Department of English. In those days, that designation was almost exclusively for the writers, present and past, from Great Britain; it omitted even the writers from all the colonies of the British Empire that had helped to establish English as the dominant world language. Indeed, even American literature was a suspect, separate category. Other languages and literatures were, and still are, passed off into "comparative literature." *Compared to what?* I remember thinking. *English* literature?

In the intervening years, the academy has shown itself to be responsive to the various claims of specific cultures and cultures within cultures that form the "other traditions." But even so, the academy still thinks about learning as subject to categories, the way journalism thinks about daily life as divided into sections. The academic epistemological frame suggests an implicit ontology: ideally, you can know everything there is to know about your subject. The academic paradigm is depth of knowledge/discrete subject. As persons ascend the academic ladder, they focus increasingly on their chosen subject within their chosen field of study, hoping at last to add to the critical discourse.

This academic categorization of epistemology, however essential for scholarly mastery, is in my view anathema to artistic thought. Artists approach knowledge as a field of disparate potentials, only partially based on the animation of textural discovery; they move across and through the hyperbolic landscape of information, processes, and materials to find what they need to know in order to make something as yet unknown, unseen. Here we might want to recall Theodor Adorno's remark: "In every work of art something appears that does not exist." He elaborates: "Quite possibly the non-existent suddenly rises in works of art, but they cannot take hold of it bodily in one fell swoop. In art, the non-existent is mediated by fragments of the existent, gathered up in an apparition." We can teach Adorno's text, but can we teach the ways in which the existent and the non-existent are gathered into a work of art? In this same section of his aesthetics, Adorno wrote: "The afunctionality of works of art has something in common with the superfluous tramps of all ages, averse as they are to unmovable propriety and sedentary civilization."[3] His image implies that works of art embody simultaneously Beckett's characters' (and also, I think, Chaplin's) ingenious, itinerant poverty, an essential superfluity, and an ecstatic

freedom. This suggests a difficulty of cultural designation that still pertains to how we think about art and artists.

Adorno's implicit image of the artist as indigent outsider, uncontaminated and uncontained by "sedentary civilization," has been joined in recent years by another, antithetical, figure. Along with the stunning expansion of the international art world, the proliferation of art schools (and their graduates) has established the notion of art as a professional career—not unlike an academic scholar, a doctor, an architect. This is a potentially exhilarating development in a culture long dubious about the efficacy, desirability, or importance of art. But new questions arise with the new dispensation. If being an artist is a career, then by what criteria of achievement is it judged? What does it mean to succeed, and what does it mean to fail? Is it simply to read success through the same magnifying lens as the culture at large: wealth or fame and their accompanying signs of social status and material ease? To become an artist, what do you have to know?

And so we might then need to ask: Are artists experts? And if they are, what is the nature of their expertise? Or to put it another way, what is the relation between the how (as in: let me teach you how) and the what (the thing seen) of the artwork? The artwork, we might say, occurs at the juncture of how/what, the transfer of mere materiality into articulated form; the complex negotiation of subject/subjectivity into an object that allows alterity to recognize itself as such. The artwork: not you, not me, but the thing that makes a kind of elastic pulse that keeps us in relation to each other and to the present presence of our shared world.

If artists focus only on their specific genre (its precedents and its forms) to find their sources and do not delve into other discourses—science (which one?), philosophy (whose?), ecology (in California? In Bangladesh?), current events (legal decisions? floods in Iowa?) economics (supply side?)—not to mention the other arts, then the artwork is likely as not to be a frail, etiolated remnant. We need, then, to teach artists to think across and through the boundaries of discourse, and we need to encourage them to look behind the immediate landscape of art world annunciations into potential resources in both the historically removed and the culturally other.

Indeed, as the Internet continues to flatten time and space into a scan that erases the "horizon" (the classical metaphor of both spatial depth and temporal aspiration), young artists are faced with a deracinated landscape. How to steady this mobile map, in which one's own presence—one's personhood—is without discernible evidence or locale? Artists need to find ways to treat history

as a layered palimpsest whose "transparency" is at once an illusory trap and an unlimited resource. Perhaps more urgent, they need to find ways to claim a physical, embodied presence within the increasingly dematerialized modality of connection. As Gilles Deleuze tells us, "Only bodies exist in space, and only the present exists in time." Deleuze elaborates: "Thus time must be grasped twice, in two complementary though mutually exclusive fashions. First, it must be grasped entirely as the living present in bodies that act and are acted upon. Second, it must be grasped entirely as an entity infinitely divisible into past and future, and into the incorporeal effects which result from bodies, their actions and their passions."[4]

As we know, the Internet's dominant trope is one of ubiquity and homogeneity; it does not make distinctions or set priorities; there is no way of knowing what to trust, since without bodily presence, intonation, and inflection, without the specific architecture of legible difference, we no longer have the means by which we have learned to measure our choices, decisions, and judgments— of both individuals and artworks. Young artists, faced with and embracing this new virtual iconicity, are challenged to invent ways to articulate its inexhaustible, mediated immediacy into structures that engage our capacities to make meaning.

2.

In 1991, Arthur Gibbons, recently appointed director of the Milton Avery Graduate School of the Arts at Bard College, asked me if I would be interested in joining the faculty in the writing discipline. I did not at the time know much about Bard's M.F.A. program, but I was familiar with the undergraduate school's commitment to the written and visual arts, as well as to music, through the activities of its president, Leon Botstein, a musicologist and conductor of the American Symphony Orchestra. I accepted the offer and have been a member of the faculty, as cochair of writing, ever since.

Although I have taught in a number of graduate writing programs, including those at Iowa, Columbia, and New York's City College and Graduate Center, and have, more recently, been a visiting critic at the Yale University School of Art in painting and sculpture, most of my thinking about arts education is grounded by my commitment to and experience in the Bard M.F.A. program. I shall briefly outline the structure of the program and suggest why what I take

to be its mission might be useful and pertinent to thinking about arts education at the start of the twenty-first century.

Prospective students apply to the program in one of six disciplines: painting, sculpture, film-video, writing, music-sound, and photography. Applications are reviewed by members of the faculty in the applicant's chosen field, and those selected in all fields are interviewed on campus on a single day in early March. We have found over the years that our most successful candidates tend to be older than the expected age, averaging between twenty-five and thirty-two. These students have been away from undergraduate school for long enough to have found some focus for their work, some bearings in their personal lives. Increasingly, the program attracts students from a number of nations around the world, adding both complexity and variety to the evolving ethos of the community. The program has no endowment, but we are able to offer some scholarship help to students in need.

The program takes place over three years but is in session for only eight weeks, in June and July. During these eight intensive weeks, students in each discipline are in contact with students in the other five disciplines, as well as with the faculties in each. The faculties are drawn from artists active in their individual fields, painters and sculptors, filmmakers, poets and novelists, and so on. They represent a range of aesthetic approaches to their medium and, like the student body, are also generationally and ethnically varied. The faculty includes those who are enjoying some prominence and those who are less well known. Members of the faculty are present for varying amounts of time, from three weeks to the entire eight-week session; many, but not all, return from year to year. Each discipline has a chair or cochairs, and these individuals are responsible for choosing and inviting their faculties. The discipline chairs, with the director, form the Graduate Committee, responsible for the ongoing workings of the program. We meet, we discuss, we change the program as and when we see the need. Over the years, many changes, small and large, have been made, giving the program an inherent flexibility, an organic and transparent structure. During the summer session, the entire faculty meets and discusses, in detail, each student's work in all three stages of their three-year journey.

There are also visiting artists who give presentations on their work, and each summer, a seminar is devoted to a theme or subject, with readings, presentations, visiting artists or scholars, discussions, and conversations. In summer 2008, the seminar was devoted to the idea of "translation," in both its specific or usual meaning, from language to language, and its broader implications:

crossing cultures, genres, and so forth. There was a packet of readings distributed to the faculty and students, and invited guests presented to the entire community; seminar groups of fifteen to twenty students and faculty met to discuss these readings and the presentations.

The core pedagogical approach of the Bard program is conversation and critique. Students are asked to make appointments with at least thirty members of the faculty, across the disciplines, to discuss their work. These sessions are up to an hour long and usually take place in the studios provided to each student. In the late afternoons, the entire body of students and faculty meets in critique sessions, in which three students show or perform works in progress, and verbal responses are offered for twenty minutes each. Once a week, each discipline holds a caucus, during which specific issues and methods germane to that field are addressed. Visiting artists attend these caucuses.

During the other ten months of the year, students are expected to continue to work in their chosen fields. When they return, their "winter work" is evaluated. At the end of their third, final, summer, students prepare a thesis statement and presentation, and a board of five faculty members, three from the core discipline, discusses and evaluates the work. This final session is recorded, and the recording is given to the student.

3.

The aim of this program is to create a school in which the sites of "authority" are multiple and mobile, moving across and through myriad synapses in an open structure, so that criteria for judgment can be calibrated to allow maximal heterogeneity within a close-knit community.

The flow of information is based on articulations of accumulated knowledge centered on a given faculty member's set of interests, on her or his specific practice and experience. This reliance on individuation gives the program an intimacy, a nearness, as if all things brought to bear were being tried immediately, in the foreground. Students, exposed to an astonishing variety of voices and arts practices, must decide what is useful or important to them. And because students meet with many artists who are not in their chosen field, they become aware of the ways in which all arts share a discourse and the ways in which a particular discipline is unique. The student painter becomes conscious of the difference between meeting with a poet, a filmmaker,

a sculptor; she becomes aware of the varieties of aesthetic experience. Together the faculty and students comprise an informed congregation, a responsive and responding community. When the program is not in session, students and faculty continue in their "real" lives—jobs, relationships, families, studios. Art, school, and life are congruent and contingent. During these months, students get to sort and ponder.

The Bard M.F.A. program emphasizes layers of individual articulation over theoretical constructs or the jargon of coteries; it collapses normal expectations of the hierarchy of power into the mobile temporal ephemera and unique individuation of the speaking voice. Students learn to speak and learn to listen, not only to what is being said but also to cadences of sentences, tone, quickness, volume, repetition, pause, vocabulary, reference. It is a new rendition of the old notion of oral history as a place of authenticity and integrity. Indeed, history as such forms and re-forms around citation; from time to time, a thematic content emerges out of the intersecting arcs and acts of an unsteady verbal commentary. If you listen, you can hear certain refrains that percolate through and across the vibratory incidents of attention and response. (This past summer, I thought I discerned a shared set of concerns around the intersection of personal and historical narratives: a renewed emphasis on themes of personhood and identity within the unfixed boundaries of a cultural disapora, which is attached to an increased anxiety about responsibility and efficacy within an arts context.)

The voices of authority, neither static nor singular, thread through and across the social fabric. Words are spoken, ideas are set in motion, and these float, like pollen, in the summer air until they land on receptive ears or are forgotten. It's an experiment in the efficacy of attention and articulated response, in the possibilities for critical discourse, based on and in experience, as an active critical tool. Students are encouraged to take risks, a pedagogical cliché, which means to question whatever habits have formed, to resist early closure to work that has not yet found its mark, to think about the dynamic relation between subject, material, and form. In a time of increased hybridity, the faculty is challenged to allow students to depart from genre-specific work while remaining accountable to sites of knowledge necessary for, and pertinent to, accomplished work in a given field. Just because you are taking pictures does not mean you are a photographer: the edge between "expert" and amateur blurs.

The program fosters mutual interest and support that are underwritten by a sense that making art and making a life in art are challenges that can be met in diverse ways. Success is not understood as a single outcome but as an

alert receptivity to possibilities that range from a show in a gallery, the publication of a book or the performance of a musical composition to teaching third graders to draw or prisoners to write. We are not naive about the desire for overt recognition, and we celebrate those who get it, but neither do we center our discourse on the means to that goal. Strong and enduring friendships are made, and the Internet has provided the means by which students and faculty can share information that ranges from the announcement of job openings to available studios and apartments, upcoming readings and shows, and so forth.

As I have indicated, this idea of teaching and learning as a quixotic intensity of articulating presences is antithetical to how the academy traditionally formulates both its relation to knowledge and the ways in which that knowledge is judged and disseminated. There is no teacher, no expert, no mentor, but rather a contingent of artists—exemplars—whose accumulated knowledge represents the obiter dictum of achievement. Indeed, it occurs to me now that there is a suggestive interface between the methodology of the Internet and the structure of the Bard program. In each, the present is animated, and various sites of authority are in constant flux, and the possibilities for contact are mobile, immanent, plural. In a sense, the Bard program mimics aspects of the Internet's most radical reformation of the ways by which we acquire and disseminate knowledge, but these processes are anchored in the actuality of physical presence. The immateriality of the virtual, as it were, becomes embodied, real. The hope is that such grounding demonstrates how content occurs at the juncture of specific subject matter with discovered form, by a praxis conditioned by individuals and their very real contexts, which cannot be abbreviated into avatars of illusory presence or abstracted into theoretical constructs. Meaning making is, after all, still an act of human interpretation: *the thing seen.*

4.

To my mind, democratic patronage would, first of all, support the arts as widely as possible. It would preserve artistic treasures from the past and enable both institutions and individuals active in the present. It would be egalitarian, a patronage not only for the rich, or the well connected, or those whose careers are well under way, or those living in centers of power, or

those who went to certain schools, or those who practice one aesthetic and not another. It would seek to empower a meritocracy of artistic thought.[5]

Lewis Hyde's utopian vision of a "meritocracy of artistic thought" is exhilarating to imagine, but it evades the crucial issue, which is how to go about shifting the ground of privilege that the arts in America increasingly occupy. How to forge links between the local high school and the expensive art school, between the underpaid art teacher and the fashionistas of the international art brigade? How to convince the young painter, graduating from Yale's School of Art (and heavily in debt from it), that she does not need to move to New York City in order to succeed? If she believes that New York City is the only place, no matter how high the rents, how small the space, how arduous the work she must do to support herself while she also paints, then she inherently accepts the notion that the art world is circumscribed by sites of institutional and financial power and their facilitators: curators, collectors, dealers, critics. This vortex of economic power eschews the local: the small gallery in Hudson, New York; the museum in Columbus or Minneapolis or Ridgefield; and the cadres of local artists and writers in Los Angeles, Chicago, Kansas City, Philadelphia, Baltimore, Washington D.C., not to mention the extraordinary proliferation of such institutions and communities across the world.

In the early spring of 2008, the artist Ann Hamilton arranged for me to spend a week in Columbus, Ohio, where she lives with her husband, Michael Mercil, and their son, Emmett. Ann and Michael teach at Ohio State University and are active members of the arts community, often through the programs and exhibitions at the Wexner Center for the Arts. I was invited to give a reading at the Wexner, to give a seminar to some of the writing students, to visit some student artists' studios, and to work with Ann at the Wexner on a collaboration (in relation to her Tower, a permanent structure for contemplation and performance, at the Steve Oliver Ranch outside San Francisco).

Ann and Michael have their studios in a large one-story industrial building in which there are many large tables, collected over decades. These tables serve their ongoing art projects, but also, as on the evening following my Wexner reading, as a kind of dining hall. Members of the audience, friends, and students are invited back to the studio building for a simple dinner of soup, salad, bread, and wine. At a certain moment, Ann tapped me on the shoulder and invited me to sit on a stool and converse with the guests. This engagement and dialogue was the high point of the visit for me. Our conversation moved over a range of issues and ideas, from poetics to politics, and I felt that arts

practice and community were in an active relation, whose ultimate effects and proliferation were unknown. I did not feel myself to be an expert or a fount of knowledge, but rather a vehicle for a continuing dialogue—one that began before I arrived and would continue after I left. This kind of real-time intimacy and communication is possible only at the level of the local.

The fear of not being a player on the game board of New York City's cultural elite pushes the young artist to accept circulating ideas, however inadvertently, of what is hot and new, and to forgo the very elements that endow artworks with the power to alter the way that we think about ourselves and our world. Those elements are drawn from experience—not only of the trajectories of artistic practice but of incidents, observations, exposures, and memories that are unique to our lives.

Ever since the so-called culture wars of the 1980s, with their lethal brew of politics, "moral" values, and tax dollars, during which art became the whipping post for antiprogressive social thought, there has been a discernible retrenchment from problematic or controversial work and a movement toward a market-driven consensus of aesthetic merit. The once influential mediation of available, informed (if at times polemical) critical thinking has all but vanished, replaced by theory-based (academic) writings on the one hand and user-friendly journalism and opinionated blogs on the other. In any case, the connections among the public, arts education, and art have become at once more extensive, more tenuous, and less provocative.

These developments are not necessarily nefarious, but they may have contributed to the perception of art as a privileged enclosure, nurtured and maintained by the proliferation of expensive graduate art schools, and their inevitable projections into predominantly urban-based art scenes, where the art market is on everyone's threshold. This is not the place to rehash the many critiques of art as the final stronghold of investment capital. But it is, I think, a place to begin to reconsider the basis for arts education in relation to art in the culture at large; to think as clearly as possible about the paradigms we have created and those we need to create. We need to answer the question of whether artists are necessary to the workings of a liberal democratic state. Unless we can answer this in the affirmative, and support that affirmation with reason as well as belief, we will continue to erect institutions that are halfhearted in their commitments, uncertain of their mandates, and vulnerable to evaluative systems that are anathema to creative thought and process. As long as we believe that art is an inessential luxury, that museums and galleries are playgrounds for social

and cultural elites pandering to "the public," then the idea of arts education will continue to be a risky, potentially spurious enterprise.

How do we inform the public that art is not a luxury, not mere entertainment, that artists are not the spoiled children of an indulgent culture? Perhaps most important, how do we slow down our responses so that our opinions are aligned to judgments that are informed by what we know? How do we convince the public that neither complexity nor difficulty in art—in thinking about and responding to art—is a formula for estrangement but an invitation to imagine solutions to seemingly intractable problems and predicaments in contemporary life? To teach persons to make art is to teach them to resist the commodification of their wills and desires, to use flexibility and ingenuity in the face of adversarial forces, to build a capacity for the attention and response to that which is not like them or belongs to them.

I believe that arts education at all levels is now more critical to the vision and fabric of democratic social space than ever before. If we construe arts practice as not limited to professional achievement within the structures of the culture industry, but as a way to invigorate dialogues across boundaries—like to unlike, local to local—then our sense of a diminished landscape of personal efficacy will be at least in part alleviated. If we understand arts practice as a means to formations of new constituencies of inclusion and belonging that, in Emerson's great phrase, "unsettle" our assumptions and realign our relation to the intersecting arcs of our presences, then we will be less vulnerable to the received habits of thought that continue to threaten and curtail our liberties.[6]

PROJECT 4

INSTITUTE FOR DESIGN (HOCHSCHULE FÜR GESTALTUNG), 1951–1968,
MAX BILL, ULM, GERMANY

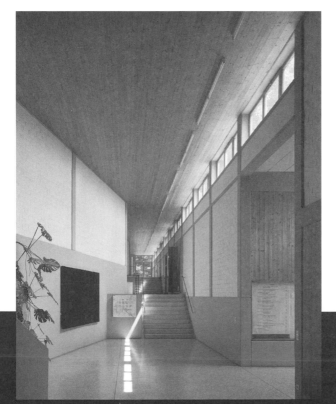

Otl Aicher and Inge Scholl envisioned the Institute for Design as a means to honor Scholl's two siblings, activists against the Third Reich who were killed during the 1930s, though it was also an early postwar project whose ambition was to restart Walter Gropius's noble educational dreams. The founders aimed to "correct" the Bauhaus's mistakes by recentering art and design within a coordinated offering of training in modern media that encompassed film, television, journalism, politics, and cultural criticism. In 1946, they initiated a new community college in the southern German town of Ulm, but by 1950 their progressive pedagogical thrust reached an impasse with the conservative city council. This forced them to seek funding for their project elsewhere, and eventually it was largely bankrolled through the Cold War machinations of the American High Command.

The founders invited Swiss architect and designer Max Bill, a Bauhaus graduate, to join them in their efforts, and he was named its first director. Bill not only argued on principle against housing the institute in any existing structure but expressed his lack of enthusiasm for any broad cultural reframing of arts education. The curriculum was eventually organized in four general areas (information, architecture and city planning, visual design, and product form), with instruction in sociology, politics, and cultural criticism located almost exclusively in the first category. The institute's primary focus on formal art education, however, soon ran afoul of the American interests that were backing it—largely as a re-education project to foster democracy in the face of Russia's influence in East Germany—but not before a stunning complex that Bill designed had been realized in 1955, two years after beginning in temporary quarters. Bill's design complicated the orthogonal, centripetal organization of Gropius's building for the Bauhaus in Dessau, in part through a series of residential towers for students and faculty. Arrayed along an undulating covered path, this "neighborhood" was separate from the classrooms and workshops housed in a large, flat warehouse-like structure.

Earlier tensions reappeared in 1958, when Bill was succeeded as director by Argentinean artist Tomas Maldonado, who advocated a shift away from the institute's implicit aestheticism by calling for designers to take on the primary role of coordinators instead of artists. This instigated a turn toward a more scientistic cooperation with industry, promoting a valorization of industrial design over other school divisions. Yet far from vacating the aesthetic, this move produced a new functionalist aesthetic of its own, one that by the mid 1960s was also being eclipsed by changes in the molding of consumer tastes. Despite the school's closing in 1968, driven by unresolved conflicts with Ulm's city government, it established an important educational model deserving future emulation.

(*Top*) Aerial view with city of Ulm beyond. (Photo credit: © Otl Aicher, courtesy HFG-Archiv, Ulm)

(*Bottom*) Interior view of hallway near administrative area. (Photo credit: © Georg Aerni)

INCLUDE ME OUT

Helping Artists to Undo the Art World

Charles Esche

There are many paradoxes in art education. Not the least is that the subject is by many standards unteachable or unlearnable. Modern art, the category we in the West have inherited from the Enlightenment, requires of its makers that they reinvent themselves and their definitions with every new piece of art that is made. Modern art was required to undo itself through its own products and then stitch itself back together differently—a beautiful

circular logic that is still part of its immense satisfaction. At the same time, there have always been aspects of skill and artisanship that have required discipline and study. When contemporary art began sometime in the 1960s, it adopted this desire for reinvention wholesale, though largely decoupled from both the demands for social or political change and specific skills. Yet contemporary art also built up a canon of exclusively Western European and North American artists to whom it would bow its head—all the while maintaining its rhetorical autonomy. Even after the great political and cultural changes of 1989, when the Berlin Wall fell and Communism collapsed in Eastern Europe, contemporary art has continued to build on its Western traditions. Arguably, skills in craft manufacture were then replaced by learned sociability and the comprehension of certain codes of behavior, though this switch was never made explicit in most academic curricula. The logic of teaching contemporary art remains one of making students unlearn their preconceptions and seek the new and the personal, even if the art that results often resembles the work of a particular professor under whom the student was studying. In short, the idea of the art academy is a paradox that can be reconciled only if we keep contrary objectives and ideals in sight.

Most of what I know about art schools comes from functioning within them. (I will use the terms *academy* and *art school* interchangeably, though they have slightly different meanings in European and American contexts.) Each academy has its own trajectory, and many have stopped at earlier stages along the chronology mapped out above. Some are still locked into nineteenth-century models of life drawing and hand-eye control, while others are still exploring the legacies of 1960s free expression. What they mostly have in common is a high degree of disappointment, populated by too many professors who feel they should be out there participating in the art world rather than teaching students. To be sure, it is very hard to combine careers as artist and teacher without becoming a name on a recruitment poster whom the student never encounters in reality. Again, we can observe a paradox of successful artists often failing to effectively feed their knowledge and experience back into the education system, while the system claims them as justifications for their continuing existence. Students too are often distracted or unmotivated, further education since 1989 having become increasingly vocational and output driven. Of course, some academies avoid the worst excesses of this trap and provide a great experience, but in comparison with social sciences or other humanities university-level research units, the status of academic exchange in art is low. Contemporary art production, which was radically globalized following

the political changes in 1989, is now more often akin to niche marketing than to academic research. The itineraries of leading artists and leading corporate executives regularly match each other flight for flight. If new kinds of academic structures are to emerge in the near future, this issue of what academic knowledge is created and exchanged in the process of teaching and its subsequent influence on students' artistic production needs to be clearly and outspokenly addressed, not pushed back under the carpet of art as a traditional academic discipline.

While an attempt to square the multiple circles that make up the challenge of producing academies fit for the twenty-first century may be quixotic, I can look at some specific historical examples and some evidence from my personal activities that might identify where the potential for academic renewal may lie. In any case, it is probably some form of renewal of orientation, rather than wholesale invention, that we are looking for. Continuity from either the nineteenth- or twentieth-century models looks hopeless given the changed landscape in which we have to operate. Whatever kind of academy we may want and however it might be realized, it must be based on a certain reading of the past of these same institutions—at least so that we can avoid repeating mistakes and take the most useful lessons from more than two hundred years of art education.

We can be confident that in the future, art schools will in all events produce new ways of reconciling the paradoxes and developing new models and ways of funding, as well as creating radical methodologies for teaching people how to become artists. My personal question in response to this is to ask how to shape these processes in ways that will aid certain tendencies to which I am committed. They are, in précis, a critical way of thinking about art's relation to society and social change; a skepticism toward doctrines and given truths; a recognition of our cultural specificity and an openness to other cultural specificities; a strong sense that our generation did not reach the end of history in 1989; and that emancipation and justice remain ideals to be realized, not facts on the ground. These opinions are my own, but I believe that they must be at the core of an educational encounter with contemporary art if that encounter is to have meaning beyond satisfying the latest market trend. In terms of the actual development of programs, the important issues are the extent to which all the participants in the process—students, young artists, teachers, the academy's workers in all fields—can influence and direct the changes that will occur and how an institution can set up the mechanisms to ensure that this is done. Contemporary art remains a protected enclosure to some extent. It is one of

the few fields in which even global corporations and national governments encourage us to "think things otherwise." While this space can often seem more disciplinary than permissive, in that the idea of art is controlled, overseen, and channeled, we are in no state as a society to abandon our few public institutions for forlorn revolutionary hopes. We should therefore take our merry jailers at their word and seek to create institutions that take full advantage of the space that we have available to cultivate art at this moment in our history.

A PARTIAL HISTORY

My current, rather peripatetic, existence allows me the privilege of seeing a number of art academies. I find that wherever I am, I am usually attracted to one particular aspect of an art school—one formal structure or group of students who have organized themselves or come together around an individual teacher or opportunity. Bearing in mind this experience, it seems to me that almost any art situation has the potential to generate something that could be understood as interesting because it resists what it is supposed to be or do. The simple confluence of a number of hands and minds investigating art in a particular place throws up, of necessity, a challenge. Art schools have, up to now, consistently attracted young people who are not so satisfied with the conditions that they have inherited, though it remains to be seen if this will continue to be true under art market conditions in which being an artist is a relatively sensible career choice financially. Nevertheless, if the engagement of nonconformist individuals in art remains a possibility, we might imagine that those responsible for the development of academies can rest easy, work within the existing structures, and follow the paths of least resistance as determined by the ever-present bureaucracies of funding. This could be quite a seductive model for the institution and it is perhaps not too far from the truth, at least partly. Often the possibilities that students are given for working against the system can be the most productive aspect of any school curriculum. In some cases and for some individuals, the most significant thing that can be said is, "No, that isn't what we do here"—a denial that can then act as a suggestive and powerful provocation to action. In any thought about the situation that might encourage the construction of the "ideal art school," we should not forget this need to be imperfect, precisely in order to inspire resistance and the search for alternatives among the collegiate body. Despite my opening plea for what

might be seen as inaction in art academies, I do think that we can try to create the most energetic and interesting situations that would achieve the conditions of learning that I've outlined above. A school that is self-aware, responsive to its participants, and willing to consider the virtues of its own demise can contribute more to its overall goals, however it wants to describe them, than one that is controlling, repetitive, and nervous for its future.

Most important perhaps, what academies do *does* make a difference. Creativity can indeed emerge in any context, but we have only to look at specific moments in art school history to see that there have been pivotal academies in the renewal of our artistic heritage in Europe and North America. Consider Kazimir Malevich's art group UNOVIS in Vitebsk and the Institute of Artistic Culture, called INKHUK, in Moscow; the Bauhaus in Weimar; the Nova Scotia College of Art and Design in Halifax and the California Institute of the Arts— or just CalArts, as it's known—in Los Angeles in the 1970s; the Free International Universities (FIUS) of the '70s and '80s under the initiatives of Joseph Beuys and Caroline Tisdall, among others; and more recently Goldsmiths in London and Jaroslaw Kozlowski's class at the Academy of Fine Arts in Warsaw. In all of these places, something occurred among the energy of the students, the commitment and courage of the staff, and the external political and social circumstances that defined a new way of working with art and its education that benefited all parties enormously. Unfortunately, none of these exemplars developed sufficiently similar structures for us to simply institute them in a programmatic way. Each was brought about by a confluence of individuals who shared certain ideals and were allowed to put them into effect by the intellectual and political climate (or simply weren't stopped from being carried forward). In fact, many of these "great moments" in art school history lasted only a few years before they also needed external challenges and renewal or imploded under internal or political pressures. This pattern of development is probably the best we can expect from any new projects or pedagogical ideas that might be implemented in the near future.

In looking in more detail at various historical academies, I wanted to discover if, despite their differences, there were certain points of consensus about structural and pedagogical issues that could be significant for contemporary art and for art schools in this new century. Much of the research that has fed my writing here is based on work that I did in the late '90s, at the time of my protoacademy project at the Edinburgh College of Art (of which more later). There are numbers of remarkable documents about the founding of the various vanguard art programs I've already mentioned, along with other texts

mostly written by artists from the late 1960s on, that share an interesting degree of agreement about certain educational fundamentals—almost regardless of their schools' structures and philosophies. I've tried to corral these under three headings that define what seems like an almost consensual opposition across time to certain preexisting assumptions: antispecialization, anti-isolation/antiautonomy, and antihierarchy.

The first of these points is that artists shouldn't be viewed as specialists or limited to activities defined by certain areas of specialty. In fact, they should oppose the philosophy of specialization that is foisted onto art education by either scientific models or economic criteria of assessment. For instance, when Walter Gropius wrote the original pamphlet/manifesto in 1919 that articulated his vision for the Bauhaus, he saw the "complete building" as the project around which to unite different art disciplines, handcrafts, and manual skills. Beuys wrote in the founding statement for his Free International University in 1982: "The specialist's insulated point of view places the arts and other kinds of work in sharp opposition, whereas it is crucial that the structural, formal, and thematic problems of the various work processes should be constantly compared to one another." Further on, he argued: "The division of the disciplines for the training of experts, with no substantial comparative method, reinforces the idea that only specialists can contribute to the basic structures of society: economics, politics, law structure, etc."

A recent CalArts prospectus picks up on this conviction in a typically more pragmatic, utilitarian style: "The faculty has long questioned the traditional categories of art production, and encourages a cross-disciplinary approach. This means that painters can work with photographers, or designers with videomakers; it can also mean that, using the resources available throughout CalArts, a sculptor can work with a musician, a performance artist with a filmmaker, or a photographer with a writer. . . . All the resources of the School are thus available to every student with an openness that also, paradoxically, leads to a kind of institutionalized friction that causes a constant questioning of boundaries, assumptions, and aims."

These ideas relate to a connected concern that art education should be directed to the whole human and that the significance of art's role in the academy, university, or broader society is as a synthesizing agent crossing and combining mutually ignorant fields of specialization.

A second point of consensus is a real commitment to opening dialogue with specific nonart constituencies, either with the "community" (vague word) or with certain industrial or intellectual environments—what I've called "anti-

isolation," or perhaps more poignant, "antiautonomy." In Vitebsk, UNOVIS organized urban decorations for the three anniversary celebrations of the October Revolution, including Suprematist designs by Malevich, proto-Constructivist banners and billboards by El Lissitzky, and images of Chagallian people flying through the air. These decorations were usually produced collectively without a single authorial voice, and the artists appear to have been genuinely concerned about how the working class of Vibetsk perceived their works and whether they increased revolutionary consciousness or were rejected for being nonrepresentational.

The new initiatives after 1945 emphasized even more the need for contact with other academic disciplines, with commerce, and with the immediate community. For example, Kasper König was responsible for an extraordinarily rich series of publications that came out of the Nova Scotia School of Art and Design in the 1970s—a program that attracted the best artists of the period to a relatively isolated spot in Canada. There is a wonderful bureaucratic document for the Free International University written by Caroline Tisdall in 1975 as an application to the former European Economic Community for the proposed establishment of the university in Dublin (which never came to pass for lack of funding). It is the clearest possible statement of the aims of these programs, many of which speak directly to our current situation. She described the ambitions of the project and its difference from traditional universities, including the cross-fertilization of disciplines toward the goal of exploring the "contribution that cultural and intellectual life can make to society"; its total independence from government bureaucracies of education; its transparency to the public; its freedom from age restrictions; its openness to cultural and political dialogue "as a basis for dialogue [without imposing] standardised opinion"; and its intention to "regard learning as a process not an end."

In the United States, Allan Kaprow had already proposed an even more radical admixture of art and society in his February 1971 essay published in *Art News*, "The Education of the Un-Artist, Part 1." After describing the morbidity of "art-art," as he put it, he writes: "Seeing the situation as low comedy is a way out of the bind. I would propose that the first practical step towards laughter is to un-art ourselves, avoid all aesthetic roles, give up all references to being artists of any kind whatever. An un-artist is one who is engaged in changing jobs, in modernizing. It is quite possible to shift the whole un-artistic operation slyly away from where the arts customarily congregate. To become, for instance, an account executive, an ecologist, a stunt rider, a politician, a beach bum. In these different capacities, the several kinds of art discussed would operate

indirectly as a stored code, which, instead of programming a specific course of behavior, would facilitate an attitude of deliberate playfulness towards all professionalizing activities well beyond art."

Kaprow is the classic example of the artist who tries to undo art. But his engagement throughout his life with teaching shows that the idea of undoing was also connected to a subsequent reconstruction. The artist is as much a synthesizing figure as a destructive one, taking art out into the world as a way to keep it alive and purposeful.

A third point of consensus for most academic models in the 1960s and afterward is the desire to flatten or eradicate hierarchies between artist-teacher and artist-student. The FIU initiated this model to some extent with its appeal for "reciprocity between staff and students [where] there will be no director and all major policy decisions will be reached through student-staff discussion since the University itself must function as a model of democracy." The Warsaw Academy of Fine Arts followed this idea, too, in requiring students to perform and take an active role in their immediate educational environment. From this basis, artists such as Artur Zmijewski and Pavel Althamer have been able to develop radically new participatory practices that resemble a social studio, making use of society as a material in itself.[1]

THE PROTOACADEMY

There is always a great danger in self-historicization, and I have been somewhat hesitant in writing about the experiment that was the protoacademy, feeling it would be better left to others. However, it was a four-year project that is now more than six years gone and, as it remains underrecorded, I think it is worth looking at some of its statements and propositions. The protoacademy was established in 1998 in Edinburgh with a very simple metaphor: the idea of an empty table or tabula rasa. Whoever came to the table was a member of the protoacademy, whether it was a teacher or a student or somebody from the outside. They demonstrated their qualifications to be part of the group by the information, the intelligence, the ideas, the questions, or the confrontation they brought to that table.

Toward the end of the project in 2002, we produced a short collective text that in many ways summed up the progress and paradoxes that emerged in the

intervening years. It needs to be read as a plural text in which each text format forms its own continuity:[2]

Proto academy thinks on its feet, not on its seat. Situated just off Edinburgh's Royal Mile in the
Flag that up. But girls don't write manifestos—except for that Russian Futurist Valentina—what's her name . . . shadow of The Crags and the Scottish Parliament, it is housed in a former Social Security
we should just record this and run it through the text—in fact we should get a minidisc and record everything . . . portacabin called Weirsland. **The proto academy is not a tapestry department.** In this secluded *A dole office, really? . . . yeah, we like that pedigree—and reminding people of it. What was that reference to the pastoral? Well it's to do with this mythical understanding of the proto academy that other people have . . .* spot, gentle herdspersons convene to exchange gifts and elevated thoughts in the noonday sun. . . . *but it's just us, exchanging work and ideas between ourselves—and the people in Malmö, Stuttgart, Seoul, Trondheim, Berlin, London . . . and it does work—like, say the Malmö show in May. . . . But community comes at a price.* **The proto academy is not its history.** The facilities at Weirsland include 24 hr multiple access, a landscaped garden with a historic fountain, and a roof terrace with bar.

Proto academy consumes bureaucracy and produces community. Parking is free. **Proto academy is not a research** . . . *and we could do with a course in feminist theory, maybe someone from the university could be pulled* **assessment exercise.** (Contributions to this space invited). **It is not run in accordance with** *in to handle that, or someone like Griselda Pollack. But what are we going to do with this, it sounds like* **conventional standards of success or failure.** The interior includes floors by Jim Lambie, a skylight
a bunch of guys sitting in an old man's bar off the Royal Mile?! We need to pep it up a bit for christ's sake. by James Turrell, filing systems by Donald Judd and a canteen by Jorge Pardo.

Proto academy *Yeah, why don't we use this space to hire out proto academy's services to other flagging art colleges?* **generates a vast number of research**

points. These are currently available for institutional *What about this "tabula rasa" thing? Let's get this over with. What does it mean? Blank slate, empty page.* assignation. Waste disposal and security systems by Gustav Metzger and Phil Niblock.

Why does it sound like "table"? No, it's to do with proto academy being anything anyone wants to make out of it.

Proto academy is not a cult, a massage parlour or a postgraduate nursing home. It is not *you mean like that issue of Metronome with our five blank pages in? Yeah, something like that . . .* circumscribed by affirmative statements or disclaimers. The proto academy's structure *Can we think of 'use value' here? I think use value lies exactly between those two terms, I mean* changes in accordance with the activities of its members. We welcome and encourage *. . . affirmation and negation. There's a lot of contradiction inside that. There should be more contradiction.* Intermittent acts of artistic practice and research, and can accommodate overnight visitors.

In this text, some of the competing, plural voices of different members can be heard. The strength of protoacademy was in allowing that agonistic kind of existence to flourish. It sometimes produced stasis, but this was always temporary until the final removal of funding by the college in 2002, by which time many of the original participants had moved on. To some extent, protoacademy was a process that led some to disillusionment with the priorities of a product-oriented system. There was a shared commitment to collective activity and communal reading that probably influenced some too strongly to continue with an individual art practice, but such a result is to be expected, even admired. It is likely that in all events, a project such as protoacademy could have had only a short life span. It is important to note that not all the participants built major careers in the existing art world. It required enormous commitment from its members to generate discussion and maintain activity without a formal administration. Such assistance and the consequent bureaucracy would have been necessary in the longer term. Yet having contributed to biennials and academies across Europe and in Asia, and having organized reading groups that established critical theory as a purposeful field at Edinburgh College of Art, it did manage to administer itself fairly well on no time and no pay. In terms of its longer-term effects, they will be seen in the individuals who participated and are perhaps reflected in such independent initiatives

as Clémentine Deliss's subsequent Future Academy project that occupied part of its intellectual space at the college.

BLUEPRINTS FOR THE NEXT EXPERIMENT

The protoacademy was of its time and place. It responded to particular realities in Edinburgh at the time—the lack of international connections, absence of theory, and the need for a broader definition of art and its relation to student activities. These issues were not unique to Edinburgh but were expressed in specific forms. A second protoacademy initiative would need to be configured differently for its environment. Nevertheless, what we can learn from the negative definitions of antispecialization, antiautonomy, and antihierarchy is that a rejection of what has gone before and a desire to undo the coordinates that locate art at any given moment must be key to any propositional plan for an art school now. Learning how not to take part, often through collective agency, can be the basis for the reconstruction of the priorities of the art world. At this stage, for instance, an explicit rejection of the art market and an attempt to produce thinking without the production of objects would seem to be a way of rejecting the contemporary status quo. Such a move would also call on the research that has been done in the past ten years around the production of knowledge and could reshape the link between artistic works and the acquisition or presentation of experimental results in universities. This construction could perhaps be anticipated only within a state-subsidized European system, though the challenge to the academic marketplace to deliver such an outcome would be fascinating to observe. At the very least, it would ask gallery owners to once again get creative and figure out how to commodify such works and once again renew their contract with collectors.

PROJECT 5

YALE ART AND ARCHITECTURE BUILDING, COMPLETED 1963,
PAUL RUDOLPH, NEW HAVEN, CONNECTICUT

Designed soon after Paul Rudolph moved north from Florida to become chair of Yale University's architecture department in 1957, his Art and Architecture building symbolizes the heyday—and perhaps also the zenith—of an icon's ability to symbolize the integration of the visual arts within a research university. The building belongs to a number of Rudolph's projects that introduced a mannerist take on vernacular spatial configurations. On being finished in 1964, it was generally either loved or hated.

Two indelible characteristics shape its primary effects: As a means to achieve a complex and nuanced sense of flowing spaces, the nine-story building has more than thirty levels, and nearly its entire concrete surface, inside and out, had its beveled ridges hammered into jagged lines by workers, creating an impression that the building's skin was literally a representation of the repetitive pencil lines of an architectural rendering. The internal complexity of the school's levels produced an idiosyncratic baroque feeling, while the unprecedented perversity of the exterior gave the entire building an uncanny and somber air.

Equally perverse, Rudolph's plan for the configuration of the building's interior space celebrated architecture and marginalized the arts. Graphics, sculpture, and basic design were relegated to the basement, with painting on the top floor, while exhibition and drafting rooms dominated the central spaces. Five years after the building officially opened, an unexplained fire made way for radical alterations to revise the internal plan in the name of practicality. Many of the peripheral spaces were filled in to generate more usable space. What had been larger studio spaces were broken into private cubicles for painters, with the resulting central spaces (now largely lacking daylight) making do as areas for communal activities, such as critiques of work. Eventually, every program except the graduate architecture division was moved out of the building, and in 2007 it was restored to its original spaciousness, though it remains the exclusive domain of graduate architecture.

A key element of Yale's approach to the arts is physically embodied in Rudolph's building. Although most contemporary art schools have forgone strict curricular divisions between artistic disciplines as artistic practices have become ubiquitously interdisciplinary, Yale has persisted in segregating painters from sculptors, graphic designers, and photographers. Even today, graduate painting and sculpture students are housed in different buildings—monuments to a pedagogical practice as contested today as Rudolph's building was more than forty years ago.

Interior view of drafting studios. (Photo credit: © Ezra Stoller/ESTO)

ROAMING, PRELUSIVE, PERMEABLE

Future Academy

Clémentine Deliss

In the early spring of 2006, a small team of artists and researchers from Future Academy flew from Edinburgh to Seattle, rented an RV from a family in Olympia, stocked up on whiskey, meat, dried fruits, and fuel, and drove deep into Oregon's national park. Over the course of ten days, we covered 2,000 miles of dense woodland, driving along dirt tracks punctuated by potholes and logging roads washed out by the melted snow. We were searching for

Bert and Holly Davis, the publishers of *Dwelling Portably*, a zine that for thirty years has provided essential tips to the significant community of individuals who have elected to live "unhouse." Disavowing walled buildings and boats, the Davis's slim manual offers updates on how best to go about eating, sleeping, recycling, storing, hiding, and constructing alternative modes of living with minimal requirements.[1] Theirs is not the life of the desperado or the hippy, but an unusual and engaging reformulation of nomadic existence that prides itself on the straight talk of structural and survivalist ingenuity.

On the team were Guy Billings, a doctoral student in computational neuroscience from the University of Edinburgh; Marjorie Harlick, a postgraduate fine art student at Edinburgh College of Art; American artist Oscar Tuazon, who had introduced me to *Dwelling Portably*; and myself, initiator and director of Future Academy.[2] Future Academy was set up in late 2002 to investigate the global transformation of the art college and, with the input of students, forecast future conditions for independent research and art production.[3] Consistently supported by the Edinburgh College of Art, Future Academy does not provide an M.A. or M.F.A. and, in fact, has no formal legitimacy in terms of official diplomas or exam qualifications. As a self-reflexive investigation that relies on the free will and engagement of students from different institutions and faculties, Future Academy is necessarily autonomous in its structure and thinking. It appears to disturb the existing coordinates of art education and traces paths beyond Europe to locations that throw up earlier cartographies of colonial expansionism in culture and education. Over the years, it has operated through a series of collaborative structures and experimental events that to date have taken place in London; Edinburgh; Glasgow; Dakar; Delhi; Bangalore; Mumbai; Portland, Oregon; Ljubljana; Patras; Tokyo; Nagoya, Yamaguchi, Melbourne; and Kassel.

Before we left for Oregon, we had written to Bert and Holly at a post office box number in Philomath.[4] We wanted to meet them in person, to understand their choice of lifestyle, and experience their self-designed architectural interventions in the hills and forests. The journey would effectively provide an empirical dimension to our investigation into the architectonics of future art colleges, testing the validity and practicalities of an educational system that was quite literally without buildings. It represented the latest point in a progression of fieldwork experiences around the theme of mobility that had engaged previous Future Academy teams in Dakar, Bangalore, and Edinburgh.

Furthermore, as an independent publisher, I was keen to reproduce the format of *Dwelling Portably* for an issue of the organ *Metronome* (figure 10.1),

Metronome No. 10

FUTURE ACADEMY (Oregon)
Shared, Mobile, Improvised,
Underground, Hidden, Floating.
$5 per issue

WORKING PORTABLY.

We are asked: What kind of working environment do you prefer?
The bare minimum. We prefer a studio without a fixed location.
Without regular hours. When we have time and are able to meet
we find it easy to procure a room for the purpose: often, there
is empty space if you know where to look and who to ask; other
times, a bar. Knowing what you need makes it easy to ask.
Oscar Tuazon, Mar 06

Mobility has to be physical, for it has to push the limits of
knowledge through migratory wisdom, just as it must be con-
ceptual, that is, able to recognise different, quietly acquired
gestures and idioms of thought in order to develop a language
form that is non-identified and subsequently non-intrusive on the
other. Tangential knowledge is the only platform upon which we
can negotiate translation. We have to be ruthless towards vague
strains of populist cohesion that refuse specialist knowledge
systems and codified forms of currency. The institution of the
future is one that can speak
its own language without
the fear of consensus.
Clementine Deliss, Oregon
Mar 06

(Comment:) I do not have any
expectations as I don't like
any predetermined things and
situations and this gives me
a sort of emptiness to move
more freely and work portably.
Nico Dockx, Antwerp, Mar 06

180cm

bed
not

shown

—3M—

SIDE VIEW: tetra and octa
hedrons arranged in rows.

(Comment:) Scientists are often
tied to large expensive pieces
of equipment. But there is much
science that can be done with
little more than a pen, some paper and a computer. If you are able
to work like this (as is often the case with more theoretical
subjects) you can work where ever and when ever you like. I have
found that varying your working location can aid your thinking.
Guy Billings, Future Academy Studiolab, Edinburgh, Mar 06

ORGASMOTRON.

We set up a STUDIO with its own very specific identity. A structure
that has to be added to, that isn't complete, will never be complete.
A negative position towards the institution. Occupying space, taking
over an existing room, filling it. An art school tries to keep out
living functions, but empty rooms are available, equipped with climate
control, running water, and electricity. Take advantage of what is
there. Take the open space of an institution, and close it off from
the others. It may be possible to live there. Recreate the feeling
of being in a crowd. OT, Nov 05

(Comment:) To create, maybe very similar to Constant's NEW BABYLON,
an architecture where you can build and take down in the same
action, able to simultaneously produce, transmit, circulate, evaluate,
criticize - like an endless feedback loop. Nico Dockx, Antwerp, Mar 06

10.1 *Metronome No. 10*, Future Academy (Shared, Mobile, Improvised, Underground, Hidden, Floating), Oregon, 2006. Edited by Clémentine Deliss and Oscar Tuazon. Printed in Portland. 20 pages, b/w. (Courtesy Clémentine Deliss)

adapting its no-frills language to a bank of information gleaned from three years of Future Academy dialogues. The Davises' pamphlet (typed on a machine from the 1950s, pasted up, and mimeographed in a minuscule font size to minimize storage problems) corresponded to a deregulated and distinctly low-maintenance form of publishing. Future Academy participants were concerned with the ownership of research in both art practice and science, and this issue found a correspondence in the precision with which the Davises had developed their distribution networks.[5] With *Dwelling Portably*, they bypassed the conventions of visibility and commerce and, for our purposes, the ideological process of legitimation and appropriation by institutional structures, such as university funding and research boards.

After several weeks, Bert sent back a message on recycled card stock, saying that they were happy for me to imitate the style of *Dwelling Portably*, but that in March they would be too far off any beaten track for us to find them. Undeterred, the four of us embarked on the field trip to Oregon. Although we never reached the Davises' subterranean dwelling, we did test out the ramifications of makeshift accommodation and, following their instructions, dug a "hill-lodge" in a muddy slope of impenetrable woodland and slept there. At the end of the search, we returned to Portland, parked the RV downtown, and typed 25,000 words on several second-hand typewriters, which we had purchased at local thrift shops. Cutting and pasting, we managed to replicate the layout of *Dwelling Portably*. We then printed this new issue of *Metronome* with soy-based ink at the seminal Natural Press printers in Portland.

In a curious manner, our nuclear group in Oregon had all the makings of an art college faculty in miniature. As a team we were able to cover fine art, critical theory, social anthropology, curatorial studies, architecture, mathematics, cybernetics, computational programming, and several languages. Driving past secluded farms and hamlets, we thought about this option, imagining setting up shop in our ambulatory educational facility with a do-it-yourself classroom

10.2 Issa Samb and Clémentine Deliss, Future Academy at the Laboratoire Agit'Art, Dakar, July 2, 2003. (Courtesy Clémentine Deliss)

modeled on local conditions. Not surprisingly, roaming facilities had played a part in gypsy and pioneer settler lifestyles in the nineteenth- and early twentieth-century American Northwest.[6] Today one might acknowledge the different migrant academies that travel across borders with their informal curricula at hand, created by a condition of imposed mobility. As Georg Schöllhammer, publisher and director of *documenta 12* magazines, noted at the meeting of Future Academy in Tokyo in 2007: "We have not spoken of the vast forced mobility of people who migrate, and the equally vast academies that migrants create with different types of knowledge. Here picnic blankets are not being used to rest on in a peripatetic Socratic situation but to mark a space that they consider their own within the condition of constant unfamiliarity that they find themselves in. We should not forget these forms of knowledge production."[7]

To conceive of the range of practices and wisdom carried through these constructed communities, whose emancipatory potential lies at the forefront of their daily experience, is to imagine probably one of the most heterodox situations in the transmission of knowledge today. In fact, the mobile faculty in Oregon ultimately reformulated proposals that had been written up in Senegal two years earlier. In Dakar, the Future Academy cell had proposed a focus on itinerancy based on a truck, equipped with audiovisual equipment, acting as a live library and production studio (figures 10.2 to 10.4). Decentralizing education, moving it out of the capital into isolated rural locations, rather like the Red Cross trucks so familiar to African countries, would highlight nonmaterial or object-based art with oral and physical performance as the primary media of aesthetic practice.[8]

In 2004, the question of mobility was debated in Edinburgh at an international symposium that was organized by Future Academy and entitled "With or Without Buildings?" It was held at the College of Art's newly purchased Evolution House and prompted by the increase in the construction of new art school buildings pretty much everywhere. Students from final-year architecture

10.3 Blackboard. Drawing by Issa Samb, Future Academy at the Laboratoire Agit'Art, Dakar, July 2, 2003. The chalk drawing maps out the different global trajectories panning out from the Islamic school (Dara) in Dakar that might affect students of Koranic studies (Talibé). Samb projects into 2025, predicting high-level problems that he lists as demography, health, and unemployment. The flow of capital falls into the following combinations: Asia: sects; Africa: wars; Europe: creative industries; Oceania: mobility; Arabia: dogma. (Photograph: Clémentine Deliss)

10.4 Members of Future Academy Dakar at the Laboratoire Agit'Art in Dakar, July 2003. The group is discussing the flow of capital, seated around a pile of golden chains. (Photograph: Clémentine Deliss)

presented their views alongside the architects Didier Fiuza Faustino, Christos Papoulias, and Allies and Morrison, who had just completed the Chelsea College of Art and Design at Millbank, next to Tate Britain. Cunningly rewriting their own college's official handbook, several architecture students came close to contradicting their studies, refuting iconic spaces and presenting a political critique of student dependency on the institution. Others described Future Academy as a "library of equipment," delivering tools "from an anchor to a needle" when and where they were needed.[9] In general, the students anticipated greater social and interpersonal communications, highly localized working situations, and informality. They could foresee an increase in mobile units, short-term rentals, and alternative energy sources—structures that generally highlight method rather than the built environment.

Two years later, in our Studiolab, a bilateral cooperation between Edinburgh College of Art and Edinburgh University's School of Informatics, these debates on the architectonics of mobility continued. Studiolab was a voluntary forum for postgraduate students from both institutions, but it provided no course structure or accreditation. Its members regularly organized public events and street-side experiments, and benefited from the workshops of guest artists and scientists.[10] The self-appointed student group from Informatics, Fine Art, Architecture, and Sound Design spent several months proposing test conditions for personal mobility, including the rudimentary wooden "Cuboid" that was shifted through Edinburgh in a van, set up in different key locations such as the main cathedral or university campus, and made to function alternatively as a confession booth or spying facility.[11] Other contrivances were built out of obsolete hardware and included a Faraday cage that shields electrical equipment from electrostatic charges and an "i-poncho," which interfered with existing radio transmissions in public spaces. However, the real movement that took place was in the interface between our different perceptions of what it means to research something, respectively, in art and in science. The specificity of art is perhaps its self-organization, use of observation, experiential approach to developing ideas, and encoding of new forms and representations. This methodology relies on the generation of different situations that qualify the educational process. The students from the Informatics program who joined Studiolab recognized the value in this diversification, and instead of heading for a predetermined investigation or for technology-inspired projects, they were ready to bring collaboration down to a base level and gradually determine mutual concerns. Out of this modest predisposition, the group designed www.voiceforum.org, an oral newspaper conceived as a

rapidly modifiable research journal for disseminating thought between artists and scientists.

Out of all of these case studies and experiments, a key figure emerged: the contemporary *polymath* who came to signify for Future Academy the ultimate embodiment of mobility. It was the polymath whose combinatory skills would ensure adequate adaptation to the local environment, the translation of aesthetic idioms, and the overall inclination to expand the foundation for value judgments. For the team in Oregon, the figure of the polymath was reflected in the group itself rather than in each person's individual competence. The principle was one of heterogeneity and generalism: contrasting sets of knowledge and skills would be carried over by both a roaming faculty of artists from different cultural backgrounds and scholars and practitioners whose work methods and approaches to production responded to contemporary concerns.[12] Art students, the Future Academy group argued, could benefit from a lawyer on immigration and identity issues, just as they might draw firsthand experience from economists or analysts whose research was founded in the methodologies of non-Western societies. Furthermore, it was to latent, often repetitive aesthetic processes and quotidian relational activities that attention was directed, including the use of various rhetorical devices, graphic and iconic registers, the daily presentation of market goods, or even sporting activities that foregrounded metaphysical discipline. The global significance of interventionist practices in contemporary art in the 1990s can be recognized here and easily referenced in the activities of N55 and Superflex in Scandinavia; Open Circle and PUKAR (Partners for Urban Knowledge, Action & Research) in India; and Huit Facettes and Tenq in Senegal.[13] The class-based hierarchy between popular culture and fine art, as well as the academic subdivisions into sculpture, painting, drawing, photography, new media, or intermedia (which all too often replace the visibility of named artists as key agents in the transmission of knowledge), would not need to be dissolved. Instead, further complementary faculties of knowledge would be introduced through an invitation to embark on new productions and exemplify through practice the simultaneous existence of cultural, epistemological, and methodological alternatives. In this manner, a future art academy might engage in a polymathic educational model, a polymathic faculty, a polymathic understanding of place, and finally a polymathic economy that situates itself between different public audiences, institutional structures, and time frames.

With Future Academy, participants acted as diagnosticians of their own art education. The best results were produced if they were able to recognize the

fine line between their current educational condition and their imminent step into a future professional environment. Interestingly, the students who signed up for Future Academy from the fields of architecture, fine art, digital media, sound design, and informatics either left within days because they could not understand the apparent lack of course structure or they became so fully involved that their ownership remained unrelenting. As Guy Billings, one of the student coordinators, described it in 2006, "I think we should try to divorce the project from the notion of a course. A course implies a curriculum and so it is no wonder that people get uneasy when they find that we don't have one. Rather we should make that our strength."

The potential underlying Future Academy's methodology is not dissimilar to Jacques Rancière's reading of early nineteenth-century educationalist Joseph Jacotot's philosophy of intellectual emancipation. Jacotot excelled in one particular style of instruction, described by Rancière as crossing a forest and not knowing where the exit lies. Experimenting in the space between authority and action, Jacotot believed that teaching something that one knew nothing about would encourage the student to use his or her own intelligence. For Jacotot, a teacher was an emancipator, traveling with the student on a journey of the mind. Inevitably, his concept of intellectual emancipation ran against the grain of the times that sought instead to standardize teaching. Yet Jacotot persisted in believing that *explanation* was not only the brutal weapon of pedagogy but also the very connection that created a social order. A social order in turn implied a distribution of rank. Rank led one back to explanation: a fiction that justified the unequal distribution of intellectual value with no reason beyond itself.[14]

Existing outside the curriculum implied that all Future Academy meetings and workshops with guest artists, or field trips, events, and publications, were the result of voluntary input. Motivating this unregulated membership were the pitches of the students. At the start of each academic year in Edinburgh, Future Academy members made presentations to students from different departments of the college and the university. In parallel, I presented the project to potential participants on research visits to India, Senegal, Australia, and Japan. The students who signed up had to contend with the tension between investing time and effort in their symbolic futures through their officially accredited education or dedicating energy to something as unresolved as Future Academy's investigations, which, while nonpaying, were still part of a college or university structure. This led early on to an interest on the part of the participants in economic models, in both practical terms and as an aesthetic and

relational proposition. Their claim was straightforward: independent practice required independent sources of support. As they saw it, the future role and value of the artist could lead to a type of international intelligence for which both a black market and a barter system might become operational. In February 2003, a week-long Future Academy seminar at the Glasgow School of Art generated a proposal by mainly foreign M.F.A. students to set up a "Future Academy Bank."[15]

The senior management of the college in question immediately quashed the proposal and, as any further development was voluntary, the students continued with their individual studio practice. Future Academy's relationship with this institution ended shortly afterward. However, the focus on economics in Future Academy did not, and it was in Dakar that the most coherent and topical economic model was developed—precisely because the nervous accountability of the host institution did not interfere with the students' conception of legitimate research.

The model proposed by the Senegalese group referred back to the "Tontine," a microcredit scheme devised by the Neapolitan Lorenzo Tonti in the seventeenth century. In Dakar, the scheme was activated in the recession of the 1980s as an alternative to the development banks, which were still closely tied to French financial institutions, although they were run by the Senegalese. Key to the Tontine system in Senegal has been the cultural and social dimension that it employs to ensure that a rotating rhythm of contribution and spending is maintained by each of its members. Tontines can fall within several categories. Some are regulated by religious and commercial interests in order to cover financial difficulties or pay for pilgrimages to Mecca. Others are smaller cooperatives based on neighborhood structures, women's groups, the organization of events, or the acquisition of health and educational infrastructures. The fundamental issue of the Tontine is that it remains outside the law, is not monitored by the police or the state, and constitutes part of the informal economic chain. Trust and social sanctions encourage a self selection process with regard to the group's core membership. Tontines can even have clandestine membership arrangements such that, although the savings will rotate from person to person, these individuals remain unknown within the group. In the context of Future Academy, the Tontine provided an experiment in alternative funding systems and actually paid for the Senegalese participants' visas to India for the Synchronisations forum organized by their Future Academy colleagues in Bangalore. The Edinburgh group also

applied the Tontine system to their collective finances and managed to raise a considerable amount for their visit to India.

As research on this financial and communal structure developed, so too did the concept of the individual who might operate it: the student on the one hand and the teacher or professor on the other, both defined as near-to-equal agents in a transactional relationship. If the example of legally extraneous microcredit associations had provided the economic and social framework, it was to be the hawker or itinerant salesman who offered the role model.[16]

Nalla Auro, Mariama Diallo, Moustapha Mané, Mar N'Diaye, and Awa Diouf presented these ideas at Future Academy's Synchronisations student think tank in Bangalore. "There is a social category that is being formed by itself," Nalla Auro commented. "We call them in Senegal the *baol-baol*, or *modu-modu*, or in English, the hawker. These people do not depend on any financial institutions. You see them circulating in Dakar and in all large urban centers throughout the world. They do business and make a lot of money. If banks go bust, they can still manage their funds and capital. They are part of an extraordinary economic system, and their wheels are so well oiled that they can get out of problems each time."

Mar N'Diaye added: "We realize that there are eminent professors of economics in Senegal who often receive travel grants to go to Europe or the States in order to study during the holidays. They come back with theories. In contrast, you have the hawker who has no formal education in economics and has only attended traditional and Islamic primary schools. This hawker enters the economic system too, the one that we call informal, and he or she travels worldwide. What have these people done to become successful in the context of an international system? They receive no support from the government. But if they could enter Future Academy, we could ask them how their system functions without formal economic principles and how it is that they still manage to survive."

Awa Diouf continued, emphasizing that "the hawker is at the heart of our intellectual debates right now. But also in terms of media and communications. The formal and the informal do not only exist in economic terms. They exist in the artistic domain too and we should open up this debate in Future Academy."[17]

In the South African context, the journalist and poet Gael Reagon elegantly exposes a parallel when she writes in the journal *Chimurenga*, "On the street everything is currency, what needs to be bought is sold. Clothing, hairdressing,

furniture, live chickens, art works, internet cafes, telecommunications, bodies, sleep, fear, so basically, Mr. President, the second economy is the first."[18]

As part of their Future Academy investigations, the Dakar group spent lengthy periods in the Senegalese capital analyzing the network of beggars with their uniform tin cans that advertise local tomato paste, the mnemonic methods of Islamic primary schools, the stock exchange of second-hand clothing (figure 10.5), and illegal taxi drivers with their speed-driven race against death. They looked at these phenomena in terms of aesthetic vectors and values, and deduced complex performative and presentational modalities from them. As Mariama Diallo describes it, "We looked into 'friperie,' the second-hand clothing market, its objectives, its interests, the target audience, and strategy and related these to Future Academy. The 'friperie' is a market for imported clothes that constitutes the source of an economy. It helps a family to save money. The target audience comes from all levels of society and the chosen strategy is that of mobility. We see a future economic impact in the 'friperie' market rather as if it might lead to the creation of a stock exchange. You are no longer limited to your own country but as a system, the 'friperie' extends to an international level. Its aesthetic value lies in the assemblage of clothes, the use of colour, and their placement. Its aesthetic vectors belong to registers of performance, animation and the voice." In another case study, the itinerant salesperson was analyzed in terms of their cry, breaking through the density of the urban soundscape with specific calls, displaying goods on their body and walking the streets. Identifying daily routes and repetition, the students were able to tap into the relational connections, which seemed on the surface to be merely ubiquitous, and assign them relevance.[19] They questioned whether these practices might be appropriate as faculties in a future art college, effectively substituting the canons inherited from colonial art education. For example, classes in mnemonics would replace life drawing. As Awa Diouf also noted, "Education is based on memorization. We want to make a connection between religious education and education in the future. We ask ourselves whether this connection will be conflictual and therefore whether it is something which Future Academy will need to surmount."

Their final conclusion was that at a certain point, probably during post-graduate education, both students and teachers needed to reformulate their hierarchical relationship and enter a flat zone where each party recognized the value of their respective input and could then pitch and barter their way forward from ignorance to knowledge. The artist and member of faculty would see the value in working with a collective of younger practitioners, and they

in turn would favor symbiosis with the artists in place of a secluded studio practice as a means to develop their own work. This follows from Rancière's notion of "horizontal distribution," a topography that does not presuppose the position of mastery.[20]

At the Synchronisations event in Bangalore, Future Academy was renamed by students as the Permeable Academy, describing the mobile architecture of the itinerant salesman as a moving repository of comparative studies, analyses, networks, and individual contacts across the world. In this Permeable Academy, expertise would be handed over to peripheral academics, traders, and crafts people who would meet at the "shack studio," the concept for an educational and conversational tea shop located outside the walls of the colonial heritage academies (figure 10.6). Here the hawker, like our polymath earlier, becomes embedded in a structure dedicated to a form of knowledge transmission that favors emancipation and exchange rather than prescribed courses (figure 10.7).

However one chooses to classify the academy, definitions usually lead at one point to a certain tension between inclusion and exclusion, formal and informal, controlled and deregulated knowledge. One might focus, for example, on the academy as a protection lodge run by an elite establishment with a structure that is necessarily nonaccessible and nonpopulist. Highly ritualized in contrast to more bohemian academies or artists' groups, entry is based on formal arrangements of convocation, strictly maintained interpersonal networks, and traditional notions of adherence. A more innovative analogy might be the one proposed in 2007 by Georg Schöllhammer at documenta 12. Here the academy is understood as an editorial group. In the issue of *Metronome* on education that I published that year in Tokyo, he states, "The idea of the *documenta magazines* project is to come back to a form of mobility that is also a form of academy, a very stable form, namely the editorial group. It has a long tradition in independent media and involves a group of people working over

10.6 Zoe Leonard, image from *Analogue*, 1998–2007, approx. 400 C-prints, 11 × 11 inches. (Courtesy Zoe Leonard)

10.7 Hawker, Bangalore, 2003. (Photograph: Clémentine Deliss)

an extended period of time on issues which they find interesting to translate from one place to another, or to present, because they have the distinct feeling that they need to speak about these in an audible and visible manner. We thought, why not use these academies, these editorial groups, and bring them into discussion with one another?"[21]

With Future Academy, the initial definition that drew me to West Africa and the Indian subcontinent was that of the art academy as a tool of geopolitical expansion and adaptation. I hoped that this model would act as a contrast medium, exposing critical routes and strategies for the production and circulation of art. Indeed, from the nineteenth-century mercantile trinity of empire, education, and trade, one can shift seamlessly into today's neoliberal threesome of globalization, learning, and the culture industries. Today's corporate, rather than imperial, model of schooling and human resource development places emphasis on models that we are all familiar with: lifelong learning, vocational training, transnational and concordant accreditation systems, virtual learning, and a powerful global market in postgraduate education.[22] It begs the question as to whether the standardization of the European M.F.A. degree is potentially a neocolonial device that is ultimately intended to be implemented beyond the territorial parameters of the European Union's Bologna process.[23] Meanwhile, the student body in European art colleges increasingly mutates, flooding the once singular character of a nation's art academy with an unstoppable flow of new influences, latent cultural backgrounds, confused expectations, and high economic and symbolic investments—all in all, a potential pressure cooker for discontent. A college with a large number of international students is heterogeneous but not necessarily able to make use of this condition.

Future Academy characterizes my activity as a curator and runs alongside the publishing I do through *Metronome*. Not surprisingly, the most appropriate institutional setting for this backstage curatorial work has been the art college.[24] In 1999, I published *Backwards Translation* (nos. 4-5-6), based on the extracurricular activities of students, and established a coproduction between the Städelschule in Frankfurt, where I was a guest professor, and the art academies in Vienna, Bordeaux, and Edinburgh. In 2001, I transited around Scandinavia for eighteen months, analyzing the use of the voice in art practice with a voluntary posse of postgraduate students. As a result, we made voice recordings in a studio in Oslo and published a further *Metronome* publication, *The Bastard* (no. 7), cofunded by the art academies in Oslo, Bergen, Malmö, Copenhagen, and Stockholm. In 2002, together with nine former postgraduates, I set up base for ten months in London's derelict yet high-security Royal

Army Medical College, which had just been acquired by the Chelsea College of Art and Design. Navigating through the vast, sinister site with students and guest artists led to *The Stunt and The Queel* (nos. 8A and 8B), a publication and twelve-hour event in the unconverted Millbank building. Finally, in 2006 and 2007, I produced two editions of *Metronome* for documenta 12 (nos. 10 and 11), collating materials from Future Academy fieldwork and developing a further constellation of backing and finance, only this time in the United States, Australia, and Japan. *Metronome* is therefore the carrier and medium through which I have transported this *research in motion*, which tends to lie somewhat to the side of recognized curatorial models, regulated art publishing, and academic norms.[25] With Future Academy and *Metronome*, there is the process of moving and working in different cities; the inclusion of local histories; the involvement of organizations in the project as it evolves; and the primary focus on idiomatic translation as a key trope in advanced art practice.[26] In this context, it seems appropriate to make reference to a scholar whose work method is perhaps less current in art college theory classes today but whose maverick approach is inspirational.

The work of Gregory Bateson (1904–1990) as an anthropologist, cyberneticist, and filmmaker offers an alternative theory and methodology for the art student. In *Steps to an Ecology of Mind*, Bateson refers to "recursiveness" as meaning that repeatedly loops back onto itself in a reflexive dialogue with its representational boundaries, building a form of "ecological epistemology," a thought structure that is naturally interdependent and interactive with other disciplines. He writes, "A metalogue is a conversation about some problematic subject. This conversation should be such that not only do the participants discuss the problem, but the structure of the conversation as a whole is also revealed to the same subject. Only some of the conversations achieve this double format."[27]

This perpetual mirroring exemplifies the liminal dimension located between researching something and producing a representation of this process, just as it evokes the distinctions and concordances between academic discourses of knowledge production and the eccentric vagaries of art practice. Indeed, in the 1970s, Bateson criticized the increasingly materialist development of academic departments, and his words remain relevant today: "Such matters as the bilateral symmetry of an animal, the patterned arrangement of leaves in a plant, the escalation of an armaments race, the processes of courtship, the nature of play, the grammar of a sentence, the mystery of biological evolution, and the contemporary crises in man's relationship to his environment can only be

understood in terms of such an ecology of ideas."[28] To develop Future Academy as a Batesonian metalogical investigation has meant to determine hypotheses together with students, gradually producing the representation of our findings as we pursue them, and thus becoming interlocutors, collaborators, and highlighters together. The work of the students has a bearing on what I produce, on my professional and domestic trajectory, and yet at the same time, each of us has the authority to retain a sense of individual development. The instability of methodological procedures and the nonprescriptive condition of empathic and self-generated learning becomes part of the production process.

As well as providing a training ground for one's artistic stance, I would argue that the art college is the primary site of "prelusive" knowledge. As with the words *prelude* and *prelusion*, *prelusive* denotes the object or experience that triggers a principal event, action, or performance. Often associated with composition and structure, the prelusive moment evokes the instance of transformative thinking that leads to the creation of a body of work. Its medium resembles the utterances of an initiate language, ideas that are expressed behind the scenes, and various private environments that articulate relationships between artists and their colleagues from other disciplines. Particularly active within the art college environment, this prelusive phase appears to dissolve as the work enters the wider frame of visibility and evaluation. If the art college is valued as a reservoir of prelusive experience and knowledge, it may even operate one step further: as an intellectual trading post between models from more than one discipline or cultural context. Here artists, scholars, filmmakers, and architects become the editors and beneficiaries: they entrust this institutional environment with their unfinished works, prototypes, and contacts. They pass on access of these relational blueprints to their students, assistants, colleagues, and friends. Emphasizing conceptual intimacy within a global condition of increased communications, the art college can enable an experimental strategy to be developed for the contact and foreign exchange of different currencies and forms of intellectual property in contemporary practice. However, unlike the arbitrary character of a Google search within a virtual learning environment, this is about the reappraisal of personalized taxonomies and creative searches that are tactile, flexible, subjective, and often incommensurable.

If the future art academy signals a complexity of transactional relationships, physical movement, dislocated architecture, and translation between idioms, practices, forms, and languages, then mobility may well be the recurring leitmotif. While we may criticize the neoliberal labor market of privileged workers in the culture industry, with artists, curators, and critics flitting from

one short-term contract or event-led production to the next, the solution to a deeper framework for knowledge transmission remains relatively unresolved within the art college context.[29] One option that reflects a broader cultural and scholarly base may be found in the notion of a *roaming faculty*. Here a flexible framework conjoins institutions such as art colleges or even smaller proto-institutional formations. Selected artists, practitioners, or researchers from complementary fields are invited to develop new ideas and formulations through a chain of interconnected situations that support progressive transformation. Led by the value attributed to the individual's work rather than a prescribed service, this roaming activity encourages the shaping of content and the nurturing of transcultural and transdiciplinary positions, which stand outside the central curriculum. If an established artist sets out to develop a new body of work, it is this emerging process rather than the person's recognized expertise that becomes the highlight of a relationship with students or younger artists. Similarly, if a lawyer or economist works inside the art college, it is less to offer classes on copyright law or tax relief than to build new legal and financial frameworks in symbiosis with the practice of professional artists. For a participating institution, the roaming faculty structure may require a part investment of no more than 20 to 25 percent of a full professorial salary. The application of the Tontine system fuels this moving group of artists and scholars and guarantees its low-level costs, which are shared in rotation. Furthermore, the participating institutions circulate not only the role of the host but also the collaborative ownership that may be negotiated with the artist or scholar as producer. Our roaming faculty member becomes the itinerant hawker not only of ideas but of ways to apprehend, analyze, negotiate, and evaluate their presence within the next generation of artists and cultural practitioners. As the roaming develops, it elicits a system of call and response from its users, in particular students, who enrich the original investigation with parallel representations. The formal growth and conceptual coherence that emerge from this group-polymathic activity is fundamentally art historical, grassroots, and international. So what may well characterize the future of globalized art academies is less the frenzy of standardization than the alternative option of being able to travel intelligently through different institutional structures with their contrasting value systems in order to perform a deep transmission of meanings that can reflect and complement the increasingly international character of the student body.

With Future Academy, the value accorded to survival and self-organization has been the route to a further set of skills: the rhetorical and analytical

wherewithal to stake a position as a student player in the revision of educational structures and, by extension, the ability to engage in a form of studying that is nonprescriptive from the outset. To impart this critical approach to the art student is perhaps essential today, helping to dissolve the idea that following a course will make her or him into an artist. Nurturing this predisposition to embark on voluntary, noncourse or examination-led investigations can increase an understanding of different methodologies in the study of aesthetic practices, just as a polymathic approach enhances a disposition toward the transaction of economic and symbolic value.

ARTEREALITY

(Rethinking Craft in a Knowledge Economy)

Jeffrey T. Schnapp and Michael Shanks

The following is both a report on an ongoing experiment and a speculative application of that experiment to the future of advanced-level arts education. Our aim is to rethink some of the most productive institutions and moments from the modern(ist) past—William Morris's arts and crafts workshops, the Bauhaus, and the laboratory of Russian Constructivism among them—in terms of the altered cultural and economic circumstances of the late industrial age. We are

making the assumption that art's autonomy, one of the decisive conquests of the modernist era, has led not only to an extraordinary proliferation of artistic forms and freedoms but also to the current impasse that places arts education in the service of upmarket commodity culture and at arm's length from other forms of knowledge production. In particular, among these forms are the very technology and media transformations that are reshaping the cultural norms of our times.

We have coined the neologism *Artereality* to designate some guiding principles that could contribute to repositioning arts education closer to the center of the contemporary knowledge economy. As we envisage it, Artereality places the design and production of art objects and goods in a more discipline-dynamic context, shifting the focus away from "pure" creation toward the management of networks, links, flows, translations, and mediations—in short, rethinking creation in terms of arteries and nodes. This implies a number of things: teamwork-based education as a complement to the traditional individualized studio; a scrutiny of process as an essential complement to a product; the embrace of project-based and performance-based learning; and a conception of arts practice that is coterminous with research and pedagogy. We draw on our experience at the Stanford Humanities Lab to outline the features of Artereality as a kind of manifesto for a new model of arts education within the academy: a model embodied by the Ph.D. in arts practice. The M.F.A. was an institutional expression of the modern(ist) era in university-level arts education.[1] The Ph.D. in arts practice is the expression of the distinctive complexities, demands, and opportunities provided by the present era.[2] Its time is now.

INTRAMURAL ART

Stanford isn't atypical of universities of its kind in publicly espousing the arts' centrality to the life of the mind while promoting a de facto segregation. However, Stanford *is* distinctive in the absence of architecture from its mix (aside from a fledgling program run out of the School of Engineering). The overall arts imprint remains relatively small. Less distinctive is the marginality of domains tainted by any whiff of work done by hand or of vocational labor: graphic design, animation, textiles, fashion, and the like. (Among the exceptions, there is a small product design major that has been sustained over several decades by a handful of faculty.) Separate departments distinguish the fine arts from

music and the performing arts, with internal partitions shielding discourse, critique, and history from studio practice, and vice versa. Almost without exception, members of the faculty teach on one side or the other, rarely on both. Studio majors cross the boundary in order to fulfill requirements; nonstudio majors do so only as a function of individual quirks. A small number of interdisciplinary programs provide formal bridges between various disciplinary silos, without, however, compromising or contesting their separation. Within this overall setting, student arts associations, campus arts programming that presents student and professional performances, and the university's museum provide standard cultural offerings. As well, a newly created center within the School of Humanities and Sciences aims to promotes campuswide "creativity" in the arts by means of sponsored events, residencies, and research support (with creativity as the defining attribute of art).

Whether looked at from the standpoint of teaching and training or from that of intramural or extramural programming, what is striking about this landscape—a landscape shared with many (if not most) leading contemporary research universities—is at once the richness of the options that are made available and what is best described as a collateral cost: the tendency for arts practice, education, and training to find themselves atomized and distanced from the university's core knowledge production and reproduction functions. Within this model, humanities scholarship that involves critical reading, reflection, and writing on the history of literature and the arts is cast in a role that is at best complementary, at worst ornamental, but never integral to arts education. The social sciences are relegated to an even more accessory role, perhaps with the lone exception of domains involving issues of cognition and perception. Even further removed are the very technology and science disciplines within which the transformative techné of our era have developed—from gene splicing to robotics to global positioning satellites to 3-D visualization.

Space often speaks far more eloquently than declarations of intent from deans and provosts, and at Stanford the location of the M.F.A. studios, which are out in a remote corner of the campus, speak all too loudly about an attitude that Artereality seeks to overturn. The location is close by the stables where Eadweard Muybridge once carried out his experiments with instantaneous motion capture and animal locomotion. That the climax of an art student's graduate career is marked by exile from the university's center is more than coincident with the availability of facilities. The attitude speaks of an unfortunate paradigm. In premodernist art and architectural education, the study and imitation of the past were of central importance, and cultural history overflowed all too

seamlessly into studio practice and vice versa. In the modernist era and our own, the gap has become a gulf. Ever more fractured or attenuated versions of survey courses, designed as background, have stepped into this curricular void. In fact, the instructors of survey courses at the beginning of the twenty-first century often feel the need to include smatterings of "theory"—meta-discourses usually stripped of reference to their genesis within distinct disciplinary genealogies, be they within the fields of history, linguistics, anthropology or philosophy—as if art practice might find itself deprived of authority and legitimacy if it couldn't establish ties to abstract narratives that may or may not have any direct relevance to the work.

The anxieties to legitimize the artist and drive such acts of theoretical self-identification are sadly well founded. There is a contradiction at the heart of the way we think in the West about artistic creation. On the one hand, market forces demand a demystified model of production, with the artist pressed to churn out a continual stream of "product" at the same time that he or she is fully immersed in the business of the art world and its marketing. Yet on the other hand, artists continue to be thought of in the romantic tradition as solitary figures who operate outside of, and comment on, society at large. The artist as a cultural shaman is construed as delivering messages from the heart of the human condition, and it hardly matters whether the tools of delivery are new (an LCD screen) or ancient (a wall) or whether the shamanism in question is sustainable, intellectually fertile, or even plausible. Entire careers, institutions, and funding programs feed a cultural market that relies on individualism as the flip side of an ever renewable system of brand names. In order to raise the value of objects, the market ties the individual to the fetish of particular artistic techniques, processes, and formats. Even while immersed in the global stock and derivatives markets for luxury goods known as the "art scene," the successful artist and artistic product are necessarily positioned as detached, unique, and "pure": as one-offs or limited-edition multiples. Even when the artist's production is invested in collapsing the divide and commenting directly on the ironies and contradictions implicit in the market and cultural perception—work that really does feel like a product and intends to—it is seen within the special, auratic frame of the artists as a "seer."

Arts education today remains mired in these contradictions. Training is individualized, and the core art school experiences—the studio, the critique, the thesis show—are interpreted as events in which "research" is ultimately conceptualized as a solitary quest. Collaboration and teamwork are rare. Humanities, social science, and science education are relegated to secondary

roles, as is the study of history. They are preliminaries to be quickly moved beyond. High-level technical and technological skills or areas of exploration with the suggestion of the manual or vocational—animation, game design, Web design, textiles, ceramics, metalwork—tend to get handed over to more narrowly vocational, for-profit art academies or polytechnics, as if they were inferior places. The terminal degree is set as the M.F.A., as if the idea of art as a mode of inquiry or a form of knowledge had no further place in the domain of research that is the university. In fact, that an art practice might be *built* on research questions that could potentially overlap with research in other disciplines is still outside the pedagogical structures of most universities, certainly in the United States. Instead, only small-scale initiatives around the world offer artists this possibility to do transdisciplinary, research-based work beyond the M.F.A., and usually in very short-term residencies.

For all of theory's often attenuated relation to artworks, at least it places the artist within larger contexts: disciplinary, cultural, spatiotemporal, conceptual, sociopolitical, material. The most adventurous niches within higher education have started to register these complexities. They have begun to expand their models of training, research, and output in keeping with the distributive nature of innovation, creation, and authorship within the knowledge economy. Among the many accompanying shifts, there is an increasing erosion of the boundary line once separating the roles of scholar, artist, and technologist, as the old means of distributing knowledge give way to far more fluid means that easily allow creative producers to function in many roles and to disseminate their productions to vast, geographically disparate audiences. What has emerged are varieties of creative practice that bridge the gap between thinking and doing, between the excavation of the past and the creation of the present, based on what Aristotle referred to as *phronesis*: knowledge integrated with practical reasoning.

Artereality represents a rethinking of arts education as just such a phronetic practice within the framework of a digitally inflected humanistic production. On the humanities side of the divide, the rise of postprint and hybrid print/postprint models of scholarship is already beginning to mark a breach with the past that is at once generational and epistemological. On the arts side, the breach is instead the more longstanding one between art practices that are oriented toward the production of artifacts for the art market and practices that are either socially based or process oriented and defy the market (or at least attempt to do so). They focus on dominant institutions (the museum, the govern-

ment bureau, the mainstream media) and how or why they dominate—what is commonly known as institutional critique.

Nowhere is the battle being fought with greater seriousness and intensity than in the cultural spaces being opened up by digital technologies, so we turn to them now.

DIGITAL POETICS

With the advent of the Web, separate media—such as radio, television, movies, and newspapers—have entered into new and far more fluid relationships. With this has come the multiplication of possible outputs, such as video, photography, CD-ROMS, DVDS and high-definition discs and downloads, paper-based printed text, Web pages, broadcasts, podcasts, blogs, wikis, archival databases, live events, exhibitions, site-specific installations, 3-D models, etc. This vastly increased variety of media has exponentially expanded the modes of authorship, while the rise of social networks, with their delocalized arenas of association, exchange, and interaction, has created another global means of distributing interests, tastes, recommendations, and direct links to media. These are new social settings for innovation and creation.

At the heart of digital mediation is *fungibility*. Digitization allows the gathering of moving image, still image, music, text, 3-D design, database, geological survey, graphic detail, architectural plan, virtual walk-through, and so forth into a single environment. These may be infinitely manipulated and remobilized without loss. The eventual medium of expression—the outputs listed directly above or some combination of them—is only weakly constrained by limiting factors that are inherent in the "originals" being reworked, and the ways in which they are reworked (cutting, pasting, reformatting, mixing, layering) implicitly take on a speculative, investigative, critical, or creative character. All of this reflects a powerful game-changing fluidity that is only made more powerful by the ease with which these new expressions can move through the digital networks that encircle the globe. This raises issues about differences of power and influence between center and periphery, urban and rural, and traditionally privileged and newly empowered classes. Small-scale and locally based artisanal practices gain enhanced potential. The virtual world, as an ever-expanding experiential, cognitive, sociocultural, and economic domain, moves alongside or into competition with the physical environment. "Mixed reality"

experiences (think of the online community Second Life, for example) are gaining recognition as creative and capitalist economies in their own right.

To this volatile and still somewhat inchoate mix must be added the digitally enabled deterritorialization of data. Vast amounts of cultural, social, and other information are now available online, wreaking havoc with Enlightenment and post-Enlightenment ideas concerning intellectual and private property. The culture of remix is everywhere around us, in which artists create while entering a contested field that pits law against creative prerogatives. The ongoing efforts to restrict data are regularly thwarted by the sheer ubiquity of means to promote their uncontrolled circulation and proliferation. There can be little doubt that this process of deterritorialization will continue. What we have entered is a "poetic" space, and we do not mean by "poetic" the idiosyncratic modes of writing that give birth to expressive voices. No, what we mean is the definition of the ancient Greek word *poesis* that focuses on making, especially in the material and manual sense. In fact, for us *poesis* holds the seed of making and remaking, so much in keeping with the varied sources and informational strata combined in the digital field. And with these paradigm shifts comes the issue of how this poetic space and its processes of deterritorialization need to be reflected in the teaching of artistic practice and cultural production. That is the task of Artereality.

MODES OF ENGAGEMENT (MEDIA) AND THE CHARGING OF CULTURAL FIELDS

The passage of diverse materials into the digital realm inevitably attenuates their integrity as isolated media. The fluid, rapid manner in which visual materials can now be transmuted back and forth from and into animations, photographic prints, paintings, video footage and digital video grabs, and so on points to the loss of "stickiness" that once cemented a medium to a given material substrate, guaranteed its particularity, and limited the ways in which it would be received and used. But today, given this mutability, the medium is less the message, while the way that it is framed and engaged by viewers and readers is crucial. *Modes of engagement* is a more useful term for the task of analyzing the creation, placement, and circulation of cultural works, in both public and private arenas, and for understanding the poetics of ubiquitous design, reworking, and redistribution.

Some typical examples of contemporary modes of engagement include private engagement, such as Web sites, interactive CD-ROMs, single-player games, headset-based music and video players, and most printed materials; experiences within small groups, such as TV, radio, film, multiplayer games, speaker-broadcast music, and vocalized forms of reading; workplace experiences, such as lectures, demonstrations, and multimedia presentations; and experiences in the public arena, such as digital or printed billboards, exhibitions, live performances of performance art and theater in public spaces, and films viewed publicly.

As we envision a program that meets the requirements of twenty-first-century arts practice and education, an understanding of engagement is essential. The immense flow of data needs to be controlled by the artist and directed toward the viewer in such a way that the viewer enters the rich strata of data that are joined in the work and are completed by the viewer. This flow, its processes and enactment in the work of art, must be understood to be endemic to the networked media culture in which all art, digital or not, now belongs.

Rigor and discipline, imagination and technical skill, expanding knowledge, and exploring the boundaries of communication, representation, and recreation are all elements of the education necessary today. Essentially the ambition is to resituate art within larger knowledge-making processes and expand art's potential impact and reach. Already a good deal of contemporary art, particularly socially oriented work, is engaged in an intensive dialogue with research questions from other disciplines. Artists pick up the skills necessary or outsource them to execute their visions. In this same way, we see individualized models of training coexisting with collaborative counterparts in which students learn through disciplined, constrained, and directed doing, much as in a science laboratory or a digital humanities research center like the Stanford Humanities Lab.

Artereality imagines a new quality of commitment to research and interdisciplinary depth. We think that the current terminal M.F.A. needs to be enhanced with more extended periods of research and production. The answer is a Ph.D. in art practice, based on high-level pairings between studio or post-studio work and advanced inquiry into other fields of study, or both. The aim is to revise the notion of craft and design in keeping with the current demands of the networked knowledge economy.

The main features and principles of Artereality's arts curriculum for a doctoral program in arts practice are extrapolated from eight years of experience within the Stanford Humanities Lab (SHL), a lab embedded within the larger setting of Stanford University, though we consider the plan broadly applicable to a reform of advanced arts education. (SHL's courses are electives, and the lab does not offer a degree.) We have categorized these features and principles as follows:

An expanded humanistic base
Modeling
The animated archive
Research, theory, context, and process as product
Risk taking
Cocreation
Community
Digital technologies as (situated) means
Craft in the laboratorium

SHL is a diverse, collaborative ecology of experimental research and pedagogy. The lab operates as a kind of incubator for work that links the arts and humanities to science and technology—not in abstract terms, but by means of large-scale, hands-on projects with concrete deliverables as outputs. Much as in a natural science lab, SHL projects are based on teamwork. They explore matters of common human concern with a risk-taking ethos that involves a triangulation of arts practice; scholarly research rooted in commentary, critique, and interpretation; and outreach beyond the academy in the form of partnerships with museums, public performance spaces, industry, and foundations. Staffed by students working under the supervision of a faculty principal investigator, they wed knowledge acquisition to knowledge production: the development of high-level specialized knowledge to communication with nonspecialist audiences. Students learn by *making*, whether this involves producing a piece of original scholarship, writing a piece of code, developing a visualization, storyboarding an animation, or building a physical structure. Each

serves as a tessera within a large transdisciplinary mosaic. Projects have been devoted to the reconstruction of lost Renaissance optical instruments and the material culture of their production; the role of physical and virtual crowds as the protagonists of public life in the modern era; the cultural impact of interactive simulation and video games; experiences of presence in contemporary performance art; body language in twentieth-century Russian and Soviet society; and the analysis of the cultural-historical strata of Berlin, Shanghai, and Paris. (See http://shl.stanford.edu for a full list.)

SHL projects have resulted in scholarly publications, software tools, interactive time lines, Web sites, games, databases, exhibitions, analytical and analog models, hardware devices, works of installation art, reconstructions of lost or imaginary structures, and, most characteristic of all, in combinations of these outputs merged into experimental hybrids. Media hybridities are at the core of the SHL experiment in the belief that the hybrid of today is the likely standard genre of tomorrow. All creation is re-creation; every revolution marks a new return.

AN EXPANDED HUMANISTIC BASE

Artereality implies a shift in scale from the small to the big (driven by collaboration and teamwork) and a shift in focus from the gated communities of disciplinary orthodoxy to matters of shared human concern (driven by a desire to build bridges between high-level research and expanded audiences by means of new communicative tools). In contrast to a conventional interdisciplinary agenda premised on longstanding disciplinary borders, Artereality assumes the complementarity of the arts, humanities, and social, behavioral, and natural sciences, precisely because of its focus on the big picture. For some decades now, deans, presidents, and other academic opinion leaders have gone about waving the banners of interdisciplinarity and innovation while defending institutional practices that remain backward looking and tradition bound. Deep interdisciplinarity (or, as we prefer to call it, transdisciplinarity) begins where and when one summons high-level expert practitioners to alter their disciplinary practices: to adopt new media and modes of communication, to speak new hybrid languages of expertise, to do *otherwise*. Artereality issues such a summons.

MODELING

Artereality favors modeling and simulation as part of the research and learning that are integral to any art practice. Rather than simply reflect on presence effects in performance, for example, we have found it better to model them, work them out in practice, track the design of a performance, build virtual worlds, operate avatars, monitor and document, analyze and interpret. In order to better understand the temporal topography of Berlin, an SHI project built various "deep maps" and visualizations of the city, working out conceptual and design issues in a hands-on fashion.

THE ANIMATED ARCHIVE

We think of the archive in two ways. In the figurative sense, it is the cultural storehouse of knowledge concerning human achievement, commonly associated with the arts and humanities. In the literal sense, it is the physical institutions entrusted with the organization and preservation of human memory—be they museums, libraries, depositories, or historical archives. As much as a heritage to be curated, preserved, and studied, works of art and culture handed down to the present are resources for contemporary work and reworking, as we have already described. Today the digital juggernaut has collapsed a great deal of the distance between the present and the past, as societies have traditionally experienced it. Modern institutions of memory have begun to be knocked off their conventional moorings.

The contemporary archive has exploded, moreover. It now contains not just manuscripts and letters, but vast seas of ephemera, locks of hair, a century of recorded sounds and gestures, legions of celluloid ribbons, terabyte upon terabyte of memories. The library is at once a world of paper and pictures and a digital repository a million times more extensive than the Library of Alexandria, readable from the office, a coffee house, or your living room. In the premodern era, information was scarce, and the Muses were put in place for purposes of preservation; in a mnemonically superabundant world, data preservation and retrieval have become decentralized and democratized activities—expressions not only of an institutional will to promote the conservation of collective memory but also of individuality, personality, and selfhood.

Artereality champions the notion of the animated archive in order to emphasize the need for *active, affective, and effective engagement* with the cultural past. It implies an intensified concern with the interface between the lived present and the material remains of human achievement. The remix of data and materials poured from the digital crucible obviously draws from the life lived and from lives and achievements drawn from the archive. This understanding and praxis are of critical and creative importance if pedagogy is to have a *contemporary* usefulness to artists and thinkers in the activities of their practices.

RESEARCH, THEORY, CONTEXT, AND PROCESS AS PRODUCT

Research, theory, and context are all essential features of the program we propose. In order for the past to be known and brought to bear in cultural production, research must be done. In order for multiple fields of knowledge to be active components in a work of art, research must be done. Just as the past and its materials are of equal use in the digital foundry as materials from the present, theory is an integral element along with empirical research. Force can be given to research and practice through both rigorous historicization and an insistence on theorization understood as a critical practice. Long a mainstay of the academy, theory as critique is an essential component of Artereality and offers a way of assessing certain aspects of an artist's practice, holding it up to philosophical, social, and historical models that may help to substantiate its internal logic and integrity. In the same way, context needs to be considered for the framing, execution, and reception of the work. The "background" cannot be separated from the "foreground," historical data from current experience, research and theory from artistic practice.

All of these figure in what we call project-based learning. Artereality draws on age-old paradigms of apprenticeship. Project-based learning implies an emphasis on both process and output. Process involves a focus on the ways in which different forms of work (leading to the creation of objects, textual artifacts, soundscapes, constructions, and so on) are carried out, and it assumes the form of iterative trials: create, monitor process, test reaction, adapt, and repeat is the standard pattern. Output sets the bar high, though within the confines of a structure akin to an apprentice system. Instead of deferring the moment of "truth" until the end of the training period, when what students

do and make is placed in public circulation and evaluated as the product of an expert practitioner, we think it is crucial to demand high-level outcomes right from the start—though within the limited capabilities of each student.

RISK TAKING

Iterative processes and modeling, as well as a transdisciplinary reach that moves one out of established disciplinary domains into ill-defined though compelling new fields of inquiry, work best with an experimental attitude, precisely of *making trials*, of learning from experience by prompting problems and failures, of crisscrossing media and language boundaries. This contrasts with standard academic practices in the humanities of sharing early or intermediate iterations of a given research project only with close and unthreatening colleagues so that final publication will be as invulnerable to "failure" as possible.

COCREATION

A transdisciplinary approach to themes of overarching common concern means that projects in Artereality exceed the boundaries of any individual specialist's expert field of knowledge. Accordingly, we see the value of projects that are collaborative almost by definition, involving as they do many fields of substantive and expert knowledge.

Our proposed program is not about the vulgarization or watering down of expert knowledge for purposes of outreach or in the service of some sort of throwback to a happily comprehensive humanism. On the contrary, it is about building ambitious, high-impact, large-scale mosaics out of the dense tesserae provided by located and specialized forms of knowledge. Individual thinking serves as the foundation for making, but the creative act is carried out within a setting of collaboration and teamwork rather than the hierarchical structure of the traditional artist's studio or classroom.

Cocreation implies a model of collegiality, unlike the reality of traditional humanities and art research centers, not to mention the typical management and labor hierarchies found in corporate structures. Within the academy, collegiality has been associated with congenial listening and commentary: exposing

one's ideas to colleagues for their reactions and commentaries in the process of improving one's work. So-called interdisciplinary projects in the humanities and arts have rarely moved far beyond *parallel* approaches to a common theme, as exemplified by the themed conference or the standard edited multiauthor book. The norm remains centered on the individual researcher or author endowed with acknowledged expertise, however complementary their work may be to those of colleagues and however much their expertise may be rooted in the work of their own students and research assistants.

We think that the team-based process is a core component in rethinking and redoing advanced training in the arts, with these features as crucial elements:

Devolution of project management from top-down design to team decision making—a flat project management structure, incorporating various levels of expertise from apprentice to expert, from undergraduate to senior tenured faculty.

Devolution of management from top-down direction of tasks to project housekeeping. The crucial management task is housekeeping, maintaining clarity and order in order to enable team decision making.

Small enough teams to enable the personal relationships that facilitate this flattening. Community and affiliation are essential to collaboration.

Clear translation of interests and reciprocity. Each team member needs to value what he or she stands to gain from contributing to the project.

Iterative and organic research and learning—agile adaptation of the project to what is learned as work proceeds.

Extensible tasks and contributions. Projects need to be able to adapt to such change by facilitating many different scales of contribution.

COMMUNITY

Cocreation requires focus on personal, team, and community dynamics. Artereality puts people at the heart of projects in their roles as creators, researchers, learners, audience, or simply as those who pose the questions considered worthy of address. As a corollary, Artereality implies that projects maintain a pragmatic and opportunistic aspect that looks out beyond the traditional

confines of the academy and its disciplines and schools in order to establish links wherever they might enhance the project's address to a particular matter of common concern, just as contemporary artists regularly cross boundaries to work with experts in diverse fields to realize their visions.

DIGITAL TECHNOLOGIES AS (SITUATED) MEANS

We find that social software like wikis, blogs, and Web 2.0 authoring and content management systems are extremely useful for enabling the features of cocreation that we just listed. But rather than a driving force behind the establishment of a new field, such as "digital humanities," digital technologies should be located within an evolving political economy of creativity as a means and not an ends. They are best understood as project-specific tools, not as the stable foundation for a new field of knowledge. Media foreground modes of engagement, as described above. Rather than envision a single predetermined, normative output for each project—a published monograph or scholarly paper coming at the end of research, a gallery exhibition coming at the end of a period of artistic production, a performance after a long series of rehearsals— Artereality embraces the designed-in multiplicities and even redundancies of the digital age, such as scholarly papers, books, blogs, Web sites, art works, catalogues, videos, performances, radio programs, public exhibitions, lectures, classes, and so on. Media are chosen as integral parts of a project for their cognitive and communicative value, at once to enhance the production of knowledge and to cement the bond of theme, researcher, student, and audience.

CRAFT IN THE LABORATORIUM

Craft is power in its ability to unify design through the articulation of hand, heart, and mind. We wish to recover craft's power through intelligent physical making and reject the thinness of any conceptualization that would place "art" in an antithetical relation to craft. This is because we consider craft the deeper, abiding meaning of the word *art*. Craft bears witness to the complementarity of know-how and propositional knowledge, of ethical and political responsibility and productive capacity.

Both project-based learning and practice as research and craftwork find their home in the laboratory. Labs are places where knowledge and power are conjoined; where learning is not limited to the discourse but instead based on a richer experiential sensorium; where labor is carried out. They are usually associated with the sciences, where teamwork and multiauthored papers are often the norm. In the humanities and arts, we are regularly asked about team projects—"Just what or how much did so-and-so actually contribute?" "Who was its real author?" The standard practice is to assign credit only to individuals and to relegate acknowledgments of debts to footnotes. The single artist's work, the monograph, the individually authored paper are all granted automatic primacy of collaborative works. The distributed nature of our creations is either treated as inconsequential or is buried like a dirty secret.

That this is an obstacle to collaborative lab and craftwork may be taken for granted. The problem is complex, intertwining an array of nontrivial cultural, anthropological, and economic factors. It is not reducible to appointments and promotions committees and examinations boards refusing to grant tenure and qualifications on the basis of jointly authored work. At stake are also far broader issues of trust that involve the politics of individualism and (political) representation: How do you know that a particular person within a particular community is not a freeloader? How do you recognize and reward individual performance when it can be viewed only within a collectively produced artifact?

Artereality, with its focus on flows through distributed networks, suggests that a way to address this legitimate concern is to rethink the future of advanced arts and humanities training. The program we envision identifies collaboration with continuity and community, which is to say with the framework within which reputations are established. This, of course, requires various forms of peer review and appraisal of individual progress and contributions. An established lab has a history independent of its members. A track record will establish a reputation that facilitates trust in the lab's collaborative practice—that people there genuinely work together. So when a new joint publication or work is produced, it will be far easier to associate individual effort and talent with that of the group. Individual scholarship gains credit from its location within a discipline that is precisely identified with its peer practitioners and community. At the core of Artereality lies a new conception of collegiality and of a teaching-learning community: the craft workshop for the digital age.

UNDESIGNING THE NEW ART SCHOOL

Charles Renfro

In recent years, arts institutions have grown dependent on image-boosting architecture as a cornerstone of their fundraising programs and mission statements. The architecture of the museum has grown increasingly flamboyant and photogenic. The architects responsible for these buildings have enjoyed the kind of mass media and tabloid popularity usually reserved for rappers and Hollywood celebrities. They have been assigned a new name: the starchitect.

Together, the museum and the starchitect have become an indispensable culture industry combination, each relying on the other for their continued existence.

On the surface, everyone involved is benefiting from the trend. Theoretically inclined architects are finally building major buildings; young architects are given great opportunities early in their careers; arts organizations can attract new, younger members; and cities market these new structures as tourist destinations. It is hard to question such a successful business model.

The architecture of a new art school could easily reflect this set of values. Like the museum (and its for-profit half-brother, the commercial gallery), the art school, once considered outside the crass realities of the commercial world, has found itself squarely in the crosshairs of the art market. Curators, dealers, and collectors ply its halls, hoping to discover the Next Big Thing. As with the museum, architecture can be used to attract attention and stake a claim. What better way than with a spectacular new building to lure deep-pocketed trustees and star faculty members to the school?

But an art school could illustrate an alternate path that might lead its architecture away from image obsession. Unlike the museum, a school is, by definition, a place of learning, of process as well as product. The architecture of an art school could be part of that process. If a new art school is to be thought of as a creative learning environment, how does architecture foster creativity? And how does an art school address the changing landscape of contemporary art practices? Building an *institution* is quite different from building an institutional *building*. Unlike the work that occurs inside the art school, a new structure that reflects current architectural practice is doomed to be a relic of a particular time and place. As a pedagogical tool, a purpose-built school may be rendered obsolete in a generation. Nonetheless, architecture is powerful. We should not be afraid to commit ourselves to bold design. Architecture can inspire thought at the same time that it can engineer behavior. When considered as a manifestation of social and economic relations, architecture goes beyond building into culture itself.

The architecture of the art school has a unique opportunity to grow out of the intersection of building culture and art education. Rather than accepting the notion that a new art school requires a new building as a right, a more fluid paradigm that fuses art school inquiry with building culture should be explored. The result may call into question not only the way that art schools address their pedagogy through building but also help to determine if building is really necessary.

Slippery Pedagogy, Slippery Architecture The art school for the twenty-first century will operate on an entirely different playing field from previous generations of art academies. The breadth of work being produced by artists today prevents schools from providing facilities and equipment that are specific to every practice. Does its building therefore foreground spaces of presentation and discussion over spaces of creation and production? If specific facilities and equipment are eliminated or outsourced, what is the academy's role in the teaching of craft? How will the school address issues of technological innovation that will inevitably shift artistic practice even more? As art schools increase their engagement with national and international art communities, should its facilities be more open to the public? How does one address the needs of a conceptual artist? And how will a school's online presence be reflected in its built environment? The pedagogy of the school and the program for the building go hand in hand. Since the pedagogy is somewhat slippery, can the architecture be slippery too?

From White Walls to No Walls The typical art school supports only a limited range of art practices through the construction of its spaces. The disciplines of the visual arts have traditionally been about the creation of physical things. Paintings, drawings, and sculpture have particular spatial and infrastructural requirements, and work spaces have been defined accordingly: large rooms with solid white walls and ample but indirect light. Equipment has been geared toward known products. These conditions are still supported in our most venerable art academies and art colonies. Consider, for example, the Web text describing the studios at the MacDowell Colony in Peterborough, New Hampshire (figure 12.1). Visual artists' studios have ample wall space, natural northern light, and full-spectrum lighting. The two photography studios have fully equipped darkrooms. Filmmakers with an editing project can request the exclusive use of a 16mm editing suite. Printmakers will find their studio equipped with lithography and plate presses, aquatint equipment, and ample ventilation.

These spaces, free standing and remote from one another, perpetuate old-school concepts about artists' work habits that have long driven our attempts to accommodate them. The art school must accept new methods of intellectual and physical production without knowing them ahead of time. In addition, presentation spaces not only need to support new methods of display, they must be open to wholesale redefinition. Walls may be a thing of the past.

12.1 Lisa Dahl, *The MacDowell Colony Project: Log Cabin*, 4 × 5.5 inches, acrylic on photograph, 2006. (Courtesy of Lisa Dahl)

Thoreau It All Away The romantic notion of the artist working in rural isolation is still a dominant feature in art school facilities, particularly in the art colony model. MacDowell, Skowhegan, and Yaddo are just a few examples. Black Mountain College in rural North Carolina, one of the foremost programs for young artists in the history of American higher education and lasted from 1933 to 1957, used isolation as a key element of its pedagogy. Its model was the Bauhaus, which remains the fundamental model for most contemporary art schools in the United States and Europe. In Weimar, Germany, where the Bauhaus opened in 1919, isolation and the cult of nature figured prominently in artistic training, particularly under the influence of Johannes Itten. It was a philosophical conceit of education in these rural settings that the primacy of nature encourages thoughtful work. The rural was understood to be good and wholesome, while the city was considered distracting, even corrupting. Socializing and collaboration among students was acceptable at the Bauhaus and Black Mountain, but isolation was intrinsic to the attitudes in Weimar (things changed in Dessau) and in Black Mountain. Interdisciplinary collaboration has become increasingly important for contemporary art practices and therefore for contemporary art students, suggesting that the new art school enfold this more fluid way of making and being in the world into its plan.

The Studio Explodes Art practices of the late twentieth and early twenty-first centuries have challenged the very notion of the studio. While the artist working solitarily within a single discipline persists, it is becoming just as common for artists to use an array of traditional media (painting, sculpture, photography, video, performance, etc.), as well as to tackle new media on the computer and the Web. Some rely on collaborations with fellow artists and/or others, whether artists in complementary artistic fields, professionals in different fields, or simply people who are brought into the artist's activity for the work. Many artists outsource their production, often embracing technological innovations and manufacturing processes and facilities from the commercial world, their "studios" decentralized and distributed among their various vendors. Outsourcing has allowed many artists—Damien Hirst, Richard Serra, Jeff Koons, Matthew Barney, and Olafur Eliasson, to name a few at the beginning of the twenty-first century—to work at a scale previously unimaginable and rarely accommodated by even the most well-appointed school. While the resources available to these artists are undoubtedly beyond the means of a student, the tactics they use aren't. These artists are the students' models, if not

their teachers' models too. Equally prophetic in considering the space of the studio are artists who forgo the making of products altogether and whose art is embedded in constructed situations or performative acts that take their meaning through their insertion into the "real" world. These "poststudio" practices suggest that work space can often be nothing more than an office where the conception of a piece and the logistics of its fabrication can be realized over the phone and the Internet.

As the studio loses its time-honored spatial definition, so too may the spaces of teaching. The cafés, hallways, and lounges of a school may provide as good a setting for the review and discussion of contemporary work as a formal jury space. Schools can be designed to engineer chance encounters between students and faculty and also between the school and the public. Delfina Restaurant was created as the social and intellectual nexus of Delfina Studios, an artist residency program in central London. Similarly, instead of providing studios, the Architectural Association provides a bookstore and a café; the latter, open to the public, has become one of the liveliest intellectual spaces in all of London. If education is dependent on discursive exchange, as it may arguably be, could a restaurant replace the classroom as the programmatic backbone of the new art school?

Engineered Exposure The new art school must acknowledge its complicated relationship with the public. Art school is dedicated not only to developing artists but also (and ultimately) to enriching public life. Exposing itself to the public has a practical side effect in that it educates and develops new art patrons and collectors. As the art market penetrates deeper into the academy, the academy has the opportunity to carefully embrace the market. While this notion may be controversial, is it necessarily bad or harmful? Shouldn't a school be interested in the success of a student both during and after his or her tenure at the academy? As other academic programs regularly convene "job day" events to place their graduates, the art academy has the reputation of avoiding the commercial question for fear of sullying its intellectual reputation. Buildings and spaces can be designed to choreograph access to the public and private spaces of the school in a kind of engineered exposure. Studios, classrooms, galleries, and gathering spaces will be redefined in the process as access and openness become essential physical characteristics of the facility. The art school for the twenty-first century should be a reflection of current art practices, including acknowledgment of the art market, its physical image being informed by the dynamic between the two.

In 2001, Diller + Scofidio, the architectural practice in which I'm a partner, was invited to join an international competition for the design of the new New York–based headquarters for Eyebeam, an organization dedicated to facilitating interdisciplinary collaboration in the arts and technology. Part school, part research lab, and part exhibition space, the program for the new facility embodied and embraced the seismic shifts that digital technologies have been bringing to the world of art and commerce. The facility was intended to foster cross-fertilization of thought by encouraging collaboration, the free exchange of ideas, and public access to all activities.

A Place for Everything In Eyebeam's brief, the program for the new facility was described to the point of obsession with program areas and adjacencies defined. The building was to house technology laboratories, artist studios, a wood and metal shop, a recording studio and mixing booth, a television studio, two technology classrooms, a media library, a black-box performance venue, a series of exhibition spaces, a restaurant, and a bookstore. The work made there could range from film and video, dance, performance, and visual art to interactive new media, gaming, and software design. Every conceivable medium and discipline was to be supported by a specific space in the facility.

Controlled Contamination We developed a solution that was based entirely on the program requirements. In our first analysis, we determined that the elements split roughly fifty-fifty between production spaces (studios, classrooms, and workshops) and presentation spaces (galleries and the theater), leading us to our basic concept. The building would be formed out of a single two-sided surface, a ribbon physically and metaphorically linking all spaces together, undulating back and forth as it climbed up the fourteen stories, alternately enfolding presentation floors and production floors (figures 12.2 and 12.3). The floors were sheared, allowing parts of the program from one side of the building to slip down or up into adjacency with elements from the other side. This

12.2 Eyebeam facade, southeast view. (Courtesy Diller Scofidio + Renfro)

12.3 Eyebeam's two-sided ribbon. Production spaces shown on left with flipside presentation spaces on right. (Courtesy Diller Scofidio + Renfro)

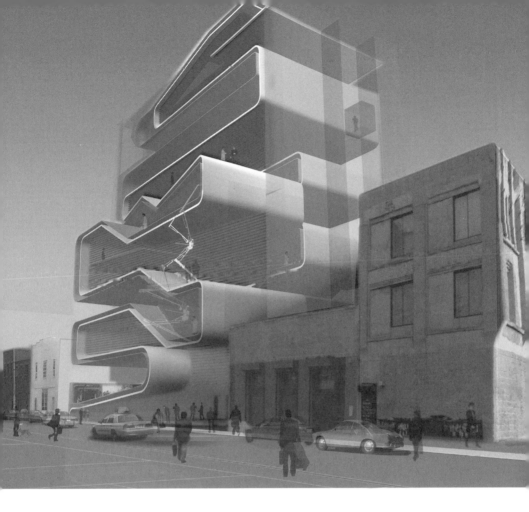

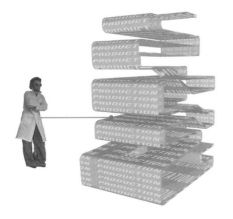

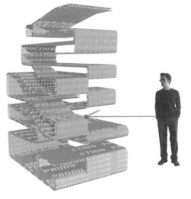

act produced a controlled contamination of spaces and populations, at once illicit and determined. Each program element was disturbed by an incongruous adjacency. Gallery space found itself invading classrooms, workshops, and studio space, and vice versa. Artists came face to face with the public and with other artists by necessity, their work scrutinized through a series of glass walls that contained and mediated the invading program.

Perpetual Newness Because the building had to support new media, the relationship between structure and technology became a driver of the design. Information technologies change more rapidly than conventional buildings can adapt to. The ribbon was conceived as a technology sandwich with two different materials that formed the bread slices and with building services that filled the void. The "smart" material of removable panels made of phenolic resin on the production side allowed artists and technicians to rewire their spaces at will. The "dumb" material of cast concrete on the presentation side of the building provided structure for the building and neutral environments for display. "Pores" that were regularly spaced in the concrete allowed cabling that was specific to an installation or performance to be pulled into the presentation side wherever needed (figure 12.4). The production spaces acted as the backstage spaces for the galleries that they enfolded. The building revealed its DNA from the street as a sculptural section through all spaces. Its iconic image was a result of its programmatic specificity.

9/11 The final award of the commission came days after September 11, 2001. The project was put on hold seemingly as a response to the financial and emotional jitters of the day. However, I contend that 9/11 not only changed the political and financial climate of the United States, it also underscored the unpredictable nature of contemporary art practice and rendered Eyebeam's building program obsolete. As Steven Winn suggested in an article titled "Art and Terror," that was published in the *San Francisco Chronicle* the day after the attacks, "There is the particular 21st-century character of the attacks and the way they were felt in the global village that technology has created."[1] The quotidian systems we had developed for our convenience and pleasure—the Internet, transcontinental banking, and air travel among them—had been ingeniously manipulated to spectacularly tragic results. These are the same systems that allow many contemporary artists to produce the work that they do in the variety of places that they do. In some cases, artists have manipulated similar systems themselves to reveal the content of their work, establishing an uncanny

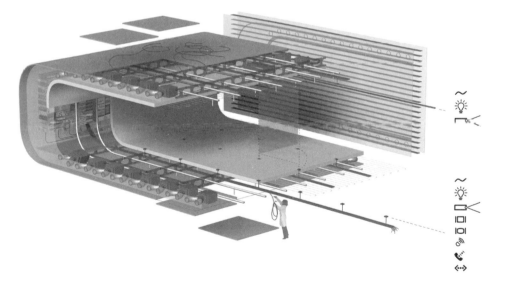

12.5 Eyebeam redesigned as a collection of loft spaces. (Courtesy Diller Scofidio + Renfro)

12.6 Existing parking ramps converted into an art atrium. (Courtesy Diller Scofidio + Renfro)

and uncomfortable link between the tactics of the terrorists and the tactics of some artists. While this is an extreme comparison, I contend that it parallels the evolution of contemporary art practices in a poststudio, postgeographic, and almost postarchitectural phase. Affecting work can be conceived anywhere and produced by using publicly available computer technologies and the Web. Space particularized for the production of much contemporary art is no longer definable and much less buildable. While conceptually based art has not obviated the need to make basic space to house knowable and predictable artistic practices, the concept of spatial specificity as a requirement or desire of art creation has never been more in question.

Meta-Architecture Eyebeam began to acknowledge these shifts in practice by emphasizing explorations in new technologies with commercial sector collaborators. Rather than require specific spaces for specific media, the new program for the building became simply about flexibility (figure 12.5). Projects could range from the microscopic (bacterial manipulations, for instance) to the mega (citywide digital graffiti), from robotics to computer programming. The new design would be smaller and cost less but would also address the change in program. The building would be open to the dynamic repositioning of the creative process. *New media*, a term championed by Eyebeam, can't be new forever. Technologies are fungible, mutable, quickly obsolete, and just as quickly replaced. Collaborations are fluid and roving. The new building was to serve as a meta-architecture for the activities within, a new form of open source building that would parallel user-defined, participatory trends in software development in vogue at the time. The Deleuzean notion of a "Body Without Organs" was to be given full expression, as no particular thing was to be made within the space.[2] Rather, the building would be a fabric with denser and coarser weaves, allowing the unpredictable to be made manifest.

Kinetic Not Our new Eyebeam proposals distinctly dispensed with the idea that mutable architecture is the answer to programmatic uncertainty. Kinetic architecture was a fascination of modern architects throughout the twentieth century. With it came the promise of infinite flexibility: a society that would not be hindered by its buildings but rather would make buildings at the service of the whims of their occupants. While aspects of a kinetic architecture have been realized (moving partitions, sliding stadium roofs, cruise ships), many other factors can be cited as reasons that this utopian concept never took root. Technical limitations, expense, and the realization that space in itself is inherently flexible have all undermined the basic premise of mutable architecture. Wiring and data streams have replaced hinges and wheels as the ultimate flexible architecture. The loft and its ubiquitous repositioning as the perfect envelope for everything from apartments to galleries to supermarkets have sealed the fate of the kinetic building once and for all.

Espace Trouvé This is not to say that space should not be interesting. In our final Eyebeam proposals, we embraced architectural particularities at the same time that we avoided programmatic specificity. We proposed reusing Eyebeam's existing buildings with their quirky, bricky irregularities, which provided a found (and therefore excusable) kind of architectural flourish that didn't wear its formal manipulations on functionalist sleeves. It provided impromptu places of discourse between artist and building at the same time that it provided basic, flexible, and loftlike spaces to accommodate most project requirements (figure 12.6). Creativity is a form of reaction. Artists are more likely to find creative expression and programmatic accommodation by reacting to fixed space that contains provocative or insurmountable obstructions. If a building is intended to be a collaborator in the creative process (as was the case with Eyebeam), generic space allows the activities to take place, but particular space provides the creative pushback.

PART 3: WHY BUILD

In many ways, recent architecture has been a victim of its own success. By assuming a new role as the most powerful marketing tool available to corporations and to institutions alike, it has been stripped of its ability to contribute to the discourse of building. Image has triumphed over experience, stasis in

favor of change. There is a parallel opportunity for the architecture of the new art school to engage in the culture of building and to respond dynamically to the same changes in society that drive contemporary art practices. A new parity between art and architecture can be forged. Constructing an iconic, purpose-built new facility is only one possible response. It precludes a host of other directions that might allow a more dynamic, pedagogical approach to building making. The charge in the building program for the new art school should be as much about building architectural investigations as it is about building buildings. Here are some guidelines.

Mingle The new art school will operate as a cultural cornerstone in its community. It should embed itself in the urban milieu, mine the surrounding offerings, and invite local constituents in to watch. Construction techniques, material selections from the area, the local real estate market, weather patterns, private wealth, and political will should become part of the school as much as internationally acclaimed artists and critics. A local mix will guarantee a long-lasting and supportive environment, regardless of what the architectural expression becomes.

Network As current art practices morph and the physical needs of artists become ever more unpredictable, perhaps the most valuable construct a school can provide is invisible: a network. There is no reason for a new art school to physically accommodate the technological demands of all the artistic practices that it hopes to nurture. In addition to providing Internet access, it should foster networks of expertise and connections to facilities within the community and beyond that will provide artists and faculty members with access to the most up-to-date technologies, processes, and collaborators. Simultaneously, engagement with a network of local and international artists, collectors, museums, philanthropists, and intellectuals can do as much to stimulate a career as a school can.

School as Performance In many countries, art fairs and biennials have become a standard feature of the cultural economy. They have become cultural institutions themselves. Should the new art school find itself in proximity to one of these fairs, it should take advantage of the flood of visiting artists and scholars to hyperenergize its programming and show itself off to the public. The art school is a performance. Its buildings are sets in the show. And its artists can be embraced by the same cultural and market forces that have made these fairs and biennials such a success. Of course, the economics of these

fairs and biennials will inevitably change, and the programming of the school must be nimble enough to change too.

Buy/Sell The new art school should be a player in the real estate market. Booms and busts might provide an outlet for dynamic intervention in the community. Abandoned factories, foreclosed houses, and undersold condos can be appropriated by the school as temporary (or long-term) studio and gallery space, changing as economic trends and artistic desires diverge and converge. Purpose-built facilities can act as a core for the school, while these additional facilities can morph with the program, reaching out into the city. Architecture fellows, if admitted to the school alongside art students, could determine the up-to-the-minute building program as part of their residency.

Typological Perversion Purpose-built facilities must carefully negotiate between the specific and generic in order to achieve perpetual newness. One approach might involve a simple perversion of the warehouse typology. By using a typical long-span shed structure and tipping its roof to meet the ground in one corner, a new spatial condition based on infinite variation is invented. In a mix-and-match matrix of spatial qualities, low, tall, narrow, wide, and light and dark spaces are all available under one roof. By overbuilding the roof and programming its spaces only with infrastructure, the building can act as a stage for open source architecture, allowing periodic redefinition. The top surface of the roof could provide a new landscape for artist residency cottages, communal forests, and beaches. These playful spaces will sit directly above and possibly even penetrate into the spaces below, asserting themselves as programmatic equals to the teaching and production spaces they invade.

Kitchen, Living Room, and Bedroom Social spaces are as central to the school as teaching facilities. A new restaurant managed by a local restaurateur and subsidized for students, faculty, and staff should be a central component of the program. The restaurant will be open to the public and will be a creative hub for the school. The interstitial spaces between other program elements can be considered much like a rambling living room, an undefined, unprogrammed location of chance encounters. In the same metaphorical way, the bedroom as a place of repose and private liaison can be reconsidered as a vital and central program element, sharing adjacencies with more public components.

Cocktail Party Within the giant shed, programs should migrate and mingle likes guests at a cocktail party. Classroom facilities, studios, galleries, offices, shops, and lecture spaces should be evenly distributed across the field and available to all, including the public. Public engagement in the spectacle of the school will serve as a tool for outreach, enfolding and educating the future supporters, benefactors, and collectors of the community and the art world at large.

IQ Rating Facilities must take care to be neither too refined nor too rough. An "intelligence" (IQ) scale should be developed for the facility that establishes the amount of technological infrastructure required. Data and electrical networks can be housed in a smart skin: an overhead or under-floor plenum space that is simultaneously accessible and concealed. The smart skin can be removed or added at will, exposing the building's central nervous system. Distributed smart spaces will include heightened environmental control, acoustical isolation, and lighting control. Smart spaces should be balanced with and interspersed with dumb spaces. Dumb space will be constructed of basic rough materials and will provide the essential enclosure of studio and display spaces. The facilities should invite architectural and artistic redefinition at the same time that they provide spatial resistance. Activities within the building will gravitate toward the areas that best suit their purpose.

Permanent Impermanence A purpose-built architecture is a closed proposition. If successful as an icon, the building will be doomed by its own image, forever paying homage to itself at the expense of the lived experience inside its walls. While such strategies may make perfect sense for corporate buildings or even other arts buildings, it is a shortcoming for an institution whose very mandate is to make change visible. The new art school should use the opportunity to question building, question permanence, and advance a multifaceted building program that is as open-ended as the work being made at the school. By adopting permanent impermanence as a building strategy, the school can make its architectural image based on action rather than stasis, ideas rather than form. It allows the school to engage in intellectual discourse in much the same way as its students and faculty will.

CONVERSATION

Marina Abramović and Tania Bruguera

TANIA BRUGUERA: One thing that I've encountered, mostly in the United States, is that a lot of people taking a performance class think they are entering into a kind of therapy session situation. That can be problematic in teaching performance because it jeopardizes the conversation about the process that transforms the personal into the collective. The other thing that I've encountered is a lot of tight restrictions in the art schools in the United States about liability, as well as a predisposition to censorship. Like, the first thing that a chair of the department tells you when you start teaching a performance class is that they are really afraid about its potential for institutional problems. They say, "No nudity, no cutting, no blood, no porn," and they don't say no to political disturbance, but it's somehow implied that the institution doesn't want to be sued or enter this discussion, almost as if they wanted a nonspoken agreement with you. It's like they want you to teach a medium that has transgression as one of its main elements, but without being transgressive. I don't know if you've had that experience.

MARINA ABRAMOVIĆ: Yes. This question is always there, but not only from the outside. Let me tell you a story about when I was the professor of performance in Braunschweig, Germany, and the school decided to do an event for the end of the year called "My Seventies." Now, you know, I really lived "My Seventies," but my students saw the [decade of the] seventies only as it was reflected in the works of older artists; they were too young to make them then. So one of my students did an action where she drank an entire bottle of whiskey, just

straight, and she had a T-shirt printed with my performance *Rhythm 0*, when I was experimenting with being conscious and being unconscious. And she's drinking this whiskey, lying down on the floor just in the middle of the school. So everyone was thinking that she is acting this idea of being drunk—you know, the seventies, wasted, drugs, and all the rest. People were doing other things, just kind of jumping over her, and after maybe two or three hours, I was looking at her again and I saw foam coming out of her mouth—something is very wrong. So we went for the school doctor, and he says, "She's in a coma." I really lost control at that point. We took her to the emergency. I spent the whole night with her, and she woke up in the morning.

For me, this was one of the most dramatic moments of being a teacher because I was thinking if something happens to her, I will just not teach again. It's such an incredible problem of responsibility. Yes, here in New York everything is forbidden. In Europe you really can experiment, but then it's your responsibility as a teacher how far you can go. I personally never show my work to my students. And I won't encourage them to do something similar. If they want to do something potentially dangerous where in the process they could hurt themselves and they give me the concept, I will absolutely stop it. If they become artists themselves and could take full responsibility, that's fine, but not in the frame of my class.

TB: It's true that performance works with limits and the understanding of danger, either body limits or social limits. And it does play a lot with some aspects of fear, or at least with elements that one usually doesn't encounter. For me, teaching performance is like a rehearsal for what is going to happen later. If students have to deal with danger, I think it's good to have a safe environment where they can try it, try all these limits—and where there's conversation about the process with someone who has already experienced it. An environment where they can get it out of their system and know if it's really what they want to be focusing on without the pressure of the critics or the expectations of the audience. Where they can learn how to negotiate all of these things with institutions for which the school can serve as a dry run.

MA: And this is another aspect that we have to think about—how important the presence of the public is when someone is doing a performance. When students do performances in class, somehow they never really give 100 percent of themselves because they are always kind of self-conscious, where they have friends that make fun of them. There was never really that kind of indication

of seriousness. In all my experience of teaching, most of the students are not very motivated, and they just start working toward the end of the semester for the group exhibition. I always think that art has to have a function, to communicate precise ideas. And when I was teaching at Braunschweig, I went to the closest Kunstverein, at that time it was in Hannover. In every Kunstverein in Europe, there is always time between exhibitions. There is always the time when you take down an exhibition and before the next one is put up. So I went there and I asked, "How much time do you have between shows that are coming up?" And he said, "We have twenty-four hours." So I come to my lazy group of performance students and I said, "Okay, we have twenty-four hours in the Kunstverein with all the spaces and infrastructure to set up a twenty-four-hour performance event." It was absolutely a miracle—what energy, and what kind of incredible dedication they had, because they had a real purpose. And they had a public for twenty-four hours. The title of the show was "Finally." There was a huge amount of people throughout the twenty-four hours, and for the public that didn't want to leave, there were sleeping bags, bottled water, and sandwiches. It was a real success. Immediately after, we were showered by invitations from different institutions to do similar performances. That was one of the most moving things for me. With performance, you have to deal with some kind of reality, and when this reality is removed, it doesn't work.

TB: Absolutely. I think it only works at the beginning of the class when they don't know each other and they want to impress each other.

MA: How do you make them audition for your class?

TB: Well, I'm not so interested anymore in body-related performance. I'm more interested in what I call *Arte de Conducta*, which can be translated as behavior art. I didn't want to carry the assumptions that come with the word *performance*. *Behavior* is a word that goes back to the beginning of performance art's aspirations, combined with the desire to make an art that activates society. For these kinds of works, reality and context are very important. So I ask the students first to forget they are artists.

MA: That's *so* refreshing.

TB: (Laughs) I have a few exercises I do with them. One is asking them to think about an unbearable thing in society for them and then, through a series of

mini-assignments, figure out a new job that would change or transform that thing. Then I ask them to become the person who creates the infrastructure and then who does that job. One thing that I am interested in, in terms of performance, is that it would be good for them to start acting within the parameters of reality and forgetting about art as they know it. And then they present a piece where they have to interact with that reality in concrete and functional terms. The work is not only for the art world but for the people in the place where that reality is. It becomes a way to see art as a temporary state of things, as a nonpermanent condition.

MA: That's really interesting. I love this behavior art because "performance" as a discipline is always misunderstood for dance or for theater or stand-up comedy. I mean, you come from Cuba and I come from Europe, and what we mean by performance is exactly something else.

TB: Exactly. I came up with this idea when I was doing my M.F.A. in Chicago because I felt that I didn't fit in. I was coming from a different context, like you, where societies and art have another role, mostly a useful one. So I came up with the idea of behavior because if your work is about society and politics, you should use their language and elements for your work. It isn't about representation, but about *presentation*. And behavior is one tool that society uses to judge and define who you and we are. It's a very social term. It's to have life as a point of reference, not art. Performance is *live* art.

MA: And in performance, acting is such a big obstacle. If a performer was a dancer before, we must reprogram them. If they were actors, we must make them forget what they have learned in order to be able to deal with a real performance attitude. We have to de-dance them, de-act them, somehow take it away. I think the only chance is to do long durational pieces. Because you can act for five minutes, ten minutes, three hours, fine, but after five or six hours, you drop acting, dancing, and everything. You just drop. You get to the kind of naked truths, which is, to me, the most interesting state.

You know, performance as a subject hardly exists in schools in Europe, or it is mostly part of something else. It will be film, video, *and* performance. When I got the job in Braunschweig, the title was *Raum-Konzept*, which means "space concept," which is basically a version of sculpture. They knew that I wanted to teach performance, but still they could not give me the job because it didn't exist and I wanted it to be precise: "Performance." So then I made lots

of paperwork, writing to the local government, and it took two years to change that *Raum-Konzept* into "Performance." I was the only professor who taught performance under that title, and then it was really amazing because every month I started having one day in which we would have an open class. Anybody from any country in the world could come and show their work. It got to the point where I'd have a hundred people from everywhere because there was not anywhere else where they could actually show their type of performance. That was a really great time, but unfortunately I had to leave Braunschweig because I started living in New York. The academy changed the class back to the *Raum-Konzept*, and it was absolutely old-fashioned. I still regret this.

TB: I have a question, because I have encountered the same thing. When you're a performance artist, that's what you want to teach. And sometimes you are kind of forcing performance into what they give you to teach—

MA: They give you the painters, the sculptors, they want you to have class visits—

TB: And you try to force it to go back to performance, but it's a big tension, I agree with you. Do you think that has to do with the fact that performance is not seen as a possibility for a successful career?

MA: I think in the past, to be a professor in the academy meant being a failure as an artist. Well, a person who was an exception was Luciano Fabro, you know, from arte povera in Milan. He created a completely new generation of artists as performers. But being in the academy meant that you failed to be an important artist—still today in most places the academy just doesn't want any progress. They are against technology. They are against the idea of what a new school of art can be because they actually feel like they're losing their territory. In Germany, there are really important artists who become teachers in their time, but you go to the academy in Rome and they're still painting the Acropolis! It's amazing! Greece is the same. There's an amazing number of incredible artists who never really put a foot in the academy and change anything. And I think that's one of the roots of the problem.

TB: But it also feels like performance is not a successful art form compared to a painter or sculptor, and it seems to me that at least in the United States the education is very oriented to success.

MA: Yes, but performance has never been accepted as a real form of art because it is so ephemeral. But maybe almost not being material lends to its strength and vitality. You do it and it disappears.

TB: I think in my case, the only way to deal with this is through the approach to documentation as the tangible trace in the aftermath of the experience—but not as a given. It's always a requirement to think about ways of transferring information, about transferring the experience as part of the tangible side of performance, even if it doesn't become manifest as an object.

MA: To me, a part of doing the workshops and trying to make the students great performance artists is to give them advice about how they can live from their own work. They can't live from their performances, but they can live from the products out of the performance. You know, objects, or if there's photography or there are installations. I really teach them how it should be done professionally. If you're going to photograph—what "edition" means, what "artist's proof" means—how you can sell it, how to approach the galleries, what the relation is between you and the gallery. And this is something I never learned on my own when I was a student because there was some kind of taboo about art business. I've had so many bad experiences, so that means I want to protect my students from bad experiences.

There was this Turkish girl, and she came to me and said, "There's a gallery that wants to make my work," but the dealer wanted five, like, major pieces to donate to the gallery. I said, "Just say no." And she said, "But this is my only chance." This is exactly how it works because she thinks she will never have a second chance. I said, "Just go tell her no." So she goes and tells her no. And then that woman, the dealer, just throws her out of the gallery, and the Turkish girl, she's crying, and I say, "Just wait." The next week, the dealer calls her and says, "Oh, let's talk." And then she asked her to do whatever . . . an edition, and she would pay or give her one proof. I said, "Say no." (Laughing) Until she really, through the process, learned actually to negotiate because young artists will be used until they get this experience.

Then, my other idea is to teach them how to explain their work.

TB: Exactly.

MA: So I was combining art critics of their generation who were in the same school, to put them together. And I say, "We'll make performances for you, and

you make interviews with these performance artists and see what this work is about." So we were printing these little kind of like manifestos, with interviews between young critics and young performance artists, so that the young critics started thinking and seeing how they can write about performance. Then I was also interested in the painting class. So I was saying, "Come and paint a performance because this is a subject." So they combined different activities, which is really important because everything's so isolated. I think that young critics and young performance artists should go together from the beginning.

TB: I totally agree. At the art school project I created in Cuba, which is, I think, the only performance art program in Latin America, we have eight or nine students per year (officially, because we have a lot who "audit" for years). We always have people who are nonartists, who have not studied art before but who want to do art each year. We have an art historian who has to do artwork like everyone else, in addition to recording the experience critically, and who said at the beginning, "I'm the viewer, the critic, I need distance." And I said, "No. You have to do performances, experience it, like everybody else and then write about it." It's the same for everybody. So for two years, they go through this experiment, this time in their lives when they go back and forth between being artists and critics, and they have both approaches from the inside and the outside. The students have to learn how to write about their own works and their ideas about art. It's a legacy we shouldn't lose.

MA: That's a very important side because the students, they usually can't articulate. And then one thing that's really interesting to address is the relation between the master, meaning the professor, and the student. It's just unbelievable. For me, the most striking example is Japan. I was teaching a lot in Japan, and the relation is really like a God. First, they don't look you in the eye. They're in a submissive kind of attitude of the body, always looking down and always saying, "Yes, yes." You have the power to say, "Open the window and jump." They, without questioning, open the window and jump (claps)—and that's really something that I hate. It's very important to have a democratic kind of relationship based on equality, and showing that anything you're asking them, you can also do it. Like if I say, "We don't eat for five days," I'm doing the same.

TB: Yes, the first thing is to break the power relationship and establish a kind of comrade relationship, where everyone respects everyone else and it's earned

through the quality of the work. At the end, after a few years, we all show together, and it's very important to learn how to interact with other artists.

I want to go back very quickly to documentation. When I teach about documentation, I want them to problematize documentation—not only to assume the traditional ways of documenting with photo and video but to try to see how they can problematize ways of transmitting the experience. Because the idea of having a photo taken from a performance is almost like making that performance an icon, meaning making the *lived* thing *dead* and taking away the most important part, which is the experience.

MA: It's extremely important how you transmit. The closest is video or film—

TB: But it still has this kind of journalistic quality, where people are just talking about what happened—where and when—which diminishes how it was felt.

MA: But there is one possibility if you don't have the public. If you just have the camera, and the camera is this imaginary public. So the product is different; then actually the film or the photo becomes the artwork.

TB: That becomes a different kind of performance. Trust is very important for performance, and it should be part of the documentation of the performance. I try to teach that by transferring the work from one person to another. For example, I have an exercise where somebody does a piece and then the next person takes it, so people understand there is no property in the work.

MA: Oh, that's interesting.

TB: A performance is not like an object, and it shouldn't be forced to follow the rules that come with making objects. Performance should bring with it new ways to conceive old solutions; it should keep its revolutionary and evolutionary qualities. It should bring its own sets of problems to be solved in its own terms. That's how I think about ownership. For that exercise where we transfer a piece from one student to another, they are changing it, doing it with their own elements as a way to document it. It creates a dialogue in the classroom where everybody feels connected to the art and to the idea of the context and conditions for an action, to performance as a nonpermanent form. And performance class should be something that makes the students go out of their

center—out of their comfort zone. It's important that they bring up their fears and their established patterns, and then we work with that.

MA: Yes, and it's important to work with them after the class is over, after the school. I started the IPG [the Independent Performance Group] after Braunschweig for this reason: to continue with some of them when they became artists. And this was interesting—to fill this threshold of leaving the academy and becoming an artist. For me, the biggest problem with teaching was that every time one group finishes, a new group is coming—and you always start from the beginning. And somehow you never really went to the end, and I really wanted to go to the end.

TB: That's something that most professors don't think about, but good professors actually understand that it's a path they have to walk together.

MA: So I made this performance group, but after all these years, I don't know—maybe seven—it's not working. They would never do anything for the group; they would do just for themselves. And then I was constantly exuding this enormous energy to create a spirit. If I didn't put them together, they would never be together. They would never develop their work together or take work from each other. So I'm dismissing it. This is a big deal for me. I just wrote this letter to them. I'll read you a little bit of it:

"Dear IPG Members, I'm writing to you after a long reflection about my relationship with IPG and about the future of IPG. Here is my conclusion: After all these years, I still feel treated by IPG as a professor at Braunschweig." That was a big problem. I could *not* get out of that function, you know? I was a professor to them, and I am still a professor. I couldn't pass this threshold to become different. "So, unfortunately, IPG never developed the group spirit I hoped for. IPG comes together only during events that I organize. My dream was, always, that one day you would develop a group spirit like the past—the Futurists, Fluxus, Dada, the Russian Constructivists. I strongly believe that an individual does not lose his or her identity in a group. On the contrary, the group helps to nurture the development of an art career and to give the support which young individuals need at the beginning of their professional life."

So now I'm making a foundation—the Marina Abramović Institute for the Preservation of Performance Art—which will have much more freedom.

TB: Was it always the same group of people? Because something I've found out in my school art project in Havana is that it's really good when people enter the group at different times, when there is a constant redistribution of power in the group, when people who feel secure, with their clear place in the group dynamic, have to at least consider this distribution when new people arrive.

I started the project five years ago, when I came back from documenta. I always wanted to do something with performance studies because I couldn't study performance in Cuba. It's called *Cátedra Arte de Conducta*—*cátedra* means "studies department" to emphasize its pedagogical intentions. It's a mobile space of discussion, creation, and learning, with the core space being my house—but we do events and classes in people's offices, in a park, at a barber shop, at other people's house, in the woods, etc. And we do this every week for forty-two weeks. We have one guest who presents ideas about creation in a larger sense, and we encourage diverse points of views—a mathematician, a lawyer, an architect, a journalist, a sociologist. I want the members of the project to learn how to work with limitations—either the limitations society puts on them or the ones they have to create for themselves. I don't know, maybe it's not that you have to have a school. It's maybe about creating a moment, like opening a space where people can go in, interact, get stimulated, and get out of there with something to be developed later. The challenge is how to rethink continuity and collectivity.

And things are changing so much now that how we show and how we think about learning or who we are learning from is forcing us to change our ideas about what a school and a learning experience are. I mean, YouTube has made a huge impact on performance classes right now. I think this game—at least in the United States—about what is real, what is not real, what is being performed, what is the reason for that performance, who is the audience for that performance, and what is the degree of the performance's permanence . . . YouTube has put all this out there. And this has become a reference point for a lot of students. Not everybody's doing this, but a lot of young kids are because that's their everyday medium of communication. It's almost like, how do they respond to this everyday way of displaying information and defining the construction of the real?

MA: You know, thinking about the future academy, they've been such isolated places. They have to address media. They should have their own technology programs. They have to have professors who really come from different areas, disciplines, scientists. It should be more of a laboratory, a real laboratory with

more than just art techniques being taught. I mean, it's like you go to a classical academy to learn classical languages, Latin or Greek, but if you don't want to, you go to a modern one. So there should be the one classical academy for everyone to create their own drawings or paintings or whatever—it's fine. But there are so many artists who never touch their artwork with their hands. The kind of people like Jeff Koons, who has eighty-six assistants, or Damien Hirst, who doesn't touch his paintings, somebody else is making them, or Donald Judd before them.

TB: Well, it would be nice to talk about creativity instead of production, experiments instead of career strategies. And it would be nice to provide conditions for artists who are dealing with other spheres of knowledge to be in direct connection with those fields, instead of observing from a distance. But like you say, art schools have to have some sort of structure where students can interact with people doing research on the same subject but in other fields, a school where those researchers are teaching alongside artists. That way, the artists we're training really can bring new languages and propositions not only to the art world but to the world.

FROM EXHIBITION TO SCHOOL

Notes from Unitednationsplaza

It is self-evident that nothing concerning art is self-evident anymore, not its inner life, not its relationship to the world, not even its right to exist.
—Theodor Adorno, *Aesthetic Theory*

Anton Vidokle

Adorno could well have added the status of art schools. At the beginning of the new century, the form and purpose of institutions for art education are fully open to question. Even the institution as a stable entity must be reconsidered. One reconsideration is the project Unitednationsplaza, an exhibition as school. I realize that this sounds somewhat paradoxical, yet it's the only way to describe the project that was intended to start as a biennial

(Manifesta 6), scheduled to take place on Cyprus in Nicosia in fall 2006. Instead, after much turmoil, it was realized as an independent temporary school in Berlin, and then crossed the Atlantic to continue under the name Night School at the New Museum in New York City.

Despite being an artist rather than a curator, I was invited to join the curatorial team, which also included Florian Waldvogel and Mai Abu El Dahab, to develop the concept for Manifesta. Our thinking at the time was: Why do another biennial? We felt that the incredible proliferation and monotony of such events has largely rendered them meaningless. While at a certain point they offered an alternative to the conservatism of art museums, in more recent years biennials started to resemble white-elephant-type government projects that largely drain local budgets for cultural production, while offering a rather formulaic digest of participants and content. We decided to use the budget, resources, and network of the exhibition to start a temporary art school. There were several reasons we were interested in an art school model rather than an exhibition. Perhaps a discussion of these reasons could shed some light on the possibilities for both exhibitions and art schools today and tomorrow.

I hope that it is sufficiently telling to give the titles of a couple of large-scale international exhibitions in recent years—say, documenta X's "Critical Confrontation with the Present," curated by Catherine David, and the Third Istanbul Biennial's "The Production of Cultural Difference," curated by Vasif Kortun—to point out that there is a strong desire on the part of the organizers and participants of these shows to see their work as transformative social projects rather than as merely symbolic gestures. Such language and positioning has become the norm, and it now seems that artistic practice is automatically expected to play an active part in society. But is an exhibition, no matter how ambitious, the most effective vehicle for such engagement?

In 1938, André Breton and Leon Trotsky (though Diego Rivera is named as Breton's coauthor) wrote the manifesto "For an Independent Revolutionary Art."[1] They called for a "true art, which is not content to play variations on readymade models, but rather insists on expressing the inner needs of man and mankind in its time—true art is unable not to be revolutionary, not to aspire to a complete and radical reconstruction of society." What may appear to be a naive call for all-or-nothing revolution includes a subtle and important justification for that demand—that we as artists, curators, and writers need to engage with society in order to create certain freedoms, to produce the conditions necessary for creative activity to take place at all.

But what precisely does "the desire that art and artists should engage with all aspects of social life" mean? Is it merely a democratic impulse to open up the places of art, a desire to bring art out of rarefied and privileged spaces and into more "real" contexts, or is it a move toward the further instrumentalization of art practice by assigning to it a concrete social use-value?

Public exhibitions of art started at the time of the French Revolution. The king of France was evicted from his home, the Louvre, and executed along with his queen. Shortly afterward, a part of the palace, the Salon Carré, was used for the first fully public exhibition of painting and sculpture by contemporary artists.[2]

The audience for this salon show was, in a sense, the first real "public": a group of citizen-subjects who had just violently gained political power and instituted the First Republic. The works in this exhibition did not contain any artworks that were explicitly engaged politically or socially. There were traditional paintings of landscapes, nudes, mythological and religious motifs, etc. Yet the actual experience of being able to enter the royal palace to view art was surely political and was intimately connected to the Revolution taking place at the time. Perhaps attending the exhibition was no different from voting or going to a public hospital or visiting a state ministry for the first time—all part of the new political agency that citizens experienced, which allowed them to truly shape their communities and change them via political means.

What is of real importance here is that this situation simultaneously created new and unprecedented positions and opportunities for both artistic practice and art institutions. This novel presence of a public for the first time offered artists the potential to transform community through art's critical function to engage groups and influence public opinion, which in turn can result (and has resulted) in tangible social and political change. It is in no way accidental that several decades later, we see the emergence of such figures as Gustave Courbet, Edouard Manet, and others, who helped to institute the paradigm of critically engaged art practice that we are still following today.

For art institutions, the emergence of the art-viewing public implies a transition from mere private collections to a much more meaningful social function. In this way, both the artist and the art institution suddenly managed to obtain a sovereign position. Interestingly, all this was possible within a process of mere spectatorship: looking at art objects and representations.

But there is a catch: by now the spectators of art have largely lost their political agency as such. Already in the early 1980s, Martha Rosler observed that the public, in the sense of groups of engaged citizen-subjects, was being

replaced by audiences.[3] The difference between these two terms is easily understood if you just think of a situation like an opera house or a movie theater where audiences sit passively in a darkened room, rather than situations where people participate in a more active way. In this sense, audiences are groups of consumers of leisure and spectacle; they have no political agency and no necessary means or particular interest in affecting social change. My feeling is that what Rosler started to observe in the '80s is now a fait accompli: the audiences for art have become enormous, but there is no public among them.

It is still possible to produce a critical art object, but there seems to be no public out there that can complete its transformative function, possibly rendering the very premise behind contemporary art practice effectively futile or, at the very least, severely reduced in its transformative political and social agency. So if the transformative function is what we are after, an exhibition may not be the place to start. Perhaps the school as a model can point the way to recuperating the agency of art in the absence of an effective public.

Art schools are one of the few places left where experimentation is to some degree encouraged, where emphasis is supposedly on process and learning rather than on product. Art schools are also multidisciplinary institutions by nature, where discourse, practice, and presentation can coexist without privileging one over another. The activities that typically take place in a school—experimentation, scholarship, research, discussion, criticism, collaboration, friendship—are a continuous process of redefining and seeking out the potential in practice and theory. An art school is not concerned solely with the process of learning, but can be and often is a superactive site of cultural production: books and magazines, exhibitions, commissioned new works, seminars and symposia, film screenings, concerts, performances, theater productions, new fashion and product designs, architectural projects, along with resources such as libraries and archives of all kinds, outreach, and organization. These and many other activities and projects can all be triggered in a school.

My research for Manifesta yielded a range of models, from art academies and experimental schools to collaborative projects, accompanied by the insistent voice of critics lamenting the "crisis of the art school." Yet there has been an amazing range of schools in the past one hundred years: from the ultra-academic École des Beaux-Arts in Paris to the high-priced Columbia M.F.A., from the inclusiveness of the various heirs to the Bauhaus tradition or the dynamism of the Städelschule in Frankfurt to the elite coteries of the Whitney Museum of American Art's Independent Study Program, simply known as the ISP. Given this proliferation of models of art education, the notion of crisis

seems at the very least a misplaced one. Art education is not in stasis. It is being constantly rethought, restructured, and reinvented.

The Paris-based École Temporaire, run for a single year, from 1998 to 1999, by Dominique Gonzalez-Foerster, Philippe Parreno, and Pierre Huyghe, was a series of workshops conducted at several museums and art centers in Europe. In one workshop, artists rented a movie theater for a day and screened a feature film, while narrating potential alternative scenarios before the start of each scene. Another workshop was a seminar held at the top of a mountain, a location accessible only by dog sled. In yet another, the artists interviewed each other Hollywood-style, with lights and cameras positioned in the middle of a frozen lake. Each workshop was filmed and edited by participants and shown at the beginning of the next class or workshop, creating a chain of connections and continuity, in this way constituting a school that stretched over a range of times, spaces, and institutions.

The Copenhagen Free University was started by Henriette Heise and Jakob Jakobsen in their apartment. As they describe it, "The Copenhagen Free University opened in May 2001 in our flat. The Free University is an artist run institution dedicated to the production of critical consciousness and poetic language. We do not accept the so-called new knowledge economy as the framing understanding of knowledge. We work with forms of knowledge that are fleeting, fluid, schizophrenic, uncompromising, subjective, uneconomic, acapitalist, produced in the kitchen, produced when asleep or arisen on a social excursion—collectively."[4]

The Mountain School of Art was started in Los Angeles in 2005 by artists Piero Golia and Erik Wesley. In their letter of introduction, they write:

MSA^ [Mountain School of Art] is not to be considered an "art project" but a real, fully functioning school. Although the school is small in size the program as well as its collective ambition is substantial. It is important to understand the intentions of developing as a serious contender in the field of education and culture while maintaining a position as a supportive element in relation to other institutions. MSA^ members often liken their pursuits to those of 18th century European revolutionists. Our present location at the back rooms of the Mountain Bar, one of LA's hippest "Art" bars and hottest nightlife spots, provides a pungent metaphor for this as these revolutionists held court in the back rooms of bakeries, print shops, etc. The cultural undercurrent is perpetually condemned to the backroom

of the establishment. It is the intention of MSA^ to continue this tradition while holding onto a more orthodox notion of educational impetus.[5]

What is remarkable is not what these programs propose, but that they should exist simultaneously, offering such varied approaches at the radical end of the art education spectrum. But bringing up these examples is only to underscore how far the nature of education has evolved in the past one hundred years. Only when these experiments are set alongside the historic establishments of the Beaux-Arts, the Bauhaus, and the Art Students League do we have a complete picture. And complete it must be, despite what type of practice one may wish to pursue or what political relevancies one might wish to promote. As Boris Groys points out in a talk we did together several years ago, artists' practices are often formed in opposition to their education; methodologies and techniques borrowed from fields seemingly irrelevant to advanced cultural practices can also form the basis for the production of advanced and radical art.[6] Clearly, there is unlimited potential today for the artist pursuing an education.

However, unlike exhibitions, schools are most often closed to the public, with much of their programming and content available only to the admitted students. Furthermore, the academic structure of educational institutions, with its insistence on the necessity to comply with previously established rules and standards, often guarantees that for all the promise of experimentation and innovation, each successive generation of students evolves into a replica of the preceding generation—something that could be bypassed if the school was temporary. If the two models were combined, perhaps a new, radically open school could be a viable alternative to exhibitions of contemporary art and could recuperate the agency of art by creating and educating a new public.

This was some of the thinking that led us to propose the substitution of a temporary school for a biennial exhibition. Initially, the proposal was met with much enthusiasm, both locally on Cyprus and internationally. The Manifesta school in Nicosia was supposed to be structured in three departments, each semiautonomous and deploying a different model of education, ranging from a largely online, independent study program to a nomadic school with constantly shifting locations that would use existing spaces in the city, from movie theaters to bars. My part of the project, Department 2, was to take place in an old hotel building in the Turkish Cypriot neighborhood and was supposed to incorporate living quarters for participants, with more public production and presentation spaces. Several thousand artists, curators, filmmakers, musicians,

architects, designers, and others from all parts of the world applied to take part in the school, and approximately one hundred were selected to join the core group of the program and stay on Cyprus for the one hundred days of the biennial. The school was supposed to be free of charge, and selected participants were to be offered financial assistance and modest production budgets from the biennial's budget.

Nicosia, the capital of Cyprus, is a divided city. The southern part is populated mainly by Greek Cypriots, and the north is largely Turkish Cypriot. Following the end of Cyprus's colonization by Great Britain and a period of bloody ethnic tensions between the two groups, including a failed military coup initiated by military junta in Athens, Turkey moved its troops into the northern part of the island to protect the Turkish Cypriots. The northern side declared independence from the Republic of Cyprus in the early 1980s, and the two sides have been separated by a United Nations–administered buffer zone that runs through the center of the city.

When we entered this complex political situation with our project in 2004, there was much talk about unification of the island, but it did not come to pass. Manifesta was to take place in the entire city and involve participation from both sides of the ethnic divide. My part of the program was to be situated in the Turkish side of the city, which in itself was not meant to be controversial. However, as we moved closer to the opening of the biennial, despite all the assurances and agreements made with local officials, the progress stalled. Demands were made that the entire project be situated solely in the Greek Cypriot side of the city. Naturally we refused, as it was inconceivable to us that a whole community was to be excluded from involvement in an international cultural event. As it became clear that our efforts were being blocked, and after numerous attempts to negotiate a solution, we spoke to the local press and were immediately fired by the Greek municipality that commissioned the project. The biennial was cancelled three months before the opening, numerous lawsuits ensued, and any possibility of realizing the project under the auspices of Manifesta dissolved into the air.

For me this was a very important turning point. The confrontation with Cyprus officials left everyone involved completely exhausted and demoralized. Furthermore, the mere threat of legal actions scared away virtually all the international funding institutions and other partners. However, I was really conflicted about letting go of the project without ever knowing whether an experimental exhibition as school would actually work. All of the artists and writers who had worked closely with me on developing this idea—Boris Groys,

Martha Rosler, Liam Gillick, Walid Raad, Jalal Toufic, Nikolaus Hirsch, and Tirdad Zolghadr—were equally curious. After some discussions, we decided to risk realizing this independently as a self-organized initiative in Berlin.

I have found it increasingly important to think of how to do things in such a way that one does not completely rely on existing institutions for audience, funding, or legitimacy. It is not at all coincidental that many of the most important art schools, such as the Bauhaus and Black Mountain College, were self-organized by groups of artists. Sometimes I feel that it's almost impossible to realize truly innovative ideas within the framework of already established institutions and networks, which is what an international biennial is, for example. Some people pointed out to me that even if Manifesta wasn't censored by local officials, the experimental nature of the project could well have run into last-minute opposition from the establishment of contemporary art and the art market, which has very specific expectations of what an international art show should offer: the spectacle of national representation and new commodities, neither of which would have been offered by our school. So if we are interested in the kind of art projects that are not merely variations on ready-made models, it's urgent to think of situations in which the work can exist and circulate on its own, framed by itself.

Berlin, with its complex history of isolation and division for half a century, was a particularly interesting location for our school-in-exile. After the fall of the Berlin Wall, many artists from Germany and Europe settled in the eastern part of the city. This huge migration of cultural producers moved much faster than the development of any official art institutions. The result has been an incredible proliferation of self-organized exhibition spaces, collective venues, and small, independent institutions that have dominated the cultural landscape of Berlin for nearly two decades now. In effect, these self-organized projects enjoy the same degree of cultural legitimacy (and sometimes an even greater degree) as the official institutional culture of the city.

I came to Berlin and quickly found a small building on United Nations Plaza (formerly Lenin Platz) in the city's eastern section. To avoid additional legal problems with Cyprus and to reflect the radical change that the project went through, we decided to name the school after the address of the building: Unitednationsplaza. The structure of the school project was very simple: an informal, free university–type series of seminars, conferences, lectures, film screenings, and occasional performances. The focus was on contemporary art. The length of the project: one year. It was open to all who came and projected its content through publications, a radio station (WUNP, a project by Valerie

Tevere and Angel Nevarez), and online. The program was duration based. It was meaningless to come once; repeated visits were necessary to gain any value from the discussions.

Unlike a normal artist's talk or a lecture, the seminars were lengthy. Sometimes they stretched for several weeks, meeting every night, including weekends. Six of these seminars were held throughout the year. The topics ranged from the role of religion in a post-Communist state to the history of video art as a social medium, the viability of a discursive frame, the possibilities of art in the context of war, and the production of images after enlightenment, among others. Unitednationsplaza also presented various film screenings and performances, hosted the Martha Rosler Library during the summer months, and produced a film, *A Crime Against Art*, based on an unusual conference staged in Madrid. In the basement of the building was the Salon Alemán, a functioning bar put together by several artists involved in the project and open sporadically.

Naturally, the program asked for a lot of time from the audience, and even more important, it forced some of the audience to articulate a position in relationship to the project. Reciprocally, it offered all who attended a stake, a certain kind of ownership of the situation: everyone who came could participate to the degree that they wished. I would argue that this possibility of the audience having an active stake in the situation enabled the kind of productive engagement that is still possible, if spectatorship is bypassed and traditional roles of institution/curator/artist/public are encouraged to take on a more hybrid complexity. To me this means that the public can be resurrected and the modality of critical art practice can be preserved, given some changes to how art experience is conceived and constructed.

The temporary nature was a very important aspect of this project. Initially, as Manifesta, it was conceived to last for one hundred days, typical of a biennial, but in fact it continued far longer, for more than two years. The idea was not to develop a model for a permanent institution, but to put forward a functional proposition that others can take and develop in their own ways in different contexts and locations. The project isn't meant as a replacement for M.F.A. programs or existing art academies—the field of art education, if looked at in its totality, is already more diverse and varied than the field of exhibitions of art. If Unitednationsplaza intended to question something, it was the conventions of art exhibitions, substituting the experience of mere spectatorship with more engaged, educational-type experiences. Subsequently, some aspects of the project have been under consideration at a number of art schools that are

looking to rethink their curricula, and so it may add something to the field of art education as well.

Naturally, the project did not please all audiences. Some felt frustrated by the emphasis placed on discourse; others were confused by the lack of a clear hierarchical structure. For example, we were surprised to find that our kitchen turned out to be a contested area that some among the audience assumed to be a kind of closed clubby space or a "Green Room" for invited speakers only, while others felt absolutely free to enter and use it. Nevertheless, a very large number of people kept attending the seminars, and our biggest problem was the lack of space rather than audience. After the project closed in Berlin in 2008, I received this note from a couple of artists who attended most of the activities at Unitednationsplaza:

> We started to think about Unitednationsplaza as a form without content, a host without qualities, which does not indicate a lack of responsibility, but rather an intense responsibility in the most ethical sense as being responsible for something you can't take responsibility for. It managed to open and maintain a space without explicit judgment or control over its (ultimate) content; allowed it to be both a simple and deeply challenging place to be; it made guests take responsibility for their decisions in ways that conventional forms do not challenge them to do. In a way, it managed an extended version of Slavoj Zizek's exam design (which he considers fascistic, but also very funny, and the only real ethical exam) where he makes the students come up with both the question and the answer. By refusing easy conventions, you have made your collaborators create positions rather than simply take them. We wanted you to know that we regard the kind of affectionate indifference you cultivate as one of the most interesting and productive political positions available to practitioners.

Unitednationsplaza functioned very much as an artwork in its own setting: an art project that did not need anyone to display it or promote and bring audiences to it—it did all that for itself. It could engage with institutions, as in this particular case the project ultimately did as the Night School at the New Museum. It also traveled from Berlin to Mexico City before it came to New York City under its final guise, yet it didn't completely depend on institutions to manifest itself. Of course, Unitednationsplaza is not a singular example of such a practice. There is quite a long tradition of extrainstitutional art projects established for exchange as a kind of cultural production, from Tina Girouard,

Caroline Goodden, and Gordon Matta-Clark's Food (an informal cultural center in the form of a restaurant in New York's SoHo that lasted for more than a decade) to more recent examples, such as The Land in Chiang Mai, Thailand, established in 1998 by Rirkrit Tiravanija and Kamin Letchaiprasert. All of these projects stand as evidence that the transmission of cultural knowledge, which art schools and exhibitions traditionally provide, doesn't have to be traditional at all. The boundaries between these modes of transmission, as with so many other boundaries, are increasingly porous and are more easily restructured than you might think.

IN LATIN AMERICA

Art Education Between Colonialism and Revolution

Luis Camnitzer

If the development of art making in Latin America was a product of colonialism, so was the development of the corresponding educational systems. In both areas there were flashes of resistance, but the dictum of hegemonic cultures tended to overwhelm them.

In art the problems became clear very quickly: if the art was old, autochthonous, and precolonial, it was segregated and declassed as archeology; if it was contemporary,

it was considered folklore. Initially, during Spanish and Portuguese colonization up to the early to mid-nineteenth century, depending on the area, the better craftsmen were hired by the colonizers to produce art for them. It was mostly intended for churches, a rather sordid cultural castration that today is highly admired under the positively twisted term *colonial art*. At its best, colonial art was compromised, fusing colonially imposed imagery with local imagery, such as Christian saints vested with native deities. Today this colonial situation hasn't changed much. Craftsmen in art are not generally hired anymore, and they don't work for churches but for the art market and museums. Resistance to this is mostly expressed through searches for local "identity," usually anticolonial in spirit, but the art remains largely overwhelmed by the legacy of contemporary hegemonic aesthetic colonialism. Emphasis is on content, and because of this it tends to create visual pollution with programmatic kitsch. At its worst, the more radical fight against hegemony is through either endorsing other hegemonies (as was the case with applications of Social Realism) or local conventions that confirm an idealized past and arrive dead on arrival on the canvas. At its best, the fight ignores "art" as a goal and lets itself happen as a natural wrapper for ways of thinking and acting, usually also with a political bent. The definition of what comprises art and what does not has nevertheless remained relatively coupled to the old colonialist definition. Accordingly, art is whatever the centers decide. During early colonialism, this meant an emphasis on skills and representation using the two main media: painting and sculpture. Later it would be the whole sequence of aesthetics guided by an imported chain of isms. And the same happens with art education.

The push for resistance in education at large in Latin America has been more effective than in art education, although in the long run it lost its compass thanks to a spread of dictatorships over the continent that became particularly acute during the 1960s. The first formidable move to have universities seriously and radically address local needs took place in Córdoba, Argentina, as early as in 1918.[1] It was a cataclysmic event for the ruling classes and is known as the University Reform of Córdoba. It was achieved through a violent revolution led by the students. The reform, on the heels of the Russian Revolution the preceding year (and as a consequence of it), set down several crucial concepts: education was to be a civil right; the university was conceived as an autonomous state within the state, even when funded by the government; it was to be ruled by students, faculty, and alumni; and access to education was to be for all social classes and dedicated to correcting social injustices, including the elimination of social classes.

Within less than a decade, the university reform took hold in most of Latin America, and it then took another four decades to be picked up or at least echoed, albeit briefly, by the United States and Europe. Student rebellions of the 1960s, though prompted partially by the Vietnam War, reflected in their academic demands much of what had been achieved in Latin America during the 1920s. This was particularly notable in the application of governance shared with the students; institutionalized student evaluation of faculty; and student representation on committees that traditionally had been closed to all but tenured faculty. In the U.S., this became a temporary standard in new experimental colleges, and in Europe it prompted the model of free universities. Education applied to art, however, lacked these overarching reforms or any translation as it might have fit art.

There isn't yet a comprehensive history that documents the travails of art education in Latin America. Information is limited to personal experiences and tainted by the personal ideologies and wishful thinking of whomever writes about the topic. This is clearly my case with this essay, and it's only fair that I give the appropriate warning about bias and spottiness. A good history would require not only a country-by-country analysis but also a nearly impossible agreement on what the purposes of art and education in relation to the public and the power structures are. In the Latin American situation, where art education takes place as much in artist studios and through community actions as it does in university settings, it would be enormously difficult to capture all of this, particularly in a single essay.

However, it seems fair to say that the definition of art as a group of crafts, which was imported with the colonization processes that followed the trips first undertaken by Columbus, generally stood in the way of the development of a good art education program. And when some kind of a liberating breakthrough happened, it was soon hampered by repression or the dynamics of exile. Consistent with the crafts definition, Latin American schools generally taught *how* to do things—a much less demanding process than helping people to think. *What* to do was something that was taken for granted and also something that was first defined by overt colonizing needs.

National independence in the Latin countries took place primarily during the first half of the nineteenth century. However, this was not achieved by native populations, but by what were mostly first and second generations that descended from invaders and immigrants. As a consequence, despite political independence, the cultural mores and values and dynamics of the colonial past remained. Added to this, French influence became increasingly

stronger during the nineteenth century via the Napoleonic legal code, positivism, and French masonry and art concepts. Therefore, the pedagogical leaning was toward ideas informing the Beaux-Arts tradition, dating back to the late seventeenth century in France. In this approach, with its endless practice of imitation, reality ruled—and the better you rendered reality or the masterpieces that rendered it before you, the better an artist you were considered to be. Any little contribution you made to the tradition set you apart and made you recognizable.

The first major challenge to the French academic model that affected art education came from the Bauhaus in Weimar, Germany, in the 1920s, but reached Latin America much later. In fact, the changes reached the continent's architecture schools long before they affected the art schools there. The hold that the French academy had on architecture was less potent than the one it had on art, as functionalism was economically a much more viable approach than neoclassical wedding cakes. What this meant for Latin American art was that during the first half of the twentieth century, the cultural model remained in France, and French institutions like André Lhote's very popular studio in Paris only complemented the picture.

It took the influence of the local schools of architecture that adopted the changes, and then the Americanization of the teaching systems, to finally shake up art education programs and move things along. While architect-thinkers like Walter Gropius and Le Corbusier had a direct influence on the pedagogy (and aesthetics) used in the schools of architecture, it was László Moholy-Nagy's move to Chicago in 1937 and the consequent publication of his books, as well as those of György Kepes, that mark the beginning of more direct challenges to the old model. Still, it took time for influence to become actual transformation. It wasn't until the late 1950s and the Cold War that the ideas promulgated in the American publication of Moholy-Nagy's and Kepes's books made their way into the Latin American system, when the spread of American English as a more global language and the aggressive increase in U.S. cultural sway took hold of the continent. Their influence became even more powerful from the sixties onward.

Until this point, as I've said, Paris (and, to a lesser degree, Florence) had served as the artists' finishing school for roughly a hundred years, starting in the mid-nineteenth century. Those less academically prone ended up in either the Académie Julian, the heavy setting of Lhote's studio, or under the lighter touch of Fernand Léger's atelier. On their return, many of those artists went into teaching and exerted some individual influence. However, with the

exception of the dogmatic schools inspired by Mexican muralism, starting in the mid-1920s, and the equally dogmatic school of Joaquín Torres-García in Uruguay, 1943–1962, none of these had a seriously systemic impact on pedagogy. Teaching remained conventional, and these examples tended to work by indoctrinating students in issues of style.

To achieve a profound transformation, one would have needed several changes to take place simultaneously. These were a centralized public education system, a student rebellion to implement reforms that paralleled the University Reform of 1918, a shift from craft training to problem posing and learning by need, and a decision about the issue of whether art was something teachable .

One rare coincidence of all these factors took place in Uruguay in 1959. It produced a reform that stayed alive roughly between 1959 and 1965 and then stagnated (though some believe it remains alive today). Thanks to student pressure, the national university absorbed the art school, which until then had been the province of the Ministry of Education. Subject to ministerial political whims and its bureaucracy, the School of Fine Arts was given the lower standing of a high school.[2] A student uprising against the faculty forced their collective resignation and led to the hiring of new and more contemporary personnel. A new curriculum designed by the students was put into place and slowly refined during the next five years. The influences for this reform were varied and included the British art critic Herbert Read's writings; Maria Montessori's teaching model; Johannes Itten, who had taught at the Bauhaus in Weimar; information about the School of Design in Ulm and the School of Art in Kassel; and all of these combined with much serious anarchist thinking. The school abolished authority, grades, and degrees, and people were allowed to graduate and exit at their own pace. There was an institutionalized refusal to formally declare when a student became an artist. A group of exploratory workshops formed the foundation period, and the technical studios became satellites to the creative studios. The foundation period started as a circulation through different techniques and then increasingly evolved into the posing of creative problems in "small-scale" and "big-scale" studios.

Overall, it was assumed that art was a natural activity that could be taken up by anybody. Not unlike what Joseph Beuys would preach in Germany, everybody was considered a potential artist who was waiting to be educated as one. The aim was not to generate competitive art makers but better and creative citizens. The project was seriously weakened by a false sense of populism that

led to emphasize the organization of craft fairs and the decoration of walls in worker quarters.

In most other countries in South America, changes were slow, gradual, and fragmentary. Progressive approaches were mostly possible by giving autonomy to artists in charge of studio courses. Good artists would emerge from these schools, but most serious aesthetic ruptures bypassed academia. One exception to the pattern may have been Lucio Fontana's "Manifiesto blanco" (White Manifesto) in 1946. Fontana, who alternated between figuration and abstraction from the 1930s on, had challenged his students at Altamira, a private art school he founded in Buenos Aires, to come up with a more radical manifesto than the "Manifiesto invencionista." This manifesto had been published that same year by the Asociación Arte Concreto-Invención, also in Buenos Aires. The students responded to the assignment, which included the proclamation, "Matter, color, and sound in motion are the phenomena whose simultaneous development makes up the new art." This led to Fontana's path-breaking ideas that he captured under the name *spatialism*, which eventually brought him to his most famous work, his slashed canvases, begun in 1958. And yet all this amounted to a rupture produced by one individual artist.

While the Altamira manifesto was in many ways esoteric, the Asociación manifesto was straightforward, proposing "an aesthetic against good taste" and asking artists "not to search, not to find, but to invent." Unknowingly, it also echoed the memorable and unheeded anticolonialist appeal—"If we don't invent, we fail"—that Simón Rodríguez (the tutor of Simón Bolívar) had published during the early 1820s. The "Manifesto invencionista" instigated the relatively long-lasting abstraction and concretist movement in Argentina, which peaked from the mid-1940s to the mid-1950s, though its total span was closer to twenty years.[3]

Tomás Maldonado, a concretist painter and the writer of the *invencionist* manifesto, represented the position that the creation of art needed scientific rigor.[4] During the early 1950s, he befriended Max Bill, who invited him to join the faculty of School of Design in Ulm in 1954. The school in Ulm, cofounded by Bill in 1953, was a postwar heir to the Bauhaus. Its primary focus was on industrial design as a broad cultural, rather than narrow sales, component.[5] Soon after joining, Bill and Maldonado developed serious disagreements, which, according to some commentators, were about the issue of whether art could or couldn't be taught. Bill believed that it couldn't be, while Maldonado believed that indeed it was possible. Maldonado's position won, and he became the second director of the school. To add precision to the methodology used in

the school, he introduced semiotics and aesthetic analysis into the curriculum. It was a typical paradox that the person who could have changed art education in the Southern Cone left to have an impact in Germany. Typically, instead of being mourned as a loss, he was admired for succeeding somewhere else.

The point of art being teachable or not still remains one of the primary pedagogical issues everywhere. It has certainly plagued Latin American art schooling, although it has been discussed more in political than in pedagogical terms. If art is teachable, it follows that the elitist establishment power structure that rules taste and the market can be demolished. If it isn't teachable, then the primary function of art institutions is to skim off the talented cream and make it serve a consumer society.

Mostly, art schools today still act, implicitly or explicitly, as filters for the identification of innate talent. After sifting through the applicants and selecting their students, art schools develop and refine abilities. This is seen as a rational investment of resources, since so-called talented students will evolve on their own no matter how bad the faculty teaching them. If the selection process is applied efficiently enough, the emerging talent will be credited to the institution, enhance its fame, and bring in more students. Since famous artists will attract talented students, schools tend to hire art stars instead of spending time looking for good educators. When student A becomes successful in the market after graduation, school B takes the credit because star artist C is on staff, regardless of the quality of pedagogical interaction. Since all this adds to profit, this selection policy and attitude are particularly strong where schools are private. In Latin America, this process was delayed, given that for a long time the tradition of public education remained dominant.

Since the late nineteenth and early twentieth centuries, democratic governments all over the continent favored state monopolies or semimonopolies of education, which didn't necessarily preclude the existence of private (mostly parochial) universities.[6] However, the flourishing of military dictatorships during the 1960s and '70s made public education a prime target for change and opened Latin American countries to education for profit. But profit was not the only motivation. Several interests systematically sought to undermine the system. Generally, public universities were havens for leftist ideas that were equated with a communist threat to "God, fatherland, and family." The church, the ruling armies, and the U.S., which backed the military, all perceived them correctly as their enemies, and so promoted regressive changes.

Another problem these forces faced was that most public universities in Latin America were structured after the Napoleonic university model (a

centralized university with career-oriented schools or faculties and rigid curricula that reflected the notion of a state monopoly of education and its certification) and therefore lacked compatibility with U.S. ideas about the development and use of local research. To secure U.S. financial help, public and private universities started to adopt some of the arcane constructs used by U.S. universities, such as credits and subdivision into departments (which have now been adopted by universities in France as well).

The consequences of this privatization process were socially dramatic. Private institutions paid better than public universities did and started drawing the good teachers. The imbalance in quality made private degrees much more market friendly and desirable, therefore increasing social class differences among students and graduates. While the actual pedagogy in private institutions wasn't much different from the public system, the filters for application ensured a two-tier system that was based on both affordability and motivation, and later on the quality of networking after graduation. A self-fulfilling vicious circle obscured the aberration of losing education as a natural right by its transformation into a commodity and killed, or at least diluted, the conquests of the Córdoba Reform.

During the long period when the Beaux-Arts model ruled, when the criteria used for the selection of art students were based on manual skills, the identification of students presumed talented was relatively easy. If students knew how to draw well (that is, how to copy reality), they were accepted. This process was radically refined when the Bauhaus introduced Itten's *Vorkurs*. In most Western schools, this course eventually became the guiding model for any initiatory foundations curriculum—the basic artistic training leading to the crafts of drawing, painting, sculpting, and so on. In the Bauhaus, one had to take this course in order to be allowed to continue with the rest of the studies. The most radical by-product of this was the extension of the notion of talent beyond skills in order to include the generation and use of ideas.[7] This extended notion of talent also started permeating Latin American art schools.

Regardless of the degree of democracy in each country, the creation of art departments in private universities was not an immediate priority. Their main focus was architecture, industrial design, and advertising, all considered better potential profit makers. The Universidad de los Andes, a prestigious private university in Bogotá, Colombia, with one of the best art departments on the continent, started in the late 1970s with a studio for textiles. It took five years of politicking to have it changed into a visual arts program, and many years more to be full-fledged and able to offer a B.F.A. degree. In Venezuela,

the most extreme ideas appeared at the private Instituto de Diseño founded by the industrialist and patron of the arts Hans Neuman, together with artists Gego (Gertrud Goldschmidt) and Gerd Leufert. The institute became a creative haven in 1970 when President Rafael Caldera closed the Universidad Central for two years to stop student protests. The most original and interdisciplinary program in Chile probably is taught at the School of Architecture and Design of the Universidad Católica de Valparaíso, which in 1952 started teaching architecture as a form of poetry. The main founders, the architect Alberto Cruz and the poet Godofredo Iommi, believed that poetic thinking precedes and informs action and that the awareness of this is what generates proper spaces. But overall, a general lack of interest in institutionalized art education, often coupled with the problems caused by repression in public universities, led to a flourishing of private artist studios as the best places to study art.

The tradition of well-known artists opening little academies wasn't new, and it always suffered from the disadvantage of having the fame of the artist override the quality of the work or the ability to teach.[8] While the artists who were products of these academies can't be dismissed in terms of quality, the loss of public and free education meant that art making itself became increasingly associated with the middle class, sometimes even with the idle middle class. David Manzur and Humberto Giangrandi countered this dynamic with their influential studios in Bogotá, Colombia, during the 1970s and '80s, and similar examples are found throughout Latin America. For instance, Nelson Ramos's studio in Montevideo helped to form one of the finest generations of artists in Uruguay, until his death in 2006. And there is Guillermo Kuitca's studio in Buenos Aires, which offers fellowships to about fifteen students who work under Kuitca's guidance (but with aesthetic independence) for a year. The spread of private studio activities has typically been supplemented with *clínicas* (clinics), where invited artists and curators are presented with the work of local artists for evaluation and suggestions. And while the term may be unfortunate, presuming that the artists who show their work can be "cured" by the guests, the clinics help to fill the gap left by the single-teacher system.

In thinking through this complex Latin American history, the approach that Cuba has taken is entirely its own. The filtering system developed there is carried to an extreme not shared in Western academia. Cuba operates on a tracking system that starts very early within the course of studies and allows students to double their curriculum. Anyone interested in studying art at an early age takes both aptitude and creativity tests that are evaluated from assignments and free work. When the students enter the ISA (the Instituto Superior

de Arte, or Higher Institute for the Arts in Havana), they're already considered professional artists. By the time they graduate, they have gone through roughly twelve years of training. Pedagogical processes are quite eclectic. From a period in the 1970s, when academicism was introduced by some Soviet artists invited to teach, the general trend went toward Western experimentation and included the same contradictions.[9] It's particularly noteworthy that all of the artists who graduated from the ISA during the 1980s had guaranteed employment in some activity connected with the arts. Today the situation is somewhat different. Many of the artists who shaped Cuban art in the '80s and early '90s and taught at the ISA left Cuba, mostly in exile (Flavio Garciandía and Consuelo Castañeda, among them).[10] Art became a competitive activity, feeding the international market and the art-tourist market. Some of the artists who remained in Cuba and teach at the ISA today, like Lázaro Saavedra and René Francisco Rodríguez, try to hold to the high standards of the past while adapting them to current practices. Others, like Tania Bruguera, are splitting their time between Cuba and other countries. Every year Bruguera offers workshops at the ISA to which she invites prominent international artists.

Given the politicized atmosphere in which education takes place, it makes it even more difficult in Latin America than in other regions to limit an analysis of art education to the academic sphere. Much of the art made there in the twentieth century has been produced with political and social agendas for change, which makes the relation to the public as much a concern as the actual production of art objects. The works produced by Mexican muralism, particularly during the 1920s and '30s, probably have to be given as much credit in developing artistic criteria as any class in art history or in teaching students how to dip and slide paint brushes. The same can be said about Salvador Allende's mural campaigns in Chile during the early 1970s or even of Tucumán arde, the Argentine collective that in 1968 gave up traditional art making to organize an exhibition that denounced hunger and exploitation by the dictatorship in the province of Tucumán. In Colombia, artist Antonio Caro travels to small villages to organize community workshops and probably has more cultural impact than an art department. Regardless of what one may think about quality and taste produced by these activities, they may have had a greater impact as educational agents than academia has had. Meanwhile, a network of alternative residence groups is appearing throughout the continent now. El Basilisco in Buenos Aires, Incubo in Santiago de Chile, Capacete in Rio de Janeiro, and Lugar a Dudas in Cali are some of the organizations that bring together international artists and local artists for residencies and activities that promote

artistic production and the exchange of ideas. Casa Daros in Rio de Janeiro organizes semester-long workshops for beginning artists, in which international theoreticians and artists teach groups of younger artists, focusing on the public and social impact of their projects.

Regarding such fringe pedagogical activities, let me jump to the recent past, to the Sixth Biennial of Mercosur in Brazil, in which I was deeply involved. The biennial was first organized in 1997 as a traditional regional exhibition event. The chief curator for the sixth, in 2007, was Gabriel Perez-Barreiro, who wanted a high-quality biennial that focused on the pedagogical relation with the visiting public and the surrounding communities. I became the pedagogical curator for the project, and rather than attach an educational program to the finished exhibition, we designed the whole event as an educational tool. The visitor was to be drawn into the creative process of the artist, the consumer was to be equipped to become a creator, and art was to be reclaimed as a methodology to acquire and expand knowledge. We decided not to use the exhibition to flaunt the artist's intelligence but to stimulate the intelligence of the visitors. We inverted the terms by defining the biennial as a pedagogical institution that, among other things, expresses its purposes through an exhibition every two years.

We asked ourselves: What benefits, if any, does the public derive from anecdotal information about artists and their works? How can a critical distance be generated in a public that lacks experience with works of art? How can one break through the barrier erected by taste when appreciating art? How can one work simultaneously with a multiplicity of publics when the artist usually only addresses one of them? And we made several decisions:

The process of preparation of the docents who mediate between the works of art and the public was revamped, lengthened, and deepened. Rather than training the mediators to supply detailed information about works and artists, they were prepared to think with the public. It was stressed that it is preferable to share ignorance with precision than to share knowledge imprecisely.

Emphasis was placed on the importance of speculation about art over the repetition of digested historical data. The docent was to propose the work of art as a solution to a problem rather than to look at it as a hedonistic object.

All through the exhibition space there were pedagogical stations—places for the exchange of information that concerns those artists who participated in the pedagogical project and their works. The artists were asked to formulate in one or two paragraphs the research problem that the exhibited pieces were addressing. The public was encouraged to understand the problem and to leave comments useful to both the artists and the subsequent visitors. Thus, the public started to educate the public.

Along the walks through the biennial, we had spaces designed to hold discussions. The biennial was conceived like a park, with manageable walks frequently interrupted by areas for rest and conversation.

As part of the exhibition space, there was an ample educational center with classrooms, studios, an auditorium, and a library. Teachers and students were able to discuss and work there in relation to what they had just seen in the exhibition and to produce works that followed problem-oriented assignments. The results of their work were exhibited in the studios and on surrounding walls. The space dedicated to these educational activities, along with the pedagogical stations, took about one-tenth of the surface of the biennial.

A Web page with an information and exchange center operates during and in between biennials. The main topics for the exchanges are creation processes and art pedagogy. Chatrooms were organized so that in real time, the public was able to engage in discussion with both artists and curators. The biennial aims to become a clearinghouse for pedagogical ideas and curricula applied to art education.

Teams for preparation were sent to schools all over the state of Rio Grande do Sul. Day-long workshops were given to put the biennial in the context of contemporary art history and discuss methodologies and ideas present in the works expected in the biennial.

Teachers were prepared to become a nexus with the biennial, telling visitors about their schools and their fellow teachers and students about the biennial.

Five months before the opening, the schools received pedagogical exercises with problems related to the work exhibited in the biennial. The point was to stimulate creation instead of reducing information to anecdotal data. Students were able to make works that related to the ideas that informed the work rather than simply copying particular pieces. That way, they could understand the art in the exhibition far better. They were able to look at the works with a more experienced critical eye, seeing the art as an artistic colleague rather than as a passive consumer.

Symposia were organized so that the artists and art teachers involved would promote the idea that both activities, making art and teaching art, should be considered a single activity that takes place in different media. Both demand the same amount of rigor and creativity.

The biennial was highly successful. Meetings for the art teachers were organized in fifty-two cities of Rio Grande do Sul by an educational team of the biennial, with the participation of 7,350 teachers. The exhibition had over half a million visitors, 156,887 of them students. Buses were sent to pick up and return students in a radius of 100 kilometers.[11] Twenty-three states in Brazil asked to share the pedagogical template of the biennial, and the Ministry of Culture awarded the pedagogical project one of its 2007 Cultura Viva (living culture) prizes.

When discussing the education of artists, we are conditioned to envision an activity that mostly takes place in a school setting and leads to the formation of a professional, much as in other disciplines. But the experience in Latin America indicates that if we're to consider art as a cultural factor, more education is taking place in nonacademic settings than in schools, and professionalism in the sense of disciplinary proficiency is only one of the aspects. It seems to me that this realization ought to lead to a revision of what we consider important in the education of artists; what we actually consider the education of artists to be and want it to be; and what methodologies should be employed to achieve those goals once they're decided on. In the absence of any glimmer of clarity, it isn't surprising that art education is always the first victim of budget cuts. On the other hand, the artist's identity as a producer of high-priced commodities is spreading in Latin America. Gallery success—and preferably international gallery success—is a primary aim for many art students. For example, students at the art school Prilidiano Pueyrredón in Buenos Aires, a public university school, complained to me that after graduating they don't have comparable access to the market as graduates from other institutions or from private studios because their school isn't good at professional networking. These students follow the contemporary notion that a university degree is important for their credibility, and when affordable (through personal wealth or fellowships), they prefer an M.F.A. from a star international institution.

The situation of the arts in Latin America isn't particularly clear at the moment. Thanks to the U.S. distraction in Iraq, a temporary breathing space has been created for Latin America that allowed the improvement of both democracy and the economy, which could have some lasting effects. Local art markets

have been augmented by a sprouting of biennials and art fairs, all of which helped raise levels of professionalism. The interest and power of international Latin American collections (Daros, Cisneros, Tate, and The Museum of Fine Arts, Houston come instantly to mind) nourish the image and standards of Latin American artists as significant cultural producers on the world stage. And yet it's refreshing that the interest in communities as a locus and destination of the artists' creative efforts has increased as well and seems to balance the otherwise impoverishing trend against locality. Still, while alternative organizations and some private foundations recognize the latter case, there has yet to be a serious curricular response.

The political and economic outlook for the world and therefore the outlook for advanced cultural independence for Latin America are very fragile. It is a fact that institutional art education is still operating in the past and that it isn't correctly addressing a high-powered market or any true social involvement. One would hope that the democratic left, if it is allowed to settle and stabilize, will be able to develop university reform that addresses local issues on both levels so that producers of art objects and art activists can help to improve their communities and give less of a priority to the predilections of the international market. That would be a phase of new educational practice in Latin America, and it might also become a lesson worth noting throughout the world.

PROJECT 6

MARFA COMPLEX, 1973 ON, DONALD JUDD, MARFA, TEXAS

In the early 1970s, the sculptor Donald Judd rediscovered a sleepy Texan desert town that he had passed through as a soldier in his youth. His involvement there eventually expanded to encompass two foundations for the exhibition of his art, along with work by his Minimalist peers. He began with a small property at the center of the sparsely populated town, part of a former U.S. Army base used for interning German prisoners of war, where he produced a domestic-scaled complex, including renovations of existing structures and new designs that he undertook himself. This walled residential compound, forged primarily from existing buildings, was later joined by renovated vernacular structures converted into studios, a furniture atelier, Judd's architecture office, exhibition spaces, and studios for visiting artists, which comprised the Judd Foundation (upper center of figure opposite, on either side of railway tracks slicing the town in half).

To the southwest, on the edge of town, a number of larger army base buildings were also converted to Judd's specifications, becoming exhibition spaces for the Chinati Foundation (foreground of image). This complex, with spacious exhibition spaces suitable for extremely large-scale works, as well as a number of areas for outdoor installations, is clearly marked by Judd's Minimalist sensibility (center foreground).

While not a school per se, Judd's monument to his art offers an innovative model for alternative concepts of transmitting cultural knowledge, with an artist residency program and a yearly symposium held there. Through them, these complexes nestled within the seemingly timeless Marfa environment offer an ongoing distribution of knowledge concerning one particular artistic legacy: Minimalism. Yet the fact that Judd did not begin his career as an architect but moved into the field as an extension of his sculpture brings with it a tension of sorts. The generic vernacular buildings that his efforts subsumed—under the auspices of a spatial understanding that conflated personal vision, place, and an institutional ethos—weren't normally associated with art (architecture with a capital A), but with vernacular and unself-conscious construction. In an analogous manner, the production and discussion of new work on the site can't escape comparison and contrast with the Minimalist approach that Judd pioneered, raising precisely the sorts of questions about cultural specificity and timeliness that art education has traditionally offered to artistic production.

Aerial view of Marfa, Texas. (Image courtesy Chinati Foundation)

UNDER PRESSURE

Ute Meta Bauer

Art schools and university studio art programs, previously free and open zones for experiments, have found themselves pulled further and further into the orbit of the art market. Art students have more knowledge of the market than ever before, and to "create" successful artists—which largely suggests commercial success as a career artist—has become a standard promise read in almost every mission statement and call

for applications by M.F.A. programs not only in the United States but around the world.

What may be more specific to the situation in the U.S. is the very short route from the art school to the gallery to the collector's walls. This may be the case in London too, but the very high tuition fees in the U.S. put a certain pressure to succeed on both the institution and the student. Today's strong market has made art education red hot and an increasingly attractive field within education—and not only M.F.A.s. In the expanding market of the culture industry, critical studies, curatorial studies, M.A.s in public art, and Ph.D.s in artistic production have either been recently invented or have risen to new popularity. (The inevitable cooling, and just as inevitable reheating, of the market will unlikely cause the institutional structure to regress.)

This isn't in itself bad. The proliferation of these new, specialized programs interrupts the dominance of hundreds of years of the European master schools tradition that was established to select and form "the best." Or this would seem to be the case. A question that immediately arises is whether the influence of the market is inducing a different uniformity. Of course, another question to ask is where all of these art students are going to go when they leave their alma mater with a degree in their pocket.

As part of the selection process for a specific degree program, if you intend to invest so much in your art education, you want to know where the revenue will come from when you are finished with school and out in the world. But the pressure isn't only on the students. The pressure is on the art schools and programs to connect early with the art market and generate a smooth entry into the system while young artists are still under the school's umbrella. That is a major shift from even a decade ago. The debate then was about what that majority of art students would do who never reach the first stage of the magic "success" triangle of academy-gallery-museum. But with the globalization of the market, the boom in biennials and art fairs around the world, and the rapid expansion of a new generation of collectors, the chance to catch a ride on the art carousel has increased enormously. The ambition to pass through the gate and gain access to this field of distinction for larger and larger numbers of fledgling artists has become a reality. There are more exhibitions taking place, more art institutions with their doors wide open, more new museums and Kunsthalles getting founded, and more private collections welcoming the public than ever before. But was this what art students and young artists were after, say, twenty-five years ago, when they asked for more visibility as they addressed the exclusive politics of major art institutions?

Today it feels as if the art market has replaced the music industry, with its annual top-of-the-pops and one-hit wonders. And although I appreciate the democratic component that almost everyone can be a producer of some kind today, I am not so sure that this is a good thing. If the art market now seems more integrated into the educational system than ever before, we have to ask what its far-flung biennials and fairs are providing. It is important to support access to discourse and to modes of production that we now find spread all over the world, just as I still believe that artistic practice is a critical contribution to the formation of societies. But the market embraces each new spot that pops up on the global map all too fast. Yesterday it was China, today it is India, and tomorrow Dubai and the Gulf. Who knows what it will be a year or two from now? And as much as I support this expansion of respect for and acceptance of artistic production in all parts of the world, the question is the degree of disciplined analysis, of filtering and criticality that this expansion has lacked. Instead of this, art has simply become a huge operating machine in need of skilled and "educated" labor—a neocolonialist approach that takes advantage of postcolonial ambitions.

This brings us back to art schools. Before the incursion of the market, art schools could still more easily be testing grounds for experimentation and innovation, including failure. But are they still places where you can discuss the meaning of artistic production within the larger field of culture, or, perhaps more precisely, debate what *is* culture today in such a globally expanded field of experience and how art schools have adapted to this fact? But have they indeed? And given this contested space of authority, can art schools truly help to negotiate and problematize what role art and its institutional apparatus play in our globalized and commodified societies? It seems, on the one hand, that art students are allowed to do whatever they have in mind. Yet what they have in mind is increasingly shaped, if not dictated, by the allure of success in the market, which is to say that the wild growth of experiment is more and more subject to the biotope of uniformity that the market enforces. Perhaps this was always there—the same when a "master" taught his novices skills, techniques, and his own style as today, when the market enforces its own means of determining quality, techniques, and styles. But isn't it even more so now, with the endless output of colors, forms, two-dimensional works, voluminous installations, sparkling pixels, and the offer of so many diverse topics to fulfill the demands and desires of an "educated" consumer society that wishes to express its "fine distinction"?

Under these pressures, art students and art schools seem to be without any useful, utopian naiveté. All kinds of strategies are incorporated to serve our post-naive system. Perhaps the most flagrant is the end-of-term "open studio," which is advertised as an event that courts art dealers and collectors, replacing critics and curators, the global players of the 1990s. This is the reciprocity between the market and the academy. As art events have become part of the lifestyle, with a substantial cash flow involved, there are huge demands for fresh artists, young curators, new terrains for biennials, galleries, and so on and so forth. It may feel as exciting as Paris showrooms during fashion week, but the question that we as educators and intellectuals need to address is what this reciprocity actually creates.

In his article "Bureaux de Change," Alex Farquharson addressed "new institutionalism," referring to the number of high-profile freelance curators who have joined the "safe haven" of institutions for higher artistic education. I don't necessarily agree with his argument.[1] To me there is no *outside* of the institution, no outside of the art market and vice versa. The market is part of the discursive field, as educational institutions are too. The art world is and has always been a complex system, a field of constellations and interrelations; some are friendly to each other, some are of a more antagonistic nature. Traditionally, the critical field has distinguished itself from the commercial sector, but the field has changed. These are not fixed configurations. Roles shift. The market brings both uniformity and proliferation, which means the opportunity for actors to decide on the coordinates of the positions and the directions in which they'll move. Indeed, institutions today represent far more positions than they did twenty-five years ago because they have to address and attract a more diverse audience, if not many audiences.

When Farquharson brings up the topic of curators' flirting with educational institutions, this too is not about an outside and an inside but about the shifting fields of education and commerce in relation to one another—and the larger effects brought into clear play. The commodification rampant in the art world has made it more difficult for curators to act within institutions as creative agents. It is the same for museum and Kunsthalle directors today, who are more occupied with management and fundraising activities than with working on shows or working directly with artists, as has been the case in the past. I do not want to criticize my colleagues in art institutions, but I want to express (and this I share with a number of my peers) a strong feeling of unease about the economic and political pressures that museum directors and curators increasingly face. And while art schools currently face

the influence of the marketplace more strongly, by comparison they still seem to offer a kind of temporary refuge for those who want to sustain a more critical and discursive practice.

This doesn't mean that the migration into the art school environment that we see at the moment is simply a means of escape. The opposite could be said as well that art students are getting ever more prepared for "real life" by professionals in the field, such as curators and critics. But the potential and pleasure of working with students and doing research in related fields shouldn't be underestimated either. My own motivation for shifting from my original training as an artist and stage designer to my practice as a curator and educator already seems dated. The exclusion of a younger generation of artists, specifically female, from mainstream art institutions in the 1980s was a motor for me and for my artist friends to generate something else. We were not completely opposed to art institutions, but there was no space for us available, and what we saw exhibited often failed to address what mattered to us or to our discussions about art. Instead of complaining about this situation, we simply created our own formats and spaces, generating our own audiences—a typical do-it-yourself approach. We descended not only from visual arts but as well from the fields of performance and theater, film, music, and poetry. Today, with so much interdisciplinarity and the greater (though still unequal) acceptance of women in the art world, this seems far away.

It was not until later that I understood that art history isn't made in the garage; the art historical canon is to a certain extent still in the hands of the major museums (and their trustees), based on what they choose to collect, exhibit, and publish. But more and more the market dictates what kind of art is produced and shown in art institutions, and the rapaciousness of its desire for the new discourages memory and deep criticality, while addressing cultural diversity and gender only in its search for novelty. Price and collecting prestige invent new types of segregation.

There is a need for serious debate within universities and other social institutions to focus on these issues in order to understand the major implications of this development. But for obvious reasons, those debates should also take place at art museums and at opinion-creating blockbusters like documenta; the Venice, São Paulo, Sidney, and Whitney biennials; and the Carnegie International. *Especially* at these places. They have the budgets, infrastructures, and media power to "correct" and rewrite art history, as they are the events at which the critics and opinion makers show up in vast numbers. But are we seeing these sorts of debates take place at these venues? Perhaps informally, but rarely

as part of a regular public platform. A network of institutions addressing these issues would be of huge benefit. And closer to my main subject, what we need to see more in art schools is the development of alternative cultural stances to the predilections and short-term memory of the market.

I see my own teaching in art schools as a practice in line with curatorial work. The BBC's founding phrase, "Education, Information, Entertainment," is a healthy mix that is still a valid model. The relation between art and exhibitions, which offers the option to test situations and combinations and explore thoughts through works of art is no less needed as a focus in art education. An exhibition is equal to a seminar for me; both formats produce a communicative space through artistic and intellectual means. Nothing is wrong with the involvement of students in exhibitions, but the idea behind such participation has to be made clear. It shouldn't be to create a showcase for students entering the market, or certainly not that alone.

When I studied art, being unpredictable was enough to prevent my fellow students and me from getting co-opted. I must have internalized this attitude, and in any case we were far from having a master plan to develop and manage our careers. Of course, it's also important to remember the practical lessons of any number of conceptual artists, such as Hans Haacke at Cooper Union and Michael Asher at the California Institute of the Arts (CalArts), who were able to sustain their independence throughout the pressures of previous market booms because of the independence that their teaching positions provided. For a female artist, often the only way to survive was to become a teacher.

Of course, this isn't only about financial independence from the market. This is about the possibility and responsibility to transmit a specific notion of a critical artistic and cultural practice to a younger generation of artists, while giving teachers the distance necessary to remain cognizant of the market but not in thrall to it. As a curator within the academy, I'm always trying to find company to explore, discover, reflect, analyze, and share what I perceive in order to implement a correction through a multitude of voices—which is precisely what a curator does in the selection of works for an exhibition. Alongside the pressure to produce "successful" artists, the pressure has to remain to support the development of critical subjects.

This understanding, this continual generation of a public, communicative space within an institution for *education*, is still important to me. But the more the market encroaches, the more difficult this is to achieve. Perhaps to a certain degree, this has been caused by curators entering the teaching field, bringing the dynamics of the market along with them. But it is clear that the

fact of the omnipresence of the market means that art schools need to work on new ways of configuring and positioning themselves. Just as we have begun to see biennials reformulated as art schools, we must think about inverting this outside and inside of the market and the academy and think of a reverse practice that uses art fairs and the market more emphatically as educational tools and as the terrain for (counter)actions.

Of course, it is also true that other possibilities remain if we take a longer historical view. The idea of making ephemeral and process-oriented work that cannot be absorbed so easily by the market still exists within the academy. Dada, Letterism and Situationism, land art, arte povera, Fluxus, and Conceptualism have all been artistic movements that, at least at first, couldn't easily be swallowed by the art market and its consumers. New art will undoubtedly offer new possibilities of resistance, while the equal challenge remains to find ways in which what is useful about market thinking can be incorporated into art education and artistic practice. And while the market's influence is in the ascent now, this is a perishable fruit—just as it has previously been the case that art historians, critics, and curators have each taken their turns as influencers. We have seen the same situation within the academy as it took up theoretical positions on colonialism and postcolonialism, gender, and class. They have all been great engines of debate and then have been pulled into the curriculum and disappeared through the back door of esteem, smelling too much of (necessary) political correctness, of doing good rather than thinking freely and widening our perspectives.

Is it still possible to believe, as Antonio Gramsci did, in the artist as an organic intellectual whose role is not to act subordinate but to be a critically independent voice that negotiates civil society? In some ways. But it is most important not to fall into the trap of considering any of the art world's players or institutions as fixed entities. This constant flux, this shift of what outside and inside even are, makes it possible to open a space in education for rethinking values and judgments and to develop new critical practices. The biggest challenge may not be the pressure of the art market, but the willingness of the academy to challenge itself.

PROJECT 7

ART CENTER COLLEGE OF DESIGN, COMPLETED 1976, CRAIG ELLWOOD, PASADENA, CALIFORNIA

Established in 1930, the Art Center College of Design (ACCD) was among numerous commercial art schools that blossomed during the postwar era, with the sizable growth in demand for advertising (an early major at ACCD), graphic and industrial design, photography, animation, and other fields of applied art. The college regularly outgrew its lodgings, and when a design for new facilities was scrapped in the 1940s, a former private high school for girls was taken over, suggesting (as at Black Mountain) that existing educational complexes could productively be retrofitted for art instruction. When a new campus was again envisioned in the 1960s, ACCD director Donald Kubly turned to Craig Ellwood, who had recently designed Kubly's home. The building Ellwood produced appears as one large rectangular glass and steel volume, nearly 1,000 feet in length, effortlessly spanning a ravine on a hillside in Pasadena. It was less a campus than a somewhat perverse version of an increasingly ubiquitous suburban type—the corporate office park, employed here for the production of artists.

Divided in three segments along its extreme length, the middle portion held public programs (entrance, exhibition, sound stages, as well as administration and library facilities spanning the ravine), with classrooms and individualized studio spaces located on the ends. Ellwood's work was marked by both an explicit expression of structure and a no-nonsense practicality that reflected less a master's influence (often assumed because of his building's obvious indebtedness to the architecture of Mies van der Rohe) than an abiding interest in supposedly unbridled flexibility. His ACCD building's strong image, however, was countered by the very specificity of the spatial arrangements that it provided, paradoxically generated by the architect serving his client's desire for ostensibly "flexible space." The portion south of the ravine was in fact two stories, with an entire hidden floor buried in the hill beneath the slab, thwarting any unified reading of a symbolic clarity to be found in its formal arrangement. A decade after the building's completion in 1976, the first of a series of "additions" was constructed, beginning a phase of retrofitting that has ultimately produced an offshoot of the institution elsewhere in Pasadena, which accommodates its graduate and public programs and is housed in a converted former aircraft-testing facility.

The sprawling complex suggests a typical aspiration toward an industrial model of knowledge production and the International Style's image of cool utopian unity, with its less-than-enthralling indifference to the specificity of cultural place. Nevertheless, together with the art departments at the University of California, Los Angeles, the University of California, San Diego, and the California Institute of the Arts (CalArts), the ACCD nurtured a southern California art scene marked by an emphasis on theory during the 1980s, as elsewhere, suggesting that regional connections might matter more than national and transnational trends.

TEACHING ART: ADORNO AND THE DEVIL

I: *One could know all that and yet acknowledge freedom again beyond criticism. One could raise the game to a yet higher power by playing with forms from which, as one knows, life has vanished.*

HE: *I know. I know. Parody. It might be merry if in its aristocratic nihilism it were not so very woebegone. Do you think such tricks promise you much happiness and greatness?*

I: *(repost angrily) No.*

—Thomas Mann, *Doctor Faustus*

Daniel Birnbaum

I: The same story appears over and over again in the annals of Zen Buddhism: The student comes to the teacher and begs him for instruction. The teacher says nothing; he is just sweeping up leaves. The student goes into another part of the forest and builds his own house, and when he is finally educated, what does he do? He doesn't thank himself; he goes back to the teacher who said nothing and thanks him. It is this spirit of not teaching that has been completely lost in our educational system, says John Cage.

HE: And you agree?

I: Well, art is taught. But nobody seems to know how.

HE: And yet people like you keep doing it for years. Isn't that hypocritical, even cynical?

I: "I don't think art can be taught. I really don't," says John Baldessari in an interview our students made with him recently. We printed it in a book called *Kunst Lehren/Teaching Art*, which seemed a bit paradoxical perhaps. I don't think one could call John a cynic. He seems to me a deeply optimistic person, and he has been teaching art, whatever that may mean, for half a century, so his account is probably realistic: "I do think that one of the advantages of an art school is that the student gets to meet artists, other artists that are practicing."[1]

HE: And what exactly would be the point of meeting artists?

I: Baldessari continues: "The value of that is they see that the artists are humans; art isn't something esoteric that's in books and magazines and museums, it's done by real people, and sometimes they're real jerks, and sometimes they're very articulate, sometimes they can't barely get two words out. Sometimes they do a lot of garbage, sometimes they do a lot of good work. But at least the students get exposed to that." And yet he insists, "But, no, I don't think you can teach art at all."

HE: So perhaps we should end the conversation here.

I: Well, perhaps there are a few other approaches. Some artists who teach emphasize the importance of unlearning things, of removing the kitsch and the clichés about art and the role of the artist as a first necessary step, followed by something constructive that is much harder to specify. "Ignorance is a treasure of infinite price," says Paul Valéry. Tobias Rehberger, who is one of the best teachers I know, is optimistic enough to think that removing the layers of sediment will set more interesting things free.

HE: One of the best teachers? That you have to explain.

I: Well, there are lots of great young artists coming out of his class. He says: "You have to surprise me. You have to go beyond what I'm telling you. Otherwise you can only reach my level, and that is not very interesting because you are already there." And how is this step possible? The answer may sound too simple: "If you're able to get rid of the kitsch you're carrying around, then you automatically get there." This is probably largely the kind of optimism that is necessary for everyone who works in education, but it is also a way of teaching that insists on the necessity of an individual cure.

HE: Okay, but let me ask you a few questions about a disturbing tension, an irritating contradiction, in what you keep saying about schools and about teaching art, which, after all, has been your profession for years now. You claim things like this: "We should remember that every school is a temporary space intended to give young artists the theoretical and practical tools to navigate an ever-changing now themselves. In the end, that capacity to navigate on one's own is what it's all about. Really, nothing else matters."

I: Yes. Where is the problem?

HE: No problem with that, really, but on the other hand, you talk about the school as a production site, and sometimes you make it sound as if the academy could be a curatorial model.

I: Well, that is really nothing new. Do you know Robert Filliou's *Teaching and Learning as Performing Arts*?[2]

HE: The book edited by Kasper König in 1970.

I: Yes, it's an interactive book in the sense that there are lots of blank spaces where the reader, "if he wishes," as the author puts it, can contribute his own thoughts. John Cage plays a major role in the book, and the Zen story above is quoted there. He also says: "I think, first of all, we need a situation in which nothing is being transmitted: no one is learning anything that was learned before. They must be learning things that were, until this situation arose, so to speak, unknown or unknowable."

HE: If teaching and learning are performance arts, then the collective zone in which these creative activities take place is a kind of stage or even an exhibit. Does that make any sense today?

I: Well, the Städelschule in Frankfurt is an art school with a Kunsthalle, the Portikus. The hybridity arising by virtue of the proximity of education, production, and display has made it an interesting location for collective productions.

HE: For instance?

I: All kinds of things instigated by both teachers and visiting artists: from the renderings by students of Yoko Ono's almost haiku-like "instruction pieces" to a colorful and pretty wild parade organized by Arto Lindsay, the rock musician; from Rirkrit Tiravanija, Pierre Huyghe, and art historian Pamela M. Lee's installation of a Gordon Matta-Clark show inside a house built from a few hundred large loaves of bread baked by students—our school has a cooking class—to John Bock's real collision of disciplines, wherein he screened a new film onto a baroque structure designed by architect Ben van Berkel. A school

is a school, but it can also be an unusually energetic production site of art that finds new forms of visibility and new forms of display.

HE: That's the problem: you say that a school is a school, and that the students' capacity to navigate is what is most central. But on the other hand, it seems that you use—or should I even say abuse?—the students, as if they were simply material in some kind of living *Gesamtkunstwerk* that you construct together with all kinds of artists you invite.

I: Let's take a closer look at one example: The first new teacher I invited to the school was Rirkrit. Over the course of two years, 2001 and 2002, he did three things: he taught at the school (which in his case means that we met, cooked, ate, and talked); he put on a show at the school's gallery, the Portikus, centering the exhibition around a wooden platform (on which we all met, cooked, ate, and talked); and in the summer, he initiated—together with artist Dirk Fleischmann and curator Jochen Volz—a large workshop that turned the whole school into a kind of inn, or *gasthof,* as the event was called. Together with students from the Städelschule, hundreds of artists and students from other schools were invited to stay in our studios; we all met, cooked, ate, and talked for an entire week. Do you think that these activities represent a kind of abuse?

HE: Well, did not Tiravanija—with your eager support—try to turn the entire school into a work of art?

I: I really don't know how to answer that.

HE: That is certainly how some people saw it—not merely because claiming the production site itself as a work of art seems the logical consequence of many recent developments in contemporary art but because Gasthof seemed to represent the very essence of that art that Nicolas Bourriaud christened "relational aesthetics" in the 1990s. And that is a problem!

I: What exactly is the problem with that?

HE: For Tiravanija and other "relational" artists that Bourriaud discussed, social exchange is not just a side effect or backdrop but the very core of an artwork—a standard by which the art school, where a certain kind of group dynamic is

bound to occur and where collaborative modes of production are near at hand, would seem a place uniquely suited to their endeavors. The problem of course is this: the students are at school to develop their skills, not in order to realize your or anyone else's curatorial ambitions. It might be quite pleasant and even lots of fun to march in Art Lindsay's parade or to cook with Rirkrit, but that is not what becoming an artist is about.

I: So what *is* it about?

HE: It's about learning to use the theoretical and practical tools required to navigate an ever-changing now. Didn't you just say that yourself?

I: But perhaps Gasthof, rather than being a work of art itself, merely highlighted what was already there in the school and made more conspicuous the give-and-take that constitutes the basis of the educational situation. It's not really my fault that some people interpret it as a collective work of art.

HE: Don't pretend to be innocent. When a similar project, involving many of the same people, was presented as an exhibition called Utopia Station at the 2003 Venice Biennale—organized by Tiravanija with Molly Nesbit and Hans Ulrich Obrist—there was really no question about whether it was a show.

I: Wait a second: At Gasthof everybody present was part of the gig, so perhaps it wasn't a show after all. Utopia Station, by contrast, introduced collective production and interactivity into a biennial where these things still appear a bit alien. To look at the school as a kind of exhibition and at the activities going on in the school as art is only one of the possible ways of understanding the situation. Is it not interesting that it seems increasingly difficult to draw a line between shows and education? Perhaps this is more relevant for an assessment of the state of art itself than for a discussion of schools . . .

HE: . . . whose primary purpose, let me emphasize this, remains to educate students and not to put them—or itself—on display. So what does this say about the state of art itself?

I: That you get the art you deserve.

HE: Well, perhaps you get the schools you deserve. In order to gain some perspective on the question of the educational institution's relationship to art here, we would do well to go back to Thierry de Duve's essay "When Form Has Become Attitude—and Beyond," which was written in 1993—roughly the same moment that relational art practices were coming into being. In de Duve's analysis, the contemporary art school is a debased successor to the Bauhaus model, with its emphasis on creativity rather than talent.

I: The description of the modernist art school based on the creative individual is convincing. The cult of creativity is grounded in a utopian belief that is summed up in the modernist slogan: everyone is an artist. As de Duve points out, one finds this throughout the history of modernity, from Rimbaud to Beuys.

HE: The Bauhaus stressed the qualities inherent to a medium rather than artistic techniques, invention rather than imitation, and creativity rather than talent, which had been typical of the "academic model." De Duve writes, for example: "The difference between talent and creativity is that the former is unequally distributed and the latter universally."[3] But today, he says, these key concepts—creativity, medium, invention—have been hollowed out by theory-based programs that stress attitude, practice, deconstruction. Do you agree with this account?

I: No. I think that perhaps the Whitney program in New York came close to this for awhile. If you have read and assimilated Roland Barthes and Michel Foucault, perhaps these concepts, especially practice and deconstruction, sum up what you think about cultural production rather well. But most art schools in Europe, and in the United States, as well, I think, have been more eclectic in their approach. Of course, nobody is supposed to believe in old-fashioned expressionist subjectivity, but some stage it so wholeheartedly and so convincingly that they tend to forget that it's not the real thing. Is Jonathan Meese creative, or is it all just a pose—I don't think he knows that himself, and he doesn't want to know.

HE: It's just a question of . . .

I: . . . attitude. That sounds like the young artists of the Städelschule to me, I'm afraid. But what's so bad about attitude and deconstruction?

HE: De Duve claims that although such an approach has produced some good artworks, it makes for bad art schools that are, as he puts it, "the disenchanted, perhaps nihilistic, afterimage of the old Bauhaus paradigm."[4] We all seem to work in the aftermath of a time with more powerful ideas.

I: Actually, I think we live and work in many different times, and that the asynchronic nature of our moment can be rather productive.

HE: How do you mean that?

I: Nobody believes in medium specificity, that is true, but nobody believes in the values of the old academy either. Students are torn between incompatible worlds, whether they realize it or not, and sometimes this schizophrenic condition can be a good place to be. We live in an asynchronic moment when the old academy, the modernist model, and the deconstructive afterimages live side by side in a world increasingly driven by market interests.

HE: So all those tools are good as long as they can be made productive in the art market?

I: No, no, that's not what I mean. One has to ask: Should the art school turn itself into a monastery that protects students from the evil forces outside or should it invite the market in and become a kind of lively bazaar? It seems to me that the answer is neither and both. The pressures of the outside world no doubt bear within the school too, and the idea of an inside and an outside is probably too simplistic. What is "out there" can be of interest for pedagogical reasons. It's a question of perspective rather than of content.

HE: You mean that the students should study the market but not be part of it?

I: Well, sooner or later they will be part of it, so perhaps it's important to understand a few things about the forces involved.

HE: Perhaps you could specify what you mean by market.

I: I think that at least two kinds of market should be distinguished when we talk about art education. On the one hand, there is the commercial interest in

very young artists' work, indeed even in works by students. On the other hand, there is a different economy that is relevant: education is today a hot commodity. Education is capital. And, as Jan Verwoert has spelled out recently, capital must keep circulating. Hence the Bologna Process. He writes: "The [Bologna] accords aim to introduce unified standards for evaluating the education at institutions of higher education all over Europe. There is an economic purpose to this: in order for education as a commodity to circulate, measures must be taken to ensure that its value is calculated everywhere according to the same pay scale."[5] Thus, the Bologna Process represents the comprehensive subjection of education in Europe to economic terms.

HE: But that is a different theme altogether.

I: True, but perhaps it is important to remember that there are different economies involved when talking about art education, not only the one that involves the money exchanged by dealers, artists, and collectors.

HE: And what really is the main problem with the standardization implied by the Bologna Process?

HE: If one is interested in diversity and plurality in the arts, or in culture in general, I think it's important to challenge this leveling process. More than most other institutions, art schools are always local. No matter how large and international the city, the local art academy will always display features that one cannot find in other places, and this is probably quite natural. Who, if not the young artists studying in a city and the professors teaching them year after year, should define the local art situation?

HE: So what was typical of the Städelschule, and which original features appeared worthwhile cultivating when you first came there?

I: Some characteristics immediately stood out: No other art school I know of has a kitchen next to the administrative director's office and takes cooking as seriously. That seemed peculiar and interesting enough to cultivate. And no other art school I am aware of has an exhibition program as ambitious as that of Portikus. I did know a few young artists who had come out of the school, but what about the teaching itself? Was there a pedagogical program, even an educational philosophy?

HE: More important: Do you have one now?

I: In the end, it's all about individual artists. It was and still is impossible to reduce the teaching taking place here to any kind of doctrine because the school has always been centered on the input from a small number of strong teachers, each with different, sometimes opposing, views on what art (and architecture) is all about—from Thomas Bayrle, Peter Cook, Hermann Nitsch in the recent past, to people like Ben van Berkel, Isabelle Graw, Michael Krebber, Tobias Rehberger, Martha Rosler, Simon Starling, and Wolfgang Tillmans today.

HE: That's disappointing. No program.

I: Of course someone like Isabelle Graw builds a program, since she prefers to read certain very specific things with the students. They read Jacques Rancière and Theodor W. Adorno, so there is a certain direction. But it really depends on who is teaching at the moment. Together with their students, these individuals define what the school is. Doing that, they take plenty of liberties, and my true belief is that this freedom is what is most important. What they offer is not only their experience and their skills, but ultimately something even more significant: themselves as examples of what it is to be an artist today.

HE: Total pluralism?

I: No, but the individual artist is more important than any educational program or doctrine. A successful art school must involve important artists, as Baldessari has often insisted. A great faculty attracts interesting students, who teach each other. It's about participating in a collective sphere of challenging and critical exchange rather than being taught specific techniques (even if knowing certain techniques can be helpful).

HE: And how do you know if what you are doing is successful?

I: I guess it's all about the artists who come out of the program in the end. Strangely enough, some of the most famous programs had incredibly prominent teachers but few interesting graduates—the Bauhaus, for instance.

HE: So the commercial success of the graduates is what counts? Should there be courses in how to promote oneself?

I: That's not what I'm talking about. But if you are an artist today, it could perhaps be of importance to be aware of those violent, sexual, and sometimes uncanny forces that turn the commercial art world into a stage for fetishistic desires and excess rather than a platform for sober exchange.

HE: The capacity to navigate an ever-changing and increasingly commercialized world on one's own requires theoretical and practical tools. Isn't it time you spell out what these are? If you aren't happy with de Duve's "attitude, practice, deconstruction," then I suggest you come up with a more relevant trinity of concepts.

I: So there has to be a three-step dialectic?

HE: What about hospitality, collaboration, exchange? That at least seems to sum up what you've been up to in the past decade.

I: That sounds nice. But I'm not sure that those aren't simply concepts that neatly sum up what happens in any educational institution that allows, or even emphasizes, a collaborative mode of research and production. The interesting thing is perhaps that the art world in its entirety has moved toward these structures typical of schools.

HE: Is that really something new? Some kinds of art are possible only at art schools. Think of many of the Fluxus events, or the party in 1966 organized by John Latham and his student Barry Flanagan at which guests chewed up pages from the library copy of Clement Greenberg's *Art and Culture* at St. Martin's School of Art in London.

I: True. De Duve mentions this happening as a symbolic marker of the radical redirection of the art school toward Conceptualism—as well as toward innovation and subversion—which took the place of formalism and modernism in the teaching of art. Latham was fired after he attempted to return to the library a liquid made by fermenting the paper and saliva in place of the book. Today, de Duve asserts, an artist "could do the same performance with the principal's blessing, and the librarian wouldn't even bother to reorder *Art and Culture*."[6]

HE: So it's not new, after all?

I: Well, think of Stockholm's Moderna Museet during the 1960s. That was probably Europe's most daringly experimental museum, with initiatives such as "Poetry Must Be Made by All! Transform the World!" (1969), a show about gestures of radical politics that, instead of original artworks, presented documentation and happenings such as visits from American draft dodgers and Black Panthers, as well as free-jazz sessions inside a replica of Tatlin's Tower. But still, no one would have said that they were in school. Back then, that probably sounded boring. For some mysterious reason, school now has become something appealing.

HE: This announcement recently reached me: "Night School is an artist commission in the form of a temporary school. For this project, artist Anton Vidokle is organizing a yearlong program of monthly seminars and workshops that use the New Museum as a site to shape a critically engaged public through art discourse." One wonders: Why does a major museum get involved in this kind of thing? Shouldn't a museum concentrate on exhibitions and leave education to the academy?

I: Part of the explanation is perhaps that the highly commercialized art world has become a bit gray and monotonous. Where do we find challenging spaces for artistic experimentation today? Certainly not in the corporate museum, the art fair, or in the global circuit of blockbuster shows that are expected to attract mass audiences. It would seem that the interest in the art school among curators has to do with a certain crisis in the world of exhibition making as we knew it. The global cultural industry is increasingly ruthless in its logic of commodification, and curators across the globe are desperately trying to dodge the reductive language of bureaucrats and marketing people simply to get space to breathe. There must be some alternative to the biennial model, which is too closely linked to issues of tourism and city branding and to the blockbuster spectacle: *MoMA in Berlin = 1 million tickets sold!*

HE: And yet this new popularity can seem strange, since concepts such as "school" and "academy" rarely sparked enthusiasm in progressive circles in previous decades. Asked if the Black Mountain College was to be an art school, founder John Andrew Rice replied, "God, no. That's the last thing I want. Schools are the most awful places in the world." And, echoing generations of

avant-garde artists eager to express their contempt for schools, German painter Gerhard Richter in 1983 explained that the most gruesome aspect of our misery is to be found in the art academies. "The word academy," he continued, "merely serves to deceive ministries, local governments, and parents, and in the name of the academy young students are deformed and misshaped."[7]

I: But things have obviously changed, and "school" has become an attractive thing.

HE: Perhaps too attractive a thing?

I: It triggers a lot of art world excitement, and historical precedents for alternative art education—the Nova Scotia College of Art and Design, Pontus Hultén and Daniel Buren's short-lived Insitut des Hautes Études en Art Plastique in Paris or Cedric Price's visionary proposal in 1963 to establish a mobile school housed in train carriages running on disused railway tracks in Staffordshire—are being dug out of the gray and dusty archives. Suddenly all of this seems fascinating and full of promise. Anton Vidokle's New York project for 2008 will probably be the most visible example in a line of recent endeavors. Vidokle and his colleagues initiated research into education as a site for artistic practice for Manifesta 6, which was cancelled. In response to the cancellation, Vidokle set up an independent project in Berlin called Unitednationsplaza—described as "a twelve-month project involving more than a hundred artists, writers, philosophers, and diverse audiences."

HE: Just wait until these people rediscover Robert Filliou's *Teaching and Learning as Performing Arts* and its vision of mankind as a source of continuous and all-encompassing collective creativity.[7]

I: That's when we will finally long for an old-style academism and the reintroduction of strict rules.

HE: That's an easy way out. Isn't there a more positive way forward, into the future, rather than returning to conventions that nobody believes in?

I: Perhaps. Recently, I witnessed an unconventional educational model—at Olafur Eliasson's studio in Berlin. In his pleasant and not-too-orderly garden, a group of young artists and architects were building an incredibly complex

geometric structure of wood and metal. Indoors, another group was producing drawings on computers, while yet others were researching vibrations and waves in physics, optics, and musicology. The day before, a symposium had taken place in the garden, involving an Icelandic violin maker, various artists and writers, and Sanford Kwinter, the visionary American architectural theorist. As well as being a kind of factory where works are produced for exhibitions across the globe, then, Eliasson's studio is a laboratory where all kinds of technologies and devices are tested just out of curiosity, and where different disciplines enter into a productive dialogue.

HE: But the people at the studio are assistants, not students.

I: A number of great young artists have worked for Eliasson; some, such as Jeppe Hein and Tomas Saraceno, have gone on to become prominent in their own right. The place appears to me to be an unusually inspiring educational site. For many, what it offers is a modern version of an old-fashioned apprenticeship, falling somewhere between the research period of the art school and the production period of the art career. Eliasson has, it seems, used his own financial success within the market to create a temporary oasis whose values are antithetical to it—a privileged zone of noninstrumentalized experimentation and research.

HE: So new technologies offer new modes of creation and research.

I: Yes, but now it is no longer a problem how to get the information. The problem is what to do with it and how to navigate on your own.

HE: So this is the future: reflection, navigation, creation.

I: Hmm, creation. Okay I could accept that.

HE: Nam June Paik's 1971 contribution to the German journal *Interfunktionen*, "Expanded Education for the Paperless Society," starts with a note on what he calls great thinkers: "It is a blunder, bordering on a miracle, that we have no, or very few, images and voices of the great thinkers of the recent past on record."[8] Where, asks Paik, are Edmund Husserl, Sigmund Freud, Marcel Proust, James Joyce, Wassily Kandinsky, Maurice Merleau-Ponty, Ludwig Wittgenstein? Why do we not have documentation of these influential people speaking about their

work? This blunder, a negative miracle according to Paik, is the biggest waste of instructional resources, and nothing is more urgent than documents of the major thinkers of today. Has Paik's vision become reality now that you can listen to Foucault, Adorno, Derrida, and Chomsky on YouTube at your kitchen table?

I: Well, the kitchen tables in Shanghai and Reykjavik provide the same philosophical information. That is new. Which makes even more evident what has been the case all along: the question is how you assimilate the information and make it into meaningful knowledge for yourself. In the end you have to navigate on your own.

HE: You once formulated a retroactive manifesto for the school you are running. Do you still believe in it, or is it a parody, playing with forms from which life has vanished like the devil in *Doctor Faustus* would say, quoting extensively from Adorno?

I: That I leave to others to decide.

HE: So spell out your seven words of wisdom.

I:

"Ignorance is a treasure of infinite price" (Paul Valéry). Most of us have a lot to unlearn.

Key artists who are also great teachers are rare. Find them and much else will follow. They don't need to agree on anything and should represent only themselves.

Wonderful things can happen between disciplines, but you don't need to tear down the walls. There are doors. (Just leave them unlocked.)

Something happens to a thing when it's displayed. An art school is not an exhibition, but students should be close to exhibitions.

Food can be as important as philosophy: The best teaching may happen during meals. (A good canteen is helpful.)

Money is not evil, but don't forget: There are much more exciting things than a sold work of art. Is the ideal school a monastery or a bazaar? Yes.

There is never just one way to do art. John Baldessari and Thomas Bayrle (my heroes) have shown this in their teaching, and their students around the world keep proving it. As Wittgenstein made clear, what can be shown cannot be said: "Whereof one cannot speak, thereof one must be silent." Just do it!

HE: Anything missing?

I: Perhaps the school can be a ladder: one that is thrown away once it has been climbed.

NOBODY ASKED YOU TO DO NOTHING/ A POTENTIAL SCHOOL

Liam Gillick, Erik Wysocan, Georgia Sagri, Seth Scanlen, Ian Cheng, Christian de Vietri, Dennis Santella, Jason Boughton, Keil Borman, Mads Lynnerup, Nate Wolf, Gilad Ratman, David Brooks, Mary Simpson

Proposal prepared by Gillick with his students in
November 2007 at Columbia University, School of the
Arts, Graduate Studio Program.

TWENTY-FOUR TERMS FOR EXAMINATION

1. Historical context
2. People/subjects/individuals/other people/us/them
3. Infrastructure
 Facilities
 Architecture
 Transport
 Networks
4. Geography/location
5. Built environment (building and immediate surroundings)
6. Power relationships
7. Time projection/occupation
8. Theoretical orientation
9. Strategy (application of the theoretical orientation)
10. Parallel spaces
11. Institutional relationships
12. Generational context
13. Self-consciousness
14. What does it provide/produce/exclude
15. Modes of refusal
16. Assumptions of smoothness
17. Social status

18. Requirements and obligations

19. Mapping and location

20. Funding

Things will be out of sync. There will be a large sauna. The edge will be perceived from the inside and outside simultaneously. The idea of boundary pushing will remain. There will be lots more bicycles. Some surprising things will be free. There will be more difference. There will still be a studio problem. There will be big sheds. There will still be a sense that one is forced to find an activity. Delusion will remain. The question will remain: What kind of space are we in? There will be an increasing use of enormous wooden headphones. A sense of the historically determined quality of art school decisions and conditions will increase over time. There will be an attack on pragmatism. There will remain a focus on the idea of student choice. This will remain an incomplete project. There will be many places to sleep. There will be showers on demand. There will be the possibility of collective action. There may well be citizen artists. There will be a free or progressive tuition scale (increasing expense with duration of attendance). There will definitely be massages from trusted people. There will be new forms of social engineering. This will take place close to fresh springs. There will be a sense that there is less structure. There will be an increasing alienation of labor. There will be an increase in proximity. There will be new protective systems. Some things will be more mobile. Some people will be more migratory. Some effects will remain local. There will still be a feeling that there is a problem of vacuum. Ideas will remain deterritorialized. Some structures will be disintegrated. There will be fewer clear representations of power within the hierarchy of the place. There will be no possibility of an architecture that clearly expresses relationships. There will be an end to the idea that architecture is loaded with connections to the future. There will be bigger dumpsters. There will be an increasing skepticism about architecture as an independent discipline. There will still have to be a building. There will be a sense that we are experiencing an excess of history from the first day. Sometimes it will be necessary to create a parasitical structure in relation to the school. There will be enormous and amazing kitchens. In the manner of preschools, there will be reading lofts and soft places to rest. There will be a dacha nearby where one can eat and read and drink. Incomprehensible wealth will circle the school. There will be no equilibrium. Other power structures will

be mimicked. There will be an increasing exposure of power and dynamics. Who is "them" will remain a reasonable question. Some people will wonder how the future can be stopped, or hindered. There will be a reduction in appropriateness. There will be an increase in duration. Some will explore the potential of every possible resource. There will be large-scale three-dimensional printers and scanners. Full-time computer programmers will be available at all times. Student status will remain unclear. There will be a free pass to every situation that is deemed relevant to the structure of the school. There will be even more examination of the idea of the university as a concept. An increasing attempt will be made to ensure an infection of disciplines by those who attend the school. Concrete, wood, and water will be combined in most of the buildings and structures. Large terraces will be covered with plants. The structure will be located near the ocean. Compositing will be used as a method of production. A cumulative thesis show will continue forever, with work being added every year. There will be a frustrated desire for consistent knowledge from the beginning of the year. There will be an encouragement of nondirected energy. Attempts will be made to create lots of seemingly arbitrary rules. There will be internal openness combined with public reticence. Friendly qualities will endure. Viewing ports will be suggested, but the idea that they are cut into studio walls will be rejected. There will be a well-loved swimming pool. There will be an abandoned climbing wall. Water will become the most popular meeting place. Fighting gangsters will still provide a romantic model of masculinity; this will be suppressed. Italian restaurants will no longer exist. The studio will be a location of desire, but some people will fight against this. Some people will dream of the creation of an honest nostalgia. There will be many spaces that produce incomprehension. Role playing will be discouraged. Repetition will be impossible. Someone will always be doing something every day. There will be designated moments when you are there on your own, and you know it. There will be clear times when you alone are allowed in the building. There will develop the option of manual labor—students can clean the windows, dig drainage ditches, and package chewing gum. A big experimental greenhouse will be donated to the place by an anonymous benefactor. Animals will roam free and cause problems from time to time. Artisanal food production onsite will go unnoticed over time. Confrontation with past desires will be accepted as a normal part of life. New relationships with service will produce a new understanding of obligations. There will be places to jump around and wrestle. Four-dimensional studies will become a well-loved fable from the past. Personal relationships will multiply. Claustrophobia will not exist. Gaps in

between shallowness and repetition will expand and fill the world with a whole new kind of artistic production. Teachers working alongside the students will forget to teach. Ghost towns will proliferate. Students choosing staff choosing students choosing staff will replace each other in perpetuity. Lectures in foreign languages with no translation will become the most popular event of the week. The institution will declare its politics, and people will wait for the statements with eager anticipation. Statements of position in the society will be greeted with warm condescension. Collectivity as an assumption will no longer need to be questioned. Social status and hierarchy within the culture will no longer have any effect on what is produced but will still be understood. No mission statements will exist outside the archives of the place. A description of what's what will start each morning. No overlaps will be accepted. Keep asking what collectivity is, even if nobody cares, and you will be thrown out. Once accepted, you will stay for a long time, but the faculty will change every other year. Beta-testing rights for all things will become the norm. A strong graphic sensibility for all outside communication will become standard practice. Who is responsible will be the question of the day. Setting something in motion will never be just for its own sake. The observation deck will be broad and wide and show a vast panorama. Populism will be excused. Good cases and bad cases will create a new language. Cultural importation will increase. Dispersal will endure. Open access will be the cause of many arguments. Medical centers will proliferate. Environmental controls will be quickly out of date. You still won't be able to change the temperature at the Whitney. There will be no institutional furniture. Custom-built databases and permanent data managers will be as common as their absence today. Drinks trolleys will be everywhere and regularly get restocked. Leakage will remain a problem. Speed of production will cause arguments. Suspended judgment will no longer be a defense. Interest from others will be the source of contentment. Continuing regardless will be viewed as a crime. Conditions of consumption and reception will be someone else's problem. Democracy and nondemocracy of space will considered at the start of each year. Abuse of space will be encouraged. Uniforms will be optional. It will feel as if unicorns are about to return. There will be lots of different buildings. Many FedEx boxes will arrive every day full of new, unexpected things. Free FedEx accounts will be created in order to forward unwanted new things to friends. Orchards will bloom. The potential for growth will be suspended. The department of rhetoric and announcements will hold people at bay. No one will feel qualified to develop a curriculum. Secondary production techniques will be encouraged. Large roaring fires will frame places of thought.

An infinite number of departments will be established to represent the diverse interests of the place. A place to play music will be maintained and well loved. No painting will take place, but not because anyone prevents it. The removal of the logo from the jacket will no longer be a dream. You can still have the jacket and the logo. Instant mythology will flourish. The question of when things should finish will become a distant memory. An extensive program of field trips and events will take place before anyone gets up. Traces of these journeys will remain in the stories of the drivers.

PROJECT 8

**GENERATOR PROJECT, 1978–1980, CEDRIC PRICE,
WHITE OAK PLANTATION, FLORIDA**

An experimental design proposed by British architect Cedric Price, the Generator was to be an artist's colony at the White Oak Plantation on the Florida coast. Price was a former member of the avant-garde architectural group Archigram, and the unrealized project pushed both the boundaries of the group's earlier work and 1960s techno-utopian visions to a new limit. Sited within a large rectangular field bordered by trees, the Generator was to be comprised of approximately 150 large cubes, twelve feet to a side, capable of being continuously linked, relocated, and recombined for employment in any and all activities imagined by the project's users (top image).

With the help of a computer, users determined menus or arrangements of these cubes, which were outfitted with various infrastructural systems (bottom image). Rather than a determinate building form, the environment changed along with the visiting artist's goals, liberating both established and unimagined protocols en route to dance, theater, performance, and traditional art production. Price's design established two classes of facilitators, who helped users interface with the Generator: "factors," who made possible and maintained the user's activities, and "polarisers," who promoted novelty and engagement. Embodying a split between administrator (or staff) and instructor, as well as one between technique and theory, this organization challenged neat distinctions between them as well, placing three types of social figures in play and suggesting a democratization of art production and education. Price also envisioned a computer program that would be linked to sensors in the cubes, prompting sensory alterations after too lengthy a period of inactivity—in effect, prodding the users to pay more attention to the ever mobile environment. Together, it was expected that these conditions would save the Generator from the straitjacket stasis of the standard architectural solution to housing an institution.

The Generator was never realized, but the project produced a series of untraditional architectural sketches, comprising various atmospheric and anecdotal images. These ranged from comparisons of the Florida site with other (primarily urban) areas of equal size to quite detailed perspectives of possible configurations and to models in which computer equipment stands in for the very hardwiring of cubes and technology on which the project depended. The Generator was far too untraditional to ever get off the ground, though its technological vision of "smart" spaces was prescient. Had it been built, it might have easily inspired and facilitated artistic and educational developments in fluid interdisciplinary practice.

(*Top*) Initial design network showing three starting points. (Photo credit: Fonds Cedric Price, Collection Centre Canadien d'Architecture/Canadian Centre for Architecture, Montréal)

(*Bottom*) Model of computer equipment, 10.8 × 78.7 × 52.1 cm (irreg.). Museum of Modern Art, gift of the Howard Gilman Foundation. (Photo credit: Digital Image © The Museum of Modern Art/Licensed by SCALA/Art Resource, NY)

CONVERSATION

Dennis Adams, Saskia Bos, and Hans Haacke

SASKIA BOS: Maybe we could start our conversation about art education with the Cooper Union, since all three of us have or had a working relation with the school. What is it that you think makes Cooper Union's art school—which is an undergraduate program, not a master's degree program—what it is?

HANS HAACKE: To begin, we should acknowledge that we have to conform to rules set by national and state agencies, two of which come to campus every ten years to examine what we do and decide whether we should continue being accredited. Without accreditation, we can't grant a bachelor of fine arts degree.

DENNIS ADAMS: For me, accreditation is something you try to get through every few years, but it's not something I'd ever think about in the day-to-day teaching of studio classes. What we do at Cooper is much more layered and complex than what's expected by those agencies or could even be explained to them. For better or worse, most of the teaching here is driven by the personalities and practices of the professors rather than the curriculum. Because we're in New York, we can attract many highly accomplished artists. So there's a lot of acting out in terms of artistic ego, and I think most of it has a very positive effect on the students. It toughens them up and offers a lot of different viewpoints that are passionately presented.

SB: Do you think Cooper Union's specificity has to do with the fact that it's a free school, which means that students are admitted in a different way and that meritocracy might be more important than at other schools?

HH: That certainly has an effect on the type of students we have. In the admissions process, we don't look into what kind of an income the parents have. In that sense, it's a meritocracy.

SB: I wonder if you think that a school like this is more comparable to a European school—because education in Europe is not as costly as here?

HH: No, I don't believe so. I can't speak about European schools in general. I just know a bit about the German system. What bothers me in Germany is the assumption that the state owes students an education without a set limit of years. The state, of course, that's the taxpayers. In effect, it means they should foot the bill, no matter how long it takes until students think they're "cooked." I find that difficult to accept. I also have a problem with the habit of some professors who make a sporadic appearance and leave the teaching essentially to assistants, while they pursue their fortunes in the art market. A rejection of this indulgence may be behind the neoliberal and ill-conceived attempt to streamline things along the Bologna scheme of quantifying "outcomes."

SB: Maybe I should explain that a little. The Bologna Declaration of 1998 basically forces a uniform structure on the European Union's universities and colleges. All the countries have to adhere to the same configuration of undergraduate and graduate degrees based on the same accounting of credits. What this does is replace the localized systems that countries have been practicing for centuries. Quite a few art schools, especially in Germany, have resisted. Does that mean that in Germany some schools would continue to offer what seems like an endless *education permanente?*

HH: If my information isn't wrong, and this may be changing as we speak, German art students could stay at the academies seven and more years—their studio is paid for, their professors are paid for (no matter whether they're present or not), the buildings are paid for, everything is paid for. In a way, the system has taught them to feel entitled to this.

DA: Well, this master-teacher idea in the European model is very different from art education in America. Here the students are thrown to the wolves of competing ideas between professors. Intellectually, I think that's a much better way to go.

SB: But that would be true for the United States and the U.K. model in general, right?

DA: That would be true of the U.K. from what I know, but I've never taught there. Compared to other art schools in America, though, this place feels more like a European academy. This is more of a sense I have than something I've thought through. I've taught in a number of European academies, and Cooper seems to share their stress on the students' responsibility over institutional programming. We treat our students more as young practitioners than as students going through a program. There's this sense that first and foremost, we're a community of working artists. So it's not just a bunch of students being filtered through a system toward a degree.

SB: Depending probably on the individual teacher, because in the traditional German system a teacher can still totally influence individual students for four to five years in a so-called *Meister Klasse*.

DA: When I'm in the classroom, I don't teach about my own specific artistic interests. I do try to convey my passion about making art. I think it's important that the students know they're speaking to an artist, with all the vulnerabilities that go along with that. They have to sense that they're talking to somebody who's a working artist. If there's ever a small window of inactivity in my own practice, for six months or a year where I don't make much work, I can hardly go into the classroom and look the students in the eye. You've got to be able to pass on that passion of being an artist against the backdrop of real honesty about the complexities of what day-to-day practice is. What I stress most to the students is to get behind their passions 100 percent and develop a work ethic.

SB: What would be a work ethic?

DA: 24/7. You've got to have passion; you've got to work hard. The rest, the talent, all the other stuff, it's like 10 percent of the picture; it's in the corner

somewhere. For me, even curriculum is more of a prompt to be upended by some wildly inspired project.

SB: Hans, what about you? Do you agree with that?

HH: I also want them to think on their own. That requires that they're challenged by their peers as well as by me. They shouldn't settle, thinking they've made a great invention when in fact it amounts to the reinvention of the mousetrap. And they need to learn to defend it; that requires reflection, perception, and rhetorical experience. But they should also check whether, indeed, there is enough to sustain them. It's the old balancing act of criticism and encouragement. They shouldn't be satisfied with a product simply because they think it sells.

SB: Is that ever talked about? Are market forces an issue?

HH: No, but students of a certain age begin to think about it. There's nothing wrong with it per se, but there needs to be more than marketability.

DA: I don't ever bring it up as a subject, but if it comes up, there are no subjects that are taboo. If students want to discuss the marketplace and they bring it up in a context of their own work or somebody else's work, I'll take it on with them.

SB: And the notion of success—is that discussed? And if so, how?

HH: I always say, "This is a long-distance run." And you may not even experience it in your lifetime.

SB: Lately, so many young students have been presented in gallery shows, even with just a B.F.A., and they're sort of waited for in the marketplace. Do you ever tell them cautionary tales?

HH: In passing, yes. During my lifetime, I've seen a lot of shooting stars.

DA: I try to present models of success that are outside the gallery system, all kinds of alternative community-based approaches that touch people's lives outside the white cube. At the very least, one has to call the question, "Do you want

to spend the rest of your life as court jesters for the rich?" And maybe they do, and that's okay too. But there are many kinds of reception, in many different public arenas. I encourage my students to consider different contexts of presentation and to invent their own venues. The rule of thumb is that the more false starts one has, the—

SB: The worse you—

DA: —No, the *better* off you're going to be. Young artists should test themselves again and again in different ways from different angles. A string of failures is probably the best way to get where you're going. It's a long road to become an artist. First of all, it's the greatest luxury in the world to get up in the morning and do what you want to do and make all of your own decisions. But it's also an incredible responsibility. And it takes years to learn how to pace that out over a lifetime around ideas and sensibility. In the end, it's the expanse of what you represent and your commitment to it. The successes and failures of individual projects are secondary to all that.

SB: So how can you teach art if it's about endurance and longevity, and success is measurable only at the end, maybe, of a career? Is it possible to teach these things?

DA: You have to discuss those things. I spend a lot of time talking with my students about artistic doubt and how it can be used in productive ways. Two things that I think are common to most artists are flashes of wild artistic ego and its sudden falloff into doubt and regret. This can be especially crippling for younger artists, who sometimes don't know how to negotiate those highs and lows that are very much a part of what we do as artists. I speak about this fault line, sometimes by simply exposing my own doubt about things. And on the other end, I would never want to pose as a master unless it was done in some ironic, funny way. So I talk a lot about day-to-day practice and its evolution and how artistic ideas can expand over a lifetime.

SB: So on the one hand, there's your own way of seeing art and maybe your own critique of many elements in the world of art, which maybe caution a young student not to jump to easy conclusions. But on the other hand, you have to let go at a certain moment, when you see that person is not thinking like you at all and has his or her own totally autonomous development.

HH: Oh, absolutely. I certainly don't want to indoctrinate them and force them to follow my ideas. When I challenge them, I don't do so with the understanding that they should fall in line. They should be working on their own terms. And then it can happen that they recognize the references that underlie their work—art historically or in view of what's happening at the moment. And that's also why it's so important that—different from the German system—up to the fourth year, students at Cooper have to enroll in more than one course, meet with more than one instructor, and get bounced around. They need to get varied input.

SB: And then you have issues like responsibility, maybe a social responsibility, for things that happen in the world at large. How is that brought into the class? I assume that in a public sculpture class, that's being addressed.

DA: That's the subject of the Public Art Studio/Seminar I teach. But even in my foundation class in three-dimensional design, I try to spiral the discussion out from the autonomous art objects the students are making into larger social, political, and urban issues. The classroom dialogue should always be overstepping what we're immediately critiquing. I always push the idea of scaling up in every sense of the word. I try to raise the stakes, the "what if" question, as it applies to their projects. It's wonderful how these small three-dimensional projects can lend themselves to larger questions beyond just form and structure. They function as models for larger questions of design and architecture. So I try to push the ideas out of the studio as far as I can because I'm assuming that young artists starting out will land in the visual arts somewhere, in ways we can't even dream of. So I like to imagine, like Tatlin did with his tower, that the artist is on the top of society, with the vision to potentially transform it. Maybe it's my fantasy, as it was Tatlin's, but it's important to present a window into the highest ideals. I have a little bit of a utopian streak. Maybe not so much in my own work, but I try to offer glimpses of that ideal to young artists. If they aren't exposed to that at the undergraduate level, where are they going to get it? Probably not in some professionalized M.F.A. program.

SB: So how does it affect your own way of working, the fact that you've taught so many years and that you're a professor at an art school? For each of you, do you think you're a different artist because of that teaching?

HH: Probably. As I try to challenge the students, they also challenge me. I have to learn to justify what I'm doing and think things through—as I demand from them to think things through and stay away from artspeak. I started teaching at the college level in 1966. I've tremendously benefited from the students. They gave me a sense of how other generations understand and deal with the world. And that, of course, affects my understanding of what we all collectively are dealing with today. It isn't a sort of anthropological study of a generationally distant tribe without consequences for me. For a while, when my sons were younger, they could do that for me. But they've outgrown that stage by now. They represent an intermediate generation—however good it still is to learn from them.

DA: It's fascinating to experience one generation of students after another and try to understand those differences against your own evolution. If I might generalize, I'd say that since the mid-'90s, student production is less rigorously constructed around a single idea and less formed around style. This often shows itself in more playful and digressive modes of working, as well as in more communal projects. I think in the '80s, that would have grated on my nerves a bit. At that time, I was still teaching from the position of clearing the deck and staking out a position. There were still traces of a modernist agenda in my approach. Thank god for the change. I've learned otherwise from my students. The result of all this is that I've come to realize the stakes are high in teaching for everyone, including myself. Today I listen more carefully to my students. Between the lines of their overloaded narratives, they have flashes of insight that are uncanny. I think today I give much more of myself to the students because I realize I'm getting so much more back. Teaching is absolutely an extension of my life as an artist. I love the whole process.

SB: Although your criteria seem to have softened, then.

DA: No, just opened up.

SB: Haven't the concepts of how we view art changed a *lot*?

HH: Yes, and not only art. The entire culture is different today. If you compare how and what we were thinking and doing in the '60s, there is absolutely no comparison to what's being done and thought today.

SB: Maybe apart from some reenactments of the '60s and '70s that seem to be practiced here and there.

HH: It's a bit strange for those who were around at the time—and I happen to be one of them. We're now being interviewed—*Well, how was that? And who said what? What did they do then? And what was the reaction?* Of course, one can't give a full sense of that distant world, as it's not possible to provide a full sense of the world we're living in today, and explain to somebody from another star why people here act the way they do. I can tell you, oral history is a dubious enterprise! I believe one needs to avoid claiming that there was rationality in the behavior and in the arguments of the period. In many ways, they were as haphazard as they are today.

SB: Don't you sometimes think that there isn't such a strong movement today that wants to politicize art or to have it play a political role?

HH: That probably has to do with the fact that society is generally less politicized than it was during the Vietnam War and the violent racial conflicts of the past.

SB: Although there is this big war going on.

HH: Yes, but it doesn't affect the ordinary—

DA: We don't have a draft the same way.

HH: We don't have the draft! We don't have the draft! We don't have the draft! We cannot repeat it often enough! The war is not brought home!

SB: That's the essential difference?

DA: It makes you wonder how the Vietnam generation would have responded if there was no draft. Of course, at that moment the whole atmosphere was more politicized, with the civil rights movement and all. But it's an enormous question.

I had a realization the other day as I was reading the obituary of Alain Robbe-Grillet of just how dead the manifesto is today. There are no calls to action in that way. *For a New Novel* was one of the very first manifestos I read as an undergraduate.[1] I loved how it cut the world off from history and metaphor

and envisioned a new course. I must admit to feeling a bit of nostalgia for all of that today, if only to relieve my own doubt about so many things. There's no one making a manifesto about painting the way Frank Stella did in the 1960s. Artists then were really trimming the fat and going down a very narrow path. In the last two or three generations of students, I don't see that. I don't see it anywhere, really. They're much more pluralistic in their interests; they're all over the place; they're experimenting with a lot of tentacles; they're doing very interesting things in terms of culture and politics—but it's just more spread out. You don't draw a line in the sand the way you did in the 1960s.

SB: Hans, you said it was more haphazard than we think.

HH: Well, I believe there's a mistaken assumption that we acted in the '60s as if we had a well-thought-out plan. We made ad hoc decisions, adjusting to rapidly changing circumstances.

SB: But people reacted to one another and understood one another, and coalitions were formed?

DA: Maybe there was also more of a separation between one's social-political commitments and artistic practice then. Today artists mix those things up more, no? I mean, if I'm looking back at somebody like Ad Reinhardt or Carl Andre, there was their politics and then there was their artwork. For that generation, things were really more separated. But maybe in narrowing down and painting another shade of black on another square, it allowed Reinhardt the complexities of another life at the boundary of the canvas. It's like staking out a little territory of control, a little kernel of sanity in all of that insanity of everyday life and ethics.

SB: Maybe it's concentration.

DA: Yes it is, but concentration that allows him to put all the loose ends elsewhere. This would also be true of On Kawara's work. The idea of getting up each day and making a painting of the date sets the rest of the day in motion with all its struggles and complexities. That's a vision that had a very precise historical moment. It can't be replicated today. I can explain it to students, but it's difficult to present as a viable model in the kind of world we currently live in, where a new generation has mastered multitasking and time is viewed

more and more as scattered and shared. The idea of the artist stealing time from the world to produce an isolated studio manifesto is pretty much an anachronism or a romantic fantasy. By the mid-'90s, young artists were serving tea with every artwork; every project was a platform for social space. The club replaced the studio, and now offbeat educational platforms are replacing the club. It's endless.

SB: You mean participatory art, so-called relational aesthetics?

DA: Yeah, that lumped a lot of diverse ideas together.

SB: But don't you think that it's very important for a school like this to have more platforms than only the classes? To have these larger discussions that bring it into a societal context?

HH: Oh, absolutely.

SB: That brings me to another question about globalization. Today, so many universities—but also museums—tend to export their facilities and say, "Okay, let's have a plant in Dubai or Abu Dhabi." But they're actually constructing universities. Yale thought about it; NYU is certainly doing it. I don't know about others, but it's something that large universities tend to be interested in because these rich oil countries also pay well, so they can construct even more. Do you think it makes sense to export your knowledge and your faculty to a completely different continent? And maybe try to get that education—in a utopian sense—to offer that to a region that lacks those facilities?

DA: In a loose utopian sense, it sounds okay, but it comes with a lot of political baggage attached to it that could be very dangerous.

SB: What would be dangerous?

DA: Well, let's just say complicated for now until we know more. It's one thing to speak generally about cultural exchange. Who's going to say, "No, we're not for that"? But this is an entirely new model. I think it depends on how it's put forward—and my understanding is that it's mostly Ivy League schools that are being approached. If that's the case, this comes with a long history of elite educational ideals. Those institutions are where many of the leaders of this

country are indoctrinated, and after eight years with Bush, this gives me pause. What kind of politics is being exported through these various educational frameworks, and how will they be represented or misrepresented?

SB: A lot of faculty members seem to be hesitant to just go there and deliver. That's what I read in the interviews, even by people who've been invited to do so.

DA: I believe in the politics of strangers and the lure of strange places. That's how culture is transmitted. And we should remember there are always exchanges outside the curriculum of exchange that can't be calculated in advance. This is where things can get interesting. Strangers have a way of subverting the agenda of the invitation by their very nature as strangers. I think in this case you have to look at who's inviting whom and for what reasons, and who is being excluded and why. It's just all very complicated. When the hows, whys, and buts get all added up, I think it could become politically very funky.

SB: So we don't need to clone a little Cooper Union for the desert—

HH: I haven't really been able to think this through. What appears to be happening there was still unimaginable only five years ago. They seem to be building a whole new and hybrid society out of nothing—of course with cheap labor, imported from low-wage countries from the East: Filipinos, Indians, Pakistanis. These workers have no rights. They're crammed into tight living quarters on the outskirts, far away from the indoor ski slopes, and they don't share in the new wealth of their bosses. They're paid miserable wages and can be deported at a moment's notice. Practically speaking they are *slaves*—we should not forget that.

I'm sure what happens in Dubai is going to have a tremendous influence on a huge region of the world, probably including the U.S. and Europe! It's pretty scary—a perfect target for al-Qaeda. It will certainly change a lot of what's being imported from the West. In turn, it's likely to affect the exporting cultures and economies—with unpredictable consequences. But it's also possible that it generates something for the better. I don't know. It's a high-stakes gamble.

SB: So we could say that the location of a school is, in a sense, part of its curriculum. Place is engrained in the teaching itself, and that needs to be taken

into account when we think about what needs to be taught and how it needs to be taught.

DA: For me, what's most important is that Cooper Union is located in the heart of New York, and yet it's a small community operating for the most part out of one building where all the activity is very dense and layered. There is no campus. There's no dispersion of the students. I love to walk in the door here, and I love to walk out of it. The minute you step out of the building, you're out there bumping up against a rich dude or some homeless person—you're in the world socially and politically. There's no campus buffer. That boundary and its uncompromised suddenness is the best teaching aid we have.

STATES OF
EXCEPTION

Steven Henry Madoff

Just for a moment, let's consider one striking difference between an art academy and a military academy. In "The Means of Correct Training," an essay that Michel Foucault wrote at the time of his research into the punitive controls of the state over the bodies of its citizens, he itemizes the different behaviors that lead to punishment in military schools and remarks: "It was a question both of making the slightest departure from correct behavior subject to

punishment, and of giving a punitive function to the apparently indifferent elements of the disciplinary apparatus: so that, if necessary, everything might serve to punish the slightest thing; each subject finds himself caught in a punishable, punishing universality."[1]

The art school, on the other hand, is a coddling environment in which no disciplinary action per se is carried out—or so it would appear. It is an environment in which there would seem to be complete indulgence of the students' unique and eccentric expressivity. Even the most basic aptitudes involving physical skills of craft or intellectual abilities to formulate concepts are patiently indulged without leading to obvious punishment. Yet while the highly detailed levels of punitive cause are implicit in the practice of the military school's discipline, in the art school there are more lenient, yet nonetheless punishing, practices built into the training of the artist. The range of the student's expressions may be indulged, even at the risk that the work may dip below the bar of acceptable proficiency. But if the faculty is too patient or is even unable to say what is good enough because of the current state of aesthetic pluralism and indeterminacy, there is of course the gauntlet of the marketplace—should the young artist get that far. In fact, I'll argue that the ruthlessness of the market reaches into the art school, making implicit demands of acceptability as a "value-giving measure," as Foucault calls it, which confers either positive or negative status on the artists. Narratives of artistic strategy, logic, and "progress" are used within the art academy as measuring rods to appraise students' levels of potential and achievement, as well as to beat them with—meaning expulsion from favored circles, denial of grants, or withholding recommendations as assistants to established artists or to galleries or for teaching opportunities after graduation. These disciplinary measures aren't codified in a litany of standardized offenses and punitive actions, like Foucault's list culled from French histories of military schools, but are subtly imposed on the basis of visible signs of difference—difference that may be a matter of inferior talents and skills or difference that is more slippery, having to do with personality, inarticulateness, and other evidence of difficulty.

Despite the generosity of tolerance for the expression of artistic temperament, there is a minimal threshold of acceptable practice that is, after all is said and done, the basis of an insidious discipline that is ultimately ruled by the market, since the market now drives aesthetics more than the other way around. Furthermore, the rituals of studio critiques and the final thesis show, which remain standard procedure at art academies throughout the world, are by definition an exercise of power over the student. The final crit is essentially

juridical. The crit and thesis show don't level the hierarchy between teacher and student but affirm the faculty's authority for the purposes of guidance, which is in practice well intentioned on the scale of personal dynamics, while on the macro scale of the art world nevertheless remains a mechanism of adherence to established conceptions of art making in preparation for the executive domination of the marketplace. Am I overstating the case? In fact, don't graduating artists make whatever they please, transfixed before the private foundries of their imaginations? Perhaps. Yet with grinding regularity, the marketplace grants or sublates the privileges of success to its subjects, and so young artists enter the field.

No doubt, the liberal ideal of the art school as a laboratory free from the constraints of the world is advantageous to the ethos of the institution and the morale of its exclusive membership. But the ideal goes only so far. The behavior within art schools, as I say, may appear to allow any kind of experiment, but also as I say, indulgence is the luxury of those willing to ignore at their own risk the market and its powers of legitimation. (Even the temporary ebb of the market in its cycles of boom and contraction barely lessens its pull.) Especially in the United States, there is an enormous peril for art students who take on crushing financial debt for their M.F.A. and make art, if they're of the mind and ability, that sits outside the market's tastes—hobbling them as they enter a competitive pool so deep and thick with bodies that the world has never seen anything like it before. The debate over the predilections and sway of the market in relation to the purported cloister of the art academy admits nothing of this final truth: graduate-level students focused on their futures as artists may follow their own creative instincts, but they're rarely willing to deny themselves—and why would they?—the potential critical and financial opportunities of a world increasingly unable to parse fine degrees of quality and covetous of the seductions of celebrity and spectacle. The agonistic distinction between commercial interests and critical pathways of expression rings less true now. Precedents as far back as Marcel Duchamp, and after him of Pop Art and particularly of Andy Warhol, make these distinctions largely moot (though of historical interest)—even to artists focused on intellectual abstractions, on conceptual practices with little material production to sell, and on works that inhabit the rarefied domain of the spiritual.

The art school lives in a "state of exception"—a special use of the term. The phrase traditionally refers within legal and government circles to a "constitutional dictatorship" instituted in a time of social crisis, in which citizens have fewer democratic privileges and the government grants itself more of them.

There's a wonderful sentence written by Giorgio Agamben in his book on the subject in which he states that "as a figure of necessity, the state of exception therefore appears . . . as an 'illegal' but perfectly 'juridical and constitutional' measure that is realized in the production of new norms."[2] In other words, it safeguards by force its own norms, its own rules of production. By analogy, what I mean by the state of exception is that the art school becomes a de facto and paradoxical dictatorship of freedom for its student-citizens outside the realm of the everyday. The artist is granted the privilege of his or her creative prerogatives over and above the norms outside its walls. In a sense, this state of exception by dictum is given its permission by the mandate of modernism in which the deconstruction and disavowal of constraints on the imagination are considered the "constitutional" right of artistic exception that is inherent in modernism's investment in upheaval, rejection of the past, and invention—as every vanguard manifesto of the twentieth century reveals instantly.

To say this suggests that the art academy is an island or a fortress, but it relates (and has to relate even more strongly, as I'll discuss shortly) to various communities: the local cultural and civic communities; the local, national, and international professional communities, both physical and online; and the alumni community. These communities are invited to assimilate the parameters of the aesthetic experience provided by the art school. In this process of continual assimilation (at least in the idealized case), the communities vicariously or directly share in the academy's state of exception. The ambition for the school in providing this opened space of exception is to relieve the community of its daily habits of aesthetic conventions. Those habits for people outside the professional art world are typically inculcated through the media and the marketplace. For the cognoscenti within the art community, the current tastes of the market rule, along with art historical models that may preclude an open view of the newest expressions that appear below the market's radar.

But there is an important catch, a caveat that the presence of the art market forces on my idea of the art school's state of exception. In truth, this may turn out to be a false state of exception because the dominance of the marketplace holds the power to determine the course of artistic production—and does so with impunity to the judgments of the critical press and with curators often walking in lockstep with the most powerful collectors and art dealers. True, the ways that students are taught (the heritage of the Bauhaus model most obviously) are tied as inextricably to social and political influences as much as to the intrusions of the market. Yet the realpolitik of the art school is that its teachers and the reception of all artistic practices (including visiting artists who show

their art and influence student production) are subject to the acceptance of the marketplace, which is juridical in its powers. By the light of this logic, the school-as-laboratory, free from outside strictures, is not a real likeness or full description. The school only *seems* to be in a state of exception, and its myth of exception is a vestige of the Romantic cult of genius in which all true artists are imagined to live outside the impassive walls of social norms. Still, it seems to me that there is a middle ground between intention, appearance, psychological effects, internal morale, and realpolitik that must be figured into this equation of the actual status of exception.

So, a question: What is the obligation of the art school in its state of exception to a larger entity—for example, its situation within the larger bureaucracy of a university? Does the state of exception allow autonomy to the school if it's bound by the norms and bylaws of the university? This in turn presses the question of what academic freedoms are within the university, an institution (at least in the democracies of the West) that intends to be a bastion of intellectual freedoms. The truth is that the regulation of the production of students—as is the case with the Bologna Process in the European Union and with the standardized credits system toward graduation in the United States—impinges in laborious ways on this spectral promise of autonomy: teachers must satisfy state requirements; curricula must meet state and federal standards; budgets must go through layers of review and acceptance; facilities must meet standards for insurance purposes of liability; and so on. The state of exception becomes an ever more straitened ideal. As a blueprint for all art schools that want to be autonomous, nomadic, counter-bureaucratic, partially curricular or noncurricular, etc., the state of exception is a crucial concern lifted from the echelon of legalistic concern to the philosophical and back to the practical realm of execution.

What degree of exception the art school may have within the hegemony of the university or in keeping with obligations established by state and federal educational certification is a matter that leads to a certain preciousness, by which the "cloister" of the art school is in fact not a way to keep the world out but a way that the bureaucracy ensures that nothing escapes its binds. This isn't entirely disadvantageous. After all, the university *does* protect academic freedoms and takes on the threats of liability that those freedoms may incur. At the same time, the price paid is full autonomy, and so the state of exception is compromised, constrained, a contrived and bloated fiction. As I've noted, there are other impositions on the art academy's state of exception that can make it false—primarily the ultimate intrusion of the marketplace.

Within the school itself, this can be thought about in terms of the administration of knowledge.

From an essentialist perspective, the art school, as with every other school, is an administrator of knowledge. It is established not only to teach but to administer *what is to be taught*. A curriculum is a delimiting exercise of control, placing markers at the boundaries of "useful" knowledge and subtly impeding access to other knowledge through the apparatus of "busyness," by which the load of work demanded of the student precludes significant time to explore counter-knowledge; through the means of emphasis, by which ideological imperatives are fixed in the students' minds and make other ideologies appear less powerful, meaningful, moral, useful, expressive, and applicable; and through artistic practice, by which styles of expression picked up in the course of the curriculum's discourse and studio work exert their hold on the imagination. But this administration of knowledge isn't only exercised through the curriculum. It is exercised even more so in the pedagogy itself—the methodologies of teaching that shape the epistemological field and sanction certain speech acts while denying others their prestige.

In effect, the status of these speech acts and the methodologies that bring them into the epistemological field are managed through the halo effect of the marketplace. By this I mean that the constant need for new works by the market demands an infinitely diverse production of objects and visualized concepts, which are based on an endless vista of knowledge. These objects, concepts, and their variants are continually circulated and recirculated; they are like eddies that flow, crest, withdraw, and flow forward again. The nature of this flow is derived in part from the steady wave of practitioners introduced into the art school's knowledge-acquisitive environment. The market drives the organs of visibility: press, exhibitions, critique, collection. Through these means, the market shapes which practitioners are patronized, lionized, and distributed like fluid through pipelines into the art school, as elsewhere, and subsequently affect the visions of student practitioners.

This is the administration of knowledge in its most powerful and pervasive form. It has a multiplier effect. The introduction of these seductive knowledges is then multiplied by the many students who take them up and distribute them through their own practices and spread them throughout the world. Only the mechanism of collective accumulation stands in the way of chaos (the destruction of hierarchical order within the art world) at this point. That's to say, the status of the production of any given artist is dependent on the buildup of language and acts around their work. The accumulation of positively inflected

language and acts of exhibition and collection determine the influence of the artist on others, and this is a time-based process. Even in a culture of instant global dissemination, the appreciation of an artist's work still appears to take place over a duration of time and remains dependent on the legitimation of the artist through an anthropological process of validation that's determined by "elder" figures of power, whether specific collectors, dealers, museums, or publications. This proscribed professional community elevates its producers to acclaim for different lengths of time, underwriting their visibility within larger communities—and ultimately within the less time-bound community of posterity. While it is the dispensation of the school to administer the breadth of knowledge that it chooses to offer, it is the protocol of the marketplace that provides the points of entry through which that application of knowledge, which is the work of art, will be acknowledged and supported—or not.

Another question then: What experiential spaces are this compromised state of exception and this administration of knowledge inhabiting—what spaces of *living and doing*? True, there are many variations of experiential space that art schools offer, yet there are also some givens that every school shares regarding what a young artist is doing there. There is a term that the philosopher Edmund Husserl used in a far more extensive way: *life-world*. He talked about the concept as "the 'ground' of all praxis," as the place of the "pregiven," and he said, poetically, "To live is always to live-in-the-certainty-of-the-world."[3] I want to use the term, as I did with the phrase *state of exception*, as a special case because this sense of alertness to the qualities of life and place and the givens that we associate with them, this life-world, are precisely what I'm thinking about within the art academy. These pregivens of the art school include teachers from whom one will acquire knowledge, whether manual technique, historical references, intellectual concepts, or professional connections and how to use them. These different forms of knowledge will improve the student by broadening understanding, technical proficiency, and professional opportunities. These are deemed improvements, and the purpose of improvement is to make the student-artist more "fit" to enter the professionalized world of art making afterward, to succeed in a number of ways: critical success, commercial success, becoming part of the public discourse, applying creative skills to other fields, or becoming a teacher in turn and carrying on the transmission of knowledge.

Still, there are two principal forms of success among the pregivens of this life-world. The first is to identify within oneself the "true" artistic voice, which is historically an Enlightenment concept of the positing of an authentic self that

can be brought into self-recognition through devoted consideration. The second used to be dependent on the first because once the authentic self had been revealed in the work through the artist's revelation, the power of expression would launch the artist into these forms of success—critical and commercial. Of course, with the analytical deconstruction of the self that has its forebear in Andy Warhol and the many ways in which postmodern thinking has taken Roland Barthes's essay "The Death of the Author" as a sacrosanct text (and which was, in turn, based on Sartrean existentialism), the necessity that a "true" artistic self is the only way to success is no longer required. That has become another pregiven of the life-world of the art school. The self is more fluid, cagey, unattached to this old form of truth, this authentic self. The artificial, the "Photoshopped" notion of the world in which everything is potentially transformable, speaks to the sense of the inauthentic as a normative condition now, as, paradoxically, a new, acceptable form of trickster authenticity.

In the same way, another pregiven is that the young artist's identification with any particular discipline has undergone an almost complete eclipse in the schools considered to be the most advanced over the past two decades, such as Goldsmiths in London, California Institute of the Arts in Los Angeles (CalArts), and Columbia in New York (which is not to say that aesthetic tendencies, like art schools, don't have shelf lives). This pregiven is based on the belief that I've already mentioned: after Duchamp, the concept is more important than the medium through which it's brought to visibility, and so a conceptually based practice, which is the air that artists breathe today, is given to a disciplinary ecumenicism, a penchant for the nomadic to traverse disciplines and media freely in the expression of the idea. Then there is that pregiven of the young artist's will to iconoclasm, the natural temperament of difference, which is a sign of the urge toward inner discovery that is perfectly in keeping with the art school's focus on its inward tasks, its cult of discovery, its laboratory environment. That this life-world is now more infringed on than ever before by the market's demands for production and its effects on the process of inner discovery is also a pregiven that can't be ignored—and of course it isn't.

The many compromises that touch the art academy's life-world and its presumed state of exception need to be confronted now head-on. I'm not saying that there aren't real values within the compromised or semifictitious narrative of this life-world, with its coddled appearance of the liberal laboratory of free experiment. Students and faculty engage each other in this narrative of ludic possibility, of the modernist dream of forgetting the past and entering a creative state of oblivion from which they emerge with the New Thing. Or they

tell themselves that they can remember the past as they invent a disruptive present in this ideal state of creation in which they're informed but not enthralled. Nevertheless, the question isn't *whether* there are compromises, but what these compromises mean, how they can be overcome, or if they need to be. Is it the case that the old antagonisms between the market and the art school's sanctum of invention are "old school," that they're no longer at odds in any meaningful way with cultural production because society and culture themselves are so changed? And if that's so, then what are the new ethics of the art academy, and how should they play out within the life-world of the school and be projected outward in relation to its communities?

To think about this, there's a crucial notion that has to be scrutinized too about the way that an artist is seen within society, and that's the notion of *use*. If we look at the Russian Constructivists and the Bauhaus, the trajectory of their educational practices was toward the contribution of the artist to the state and to industry—the artist as worker, as a cultural production machine. In both historical cases, the struggle came to disastrous endings; the artists were crushed by the will of the state, forced into exile, or their work was suppressed, their practices altered, their schools closed. After World War II, Joseph Beuys reconceived this notion of usefulness with his idea of "social sculpture" and its renovation of the German spirit through democratized imagination—everyone a creative presence whose production contributes to social health. Warhol, with his signature perversity and brilliance, commodified this idea by fusing industrial and cultural production in an amalgam of the artist's wares and the artist himself as goods to be sold, as products for useful, even glamorous, consumption. And more recently, the art theorist Nicolas Bourriaud's concept of relational aesthetics and my own theorizing about what I call service aesthetics throw light on the artist's social usefulness as an agent of productivity who contributes a service of value to the community.[4]

Today, what the art school is in its particular state of exception, which is aesthetically underwritten by the marketplace, is a benign factory. Its products offer several kinds of usefulness—among them, of course, aesthetic pleasure, social critique, and therapeutic release, but also the supreme prowess of its fungible quality as a liquid instrument of capital. It is worth noting that after the crisis in the United States that erupted in the mid-1980s over Andres Serrano's photograph *Piss Christ*, which had been supported inadvertently by the National Endowment for the Arts and consequently caused draconian cuts in arts funding, there was no chill across the country in the making of artworks that were critical or confrontational nor was there any prolonged chill in the

growth of the art market. The art market has only expanded globally on an exponential scale, and what's crucial is that twenty-first-century market culture is able to tolerate and ingest oppositional work without softening the art's critical bite or suffering from it.

This takes me back to my earlier question concerning the idea of overcoming the "crisis" of compromise in the art school's state of exception. And my thought here is that this can be considered a compromise today, in the reality of the current situation, only if it's seen from the nostalgic perspective of an antagonism between the artist and society, between art and the market, with modernism's antiquarian itch to shock the bourgeoisie still intact—while in truth, that shock has largely been eradicated by a surfeit of images and videos of every kind broadcast everywhere through innumerable wired and wireless devices. The deficit of our actual situation is the inability of people in general, and art students as a subset of the populace, to maintain their attention spans in a spectacle culture of short memory, with its lack of interest in history and the knowledge of it, giving way to a thirst for quicksilver fashion and trendlets that can't be slaked. Yet the benefit is an unrivaled freedom to create as long as it's understood that whatever is made will be subject to the market's assimilation or the risk of uninterest and oblivion. In any case, these varieties of use, enlarged by a market that only continues to grow despite the occurrence of temporary troughs, are the basis of a different ethics within the art school just as they are outside it.

This transformation recognizes the flow of society's life and art's changing place within it, much as art once served kings, then served industrial kings, then its merchants. It isn't that "resistance is futile," but that the focus of passionate concerns changes with the change in society itself. The art school's space as a place of production has been altered throughout the twentieth century, and now the twenty-first, by its own inexorable waves of fascination that have incrementally encompassed more attributes: crafts; technologies; attitudes toward the handmade, the conceptual, and the outsourced; and explorations of art and artists' relations to the social sphere's ideological, political, and economic movements. Yet the majority of art academies across the world only half-acknowledge this breadth, this porosity, by maintaining the priority and myth of their state of exception, of their cloistered sanctum of creative freedom. The process of conversion from isolation and from its roots in the strains of modernism that championed a formalist aesthetics of isolation is clearly under way. Given the indomitable fact of exterior influences that are ineluctably breaking down the inwardness of the art school, the question has to be asked:

What is the *goal* that the art school as an institution should have in involving itself with its communities?

The public sphere, as the social philosopher Jürgen Habermas conceives it, is the assembly of private persons to form free opinions, to negotiate and act on matters of common interest without being coerced by the state.[5] The point of these communicative utterances is to comprehend a worldview that can accommodate differences and yet encourage collaboration for the public good. One role for the art academy today is to reach out to the public sphere and engage in the forum of opinion—specifically to share and propagate its accrued and continually shifting interpretations of the world that are made manifest in the knowledge embedded in its cultural productions. This is what the formation of an ethics is: the projection of beliefs, customs, and practices that define a community in its daily observances and routines. To reach out to communities, as the art school must, is an acknowledgment of its agency, of its ethical input through cultural practice. Anything less than this is passivity. Anything less than this more narrowly defines art making and its teaching as a species of entertainment—a component of the good life that may also have a transformative value but is not essentially political in the sense of communicating the will of the polis to direct its fate as a social organizer and overseer of behaviors and actions.

As a practical application of the power of the art school as a public institution, which is the power, as I've said, to formulate and distribute knowledge, this is hardly an unlikely activity and result. Art schools have had this influence perhaps once, with the creation of the Bauhaus. Yet particularly at the beginning of the twenty-first century, when there is a fundamental shift toward social platforms such as social networks, wikis, and blogs that are having a tremendous influence on social community and opinion, there should be no question that the art academy as a knowledge institution can also enter strategically into the social discourse and present its creative visions of the world. (Clémentine Deliss's Future Academy is an example of just such a program that throws itself into the issues of the art school's social ethos in relation to its local community and beyond.) The art academy of the twenty-first century, if it's to be an agent not only of artistic growth but of social relevance and enhancement, has to understand plainly that this reciprocity between inside and outside is essential to its future. It must invite the community into its discourse. It must invite the community in to actively take part in the discussion of the faculty's art and the students' art. At strategic moments within each phase of the year, it must include the formal participation of the local

community and the professional community. I use the word *phase* to propose that the very notion of semesters and the duration of study needs to be reconsidered. Why should an art school *necessarily* follow the established norms of these term lengths? Why shouldn't its faculty and students convene only for an intense period—say, for the summer, as is done in the M.F.A. program at the Bard College of Art in Annandale-on-Hudson, New York—with the rest of the year devoted to individual practice, to making a living in the world or following one's own plan for reflection and work? And why should an academic degree be a limit? Why shouldn't there also be a formalized program of return in which alumni rejoin the ethos of the school and its knowledge environment during scheduled periodic residencies?

All of these questions, and no doubt many more about the pregivens of the life-worlds of art academies, must be addressed now in light of the true nature of the state of exception. In fact, it's better to say *states* of exception: The purity of the art academy laboratory is mythic, not actual, and the degree to which any art school invites or resists exterior influence isn't fixed. In any case, there are already new educational models that have taken form. Anton Vidokle's Unitednationsplaza and the sixth Biennial of Mercosur in Brazil, both in 2007, are exemplary. Both were exhibition platforms that were used to inscribe art education programs, while another hybrid model, the Mountain School of Arts in Los Angeles—which is an ongoing lecture and discussion series about art issues particularly relevant to art practitioners and offers no course credits or certificate or degree—is held in a bar. For five years, I've been working on a series of symposia and inquiries at the behest of the Anaphiel Foundation in Miami to reconsider art education for the new century, which has been essential to the formulation of yet another model: an educational program in which conversation replaces curriculum—a residency that offers no degree and is essentially a two-year, theme-based colloquium. It focuses on knowledge exchange between artists and experts from every discipline of the humanities, social sciences, hard sciences, and technology in order to provide intellectual data that contribute to artistic production, collaboration, and the cultural enlargement of the local community. New models needn't be implemented only from the outside in. A temporary but nonetheless iconic sign of this took place in 2007 at the Städelschule in Frankfurt am Main, Germany, when the artist Rirkrit Tiravanija transformed the school for a few days into an inn, a *gasthof*, where students and guests slept, cooked, and hung out, talking about social issues, art making, and undoubtedly much more. These projects eschew the domination of the old routines.

André Malraux spoke in his 1947 book, *Le Musée imaginaire*, of the "museum without walls." Now we need to think about the art school without walls—or the art school whose walls are pierced and opened because the trajectory of global culture is obviously toward the extraordinarily pervasive distribution of every kind of information and market influence, a market influence that holds more dominion than the sovereignty of national governments and flows through them, lifting some up and leaving others impoverished in its wake. It would be utopian to think of the final state of exception as no state of exception at all or, more precisely, of a social structure in which no state of exception is necessary because the ultimate distribution of control and influence is so fluid and deliberative that a democracy of exchange is entirely heterogeneous and autonomous and yet joined by a common devotion to enlightened social collaboration. The art school we need now can accommodate this larger purview; it needs to be more open, more diverse, denser. But then this is the organic evolution of art making as it has always been: iterative, excursive, slow in the cycles of its ecology, with eruptive historical moments and long periods of gestation. The benign factory of the art school is now in the midst of reformulation, pressured hydraulically by the forces of a larger life-world to recognize the changed field and reimagine a more socially complex state of exception, engaged in the dynamics of community, unafraid to allow itself to be provisional, and aware of what "free" means.

PROJECT 9

LE FRESNOY (NATIONAL STUDIO OF CONTEMPORARY ARTS), COMPLETED
1997, BERNARD TSCHUMI, TOURCOING, FRANCE

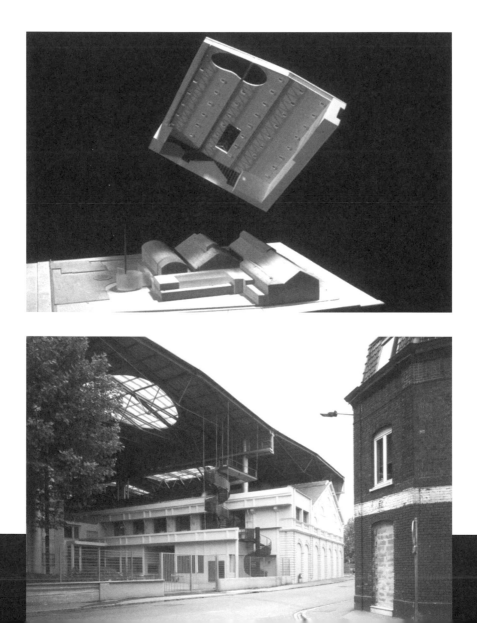

Architect Bernard Tschumi claims that his design for the National Studio for Contemporary Arts in France, an arts school located in Lille's industrial sister city of Tourcoing, is a kind of nondesign (top image). The competition brief asked for an electronic Bauhaus, which would be sited on the grounds of an existing entertainment center that dates to the early twentieth century. Many aspects of the new institution's internal programming (its distinct use of designed spaces) were unspecified, other than a general but potentially shifting set of elements. Tschumi claimed in his proposal that there was "no need to design 'new' abstract shapes or historically grounded forms, whether modern, vernacular, or Victorian." In one move, he rejected historicism and formal avant-gardism, proposing that the strength of a precise socially specific concept would result "in all the architectural, spatial, or urbanistic effects one could dream of, without reliance on proportions, style, or aesthetics."

Encompassing not only a school that includes various art forms but also a working film studio, a media center and accompanying laboratory facilities, performance and exhibition spaces, two cinemas, a bar-restaurant, and housing, the realized complex gains its integrity from being covered by a high roof roughly fifty feet above the ground (bottom image). The roof allows circuitous circulation experiences and a flexible environment for technological systems (ductwork, electrical cables, etc.). It also becomes a frontier of visual delight that liberates the ground plane from the primary responsibility of organizing activities and events. The resulting assemblage of structures constitutes a variety of what Tschumi calls "event space," a form of social condenser in which the spaces and effects produced by architectural design rub shoulders with one another and social life in general. In effect, the project deprograms and reprograms the act of determining the uses of an educational environment, itself an ongoing activity for any institution. In the face of a thoroughly mediated, postproduction vision of what education in a digital age can be, Tschumi has found a fundamentally interactive way for the conceptual logic of his architecture's design to contribute to the institution's planning rather than merely responding to it.

(*Top*) Exploded model of roof and existing/new structures beneath. (Photo credit: © Bernard Tschumi)

(*Bottom*) View of secondary entrance. (Photo credit: © Peter Maus/Esto)

QUESTIONNAIRES

Some of the twelve prominent con-
temporary artists chosen to respond
to this survey received fine art
training in university and art school
settings; one studied chemical
engineering, and another studied in
a workshop setting outside the
bounds of academic institutions.
Nearly all have, at some point, taught
art themselves. With so diverse a
group—whose practices, it should be
said, are also varied—the lessons to
be drawn from their answers are not

clear-cut. Nonetheless, several broad themes emerged. First, most of those surveyed agree that you have to learn the rules in order to break them. Whether our respondents felt that M.F.A. programs should be organized by discipline, some grounding in technique seems a necessary prerequisite to the free exploration that these programs should ideally encourage. Second, in looking back at their own educations, many felt that additional study of the liberal arts or humanities would have served them well in their careers as artists. Third, the interviewees were less concerned about the effects of the art market on art education than one might expect, given the hand-wringing tone of many articles and essays on the topic. The market is akin to the weather, they seem to say, and while you have to navigate it, you needn't let it interfere with what you plan to do. Fourth, and perhaps most important, nearly all agreed that no matter how much time one spends housed in institutions, the lessons that nourish an ongoing, sustainable career can come from anywhere—and that anywhere is often outside academic settings. This may be allied to the first observation. Beyond the specifics of discipline, medium, or technique to be gleaned from professors in art school, what young artists might benefit from most is the time, space, and gentle guidance necessary to be receptive to such unpredictable lessons—to learn a way of seeing that does not occlude any avenues for inspiration or growth. The observation may be a commonplace, but whether art schools can make a space for this—or, perhaps more accurately, whether professors and students can carve this space out from institutional demands—may be one of the defining questions that such institutions face.

ANN HAMILTON

B.F.A., textile design, University of Kansas, 1979; M.F.A., sculpture, Yale University School of Art, 1985

What was the most valuable lesson—whether in the classroom, during a crit, or from a fellow student—that you learned in school? Why? Who taught it to you? Two experiences stand out from my first year of graduate school. They rest back-to-back in my mind, but in reality they were probably experienced at distinct points in the year. They helped me to understand what embodied making might be—to see the differences between a thing and a picture of a thing; and, perhaps most important, how to work with my own hands.

The first took place during my first graduate school critique, for which I had made a pretty terrible installation in my studio, a kind of exploded room as if it was frozen in time—furniture stuck out from the walls, and everything was painted white. I thought it was capital A art. Everyone agreed the project was pretty awful, which was hard enough to admit after so much effort, and the conversation as a whole sent me headlong into working from experience. I still ask myself one of my peers' questions: "How is this a demonstration? How is this an experience for us?"

The second conversation, also with a fellow student, came a few months later. I had covered a suit in toothpicks and was deliberating what to do with it. Should it be on the floor? On the wall? On a hanger? Melinda Hunt patiently listened and then reminded me that it was a coat and I was a body and said, simply, "Why don't you wear it?"

In art school, did you learn how to sustain yourself as an artist, both creatively and professionally? Did you feel prepared to be an artist when you graduated? I don't know whether I felt prepared; I think I was all too aware of the holes in my knowledge and in my inability to be articulate about my work. I was, like everyone graduating, overwhelmed by the prospect of balancing the making of work and making a living. Actually, I don't think that has changed too much— it's not a challenge that goes away. But what I did feel prepared for was having a studio practice; I knew what that meant to me. I knew that my studio was in the books I was reading and in the flea markets and junk stores I visited. I knew I liked to look at objects and that the forms I created came as a process of response to a situation. I was just coming to understand, as I graduated, that a studio is a state of mind and not a physical location.

What matters most in art making for you? Did art school have anything to do with you coming to understand this?

What matters most to me is paying attention. Art is the result of multiple acts of attention, and I hope that art making cultivates forms of listening. It seems to me that making allows one to create a situation to find what one needs to do in the world. It's a way to short-circuit your self-consciousness. I wait by keeping busy, by not worrying too much about whether a project is "good" or "successful." In school I was perhaps too concerned about this, but I slowly began to realize how making something is very different from thinking about it. If you sit around and wait for an interesting idea, you will wait for a very long time. I now believe that making is a form of thinking; experiences are a set of questions that propel me forward. They may be small questions, but they offer nourishment for the long term.

Did your art school give you any sense of having an ethical commitment to the community that it was located in?

I remember graduate school as a tough but supportive and generous environment. We were demanding of each other, competitive, and coming to terms with our individual ambitions; and all of these things were stresses on the sense of community. We all continue to wrestle with that stress, as well as with a proper definition of community.

I remember longing for a seminar on ethics and art, but I now think that my longing was really for a seminar on the ethics of making, on what making might come to be or mean—its methodology and amplification. How does work become social? How does work participate in civic life? These are things I now think about a lot.

With hindsight, would you do it the same way if you had the choice? If not, how would you have gone about your education as an artist?

I think I would have taken greater advantage of courses outside the art program—more literature, more history. I also wish I had learned a material craft in depth; I wish I knew how to do one thing really, really well, such as metalsmithing or carpentry. I am a generalist, so I know how to link things, processes, materials, thoughts, and disciplines. But if I went back to school, I would aim for depth instead of breadth.

Does it make sense now for art schools to organize departments by discipline? Why or why not?

Yes. There needs to be a place in education for the in-depth study of processes, tools, methods, etc. Of course, this works only if these centers of depth connect to other vocabularies and processes. There is a place for the deep knowledge that comes from a discipline-based educational organization. But I want it both ways: depth and breadth.

Should M.F.A. programs resist or embrace the encroachment of the commercial art world?

I am of two minds. I want students to focus on the work and worry about the market later, but I know that probably is no longer realistic. I live and teach in an institution that is more than one hundred miles from a large, cosmopolitan city, and consequently students here do not immediately rub elbows with a large or active market. It is a good thing for artists to have tools for interacting with the market creatively. It's good to understand how a market works, how to exercise a larger imagination about how to participate in it, how to create or change a market, and how to think about the supporting role of money in a practice.

It's important for students to understand the many different economies of exchange and to see them as different places to have conversations. Some of the students here get into the market pretty actively, even while in school. What matters most is an inner strength, a confidence that allows you to continue developing by following your own questions, not outside pressures.

I think we need to hear more from artists who are both active in the market and activist in the work they do; students need to hear how these successful artists negotiate their relationship between their politics and their place in the market.

ANN HAMILTON is a visual artist internationally recognized for the sensory surrounds of her large-scale multimedia installations. Noted for a dense accumulation of materials, her ephemeral environments create immersive experiences that poetically respond to the architectural presence and social history of their sites. Among her many honors, she has been a recipient of fellowships from the MacArthur and Guggenheim Memorial Foundations and the National Endowment for the Arts. She represented the United States at the Forty-Eighth Venice Biennale in 1999. She lives and works in Columbus, Ohio, where she is a professor of art at Ohio State University.

DANA SCHUTZ

B.F.A., Cleveland Institute of Art, 2000; M.F.A., Columbia University School of the Arts, 2002

What was the most valuable lesson—whether in the classroom, during a crit, or from a fellow student—that you learned in school? Why? Who taught it to you? It's impossible to pinpoint the most valuable lesson, but many stemmed from discussions and arguments with friends. It's important to distinguish between undergraduate and graduate study. Undergraduate school for me was all about closing in on things, developing a skill base, learning as much as possible about art history and contemporary art, and trying to solidify what it means to be an artist. Graduate school was about opening up. I remember overreacting a lot in undergraduate school. You have some information, but not the whole picture. Each time you learn something new, it is like it is just happening. I remember the first time I learned that painting had died, I was in the cafeteria in Cleveland in 1996. My friend Joey told me that she "overheard it from this guy Dan." I was shocked! It was like this horrible rumor running throughout the school. I learned the most by getting things wrong and making mistakes. I learned a lot from my friend Dylan. He was older than me, a fantastic painter, smart, and endlessly cool. He had hundreds of colors of acrylic paint all mixed up ahead of time in little containers. He could be dirty in other areas of his life, but he was very organized when it came to his work. In graduate school, some of the most formative experiences involved meeting with artists whom I had read about in magazines in Cleveland and realizing that they were actually relatable—that they were real people. It made being an artist seem possible.

In art school, did you learn how to sustain yourself as an artist, both creatively and professionally? Did you feel prepared to be an artist when you graduated? Yes. I learned that it was normal to go through cycles and to try to not freak out when inevitably you get stuck. Having a good support group is important to surviving as an artist. After school I moved into a studio building with a group of friends from school. We really helped each other in terms of building out our studios, sharing resources and information. Also, having feedback in the studio was so valuable, just having someone there to say, "No, you are not crazy." We had known each other's work and working habits for a while, and I think that helps with getting honest criticism.

What matters most in art making for you? Did art school have anything to do with your coming to understand this?

What matters most to me is to make the thing that I want to see in the world, or putting something in the world that hasn't been there in quite that way. It doesn't always happen, but that frustration makes it exciting. School didn't have anything to do with this. This is more of a personal reason for being an artist in the first place.

Did your art school give you any sense of having an ethical commitment to the community that it was located in?

Not really. The year after I graduated, Columbia began buying as much real estate as possible between its main campus and 133rd Street on the west side of Harlem. The art school's studios were being located at 125th and 131st Streets. After the area started to rapidly change, you could definitely sense growing hostility.

With hindsight, would you do it the same way if you had the choice? If not, how would you have gone about your education as an artist?

Absolutely. The friends I made there are like my family.

Does it make sense now for art schools to organize departments by discipline? Why or why not?

I think organizing a program into disciplines makes sense in an undergraduate program. You learn a specific medium and its history and attendant issues in depth. Even if you decide you want to do something different later on, I think that the discipline is useful as a framework for discussion and critique. However, I think that departments should be flexible and accommodating if a student chooses to make something outside the bounds of a department and that whatever they make should be discussed in the critique of that department. In graduate school, however, I think that it is absolutely essential that a program be interdisciplinary. The exchange of ideas between media and approaches is essential and mirrors what happens in the contemporary art world. As I mentioned, undergraduate school should be about honing in and graduate school should be about expanding out.

Should M.F.A. programs resist or embrace the encroachment of the commercial art world?

M.F.A. programs should not hide from or blindly ignore the commercial art world. It's an important reality and a critical issue that should be addressed as it comes up in critique or discussion. At the same time, I think it's equally creepy and unnatural for a program to completely cater to the commercial art world by, for example, inviting dealers to sit in on critiques. Most often, students seek out advice from professors and from each other. Every situation is different, each artist's relationship to the market is different, and so each situation should be discussed uniquely.

DANA SCHUTZ is a painter who has had solo exhibitions at the Rose Museum at Brandeis University, the Cleveland Museum of Contemporary Art, and the Nerman Museum of Contemporary Art in Kansas. Her work has been included in group exhibitions at the Sammlung Goetz, Munich; the Royal Academy of Art, London; the State Hermitage Museum, St. Petersburg; Moderna Museet, Stockholm; and the Museum of Modern Art, New York. She lives and works in Brooklyn, New York.

B.F.A., Purchase College, State University of New York, 1976

What was the most valuable lesson—whether in the classroom, during a crit, or from a fellow student—that you learned in school? Why? Who taught it to you?
I don't have one "most valuable lesson," but I do remember a few important ones. The photographer John Cohen taught photography, but refused to go into the darkroom. We, the students, flailed around in the dark, but somehow we produced pictures. He was much more interested in the taking of photographs, in the image, than in the mechanics of making photographs. This, I have to say, I now appreciate immensely. He forced us to see what was important in photography and, by extension, in art in general.

The artist Tal Streeter allowed me to try anything I wanted to try, especially in combining the various arts, no matter how weird an idea, no matter how awkward or imperfect the final product. The joy and importance of exploring an idea to its end was enough.

The printmaker Antonio Frasconi was clearly one of the most accomplished artists on the faculty at the time. He had a gentle presence and a relaxed sense of himself and his place in the world, given his prominence. For a young student contemplating a life in art, this was both comforting and invigorating. He was very nice to me. As I was the only black student in the school, there was an understanding between us about the experience of "otherness" that came from his own outsider status as an artist from Uruguay whose work was socially relevant. He made being an artist who is different from the mainstream seem not only possible but also preferable.

I did not go to graduate school. I unofficially "audited" two semesters at Hunter College years ago because I wanted to study with Tony Smith and Robert Morris. I don't have specific lessons learned from either of them that I can remember, but they were supportive, and they took me seriously—not a small thing for a young black artist at that time.

Did your art school give you any sense of having an ethical commitment to the community that it was located in?
Ha! My art school was in a cloistered part of Purchase, New York, which was a wealthy suburb. We never saw the locals or even their houses. Hunter didn't have graduate studios back then. We visited each other's studios around New York City, which in the '70s meant Manhattan. The grit of the city was all around

us. It affected our work and us, but was there an ethical commitment to the community? I don't think that ever came up in any formal way.

With hindsight, would you do it the same way if you had the choice? If not, how would you have gone about your education as an artist?
Oh, yes, I would do it the same way. I would not change a thing. I was very self-directed. Though I was an art student, I took classes in dance, theatrical lighting design, stage makeup, environmental design, and anthropology. I tried to bring them together in my art.

In addition to my formal education in the United States, I studied the arts and culture of West Africa in Ghana and Nigeria. I also traveled to Egypt, Peru, and Europe long before I had any involvement with the art world. Looking back, it was amazing for me. I had real life-changing experiences, which altered what I thought was important in life and greatly expanded for me what art could mean to a culture, what art could do for a local community, and what art could leave behind for the ages. Perhaps my travel in other countries is where I received my most valuable lessons.

Does it make sense now for art schools to organize departments by discipline? Why or why not?
No, it does not make any sense to separate disciplines in graduate schools now. One might make a case for it for undergraduates, as long as there is plenty of room for juniors and seniors to abandon the categorizations, but certainly not graduate school. Nothing has reinvigorated sculpture departments more than having an elastic definition of sculpture. Anyway, it's a great benefit to all disciplines to be more in line with what is going on in the art world. The students will be better prepared to join the dialogue of art. I dislike rigid rules in art schools. They force students to choose—and for what? Art schools are not producing scientists. I know of great artists who had to wait until they finished art school to try a different discipline.

On the flip side, there is the danger of stylistic fads swaying the art schools one way and then another to keep up with what is current. "This year the hot thing is video installation, next year it's endurance performance . . ." I believe flexibility is the key, allowing faculty expertise in various disciplines to focus on the individual needs and interests of the students.

Should M.F.A. programs resist or embrace the encroachment of the commercial art world?

Graduate students need to know (and want to know) about the commercial side of the art world. They want to understand how it ticks, how they should interact with it, how to become a part of it. It needs to be demystified. They need to know the limits of its usefulness—the pitfalls as well as the importance. They need to know what role it should and should not play in their lives. But should there be a commercial art world presence in grad school? NO.

I think M.F.A. programs should resist the art world. Already legions of young artists come to New York to "make it." Art galleries, art fairs—it is all the same to them. Fresh from graduate school, they come armed with a rap about their art. Their art is finite. It is ready to be consumed. The idea that this is the beginning of a life-long journey into the mysteries of making things seems to be a back-burner thought, if it is thought at all. They view getting into a gallery as the moment when they can truly be creative because "they will be taken care of." How unfortunate. How wrong. Why would graduate schools want to encourage this line of thinking? Many young artists seem to want "success" so much that they confuse financial success with artistic success. What's unspoken is that the insecurity of being a young artist, essentially a nobody, looms large. They yearn to be somebody, and somebody important. Maybe "somebody important" means "famous," maybe it means "powerful," or maybe it just means "rich." But being a nobody has its benefits. You can decide what you think about things, realize what is important to you, develop your own way of seeing things and then your own way of creating things. And with that, you are truly in control of your destiny. This has been my experience.

FRED WILSON is an artist who lives and works in New York City. His work has been featured in more than one hundred exhibitions, including the Fiftieth Venice Biennale as the American representative, 2003; the Whitney Biennial, 1993; and the Fourth International Cairo Biennale, 1992. Among his many honors and awards, Wilson received the Tenth Larry Aldrich Foundation Award, 2002; a MacArthur Foundation fellowship, 1999; New York State Council on the Arts and National Endowment for the Arts grants, 1990; and New York Foundation for the Arts fellowships in sculpture, 1987 and 1991. A traveling retrospective of his art, "Fred Wilson, Objects and Installations 1979–2000," was organized by Maurice Berger for the Center for Art and Visual Culture, University of Maryland, Baltimore County. Wilson's art is in many major museum collections and private collections.

What was the most valuable lesson—whether in the classroom, during a crit, or from a fellow student—that you learned in school? Why? Who taught it to you? I didn't attend an art school like what most people would think of when they hear the term. At the time that I was the proper age for art school, Buenos Aires had really bad—in all possible ways—art schools. Even my parents, who were not exactly art world people, were alert enough to keep me outside that system. There is, though, a long tradition in Argentina of artists who study in workshops, and many artists my age were formed in workshop environments. Ahuva Szlimowicz, the woman who was my teacher for a pretty long time— from age nine to eighteen—taught me some of the most valuable lessons I learned. It was, after all, a decade of apprenticeship.

A specific answer, though, comes from another point in my education. The first lessons that really clicked with me, that showed me the way to being the artist I am today, came from classes I took in theater directing. It was not just that I thought the subject was interesting. Rather, somehow I got the message that what I would use for my art could come from anywhere. I got that impression by stealing concepts from one place and putting them somewhere else, still a technique I use.

Did you feel that the combination of the workshop in which you participated and studied and the theater classes you took prepared you to be the artist you are today, creatively and professionally? Or did you pick up the professional/ administrative side later?
I think my education was a little deficient; we probably all feel that way. But the assumption that an academy can pretty much cover everything is an illusion, one that students can see through pretty early on. By the time you're nineteen, twenty, or twenty-five, you realize you don't know anything. I did, however, have the impression that I was ready to begin grasping things from elsewhere, as I mentioned earlier. Though I can recognize that I had a very limited education, I don't know how else I could have gone about it. There's no way to feel prepared to be a professional artist from school alone—especially in Argentina at that time. Becoming a professional happens by the accumulation of experience (or, conversely, rejecting the lessons those experiences impart).

You mention that in Argentina, the shift from a workshop model to a North American–style art school model has happened only recently. Have you played a part in that?

No, I don't think so. My involvement with teaching began a long time ago, but it took a while until I had my own workshop with adult student participants. Only well after I created my own workshop program did the academy begin to change. The academy learned its lessons through the years, but mostly through larger institutional shifts. I don't think I was the agent of that change.

In 1990, when I created the program, my first intention was to insert it into the academy. I thought it was a good idea to combine the models. I also thought the institutional umbrella would have been nice for me. Though I was sure that my parents made the right decision by not pressuring me to go to the academy, I still had a sort of nostalgia for it. I had the illusion that the academy could have been something great. I wanted to benefit the academy, sure, but there was my own personal curiosity. But there was no precedent for this workshop-academy hybrid, and it didn't work out logistically.

To what extent did your workshop model, and the one that taught you lessons for the practice you have now, give you an ethical commitment to the community?

I'm not so sure I had a strong sense of community. My workshop is rooted in Buenos Aires and the city's art community, but in a way it could exist—with me—anywhere. It is conditional on the teachers and their ability to teach and not on the local environment. All of us recognize that the moments artists need to further their practices can happen anywhere, anytime. They happen as much in the bar after class as in class itself. It can even (or especially) happen in places where you're not formally a teacher, actively teaching.

The nature of the workshops I attended was different in a way. My teacher had a very good eye. I hope I picked up her ability to see things without exactly knowing what her own intentions were as she processed them. I wanted to pick up her viewpoint of the world as much as any particular lessons on making, and while that can encompass the local community it doesn't necessarily have to.

Does it make sense now for art schools to organize departments by discipline? Why or why not?

I think not. It never crosses my mind to work that way. I just try to push things as far as they can go. There may be a time when schools need to be specific about tools, about how to handle digital or physical or technical aspects of art making. But having school divided into disciplines seems pointless to me. It

preestablishes the idea that what you do in the academy is outside your own practice, that you get *trained* to do something.

In my program, a student could make something that was "bad," and it would be seen, still, as part of the creative process. I don't believe in teaching something—a technique, say—that will then be discarded. There's no need to teach students something they won't use. Art education should be work-centric. It may be very old-fashioned to say so, but I think the demands of the work should be respected. I respect the work perhaps even more than the students sometimes. I don't always want to listen to the students' complaints or whatever, but I will always take seriously the work in front of me. Work dictates its own needs, and those needs don't recognize disciplinary boundaries.

Should M.F.A. programs resist or embrace the encroachment of the commercial art world?
Thinking about this question is just another way to divide reality. I don't know how brutal or how obscene the art market is elsewhere, and how it intrudes on art schools. I guess I would try to protect some sense of privacy, but that is based not on an antimarket puritanism but rather a desire to reduce stimulations while work is nurtured. You protect the work and not the student, in a way. If you use terms like *mercenary*, it is useless; you cannot prepare students for a battle. That will ruin them. Things are much more permeable and flexible. We are almost all teachers, anyway, because we've been exposed to and done well with commercial galleries. There's no need to demonize the market, only to protect the work.

GUILLERMO KUITCA lives and works in Buenos Aires, Argentina. He finds inspiration for his work in the realms of architecture, theater, and cartography. Kuitca has exhibited worldwide, and his art is in several international collections, including those at the Metropolitan Museum of Art, the Museum of Modern Art, the Art Institute of Chicago, Tate Gallery, and the Stedlijk Museum. Kuitca's work has been included in the Bienal de São Paulo (1989), documenta ix, Kassel (1992), and Venice Biennale (2007). From 2009, a retrospective of his work will be presented at the Hirshhorn Museum, the Albright Knox Gallery, the Miami Art Museum, and the Walker Art Center. In 1991, Kuitca created the Studio Program for the Visual Arts in Buenos Aires. This program has been a space for work and discussion for about one hundred young artists in Argentina.

JEREMY GILBERT-ROLFE

Tunbridge Wells School of Art, 1965; London University Institute of Education, 1967; M.F.A., Florida State University, 1970

What was the most valuable lesson—whether in the classroom, during a crit or from a fellow student—that you learned in school? Why? Who taught it to you?
Uncertainty. Because it's what art does best, while conversely, certainty in art is tedious at best and usually threatens to be trivial. Maurice Weidman.

In art school, did you learn how to sustain yourself as an artist, both creatively and professionally?
I learned how to make art, but I don't think I've ever been able to keep up with what "professional" means, except that I've noticed that regardless of fashion, it consistently involves personality rather than argument to an extraordinary degree.

Did you feel prepared to be an artist when you graduated?
Yes.

What matters most in art making for you?
It has to cause an involuntary response. When it's my work, it also has to be complex without being pedantic, and also mustn't rely or seem to rely on what I take to be conventions that have become silly without becoming excitingly frivolous—such as grayness and heaviness as a sign that the work is serious, or duck-with-a-hammer thrashing about as a reassurance that it is sincere and authentic.

Did art school have anything to do with your coming to understand this?
Sure, because the more you learn how to make art, the better grasp you get of where aesthesis stands in relation to ideas.

Did your art school give you any sense of having an ethical commitment to the community that it was located in?
I went to school in the 1960s, when we were more likely to talk about the state and what a drag it was than about community. I think there's plenty of evidence that art students have long been pretty heavily invested in political engagement. Whether they get it from art school or bring it there is surely hard

to gauge, as it has to do with what kind of people, generally speaking, might be expected to want to be artists. I think I belong to the majority of artists in not being able to see how art could lead anywhere but toward the left. But on the other hand, Andy Warhol liked to dine with Roy Cohn and Al D'Amato, and since I don't think Carnegie Mellon should have to take the blame for that, then perhaps art schools can't take credit for the more general tendency toward the other direction either.

With hindsight, would you do it the same way if you had the choice? If not, how would you have gone about your education as an artist?
Possibly not. People like me have changed what art schools teach; presumably I'd prefer to go to the kind of school I teach in now than the one I went to before schools such as we have now existed. But then again, would we have the schools we have now had we not had to go to the schools to which we ourselves went . . . ? Etc.

Does it make sense now for art schools to organize departments by discipline? Why or why not?
It seems to me unavoidable at the undergraduate level and undesirable for graduate schools. The best way to see if you want to be an artist is to learn how to make art, and if one learns how to draw, paint, sculpt, make a film or video, etc., medium by medium, one gets a better understanding of the relationship between skills and the ideas that originated or have grown up around them. At the graduate level, it's best for artists to just be artists. Skill should no longer be an issue, what to do with it and why. If in undergraduate school the question is how to make a good painting, for example, the question in graduate school is no longer whether it's a good painting, but instead it is something about what one wants to do with that kind of good painting and questions of that sort.

Should M.F.A. programs resist or embrace the encroachment of the commercial art world?
Appearances notwithstanding, this is a question of far more pressing relevance to Ph.D. programs than to M.F.A. programs. As I've noted elsewhere, art history has tended to become a discipline in which people with Ph.D.s rationalize the decisions made by people who dropped out of Ph.D. programs in order to become art dealers. This negatively affects what art students read, producing as it does art history and criticism that are essentially uncritical, regardless of

the terms they employ. Art departments have always had the dealers breathing down their necks. They usually deal with it moderately well, although it is true that some have willingly become little more than farm teams for the gallery system. The trouble with that is that the students don't develop as artists, even though they get really good at learning how to be "professional."

JEREMY GILBERT-ROLFE is a painter and writer. He is the author of *Immanence and Contradiction* (1986), *Beyond Piety* (1995), *Beauty and the Contemporary Sublime* (2000), *Frank Gehry, The City and Music* (2001), and other shorter critical and theoretical essays. A recipient of Guggenheim and NEA fellowships, the College Art Association's Frank Jewett Mather Award, and a Francis Greenberger Award for Lifetime Achievement in the Arts, he is currently chair of the graduate art program at Art Center College of Design, Pasadena, California.

MATTHEW HIGGS

Blackburn School of Art, 1984; B.A., Newcastle-upon-Tyne Polytechnic, 1987

What was the most valuable lesson—whether in the classroom, during a crit, or from a fellow student—that you learned in school? Why? Who taught it to you?
I studied art at the undergraduate level in the mid-1980s at a regional British polytechnic. British art education, despite the fact that it was essentially free, was on the whole pretty grim in those days. If I learned anything at art school, it was that I didn't necessarily see myself as an artist, that there were other ways to work with both art and artists. I met a lot of interesting people at college, mostly fellow students, from which developed a sense of engaged camaraderie that persists to this day. (Gavin Brown was in the year above me, and we made collaborative work for awhile at art school. The artists Gareth Jones and Hilary Lloyd were in my year. It was an unusually fertile time for a regional college.) I remember that Jonathan Lasker once came to visit—it was fairly unusual to have an American artist visit—and he attended a party that I was playing records at and he told me, in the nicest way possible, that I was a better DJ than I was an artist. That was useful advice.

In art school, did you learn how to sustain yourself as an artist, both creatively and professionally? Did you feel prepared to be an artist when you graduated?
By the time graduation came around, I think I was sure that I didn't necessarily want to be an artist. The idea that one might make a living—either as an artist or involved with the arts—was never mentioned during my time at art school. The only apparent next step seemed to be studying in a postgraduate program in London. Or, alternatively, simply moving to London, which is what I did. The conversation we'd started among ourselves at college continued in London and ultimately acted as a catalyst for all of my subsequent activities as an artist, curator, and writer. Everything I've done since can be traced back to those informal conversations among a group of artist friends who met at art school.

What matters most in art making for you? Did art school have anything to do with you coming to understand this?
Other people. Certainly art school provided me with an opportunity to work alongside like-minded (and not-so-like-minded) people, to establish a context for ourselves. Art school in the U.K. in the '80s was extraordinarily loose. There was virtually no structure of any kind, which was—in hindsight—an

interesting scenario; it forced you to find ways to occupy and entertain yourself. Because I didn't make a great deal of work, I would spend a lot of time in the library reading back issues of art magazines, which I still do today.

Did your art school give you any sense of having an ethical commitment to the community that it was located in?
I was at college between 1984 and 1987, which was a fairly corrosive time in British politics. Margaret Thatcher and the miners' strike and its subsequent legacy had a huge impact on the region where I studied (the northeast of England). It was a very traditional working-class area, whereas the makeup of the student body was, I would imagine, largely middle class. I remember minibuses arriving at the campus in the mornings to take sympathetic students to join the striking miners on the picket lines, but I don't remember there being much discussion—formally or informally—of artists having any ethical or social responsibilities, local or otherwise.

With hindsight, would you do it the same way if you had the choice? If not, how would you have gone about your education as an artist?
I made a decision at age eighteen not to apply to college in London. As a teenager growing up in the northwest of England, London had never seemed that appealing. With hindsight I would do the same thing again. I was fortunate to meet the people I met at art school, and lucky that we met in a city without too many distractions. My art education certainly wasn't perfect or even ideal, but it did—for all its faults—allow me enough space and time to figure some things out, thoughts that I'm still wrestling with to this day.

Does it make sense now for art schools to organize departments by discipline? Why or why not?
If all art schools abandoned discipline-specific departments, it would encourage art educators (the faculty, artist-teachers, administrators, and others) to reassess what they are doing at art school. My feeling is that for the most part, students arrive at art school fairly open to working in any way that seems appropriate, but the departmental system—which is structured around historic and fiercely defended fiefdoms—seems to exist solely to counteract this possibility in order to maintain both an artistic and administrative status quo.

Should M.F.A. programs resist or embrace the encroachment of the commercial art world?

Art schools are as much a part of the commercial art world as galleries, museums, alternative spaces, art magazines, art fairs, and biennials. It is naive to think otherwise. Everything is connected. What would be more interesting is for art schools to have frank and intelligent discussions about the commercial art world, to open up both a critique and an analysis of its practices and processes. A great deal of twentieth-century art history is actually a story of art schools and art dealers. However, too often you will still find a post-hippie mind-set in art schools (typically disseminated by safely tenured faculty) that seeks to define the commercial art world as an ideological "other" at odds with the pure, utopian space of authentic self-expression. Of course the paradox is that—in the United States at least—it now routinely costs more than $30,000 per annum to attend art school.

MATTHEW HIGGS is an artist, curator, and writer based in New York City. Since 2004, he has been the director of White Columns, New York's oldest alternative art space.

MIKE KELLEY

B.F.A., University of Michigan, 1976; M.F.A., California Institute of the Arts, 1978

What was the most valuable lesson—whether in the classroom, during a crit, or from a fellow student—that you learned in school? Why? Who taught it to you? Many new experiences affected me in art school. It's hard to point to one. First was the experience of school itself—of being away from home and discovering my own interests free of the influence of my local community. Being in a place—Ann Arbor, a liberal college town where I could attend lots of lectures, see films and concerts—provided a broad education in and of itself. Second, realizing how my own interests were often in conflict with those who educated me clarified my own positions. Third, discovering that I could align myself with other creative people, outside the educational environment if it did not provide what I needed. One reason to go to school is to challenge or expand your received tastes; I believe that's the most important experience school can provide. But sometimes I had to look beyond the art program to find those challenges. Some of my greatest aesthetic challenges were provided by people I met outside of school or through my own autodidacticism. Forming my own group of people and talking through issues with them was incredibly important. When I was an undergraduate, there were very few courses in contemporary art; the only one I can recall was on Dada and Surrealism. That was considered radical in the art history program. I had to research contemporary art on my own.

One thing I can say is that I'm very glad I went to a university for undergraduate studies. Almost none of my interests were entertained within the art program. I got far more from my psychology courses and other non-art-related classes than I did from my art courses, which were primarily technical. I would not have had access to that in a pure art school. On the other hand, graduate school was very intellectually professionalized, and I was challenged with approaches very different from my own personal orientations. It wasn't pleasant; but I think it was a necessary experience—an eye-opening one. It socialized me. It made me commit to be a professional artist.

In art school, did you learn how to sustain yourself as an artist, both creatively and professionally? Did you feel prepared to be an artist when you graduated?
There was no art market when I was in school. Being a professional artist at that time was an ideological position. I showed, I traveled, I lectured, but I did not make money from these activities. I considered myself a professional artist and was trained to be one, and I functioned as one within that world. But if professionalism is defined by economic success—well, that's just not what it meant at the time. There is, of course, a far different attitude about this now. I do feel that my graduate experience prepared me for the art world as it existed at that time. It made me aware that art was an international phenomenon and that I could network within it. For example, as a performance artist, I knew where I could perform—and I did.

What matters most in art making for you? Did art school have anything to do with your coming to understand this?
Yes. Art school helped me clarify my thoughts about that, though I was already thinking about such things before I went to school. In high school I was caught up in radical politics and was part of a group of people who did not differentiate between art, politics, and other intellectual discourses. Art, for me, was intrinsically linked to left-wing activity. That idea was not the standard in the art program at U of M, though Ann Arbor itself was a radical hot spot. At CalArts the situation was different. The vogue of French theory was coming into play, so the connection between aesthetic and social theory was overtly discussed in the program.

Did your art school give you any sense of having an ethical commitment to the community that it was located in?
The art schools I attended didn't give me a sense of commitment to the community they were located in, but more to a world community. I think—or at least I used to think—that art is inherently invested in ethical concerns. That was the social function of art, to raise such issues. Because the world is molded through prescribed ways of looking, screwing with that is a political gesture. Such a position echoed my interests in Surrealism, and the work of William Burroughs or John Cage, for example. But I am not a PC artist. I don't idealize the notion of local community. CalArts, for example, was in the middle of a right-wing cowboy town. I knew I didn't belong to that community. In almost every place I have ever lived, artists were ostracized. Thus, I have a tendency to believe that one serves the community best by being the worst citizen.

With hindsight, would you do it the same way if you had the choice? If not, how would you have gone about your education as an artist?

I would do it exactly the same way. I was very lucky in my choice of educational venues. I did the right things without knowing why. I researched schools and thought a lot about what would be the best places for me, but at the time, I had a limited understanding of the reality of art practice. I unconsciously knew I should go to university first to develop my intellectual skills, and then move on to a more specialized program, and that's what I did—but, in a way, it was pure luck.

Perhaps, if I was to redo it, I would seek a broader education. I'm sorry, for example, that I did not get degrees in psychology and art history from U of M, when I had enough credits to have done that fairly easily. I did further my own education, though, by becoming a teacher, especially at Art Center [College of Design]. I ran the visiting lecture series there for quite a few years, moderating the discussions, and I worked with students on their thesis papers. I met a lot of people that way and learned a tremendous amount.

Does it make sense now for art schools to organize departments by discipline? Why or why not?

I am against that. I was glad that CalArts was not organized by discipline, like the art programs at U of M and at UCLA (where I taught) were. I especially disapprove of specialization in art education on the graduate level. I am not against having technical courses to learn certain skills. But I do not think discourse should be defined by discipline. Higher education in the arts should focus on theory, history, and discourse.

Should M.F.A. programs resist or embrace the encroachment of the commercial art world?

It's a waste of time to try and resist the market because, now, it is so much more powerful than the educational institution in terms of its influence. Art Center, for example, did not allow dealers to come and visit the students in their studios. But of course there's no way to stop them from coming to the exhibitions. I used to try to dissuade the students from having gallery exhibitions before they graduated, but at a certain point I gave up. Why try to counter how the art world is actually operating? Such a position is unrealistic. Either students can reconcile the market with their studies or they cannot; that is ultimately their decision. My problem, as a teacher, was that the students are confused when they are being rewarded in the marketplace and at the same

time intellectually challenged in school. They oftentimes saw this as proof that the educational environment is out of touch with the "real" art world. And they are especially confused when they are getting contradictory reactions to their work from different faculty members. It's difficult to convince a student that such mixed messages are good; it is how one develops a dialectical worldview and becomes aware of one's own position. I have to tell students over and over that when they are in school, they should take advantage of the situation as much as possible. It's very difficult to have the kind of focused discourse that one gets in the school environment in the "real world.-" I have to argue that it is important to not let market activities eat up their educational experience, especially now when art schools are so expensive. But I'm afraid intellectual gratification cannot compete with financial rewards.

Los Angeles–based artist **MIKE KELLEY** has exhibited internationally for over two decades. His most recent survey exhibition was held in 2008 at WIELS Centre d'Art Contemporain in Brussels. His work is in the permanent collections of over two dozen major international museums; he has taught at the University of California, Los Angeles and the Art Center College of Design; and his collected writings, statements, and conversations have been published as *Foul Perfection* and *Minor Histories* by MIT Press.

PAUL CHAN
B.F.A., School of the Art Institute of Chicago, 1996; M.F.A., Bard College, 2002

What was the most valuable lesson—whether in the classroom, during a crit, or from a fellow student—that you learned in school? Why? Who taught it to you?
Amy Sillman said to me once, "Dumb people make great work, too." The implication is that art is something you can't simply think through. Art is form in the spirit of a question.

In art school, did you learn how to sustain yourself as an artist, both creatively and professionally? Did you feel prepared to be an artist when you graduated?
No. I still don't feel prepared in that way. The school that I went to had little structure to it, rightly or wrongly. And I loved it. Fundamentally, I learned that people learn at their own pace. Never let schooling interfere with your education, as Mark Twain said.

What matters most in art making for you? Did art school have anything to do with your coming to understand this?
I don't know how to answer the first part of this question. The second part must be a yes, but I'm not sure how. My experience of art school was so unformatted that it bled into other kinds of school—the school of living in Chicago.

Did your art school give you any sense of having an ethical commitment to the community that it was located in?
No. Where I was, in downtown Chicago, you actually didn't want to be a part of the very local community. The neighborhood where I lived, with other art students, outside downtown, gave us more of a sense of participation. We started a gallery in Pilsen, on the South Side. This is a complicated question, but the school itself did not instill in us this sense of commitment. Then again, I never really plugged in to what the school would offer that would give me that chance.

With hindsight, would you do it the same way if you had the choice? If not, how would you have gone about your education as an artist?
I don't know if I could have gone through my education any other way, so I wouldn't have done it another way. The way that I work tends to be riddled with contradiction, and so I went to school, tried to understand what was happening, and then deliberately didn't do it. I did something else. I had to do

something in opposition, both in Chicago and at Bard. You go to school to be something else, and what you learn about being something else becomes you being a student.

Does it make sense now for art schools to organize departments by discipline? Why or why not?
Yes, I think it does, precisely because it is conservative, and it forces students to be progressive. And having the distinctions, in and of themselves, are important. If you don't, then the history and practice of art becomes one purely of intention, which I think is to the detriment of both art and artists.

Should M.F.A. programs resist or embrace the encroachment of the commercial art world?
I think they should do neither. Such programs should make the consideration ridiculous. Doing either gives the market more value than it is actually worth. By making it seem ridiculous, in whatever way M.F.A. programs can do so— parody, ridicule, irony—there is more room for people to make their own choices.

You can't help but see that people want to survive. If surviving means being in a gallery, then that's what people will do. Life has a perpetual sense of impoverishment to it, and if there's money to be made and survival to be had by selling artwork in a gallery, then people will do it. Hopefully, what we want out of art, though, isn't mere survival. Surviving isn't living. The logic of survival is so overwhelming that you want to hope art is a space where it doesn't dominate similarly. On the other hand, you can't give in. Hegel on systems: When systems become powerful, you can only do one thing—respect and despise them at the same time. The ethical stance is to keep it at a distance without fetishizing it.

PAUL CHAN is a New York–based artist. His exhibition "The 7 Lights" was presented at the Serpentine Gallery in London and the New Museum in New York in 2007 and 2008. He has also had solo exhibitions at the Stedelijk Museum in Amsterdam, Magasin 3 in Stockholm, Portikus in Frankfurt, the Institute of Contemporary Art in Boston, and the UCLA Hammer Museum in Los Angeles.

PAUL RAMÍREZ-JONAS

B.A., Brown University, 1987; M.F.A., Rhode Island School of Design, 1989

What was the most valuable lesson—whether in the classroom, during a crit, or from a fellow student—that you learned in school? Why? Who taught it to you? I went both to a university (for undergraduate studies) and an art school (for my master's degree). This has shaped me in a particular way. I learned about 95 percent of what I need for my art practice, as well as what I need to simply be in the world, at the university. I find it difficult to understand how one can be an artist without first, or at least simultaneously, being educated. By educated, I mean a very traditional idea of a liberal arts education: the studying of a curriculum aimed at imparting general knowledge and developing intellectual capacities, such as critical and analytical thinking. Ideally there should also be a component that includes spiritual and emotional education—two things I sorely lack even today. Whether it happens in a formal setting is less important.

A professional art program gave me the other 5 percent. Although it is tempting to be dismissive of art school, the relatively small amount of things I learned there were crucial and indispensable, as they represented a very precise understanding of art as a tradition. While I believe that I might need a critical, analytical, and creative set of mental tools to make art, I also have to understand that I am within a tradition, and tradition requires acceptance (but not necessarily acquiescence).

I want to distinguish the transmission of information from lessons. I am in a constant process of absorbing information, but information is neither valuable nor invaluable—it is a raw material. Lessons, it seems to me, are about the passing on of something else. Here are a few examples:

Lesson 1. Jane Kent. Fall 1984. "Paul, anyone can have good ideas." What a kick in the ass that was! It made it clear that my job was to create form, not ideas.
Lesson 2. Janine Antoni and Beth Haggart. Spring 1988. While in graduate school, they made a work of art for the Sarah Doyle Women's Center Gallery in Providence. It was not a someday-I-am-going-to-be-an-artist work of art. It was not a test or a rehearsal. It was a real honest-to-goodness work of art. It taught me that although I was still a student, I could start to make art right there and then.

Lesson 3. Tom Lawson. Spring 1989. "Don't waste time trying to be good at what you are not."

Lesson 4. Piero Manzoni. 1994? 1995? 1996? (I can't remember when I saw it.) *Socle Du Monde.* You don't need to rely on heroic labor, messianic form, or the persona of the genius to make the world into art.

Lesson 5. Daniel Bozhkov. 2006. "Paul, it is not about this or that, it is about this and that." Daniel told me this during a studio visit. It made me realize that I had not gotten the modernist impulse to be reductive out of my system—that I was still confusing modernism with rigor.

In art school, did you learn how to sustain yourself as an artist, both creatively and professionally? Did you feel prepared to be an artist when you graduated?
I felt prepared to be an artist, but I was not. Ultimately the feeling of being prepared might be the most valuable thing that school gave me. Somehow, in those two years, I gained the confidence and faith in myself that allowed me to rent a truck, pack my belongings, move to New York City, rent a studio, and start making work. I didn't really know much. I learned "on the job."

At school there was much emphasis on critiquing work, working hard, being self-critical, reading theory, getting to know art history, etc. Some schools today are beginning to venture into more practical professional preparation, such as how to give a lecture, how to document your work, maybe even a bit of financial preparation. What doesn't really ever get discussed is how to develop a creative practice.

There are several methodologies on how to become a great runner, and you may subscribe to one or another and train accordingly. Because there is a single form being pursued—running 100 meters as fast as you can—the methodology can evolve around achieving this goal. In the profession of art, we ideally want different and individual results from each artist, and thus it would be counterproductive to seek a standardized methodology. In the absence of a standardized methodology, how can we ever quantify what "prepared" is? The greatest disservice one can do is to either believe or make others believe that a methodology does or can exist.

What matters most in art making for you? Did art school have anything to do with your coming to understand this?
What matters most in making art for me has continually changed—and I expect it to keep changing. I did not learn this while I was a student in art school.

However, what matters to me the most right now I did learn in art school, in my role as a teacher. I live in desperate times, and what matters the most to me right now may seem humble, simple, even lacking ambition, but I am convinced that it is the task at hand. Individuals should organize themselves around individual works of art, and in doing so they form a public. In fact, to be viable, an artwork needs a public. It is a tangled relationship: The artwork needs a public to be a work of art, and a public needs something (like a work of art) to come around. I am interested in a specific kind of public, one that is not formed by membership, identity, gender, sexual orientation, religion, the state, etc. I am interested in publics that come to be through free association, that are self-organized, temporary, and engaged. If this is the only thing an artwork can do, it is plenty.

One other thing still matters a great deal to me. I did not learn it in art school exclusively. I learned it slowly in high school, university, graduate school, and on my own after school; that is that my work is but the performance of pre-existing scores and that almost anything in the culture can be used as a score.

Did your art school give you any sense of having an ethical commitment to the community that it was located in?

In a general sense, no. In a limited sense, some of my teachers thought that art should be a critique of the art world and the use of art as a commodity. My formative experiences regarding ethics, community, and politics took place as an undergraduate—outside the field of art. Although I was shy to get involved, my friends in university were extremely active in politics, environmental issues, etc. Even in high school (in Honduras), one had to complete a year of civic service to receive a diploma. It all added up to a series of examples of the importance of action, not just talk. In comparison, my experience in art school was shockingly disengaged. This contrast between university and art school reflects my current experiences as a faculty member. I can't help but think that this situation relates to my answer to the first question.

With hindsight, would you do it the same way if you had the choice? If not, how would you have gone about your education as an artist?

I am still going about my education as an artist. I have been making art for nearly twenty years. I was in art school for 10 percent of that time, and as the years go by, that percentage will diminish. Part of the problem with school is the expectation that such a small amount of time can make someone into an artist. It would be better to change that expectation. The training could instead

stress the tools needed to continue your education beyond school. In a fantasy world where I am eighteen again and I am also wise enough not to need external validation (I said it was a fantasy!), I would go to college and get a broad general education. I would then forgo graduate school, work for some artist, and form a study group with other kids from my generation.

Does it make sense now for art schools to organize departments by discipline? Why or why not?

The obvious answer is that it makes no sense. But it is a useless answer. It all depends on the institution. Some institutions are highly structured around disciplines, but the students have no obstacles moving across them. Some schools are nominally without departments, but the faculty remain quite dogmatic. As far as I am concerned, the departments can have as many labels and subdisciplines as they want. The only thing that matters is that the students' experience is free of judgment if they go this way and that there be no pressure to define themselves one way or another. Again, I am tainted by my undergraduate experience. I was at one time a computer science major, but that did not mean that I could not take art classes, history classes, literature classes, etc.

Should M.F.A. programs resist or embrace the encroachment of the commercial art world?

> *Denial:* M.F.A. programs should not allow galleries, critics, and curators to come to their studios—let alone pay these people to come as faculty or as sanctioned visitors for lectures and critiques. The two years in an M.F.A. program should isolate students from these pressures so they can grow, take risks in a safe environment, and find their true voices. There will be plenty of time for the commercial realities after the students graduate.
>
> *Anger:* M.F.A. programs are blurring the line between the commercial world and the academic world. It is ruining education and young artists. That is why I have to see so much crap in Chelsea. It is the M.F.A. programs' fault.
>
> *Bargaining:* We could do a lot of fundraising and lower the tuition. Critics are okay, but having dealers come and give lectures is going too far. We should teach how to document work, set up Web sites, and talk about your work. But we should stop short of discussing how to price a work or how to deal with dealers (but curators are okay).

Depression: It is hopeless. After the fall of the Berlin Wall and the collapse of the Soviet Union, capitalism has taken over the entire world. There is nothing to be done. The only alternative is religious orthodoxy.

Acceptance: We are part of the commercial world by virtue of the fact that we are selling education. I can't think of a tighter embrace. We have to admit it and think through the consequences of the exorbitant prices paid by young students. We should do this in a deliberate and transparent way. The worst thing to do is to take a half-baked, half-implemented posture of resistance. I once heard Arjun Appadurai say, "We need to think of the biggest problems in the world and come up with the smallest contribution toward their solution." In our world, our contribution could take the form of small educational activities that are outside the economy. Teachers would have to be willing to donate time, and students would have to forgo the idea of a degree. I am not holding my breath.

PAUL RAMÍREZ-JONAS is an artist living and working in New York City. He teaches at Hunter College in New York and exhibits internationally.

What was the most valuable lesson—whether in the classroom, during a crit, or from a fellow student—you learned in school? Why? Who taught it to you?
You learn lessons every day. In one way or another, I consider every experience a learning experience.

In art school, did you learn how to sustain yourself as an artist, both creatively and professionally? Did you feel prepared to be an artist when you graduated?
I've been thinking about this question for a very long time. I'm a scientist, and the mathematical community has little jokes that we think are very interesting but no one else cares about. They're problems that look very basic but have no solutions. Art is like this; being an artist is like this: there is no solution. There's no way to be an artist. You either are one or you are not.

It's analogous to the experience of going to galleries with my wife. There are some shows that when you walk into the room, you know immediately you don't need to stay for more than ten seconds. You can't explain why you didn't walk the extra ten feet to the back of the gallery; you just know it isn't necessary. Being an artist is just as intuitive.

It all comes down to the work, anyway. Whether you're branded like Jeff Koons or James Turrell, who has made exactly one piece in his entire life; or the guy who goes to every party; or the guy who goes to no parties—none of that counts vis-à-vis the work. The opposite happens too: good artists can fuck up their careers. I see it happen all the time.

Does Mountain School attempt to instill an ethical commitment to the community that it is located in?
Yes, Eric [Wesley] and I have been thinking a lot about this. We feel like the Mountain School is a community-oriented institution. The idea of an art community doesn't make sense on its own, in isolation. Like any utopian society, if you don't exchange your experience with the rest of the world, your efforts make no sense. The world doesn't need artists to live on top of a mountain, so to speak, unwilling to exhibit their work or to engage with the widest possible audience. That said, being community oriented doesn't mean you have to be confused about what work you like to have around you, and the people you like to associate with and learn from. At Mountain School, instead of having only a series of artist talks, we have a broad program, one that attempts to give its

students a 360-degree lens onto the world. We do philosophy, science, law, all in an attempt to keep art from retreating into a ghetto. New York's art world is a typical example of what happens if you don't fight that impulse: the art becomes about art and about the art world. It's no fun to keep remixing the same things.

With hindsight, would you do it the same way if you had the choice? If not, how would you have gone about your education as an artist?
I think that by never going to school, I never came out of school. I wouldn't change that at all. In a way, because I never graduated from art school, I'm still not done. It's easy to see today how students don't go to school to learn but rather to receive the stamp that says "I'm an artist." And if you pay $40,000 a year to go to school, you really expect that stamp to get you in to a lot of places. That's one of the big dangers of the art school system in America. If you go to law school, you come out a lawyer: I can take the bar, I can go to court and argue a case. But when you graduate from art school, you are not necessarily an artist. It's not enough just to attend, whether for a week or for years and years.

By not having a degree, I will never be able to tell people, "I am an artist," in an officially sanctioned way. So no, I don't regret anything. Well, I regret everything, but that has to do with Catholicism and a whole host of other issues. I regret everything, but I'm proud of everything too.

Should M.F.A. programs resist or embrace the encroachment of the commercial art world?
You know, it's very hard to say. Everyone blames the institutions, no? I was on the far left in Italy in the late 1980s, and we all thought that schools were evil. But now I believe that art schools are essentially companies that respond to their customers. They give people what they want.

I feel sometimes also in our students at Mountain School, who have chosen to attend courses and lectures held in a room above a bar, are career oriented. One kid, a very sweet student, suggested that he didn't think it was the right moment to show a curator his work when asked to do so. Some time later he came to me and said, "I think I'd like to show my work now so I can understand if I'm doing things right or wrong." That should be the reason why an artist wants to show. But it's not this way very often at all these days. So I won't "blame" issues pertaining to the market on schools, but rather on students themselves.

PIERO GOLIA is an artist based in Los Angeles. He has exhibited in museums around the world, and his feature-length film *Killer Shrimps* was selected for the 2004 Venice Film Festival. In 2005, he cofounded the Mountain School of Arts with fellow artist Eric Wesley.

SHIRIN NESHAT

B.A., University of California, Berkeley, 1979; M.A., University of California, Berkeley, 1981; M.F.A., University of California, Berkeley, 1982

What was the most valuable lesson—whether in the classroom, during a crit, or from a fellow student—that you learned in school? Why? Who taught it to you?
When I look back at my memories of art school, they are not as valuable as I wished. When I was admitted to the University of California, Berkeley, my country was undergoing the Islamic Revolution (1979), and by the time I was in graduate school, the borders to Iran had closed, the war broke out with Iraq, and the United States had ended all diplomatic relations with Iran. So needless to say, I was consumed by deep anxiety as these political developments were paving the way for a long separation from my country and my loved ones.

I was devastated and had to come to terms with life in exile, alone, at a young age in a foreign country, while art and being an artist became an almost incomprehensible and distant dream. Today I understand why I was making such mediocre, confused, and unsubstantiated art at the time, which seemed neither authentic to my own culture nor relevant to Western art and culture.

I remember sitting through the classes and seminars silently, feeling inadequate to participate in the discussions, partially due to my poor English, partially due to the cultural gap, and mostly because I felt emotionally and intellectually inept. While I was battling with my personal dilemma, I was admiring many of my American peers who seemed to be blossoming, producing very provocative and intelligent work, making me even more doubtful and uncertain about my future as an artist.

But when I look back, I justify this period of vulnerability as a necessary process for the development of my art, an experience that helped me to question the role of education in the course of an artist's development. I see now how, for some young students, school can provide a space, a moment for a breakthrough, maturity, self-discovery, and growth; but for others, school becomes a period of stagnation, and then only life outside school and conventional education can provide them with the necessary inspiration and earned maturity.

Did your art school give you any sense of having an ethical commitment to the community that it was located in?

For the first few years, I hardly interacted with the immediate community, as my central experience was being the outsider. Also, I was hardly impressed by the level of conversations, which seemed to put little emphasis on conceptual, theoretical discussions and leaned more heavily on issues of composition and aesthetics. I felt constantly intimidated by predominantly male sculpture students who had a very physical relationship with art and their practice of making art, and little sensitivity for a more conceptual approach. But after awhile, I was able to shape and detect my own differences and common ground with some of the students and professors, and it seemed that they finally began to notice me as I was now more present and vocal, if not through my art, through my opinion. By the last year of graduate school, I felt energized as the atmosphere became more tense and competitive as everyone nervously prepared for the challenge of being a professional artist out in the "real" world.

With hindsight, would you do it the same way if you had the choice? If not, how would you have gone about your education as an artist?

If I had a chance to repeat my education, I would take some time off between undergraduate and graduate school. My rather unproductive years in graduate school were mostly due to the fact that I wasn't intellectually prepared to be an artist, and mostly I was never able to place myself as an Iranian within Eurocentric art history. Today I firmly believe that my return to art was provoked by the way in which I immersed myself in life experiences, encountered certain individuals and institutions, and lived in particular political environments that helped to shape and develop my art.

In fact, after I graduated from school, I became artistically inactive for nearly ten years, until the moment when I felt emotionally and intellectually motivated. I generally feel that young artists should be cautious not to get too trapped in a vacuum, where their imaginations look mainly to their intuitions as the source, as opposed to knowledge and experiences that can only be gained outside of school boundaries.

Does it make sense now for art schools to organize departments by discipline? Why or why not?

I don't believe it's any longer relevant to organize departments according to different disciplines because essentially it seems to me that what runs through

all forms of art is a conceptual strategy, and that can be detected and discussed whether, for example, it's within a painting, a video, or photography.

Should M.F.A. programs resist or embrace the encroachment of the commercial art world?
The commercial art world is an inevitable part of an artist's process, which doesn't solely provide a market but visibility—an audience that would otherwise not be able to access your art. The challenge remains in the way that an artist can find a way into the art world, how to position oneself (only through a strong character) and not get discouraged by the art world's extremely competitive nature.

SHIRIN NESHAT is an Iranian-born artist living in New York City. She has held major solo exhibitions internationally at galleries and museums. She is currently completing her first feature-length film, *Women without Men*. Neshat has received numerous awards, including the Dorothy and Lillian Gish Prize (2006) and the Gold Lion Award at the Forty-Eighth Venice Biennale (1999).

Werkkunstschule (Crafts School), Offenbach, 1958–1961

What was the most valuable lesson—whether in the classroom, during a crit, or from a fellow student—that you learned in school? Why? Who taught it to you?
This is hard to say. Over many years, I felt like a field onto which relevant raindrops would fall here or there. Because I did not attend any art academy from the inside, I began to teach myself. But the spontaneous answer that comes to mind is the lessons Peter Kubelka taught me. His synthetic view of subjects like film, cooking, architecture, and music brought together for me bits and pieces that until that point had only whirred around my existence without ever cohering.

In art school, did you learn how to sustain yourself as an artist, both creatively and professionally? Did you feel prepared to be an artist when you graduated?
When I finally entered the academy, I was divided between teaching and my desire to be a student as well. I was looking for tools, mentalities, and surrogate processes (splicing, bending) to transfer my earlier experiences as a weaver, typist, composer, and bookmaker into what then seemed "now"—whatever that was. I twisted all these components into my personal experience like the warp and weft of fabric.

What matters most in art making for you? Did art school have anything to do with your coming to understand this?
Because I was able to really exploit the confused position in which I found myself, I would say that art school gave me a lot. One should always be on the lookout for the ooze of materials and reality, this always fragile tuning that may allow you to modulate your imagination. It's always better to look for vague circumstances than to fit oneself into fixed designs. The most important things fall apart accidentally but come together again without one's individual will.

Did your art school give you any sense of having an ethical commitment to the community that it was located in?
Yes, it did. My colleagues like Kubelka still had something like beliefs or convictions. Such a model has boundaries, of course, which others might not share, but such convictions offered an orientation, a way through all the productive confusion mentioned above.

With hindsight, would you do it the same way if you had the choice? If not, how would you have gone about your education as an artist?

As my situation was an exception—by no means was my industrial-professional experience an average approach to an art education—I would probably repeat it again.

Does it make sense now for art schools to organize departments by discipline? Why or why not?

Disciplines are inevitably only outside frames, and as long as they are considered as such—and no more—they are okay. But from this point begins the doctor's responsibility.

Should M.F.A. programs resist or embrace the encroachment of the commercial art world?

Whether or not is a question of form, of structure, and yet we still have to face our surrounding, everyday reality.

THOMAS BAYRLE has exhibited internationally since the 1960s. A retrospective of his work was held at the Museum für Moderne Kunst in Frankfurt (2006). His work was included in the Fiftieth Venice Biennale (2003) and the Fifth Berlin Biennial (2006). From 1975 to 2002, he taught at the Städelschule (Staatliche Hochschule für Bildende Künste) in Frankfurt.

DEAR STEVEN

Ken Lum

Dear Steven,

I've been struggling with the essay for the art education book. I just can't seem to get a proper handle on what I want to say. Much of this has to do with a kind of doubt that I have about the role of the art school in today's world. This doubt has surfaced from time to time, but never with such persistence as of late. Two years ago, I resigned from a tenured teaching position at the

University of British Columbia in Vancouver, and this year I decided not to return to teach at Bard College in New York. I still enjoy teaching, but only for defined periods of time and if it allows me immersion in a new place. Writing this letter has been helpful in that it's forced me to reevaluate my relationship to both art and pedagogy. Despite my mixed feelings about the nature of many art schools today, I've found this exercise extremely useful in reminding me of why the teaching of art continues to be important.

For a number of years, I saw pedagogy as a veritable extension of artistic practice. Teaching offered me more than monetary sustenance. It allowed me to survive without having to worry about living off art sales. I was and continue to be grateful for this because the business of art has a way of shaping and even defining artistic production in ways that might not be in the best interest of being an artist. Yet it's important not to take this space afforded by teaching as a space of refuge and retreat from the world. All too often I've seen art schools exist as cloistered spaces where art is spoken about in lofty terms without any acknowledgment of how it is manifest in the real world. And this is closely connected to a lack of attention paid to what I'd call the "life knowledges" of students. These knowledges are grounded in the body and often discernible in the movement and conduct of individuals. The operative questions that should be asked are: What does it mean to be in someone else's place? How is it even possible to express something of the pain and suffering or happiness and joy of someone else?

The answers to these questions go beyond fostering social skills or finding paths of resolution, since such answers would belong more in the domain of social science than in art. The navigation of the social world is a lifelong process, but it's especially important for artists to explore. There have been several times when I accepted teaching posts outside the frame of social familiarity— in places such as Fort de France in Martinique and Hangzhou in China. These experiences provided me with the chance to expand and deepen my understanding of the possibilities of art, particularly as it issues from radically different social contexts from those I'm accustomed to.

In 1995, I taught as a guest professor at the École des Beaux-Arts in Paris. I was happy to go there because I was deeply unhappy with my situation at the time in Vancouver. Paris gave me a renewed impetus to develop my teaching skills in a different language and setting. The école is housed in a former cloister located in the heart of the city's chicest *arrondissement*. Many of the interior walls are designated with heritage status, and the students aren't allowed to mark them up in any way. I was struck by how the working environment was

made too precious for practical use. During my second year at the école, I proposed an exhibition of student works, entirely organized by the students and in cooperation with the students of the École Nationale Supérieure d'Arts Paris-Cergy. The latter is an art school located in the Nouvelle Ville of Cergy Pontoise built atop a geological rise at the very end of a Regional Express Network commuter line. A long pedestrian boulevard located at one end of its commercial district symbolically connects this distant suburb to the axial meridian line that connects to Paris's Grande Arche, Arc de Triomphe, and Place de la Concorde. But Cergy Pontoise is somewhat disconnected from the mythic ideals inherent in its status as a planned township, as it's now home to a large immigrant community that has turned the utopian architecture of the downtown core into a souk-like environment.

The aim of my proposed student exhibition was to bring together these two somewhat separate worlds. I felt that it was important for both groups of students to be aware of what connected and separated them from one another and to work through these connections and separations collectively. The exhibition took place in a large but empty retail space in the main Cergy Pontoise shopping concourse. There was a lot of support from the art school in Cergy Pontoise, and the students there were excited (if not a little surprised) to be working with their Paris counterparts. What unfolded was an incredibly dynamic exchange between the students involved. The Paris students realized that there was much to learn from their counterparts and the Cergy Pontoise group realized that they were equal in every way to their École des Beaux-Arts colleagues. The result was a vibrant exhibition, which was well attended by the citizens of Cergy Pontoise. It was telling and disappointing that the faculty and administrators from Paris didn't bother to show up.

An important lesson I learned from the project was that it really doesn't take all that much to transform student thinking about art and to open up a world of possibilities to them. In this case, all it took was a change in locale and a sustained period of time for students to get to know the new place. A student from Paris told me she would never take the suburbs for granted again. She then added that she would also never think of Paris in the same way again. I didn't ask for her to elaborate, but I was pleased by what she said.

In 1997, I spent some time teaching art in Fort de France in Martinique. This Caribbean island isn't far from South America, and yet Martinique television aired only French stations and kiosk stands sold only French publications. The art education of the students at the Institut Regional d'Art Visuel also reflected Martinique's *outré-mer* status as a department of France. I remember

witnessing the incertitude of the students about addressing their lives in their art. They doubted the possibility that their situation could be valid content for their art. They also knew very little about contemporary art outside of France. They were familiar with Andy Warhol, but a discussion of Warhol would inevitably lead to Pierre Restany, Martial Raysse, and the *nouveaux réalistes*, not to Pop Art manifestations in the United States, Great Britain, and South America. The collation of the school's pedagogical program with Paris was reflected in the school's faculty. Almost all of the instructors were given isolation pay bonuses. And despite the paradise-like setting of Martinique, there was a palpable sense of humiliation on the part of the instructors for having to be there.

My students in Martinique weren't very familiar with Frantz Fanon and his writing about the psychological effects of colonialism and the internalization of racism. In *Black Skin, White Masks*, Fanon writes: "I am not a prisoner of history. I should not seek there for the meaning of my destiny. I should constantly remind myself that the real *leap* consists in introducing invention into existence. In the world through which I travel, I am endlessly creating myself."[1] I felt that the students of the institute didn't question enough the world that produced them. The problem wasn't that they were complacent, but that they hadn't been given the tools necessary to critique their own situation. As a result, they were unable to define themselves in relation to historical trauma in the context of the Caribbean. When I asked them where they had traveled to, they responded by saying they hadn't been anywhere except Guadeloupe, another island of France to the north of Martinique. When I asked them where they'd like to travel, they responded, "Paris." Their unanimous response reminded me of a scene from the 1973 movie *Touki Bouki* in which the two protagonists incessantly sing the Josephine Baker song, "Paris, Paris, Paris." The film presents the dream of going to Paris as a self-searching journey and makes ironic the unfulfilled promises of the postcolonial condition. The students I worked with in Fort de France saw the world in similarly bracketed terms. Their school ran counter to my understanding of what art should do, which is to raise the consciousness of one's place in the world and produce expressions at the borders of what can and can't be said in any given social and historical context.

In 2000 I accepted an invitation to teach contemporary Western art at the China Art Academy in Hangzhou. The campus was founded in 1928 and modeled after the Bauhaus campus in Dessau in both physical appearance and pedagogical direction. Many Chinese intellectuals saw the Bauhaus as a possible regenerative model for a China seeking redemption with modernity. In

this way, the China Art Academy exemplified the desire to reconcile a tradition-bound culture with Western modernism. But while I was there, students lived in dorms on campus that seemed bleak in comparison to what we're used to in the West. The hallways were dark and the rooms cold. The men's toilet was basically a communal trench in a concrete enclosure. There was only one computer for the entire school, and not a very powerful one at that. It was located in the director's office and was the only source of Internet access, via telephone dial-up.

While in Hangzhou, I witnessed the selection process for new students. Works consisting solely of calligraphic and ink-brush paintings were put on display in a large room. An elderly man with a long white beard entered the room. An entourage of school officials followed him. I was told that he was akin to a professor emeritus and was highly regarded as a master ink painter. He surveyed the room and then pointed his cane to works by those applicants he deemed of sufficient quality for acceptance into the academy. I found this process curious, based as it was on the reverence of a master, as this figure is a contentious one in Western discourses of contemporary art. I was told that a master becomes one not just because of talent and skill, but because of a lifelong commitment to being an artist.

The curriculum at the China Art Academy emphasized traditional Chinese categories and standards of art. Students were not permitted to look at Western examples of art during school hours. However, after school hours, there were no such restrictions. Students would pin up reproductions of works by artists ranging from Jackson Pollock and David Salle to Anthony Caro and Nam June Paik. I actually held a number of my classes after hours precisely because the environment then was less official and more open. What the students at the academy learned to do is negotiate the restrictive and contradictory environment of the school. In contrast to the situation I experienced in Martinique, my students in China understood their position as political beings and were learning to imbue their art with a transgressive authority.

My experiences in Paris, Fort de France, and Hangzhou are never far from me. They continue to play a relevant role in my understanding of the world. I believe that one of the artist's roles is to give expression to his or her experiences in a continuous act of self-definition. It's crucial to convey this process to your students or it seems to me that you're failing them in an essential way. In a famous passage from the beginning of Proust's *Remembrance of Things Past*, the narrator describes the experience of eating a petite madeleine biscuit over lime-blossom tea: "No sooner had the warm liquid mixed with the crumbs

touched my palette than a shiver ran through me and I stopped, intent upon the extraordinary thing that was happening to me. . . . I put down the cup to examine my own mind." The passage articulates the centrality of sensory experience to artistic consciousness. Being an artist entails the assumption that everything in life is relevant. I've learned that the expression of experience doesn't need to be determined by the dictates of the art system. Of course, that doesn't mean that I've completely extricated myself from the system—only that I've reevaluated what it means to be an artist.

In fact, I've been increasingly troubled by the attitude that many students have in art schools now. High tuition fees make art school a place of privilege that disfavors those who aren't as well off, and a lot of students come from places of surfeit and privilege. This produces a kind of insularity that distances them from certain kinds of "other" knowledge. They seem more alert to the gamesmanship of art as never before, and they know how to produce works that achieve the appearance of completeness and finish. But something's missing. They have to be taught to recognize these limitations by questioning the assumptions that they hold.

To me, an art class should hold a dynamic exchange, and that's most likely to happen when there is a heterogeneous mix of students, a mix that allows the articulation of unexpected and different ways of knowing. In a 1976 lecture at the Collège de France, Michel Foucault spoke about the place of subaltern knowledges in the formation of disciplines. I've always found his definition of knowledges meaningful in terms of teaching: "When I say 'subjugated knowledges' I mean two things. On the one hand, I am referring to historical contents that have been buried or masked in functional coherences or formal systemizations. I am referring to blocks of historical knowledges that were present in the functional and systematic ensembles, but which were masked, and the critique was able to reveal their existence by using, obviously enough, the tools of scholarship. . . .When I say 'subjugated knowledges' I am also referring to a whole series of knowledges that have been disqualified as nonconceptual knowledges, as insufficiently elaborated knowledges: naive knowledges, hierarchically inferior knowledges, knowledges that are below the required level of erudition or scientificity."[2]

Foucault turned to the localized struggles of everyday life in order to challenge the autonomous production of knowledge. His contention was that these localized struggles produce life knowledges, and that these knowledges are very different from institutionally produced and validated knowledges. I think what's important to grasp here is that life knowledges don't lend themselves

so easily to representation. This idea relates strongly to the practice of art in which the aim is not to transparently represent the real (because this is an impossibility) but rather to reframe the real in ways that ask us to imagine the world otherwise.

As a teacher, I've encountered many students who are at an impasse in terms of what to say in their art, even though they're inundated by contemporary examples of art aimed at providing a blueprint for creative and critical production. Often overlooked are the specific subject positions of the students themselves. These specificities are important, but they're in danger of being subjugated in favor of a more homogeneous narrative that complies with the expectations of what contemporary art *should* look like. What I would argue is that students should be wary of the frictionless alignment of art school pedagogy and capitalist marketing strategies. This makes me think of Frank Thomas's book, *The Conquest of Cool: Business Culture, Counterculture, and the Rise of Hip Consumerism*, where he offers an astute reading of how countercultures have been co-opted by corporate marketing forces to promote specific products.[3] If you haven't read it, I think you'd find it revealing because the same phenomenon is definitely present in the contemporary art world, where the production, circulation, and exhibition of art are anchored to corporate bodies and promoted like any other commodity in a capitalist system. This is in spite of the persistent myth that art is somehow separate from the world of commodities, despite art's obvious commodity status. Students need to be taught to recognize these myths and to find ways to challenge them in their thinking and in the art that they make. We have to help them see the world in terms not solely defined by the art system.

Of course, there are counterforces in the world that have opened up spaces for creative and critical expression not reliant on this system. Ironically enough, they're products of the same capitalist model. An example of this is YouTube, which functions as a site where people can be creative without having to vet themselves as artists through the art system. Despite YouTube's corporate ownership and increasing problems with copyright infringement issues, it exists as an open repository for all kinds of spontaneous creative works that can be posted and accessed by just about anyone. We have only to think of the outpouring of videos produced and posted on YouTube in homage to the actor Heath Ledger after his death. These came overwhelmingly not from artists, but from Ledger fans from all over the world. Many of the contributions were deeply affecting precisely because they connected directly to the feelings

of a community of mourners. They were also affecting in their disregard for any rules that all too often precede artistic thinking and production.

But sites such as YouTube aren't immune to the politics of the art world. Last year I attended a symposium in Chicago that dealt with the relationship between globalism and the emergence of new aesthetic forms. One of the presentations for the panel discussion entitled "Challenging Cultural, Political, and Formal Boundaries" included a YouTube clip that featured the Back Dorm Boys lip-synching the Backstreet Boys song "I Want It That Way" while wearing Houston Rockets jerseys, the team of the Chinese basketball star Yao Ming. Those attending the symposium were completely enthralled by the video. No mention was made of the fact that the Back Dorm Boys were art school students from the Guangzhou Arts Institute in China. In fact, the audience assumed that the video clip was a nonart expression of creativity. When I pointed out that Huang Yixin and Wei Wei were art school students making a work of art, the initial excitement in the room quickly dissipated. We live in a time when knowing something is art may actually detract from an appreciation of the effect of a work. It is significant that the Back Dorm Boys were signed as spokespersons for Motorola mobile phones while still in school. A few months before they graduated, they signed a five-year contract with the Beijing media company Taihe Rye to continue making lip-sync videos.

Despite my ambivalence toward the art world, I have to acknowledge that it has given me many experiences that I wouldn't have had otherwise, growing up as I did in a poor neighborhood on the East Side of Vancouver. Whenever I teach, I'm always mindful of my roots. I made a sculptural installation out of rental furniture in 1982. The installation was exhibited in my studio. I was taken aback by people's responses. A lot of people laughed at the perceived tackiness of the furniture. Others thought my aim was to poke fun at bad taste. But this was not the case. I rented the best sofas I could, based on what I thought my mother would have liked. Today I can see how garish the selected furniture must have looked. I recently recounted this story during a presentation I made at a well-known American art school. A noted art curator was in attendance. At the postpresentation dinner, I noticed the curator looking at me. I turned to him, and he said somewhat tentatively, "I don't believe you." "What do you mean?" I replied. He then said, "I don't believe you when you say that you liked the look of the furniture you selected. It was clearly ugly." His words shocked me. They were a prescient reminder that little has changed in thirty years. This individual refused to imagine how class inflects what is possible in terms of art production.

When I was six years old, my mother would wake me in the middle of the night. After breakfast we would walk to the edge of Chinatown, where a delivery truck would pick us up. It was filled with elderly Chinese seated on small wooden stools. They were holding onto a thick rope hooked to the wall in lieu of safety belts. My mother and I climbed aboard, and the doors were shut behind us. The interior was completely dark, except for a beam of light that streamed in through a slit at the top of the doors. This was the beginning of what would be an hour-and-a-half journey to the strawberry fields located beyond the Vancouver suburbs. The truck always stopped at the same gas station so that we could get out and stretch our legs. After this brief interlude, our journey resumed and we were eventually dropped off at the edge of the fields, ready to work for the next twelve hours. The sun was always low on the horizon. I accompanied my mother to these fields during the summer months to help support our family. I wasn't the only child there, but I was the youngest. Perhaps this is why my elderly traveling companions treated me with such affection.

I'm telling you this not to solicit sympathy, but to open up a space to consider what such an experience might have entailed. My concern is with who has the power to articulate their experiences and under what terms those experiences are validated. Gayatri Spivak addresses a similar concern in her essay, "Can the Subaltern Speak?"[4] Her central point is that the subaltern cannot speak because the channels for being heard are absent. If the subaltern could speak—that is, speak in a way that really mattered to us—then he or she wouldn't be subaltern. Spivak concludes by stating that the task is not to speak for the subaltern, but to open up a space in which the subaltern can be heard. There isn't a more appropriate place for this to happen than in art school.

I enrolled in my first art class thirty years ago. It comprised approximately fifteen students who were diverse in terms of their backgrounds, ages, and aspirations. Most didn't know much about art and possessed only a vague notion of the art world. I was a science student who didn't have any plans to be an artist. Our instructor began the class by giving us an informal exam to assess our knowledge of art. Slides were projected, and we were asked to identify the artist responsible for the work. Several seminal works from the canon of twentieth-century art were shown, and I was unable to identify any of them (including works by Pablo Picasso and Andy Warhol). Although the instructor was incredulous at my lack of knowledge, I wasn't made to feel inferior. After all, my background was in the chemical sciences. However, his incredulity revealed an all too common assumption about the accessibility and democracy of

art, and it belied the fact that art is an insular enterprise subject to specificities of time and place. If this insularity is removed, then great things can happen for art and the art school environment.

I'd like to conclude this letter by reiterating a point that I made earlier: It really doesn't take much to make a dynamic art school. The first step is for students to theorize the environment in which their school is situated. This means that students in Kansas City or Mumbai can begin by thinking about their place in Kansas City or Mumbai and the complexities of their subject positions in relation to the rest of the world as they know it. If they're able to do this, then I think that they'll be able to define art in ways not necessarily dependent on the authority of the art capitals. This is not to say that students should disregard this authority and pretend that it doesn't exist. Rather, my point is that students need to challenge dominant ideologies by coming into dialogue with them. This is one of the art school's primary roles. But such a role can be achieved only if the instructor's knowledge about the art world is convincing to students. This is one of the reasons that I think that it's important to teach, even if I continue to have doubts about the art world at large. What students need to be taught is that art is about making everything in the world relevant.

Yours sincerely,
Ken

PROJECT 10

ZOLLVEREIN SCHOOL OF MANAGEMENT AND DESIGN,
COMPLETED 2007, SANAA (KAZUYO SEJIMA AND RYUE NISHIZAWA),
ESSEN, GERMANY

Described on its Web site as a "Business School for the creative disciplines," the new Zollverein School of Management and Design is "a globally leading platform for creative economics." Designed by the Japanese architectural team of Kazuyo Sejima and Ryue Nishizawa, the institution's home is a cubic volume thirty-five meters on each side, punctured by a seemingly random array of square windows, located on the site of the former Zollverein mine in Essen, Germany. Although it is reminiscent of the scale of some of the existing nineteenth-century industrial structures there, both its use and its technological sophistication diverge markedly from them.

In 2001, the industrial ruin was designated a UNESCO World Heritage site, constituting one of a number of anchor points of a Route of Industrial Heritage that is spread across Europe. As part of a subsequent reclamation project, the school was conceived and initiated along with other cultural facilities. With a mission to educate designers in the ways of entrepreneurs and managers and, perhaps more important, to educate the latter in the ways of the former, the structure contains ample public areas, in addition to classroom and studio spaces. It is precisely the type of hybrid institution that suggests that the atelier-style art school could well become a thing of the past.

The ground floor contains public programs (lobby, auditorium, café, and exhibition spaces), with the second floor holding the classrooms and studios, the third housing the library, and the fourth accommodating the needs of the administration. The building's active thermal insulation, with warm water from the mine pumped through the structure's thin concrete walls and floor slabs, leaves its interior spaces almost totally free of traditional building systems and offering new spatial effects that connect the site's past. From the rooftop, the vista of the industrial and urban landscape sprawls below.

The building's innovative technology and the school's hybrid educational program are elegantly concealed beneath the design's clear homage to modernist simplicity and transparency. And yet it is an indicator of the new dispersion of labor, creativity, infrastructure, and connections at work within globalization. The school's radical aesthetico-economic interdisciplinarity, bringing to the same table designers and business students, suggests that the traditional housing of educational specializations and the precise pedagogical practices they entail will continue to produce new hybrids that challenge easy enclosure in conventional institutions and architectures.

View of façade looking away from former mine. (Photo credit. © Nicole Berganski)

Marina Abramović is an internationally celebrated performance artist. She attended the Academy of Fine Arts in Belgrade, where she pioneered the use of performance as a visual art form. The body has always been both her subject and medium. From 1975 until 1988, she and the German artist Ulay performed together, dealing with relations of duality. After separating in 1988, she returned to solo performances in 1989. Abramović has presented her work with performances, sound, photography, video, sculpture, and "transitory objects for human and non-human use" in solo exhibitions at major institutions in the United States and in Europe, including the Stedelijk Van Abbemuseum, Eindhoven, the Netherlands, 1985; Musée National d'Art Moderne, Centre Georges Pompidou, Paris, 1990; Neue National Galerie, Berlin, 1993; and the Museum of Modern Art, Oxford, 1995. Her work has also been included in many large-scale international exhibitions, including the Venice Biennale, 1976 and 1997; and documenta, Kassel, Germany, 1977, 1982, and 1992. In 1995, Abramović's exhibition "Objects Performance Video Sound" traveled to the Museum of Modern Art, Oxford; the Irish Museum of Modern Art, Dublin; and the Fruitmarket Gallery, Edinburgh. In 1998, the exhibition "Artist Body—Public Body" toured extensively, including stops at Kunstmuseum and Grosse Halle, Bern, and La Gallera, Valencia. In 2000, a large solo show was held at the Kunstverein in Hannover. In 2002, she participated in the "Berlin-Moscow" exhibition, which opened at the Martin Gropius-Bauhaus in Berlin and finished its tour in 2004 at the State Historical Museum, Moscow. In 2004, she also exhibited at the Whitney Biennial in New York City and had a significant solo show, "The Star," at the Maruame Museum of Contemporary Art and the Kumamoto Museum of Contemporary Art, Japan. Abramović has taught and lectured extensively in Europe and the United States, including the Hochschule für Bildende Künste in Hamburg and the École des Beaux-Arts in Paris. In 1994, she became professor for performance art at the Hochschule für Bildende Künste in Braunschweig, where she taught for seven years. In 2004, she was awarded an honorary doctorate from the School of the Art Institute in Chicago. She was awarded the Golden Lion for Best Artist at the 1997 Venice Biennale and in 2003 she received a Bessie Award for "The House with the Ocean View," a twelve-day performance at Sean Kelly Gallery, New York. In 2005, Abramović made a series of performances entitled "Seven Easy Pieces" at the Guggenheim Museum in New York. Her work is included in many major public collections worldwide.

Dennis Adams is internationally recognized for his urban interventions and museum installations, which reveal historical and political undercurrents in public space and architecture. He works in a wide range of media and methods that are adapted to the specifics of context. Over the past two decades, he has produced over fifty urban projects in cities worldwide. His work has been the subject of numerous one-person exhibitions in museums and galleries throughout North America and Europe. Adams has received many awards, including three individual artist fellowships from the National Endowment for the Arts. He has taught at numerous institutions, including Parsons School of Design, New York; École Nationale Supérieure des Beaux-Arts, Paris; Rijksakademie van Beeldende Kunsten, Amsterdam; and the Akademie der Bildenden Künste, Munich. From 1997 to 2001, he was director of the Visual Arts Program and professor in the School of Architecture at MIT. Adams joined the faculty at the Cooper Union for the

Advancement of Science and Art in 2001, where he teaches three-dimensional design, sculpture, and the studio/seminar in public art.

John Baldessari is a world-renowned artist and arts educator. His art has been featured in more than 200 solo exhibitions in the United States and Europe and in over 750 group exhibitions. His projects include artist books, videos, films, billboards, and public works. His art is in major collections throughout the world. His awards include the Americans for the Arts lifetime achievement award, the Rolex Mentor and Protégé Arts Initiative, the Governor's Award for Lifetime Achievement in the Visual Arts in California, the Oscar Kokoschka Prize from Austria, the Spectrum-International Award for Photography of the Foundation of Lower Saxony, Germany, and the B.A.C.A. International 2008. He was inducted into the American Academy of Arts and Letters in 2008. He has received honorary degrees from the National University of Ireland, San Diego State University, and Otis Art Institute of Parsons School of Design. He taught at the California Institute of the Arts in Valencia from 1970 to 1988 and University of California at Los Angeles from 1996 to 2007. Recent projects include solo shows in New York, Europe, and Los Angeles; books; films; a curatorial project at the Smithsonian Hirshhorn Museum in Washington, D.C.; and retrospectives at the Museum Moderner Kunst Stiftung Ludwig Wien in Vienna, Austria, 2005; the Kunsthaus Graz in Graz, Austria, 2005; and the Carré d'art, musée d'art contemporain in Nimes, France, 2005. A traveling retrospective of Baldessari's work opened at Tate Modern in London in 2009.

Ute Meta Bauer is an associate professor at the Massachusetts Institute of Technology and the director of the visual arts program at its School of Architecture and Planning. Between 1996 and 2006, she served as a professor at the Academy of Fine Arts Vienna. Educated as an artist, she has worked over the past twenty-five years as a curator of contemporary art, media, and architecture, with a focus on sociopolitical issues and transdisciplinary formats. She was a cocurator of documenta 11 (2002) under its artistic director, Okwui Enwezor. Bauer also served as the artistic director of the Third Berlin Biennial for contemporary art (2004). From 2002 to 2005, she was the founding director of the Office for Contemporary Art Norway. As well, Bauer was the founding editor of several art periodicals, including META (Stuttgart) and *case* (Barcelona, Porto), and was the publisher of Verkstedt (Oslo). She was the editor of the book *Education, Information, Entertainment: Current Approaches on Higher Artistic Education* (Edition Selene, 2001).

Daniel Birnbaum has been rector of the Städelschule Art Academy and director of Portikus Gallery, both in Frankfurt am Main, since 2001. He has cocurated many major exhibitions, such as "Delays & Revolutions" at the Fiftieth Venice Biennale in 2003 and the first Moscow Biennale, 2005. Over his career, Birnbaum has collaborated with numerous artists in Europe and the United States. He directed the International Artists Studio Program in Sweden from 1997 to 2000, promoting international residencies and exchange. He is an art critic and a contributing editor at *Artforum* magazine and is the author of *The Hospitality of Presence: Problems of Otherness in Husserl's Phenomenology* (Almqvist & Wicksell International, 1998) and *Chronology* (Sternberg Press, 2005), among other works. Birnbaum has taught philosophy at the University of Stockholm and art theory at the University College of Art, Craft and Design, Stockholm. He has served as an international board member for the Yokohama Triennial of Contemporary Art and the Manifesta Foundation, Amsterdam. He is director of the visual arts for the Fifty-Third Venice Biennale in 2009.

Saskia Bos is dean of the School of Art at the Cooper Union for the Advancement of Science and Art. For more than two decades, Bos served as artistic and managing director of De Appel Centre for Contemporary Art, located in Amsterdam, where she led and planned its exhibitions and founded De Appel's curatorial training program. Bos organized and implemented the program's curriculum, where she chose teachers who link theory and practice and instruct what it means to curate, promote, and fund exhibitions. Bos has also curated a variety of large-scale exhibitions, including the Second Berlin Biennial, 2001; Biennale São Paulo (Dutch commissioner), 1998; Venice Biennale (cocurator of Aperto), 1988; and Sonsbeek '86, Arnhem, the Netherlands (artistic director). She has also worked on the advisory committee of the Yokohama Triennale; the nomination committee for documenta 11; and on the board of the 2007 Moscow Biennale. Bos is the curator of the Dutch pavilion at the Venice Biennale in 2009.

Tania Bruguera is an interdisciplinary artist working on political issues primarily through behavior art, performance, installation, and video. She has been a participant in documenta, Performa, and two Venice, Gwangju, and Havana Biennials. Her work has also been exhibited at major museums in Europe and the United States, including Tate Modern, London; Whitechapel, London; P.S.1, New York; ZKM Center for Art and Media Karlsruhe; Kunsthalle Wien; and the New Museum, New York. Her work is part of the collection of Tate Modern; Museum für Moderne Kunst; Daros Foundation; JP Morgan Chase Bank; Museum of Modern Art; Museo del Barrio; Bronx Museum; and Institut Valencia d'Art Modern, among others. Bruguera has been featured in many books, including RoseLee Goldberg's *Performance: Live Art since 1960*. She has been written about in the *New York Times*, *Le Monde*, *Artforum*, *Flash Art*, *Art Nexus*, *Beaux Arts*, *Performance Research*, and *Kunstforum*, among others. She received M.F.A.s from the School of the Art Institute of Chicago and Instituto Superior de Arte in Cuba. In 1998, she was selected as a Guggenheim fellow. In 2000 and in 2007, she received the Prince Claus Grant in the Netherlands. She currently lives and works between Chicago, Paris, and Havana. She is the founder-director of Arte de Conducta, the first performance studies program in Latin America, and is on the faculty at the University IUAV of Venice and at the University of Chicago.

Luis Camnitzer studied art and architecture, graduating in 1959 from the Escuela de Bellas Artes in Montevideo, Uruguay. He has lived in the United States since 1964. A two-time Guggenheim fellow, he represented Uruguay in the Venice Biennial in 1988 and exhibited in the Whitney Biennial in 2000 and in documenta 11 in 2002. He is a professor emeritus at the State University of New York, College at Old Westbury, and served as the viewing program curator for the Drawing Center in New York from 1999 to 2006. He was part of the coordinating team of the exhibition "Global Conceptualism: Points of Origin," 1999. Camnitzer is the pedagogical curator for the Iberé Camargo Foundation in Porto Alegre, Brazil. He is author of *New Art of Cuba* (University of Texas Press, 1994/2004), *Arte y Educación/ La ética del poder* (Casa de América, Madrid, 2000), *Antología de textos críticos* (Ediciones Uniandes, Bogotá, 2006), and *Conceptualism in Latin American Art: Didactics of Liberation* (University of Texas Press, 2007). He is a contributor to an anthology edited by Rachel Weiss, *Writings on Art, Artists, Latin America, and Other Utopias* (University of Texas Press, 2009).

Michael Craig-Martin was educated at the Yale University School of Art. He traveled to Great Britain on completion of his studies in 1966 and has lived there ever since. His first solo exhibition was at the Rowan Gallery, London, in 1969. He participated in the definitive exhibition of

British conceptual art, "The New Art," at the Hayward Gallery in 1972. Over the past ten years, he has done site-specific installations and exhibitions in numerous museums and galleries, including the Kunstvereins in Hannover, Dusseldorf, and Stuttgart; Institut Valencia d'Art Modern; the Centre Pompidou, Paris; the Museum of Modern Art, New York; and the Arp Museum in Rolandseck, Germany. He represented Great Britain in the Twenty-Third São Paulo Biennal, 1996. A retrospective of his work was presented at the Irish Museum of Modern Art in 2006. Craig-Martin is well known as an influential teacher at Goldsmiths, University of London, and is considered a key figure in the emergence of the young British artists in the early 1990s. Among his former students are Damien Hirst, Gary Hume, Liam Gillick, Michael Landy, Mat Collishaw, Sarah Lucas, Julian Opie, and Fiona Rae. He was a trustee of Tate Gallery from 1989 to 1999 and was elected as a member of the Royal Academy of Arts, London, in 2006.

Thierry de Duve, a historian and theorist of contemporary art committed to a reinterpretation of modernism, is professor at the University of Lille 3. His work has long revolved around Marcel Duchamp's readymade and its implications for aesthetics, and has found a new center of interest in the work of Manet. De Duve is the author of several books, including *Kant after Duchamp* (1996). He curated the exhibition, "Voici—100 ans d'art Contemporain," at the Brussels Palais des Beaux-Arts in 2000 and was the curator of the Belgian pavilion at the 2003 Venice Biennale, exhibiting the works of Sylvie Eyberg and Valérie Mannaerts. He is currently involved in a thorough reworking of his aesthetic theory.

Clémentine Deliss is an independent curator, researcher, and publisher. She studied art in Vienna and holds a Ph.D. from the School of Oriental and African Studies, University of London. Early curatorial work includes "Lotte or the Transformation of the Object" (Steirischer Herbst, Graz, and Academy of Fine Arts, Vienna 1990), "Exotic Europeans" (National Touring Exhibitions, London, 1990), and "Seven Stories about Modern Art in Africa" (Whitechapel Gallery and Konsthalle Malmo 1995–96). From 1992 to 1995, she was the artistic director of africa95, a contemporary arts festival coordinated with the Royal Academy of Arts, London. Since 1996 she has produced the writers' and artists' organ *Metronome*, publishing in Dakar, Berlin, Basel, Frankfurt, Vienna, Edinburgh, Oslo, Copenhagen, Stockholm, Paris, London, Portland, Oregon, and Tokyo. *Metronome* has been launched at the Dakar and Venice biennales; the Kunsthalle Basel; DAAD, Berlin; documenta X and documenta 12; Galerie Chantal Crousel in Paris; and Kandada/CommandN gallery, Tokyo. Since 2003, she has directed Future Academy at Edinburgh College of Art, with research cells in Senegal, India, Europe, Australia, the United States, and Japan. In 2007, she established Randolph Cliff, an artists' residency program in Edinburgh, together with Edinburgh College of Art, the National Galleries of Scotland, and patron Charles Asprey. She lives in London.

Charles Esche is a curator and writer. He is director of the van Abbemuseum, Eindhoven, the Netherlands, and is a coeditor of *Afterall Journal* and Afterall Books, based at Central St. Martins College of Art and Design, London, and at the School of Art at the California Institute of the Arts, Los Angeles. He is also an advisor at the Rijksakademie, Amsterdam. In the past few years, he has cocurated several major international exhibitions, including the Second Ramallah Biennial, 2007, with Khalil Rabah; the Ninth Istanbul Biennial, 2005, with Vasif Kortun; and the Gwangju Biennale, 2002, in Korea with Hou Hanru. From 1998 to 2001, he organized protoa-

cademy, an international art academic research project at the Edinburgh College of Art. A book of his selected writings, *Modest Proposals*, was published by Baglam Press, Istanbul, in 2005.

Liam Gillick is an artist based in London and New York. Solo exhibitions include "The Wood Way," Whitechapel Gallery, London, 2002; "A Short Text on the Possibility of Creating an Economy of Equivalence," Palais de Tokyo, 2005; and the retrospective project, "Three Perspectives and a Short Scenario," Witte de With, Rotterdam, Kunsthalle Zurich, and MCA Chicago, 2008–2010. In 2006, he was a co-organizer of the free art school project Unitednationsplaza in Berlin. Gillick has published a number of texts that function in parallel to his artwork. *Proxemics: Selected Writings (1988–2006)* (JRP-Ringier) was published in 2007. The monograph *Factories in the Snow* by Lilian Haberer (JRP-Ringier, 2007) will soon be joined by an extensive retrospective publication and critical reader. In addition, he has contributed to many art magazines and journals, including *Parkett, Frieze, Art Monthly, October,* and *Artforum.* Gillick has been selected as the artist for the German Pavilion at the Fifty-Third Venice Biennale in 2009.

Boris Groys is an internationally recognized authority on twentieth-century Russian art, international avant garde movements, aesthetics, and cultural theory. Educated in the Soviet Union, he emigrated to West Germany in 1981 and taught in different German and American universities. Currently, he is professor of philosophy and art theory at the Academy of Design, Karlsruhe, Germany, and Global Distinguished Professor in the Department of Russian and Slavic Studies, New York University. Groys's many books include *The Total Art of Stalinism* (Princeton University Press, 1992), *Art Power* (MIT Press, 2008), and *Ilya Kabakov: The Man Who Flew into Space from His Apartment* (Afterall Books, 2006). In more than 150 other publications, he has covered topics that range from nineteenth-century Russian literature to contemporary museum culture. He has curated numerous exhibitions and has been the recipient of fellowships at institutions in the Soviet Union, Europe, and the United States.

Hans Haacke is best known for his often-controversial political works, which expose systems of power and influence. His pioneering works in sculpture, installation, faux advertising, sociological polling, and public art have targeted corporate sponsorship of major museum exhibitions, political leaders and social issues, and German history and memory. In winter 2006–2007, Deichtorhallen Hamburg and the Akademie der Künst in Berlin copresented the largest exhibition of Haacke's work so far, as well as his first retrospective in his homeland. Other major one-person shows and museum interventions were held at the Centre Georges Pompidou in Paris in 1989, the Museum Boijmans van Beuningen in Rotterdam in 1996, and Tate Gallery in London in 1984. Haacke is a professor emeritus at the Cooper Union for the Advancement of Science and Art, where he taught from 1967 to 2002. He received the College Art Association's Distinguished Artist Award for Lifetime Achievement in 1991 and the Distinguished Teaching of Art Award in 2002.

Ann Lauterbach was born and grew up in Manhattan, where she studied painting at the High School of Music and Art. She graduated from the University of Wisconsin (Madison) and went on to graduate work in English at Columbia University on a Woodrow Wilson Fellowship. Deciding to forgo further academic degrees, she moved to London, where she lived for seven years, working variously as an editor at Thames and Hudson Publishers, a teacher at Saint Martin's School of Art, and curator of the literature program at the Institute of Contemporary

Arts. Returning to New York in 1974, she worked in art galleries until the mid-1980s, when she began to teach full time. She has published eight collections of poetry, including *If in Time: Selected Poems 1975–2000* (Penguin 2001), and several chapbooks and collaborations with visual artists, including *How Things Bear Their Telling* with Lucio Pozzi and *A Clown, Some Colors, a Doll, Her Stories, a Song, a Moonlit Cove* with Ellen Phelan for the Library Fellows of the Whitney Museum. She contributed to Ann Hamilton's *whitecloth* catalogue for the Aldrich Contemporary Art Museum. Lauterbach's essays on art and poetics in relation to cultural value were collected in *The Night Sky: Writings on the Poetics of Experience* (Viking, 2005). A new collection of poems, *Or to Begin Again*, is due out in 2009. Lauterbach has received fellowships from the Guggenheim Foundation and the John D. and Catherine T. MacArthur Foundation, and grants from the New York State Foundation for the Arts and the Ingram Merrill Foundation. In addition to her work as cochair of writing in the Milton Avery Graduate School of the Arts, she is Ruth and David Schwab II Professor of Languages and Literature at Bard College.

Ken Lum is an artist residing in Vancouver, Canada. He has exhibited widely, including documenta 11, Tenth Istanbul Biennial, Shanghai Biennale, and XXIV Bienal de São Paulo. Lum was curator of the 2004 NorthWest Annual, Centre for Contemporary Art, Seattle; cocurator of the Seventh Sharjah Biennial, United Arab Emirates; and cocurator of "Shanghai Modern: 1919–1945" for the Museum Villa Stuck in Munich, Germany. Lum is cofounder and founding editor of *Yishu Journal of Contemporary Chinese Art*. He has written numerous catalogue essays, as well as essays and reviews in art magazines and journals, including *NKA Journal of Contemporary African Art, Art and Text,* and *Canadian Art*. Lum is a recipient of a Guggenheim fellowship and Hnatyshyn Foundation Visual Arts Award. He was the head of the graduate program in studio art from 2000 to 2006 at the University of British Columbia, where he taught from 1990 until 2006. Lum joined the faculty of Bard College's Milton Avery Graduate School of Arts in 2005 and worked at Bard until 2007. He has also served as a guest professor at the École Nationale Supérieure des Beaux-Arts, Paris. Lum guest-taught at the Akademie der Bildenden Kunst in Munich; the China Art Academy in Hangzhou, China; Rijksakademie in Amsterdam; California College of the Arts, San Francisco; and the École d'Arts Plastique in Fort de France, Martinique. He was project manager for the exhibition, "The Short Century: Independence and Liberation Movements in Africa, 1945–1994."

Steven Henry Madoff is an award-winning writer, editor, and poet. He was the executive editor of *ARTnews* magazine from 1987 to 1994, where he is a contributing editor. He writes for *Artforum* and the *New York Times*, among other publications. He has served on the Federal Advisory Committee on International Exhibitions for the National Endowment for the Arts. Madoff has been an art critic for *Time* magazine and was editorial director of Time Inc. Interactive. Subsequently, he held the position of president of a division of the Museum of Modern Art in New York. Since 2003 he has worked with the Anaphiel Foundation in Miami to define the future of art education, of which this book is a manifestation. His other books include *Modern Melancholia: Thoughts on Jan Hafstrom's Art* (D.A.P.); *Pop Art: A Critical History* (University of California Press); *Why We're Here* (Hard Press); and *Christopher Wilmarth: Light and Gravity* (Princeton University Press), named best scholarly art book of 2004 by the Association of American Publishers. Recent monographic essays have surveyed the works of Rebecca Horn, Marina Abramović, Y. Z. Kami, and James Drake. He is at work on a book on the theory and history of

interdisciplinary art His writings on art have been translated into many languages. Educated at Columbia and Stanford universities, he is a senior critic at Yale University's School of Art.

Brendan D. Moran is an associate professor at the School of Architecture of Syracuse University. He has been an adjunct associate professor at the Graduate School of Architecture, Planning and Preservation of Columbia University, as well as a lecturer at the Yale School of Architecture and an adjunct professor at the New Jersey School of Architecture at the New Jersey Institute of Technology. He holds a Ph.D. in architecture history and theory from Harvard University's Graduate School of Design, as well as a master's in environmental design from the Yale School of Architecture. His ongoing research examines the intersection of architecture and planning education during the midcentury in America, as well as the role of the research university in shaping various forms of professional education involving design. He was coeditor of *Perspecta 32: Resurfacing Modernism* (2001).

Ernesto Pujol is a New York–based conceptual artist and interdisciplinary curator. He did his undergraduate work in humanities and studio art at the University of Puerto Rico, Spanish art history at the Universidad Complutence, Madrid, and philosophy and theology at St. John Vianney Seminary, Miami. He later pursued graduate work in education at the Universidad Interamericana, San Juan, followed by art therapy at Pratt Institute and media theory at Hunter College, both in New York. He holds an M.F.A. in studio art from the School of the Art Institute of Chicago. Pujol has taught at the Cooper Union for the Advancement of Science and Art and at Pratt Institute in New York. He has lectured at New York University and the Maine College of Art, among others. Pujol has been the recipient of fellowships from the Mid-Atlantic Arts Foundation, the New York Foundation for the Arts, Art Matters, Outpost, and the Joan Mitchell Foundation. He has served with the New York State Council on the Arts, the New York Foundation for the Arts, the Conservation Trust of Puerto Rico, the Academy for Educational Development, and the National Endowment for the Arts.

Raqs Media Collective's members (Jeebesh Bagchi, Monica Narula, and Shuddhabrata Sengupta) have been variously described as artists, media practitioners, curators, researchers, editors, and catalysts of cultural processes. Their work has been exhibited in documenta 12; the Venice, Liverpool, Istanbul, Taipei, and Guangzhou biennials; and in other international venues. They live and work in New Delhi, where they cofounded Sarai (www.sarai.net). Together with Adam Budak and Anselm Franke + Hila Peleg, the Raqs Media Collective co-curated Manifesta 7 in the South Tyrol/Alto Adige region of Italy in 2008.

Charles Renfro is a practicing architect and has been based in New York City since 1989. He joined Diller + Scofidio in 1997 and was promoted to partner at Diller Scofidio + Renfro (DS+R) in 2004. DS+R is an interdisciplinary studio that fuses architecture, the visual arts, and the performing arts, while investigating issues of contemporary culture, such as the spatial conventions of the everyday, the influence of media technologies on architecture, the changing definitions of domesticity, and the institution in the public realm. As a collaborator with Diller+Scofidio, he served as project leader on Brasserie, Eyebeam, the BAM Cultural District master plan (with Rem Koolhaas/OMA), Blur, the Institute of Contemporary Art in Boston, and the redesign and expansion of the Juilliard School and Tully Hall at Lincoln Center for the Performing Arts, among other projects. DS+R was awarded the National Design Award in Architecture from the Smithsonian

Cooper-Hewitt National Design Museum in 2006. Renfro's work with DS+R has been exhibited worldwide at many museums and institutions, including the Museum of Modern Art, New York; the Whitney Museum of American Art, New York; the Netherlands Architecture Institute, Rotterdam; the Canadian Centre for Architecture, Montreal; and the Centre Pompidou, Paris. His independent art and architectural work has been exhibited in several galleries nationwide, including the Storefront for Art and Architecture, New York. His writing has been published in *Bomb* and *A+U* magazines. Renfro is a graduate of Rice University and holds a master's degree from Columbia University's Graduate School of Architecture, Planning and Preservation. He has been on the faculty of Columbia since 2000 and was the Cullinan Visiting Professor at Rice University in 2006.

Jeffrey T. Schnapp is the founder-director (codirector since 2005) of the Stanford Humanities Lab. He holds the Pierotti Chair in Italian Studies at Stanford University, where he has taught since 1985. Trained as a romance linguist, Schnapp is the author or editor of eighteen books and over one hundred essays on topics such as late antique patchwork poetry, Futurist and Dadaist visual poetics, the cultural history of coffee consumption, glass architecture, and the iconography of the pipe in modern art. He is the coeditor of the Johns Hopkins University Press quarterly *Modernism/modernity*, the official journal of the Modernist Studies Association. His work as a guest curator has included collaborations with the Cantor Art Center, the Wolfsonian-Florida International University, the Triennale di Milano, the Centro Internazionale di Studi di Architettura Andrea Palladio, and the Fondazione Museo Storico del Trentino.

Michael Shanks is the Omar and Althea Dwyer Hoskins Professor of Classical Archaeology at Stanford University. He has worked on the archaeology of early farmers in northern Europe and Greek cities in the Mediterranean. He has researched the design of beer cans and the future of mobile media. Currently, he is exploring the Roman borders with Scotland and investigating the Anglo-American antiquarian tradition. His lab at Stanford, Metamedia, is pioneering the use of Web 2.0 technologies to facilitate collaborative multidisciplinary research networks in archaeology, design history, and media materialities. This comes after a long collaboration with the European performance company Brith Gof and with performance artists in the Presence Project. As a director of Stanford Humanities Lab, he is championing experimental research and development in transdisciplinary arts and humanities. A key theme in his current lab projects is the future of the archive. His books include *ReConstructing Archaeology* (1987), *Social Theory and Archaeology* (1987), *Experiencing the Past* (1992), *Art and the Early Greek State* (1999), and *Theatre/Archaeology* (2001).

Brian Sholis is a writer and editor based in New York. His essays have appeared in publications accompanying exhibitions at the Museum of Modern Art and the Whitney Museum of American Art in New York, the Hammer Museum in Los Angeles, and Moderna Museet in Stockholm. Other essays, as well as exhibition and book reviews, have appeared in *Artforum*, *Parkett*, *Bookforum*, the *Village Voice*, and *Print*, among other periodicals. He is the coeditor, with Noah Horowitz, of *The Uncertain States of America Reader* (Sternberg Press, 2006). He has taught at New York University and has been a visiting critic at universities across the United States.

Robert Storr is an artist, critic, and curator who currently serves as the dean of Yale University's School of Art. From 2002 to 2006, he was the first Rosalie Solow Professor at the Institute of

Fine Arts at New York University. In 1990, he was named curator in the Department of Painting and Sculpture at the Museum of Modern Art and stepped down as senior curator in 2002. Over the years, he has taught painting, drawing, criticism, and art history and theory at schools, colleges, and universities across the United States, including the Tyler School of Art, the Rhode Island School of Design, the New York Studio School, Skowhegan, the Graduate Center at the City University of New York, and Harvard University. He has written regularly for *Art in America*, *Artforum*, *Artpress* (Paris), and *Frieze* (London), as well as for other magazines and journals. In addition, his numerous essays, exhibitions catalogues, and books have been published around the world in many languages.

Anton Vidokle is an artist based in New York City and Berlin. His work has been exhibited in shows such as the Venice Biennale, Lyon Biennial, Dakar Biennale, and at Tate Modern, London; Moderna Galerija, Ljubljana; Musee d'art Modern de la Ville de Paris; Museo Carrillo Gil, Mexico City; the Hammer Museum, University of California, Los Angeles; Institute of Contemporary Art, Boston; Haus Der Kunst, Munich; and P.S.1, New York, among others. With Julieta Aranda, he organized e-flux video rental, which traveled to numerous institutions internationally. As the founder of e-flux, he has produced projects such as "Next Documenta Should Be Curated By an Artist," "Do It," and the "Utopia Station" poster project. He also organized "An Image Bank for Everyday Revolutionary Life" and "Martha Rosler Library." Vidokle initiated research into education as a site for artistic practice as cocurator of Manifesta 6, which was canceled. In response to the cancellation, Vidokle set up an independent project in Berlin, Unitednationsplaza, a twelve-month exhibition-as-school that involved more than a hundred artists, writers, theorists, and diverse audiences. Located behind a supermarket in East Berlin, the project featured numerous seminars, lectures, screenings, and book presentations. Unitednationsplaza recently traveled to Mexico City, and a parallel project, Night School, continued at the New Museum in New York City through January 2009.

CHAPTER 1

1. Carol Becker, "The Education of Young Artists and the Issue of Audience," *Cultural Studies* 7 (1993): 46–57.

2. Michael Brenson, "The Guggenheim, Consumer Aesthetics, and the Implications of the Corporate Museum," presented as the 2002 John McDonald Moore Memorial Lecture at the New School for Social Research in New York City.

CHAPTER 2

This essay is excerpted from de Duve's book, *Faire école (ou la refaire?)* (Dijon-Genève: Presses du réel MAMCO, 2008). Translated from the French by Jeanine Herman.

1. Arthur Danto, "The Artworld," *Journal of Philosophy* 61 (1964): 571–584.

2. In 1962, André Malraux suggested the project of an ambitious École des Beaux-Arts that would be open to foreigners and would include artist residencies. In 1965, the city of Nice offered the government a villa that belonged to the Arson family for this purpose. It opened in 1970 under the name École Internationale d'Art de Nice (let us note the passage from *Beaux-Arts* to *Art* in the singular). The following year, the establishment was combined with the Centre Artistique de Rencontres Internationales (CARI), which was in charge of hosting artists in residence and putting up exhibitions, and changed its name, borrowing its new one, curiously, from the École Nationale d'Arts Décoratifs de Nice, created in 1881. There was a new name change in 1984: the Villa is now called École Pilote Internationale d'Art et de Recherche (EPIAR), with CARI rechristened Centre National d'Art Contemporain. The latter became an integral part of EPIAR in 1986 under the direction of Christian Bernard, who would remain in this position until the end of 1994. In 2000, the directorial responsibilities of the Centre and the École (renamed once again, this time École Nationale Supérieure d'Art) were split and then reunited two years later, when a "national public establishment with an administrative character," quite simply called Villa Arson, was created, composed of an "establishment of higher education associated with an art center" placed under the guardianship of the Ministry of Culture.

3. These activities were regrouped as (1) drawing/painting/sculpture, (2) video/digital media/photography/sound, and (3) editions/reproduction (engraving, seriography, lithography).

4. Christian Bernard passed this project along to the Délégation aux Arts plastiques when he left Villa Arson, hoping to bequeath an institution to his successors that was likely to pursue the policies he had established. I was asked to be a consultant at the time.

5. George Dickie, the best known of the theoreticians of art as institution, defines the sociology of the art world this way: "The core personnel of the artworld is a loosely organized, but nevertheless

related, set of persons including artists (understood to refer to painters, writers, composers), producers, museum directors, the museum-goers, theater-goers, reporters for newspapers, critics for publications of all sorts, art historians, art theorists, philosophers of art, and others. These are the people who keep the machinery of the artworld working and thereby provide for its continuing existence. In addition, every person who sees himself as a member of the *artworld* is thereby a member." *Art and the Aesthetic: An Institutional Analysis* (Ithaca, N.Y.: Cornell University Press, 1974), 35–36. I am obviously placing the accent on the last sentence, which in and of itself—does Dickie realize this?—disqualifies institutional aesthetics entirely.

CHAPTER 3

1. Kazimir Malevich, *Essays on Art*, vol. 1 (New York: George Wittenborn, 1971), 147ff.

2. Ibid., 167.

3. Jean-François Lyotard, "The Sublime and the Avant-Garde," *Artforum* 23 (April 1984): 36–43.

4. Kazimir Malevich, "Ot kubizma i futurisma k suprematizmu," *Sobranie sochineniy*, tom 1 (Moscow: Gileya, 1995), 35.

CHAPTER 4

1. Along similar lines, documenta 11, organized by the Nigerian-born curator Okwui Enwezor in 2002, was explicitly framed by a series of conferences called "platforms," with the exhibition in Kassel constituting the final event. As documentation of these conferences was made readily available on the Internet for dissemination to all interested parties, the slippage from exhibitions as a platform to considering the educational environment in which artists are groomed to think through exhibitions is itself merely a small leap.

2. My thinking about this has been strongly influenced by the writing of Howard Singerman, in particular his essay "From My Institution to Yours," in Paul Schimmel et al., *Public Offerings* (New York: Thames and Hudson, 2001), 287–266, as well as his earlier book-length study, *Art Subjects: Making Artists in the American University* (Berkeley: University of California Press, 1999).

3. This has only been accelerated in recent years. The direction of software technology nowadays is toward more and more sophisticated 2-D and 3-D production techniques, which are finding their way into the hands of practitioners who have had no need to get a degree in order to use them. This development suggests an end to the particular type of academic expansion and democratization heralded by the GI Bill and no doubt is in need of cross-referencing with such social phenomena as heightened globalization and the rise of neoliberalism. On the latter subject, see David Harvey, *A Brief History of Neoliberalism* (New York: Oxford University Press, 2005).

4. Thierry de Duve, "When Form Has Become Attitude—and Beyond," in *Theory in Contemporary Art Since 1985*, eds. Zoya Kocur and Simon Leung (Oxford: Blackwell Publishing, 2005), 19–31. This was originally presented at a conference, "The Artist and the Academy: European Perspectives on Today's Fine Art Education," University of Southampton, December 9–10, 1993.

5. Roger Geiger has carefully laid out these developments in two volumes that cover the twentieth century, with one leading up to 1940 and the other extending from there to the present. See Geiger, *To Advance Knowledge: The Growth of American Research Universities, 1900–1940* (New York: Oxford University Press, 1986) and *Research and Relevant Knowledge: American Research Universities since World War II* (New York: Oxford University Press, 1993). On the subject of ongoing transformations to the art-making environment related to these developments, see Caroline Jones, *Machine in the Studio: Constructing the Postwar American Artist* (Chicago: University of Chicago Press, 1996).

6. Mark Jarzombek has argued that an ethos of self-improvement was the necessary precondition for the successful integration of ideas about modernist art into popular consciousness. The line between fashioning a self and fashioning an artistic self was increasingly blurred in America after 1940, and the exclusion of this slippage in historical accounts of modernity's discursive registers masks an unwillingness to admit the importance of such exchanges on the part of academics who gain status through these very exclusions. See his *The Psychologizing of Modernism* (Cambridge: Cambridge University Press, 1999).

7. Spaces for administration and architecture instruction—which did not begin until 1927, one year before Gropius stepped down as director—significantly made up the elevated connecting section that bridged the street. What is not commonly known is that the Bauhaus building actually contained two institutions, a technical (vocational) school in addition to its hybrid of applied art and art school, with the first entity occupying the bar across the street from the main workshop wing. A trio of classrooms made up the end of this bar and can be read as symbolizing a not-so-clear dichotomy between full floor workshops and traditionally grouped rooms for instruction.

CHAPTER 6

1. Allan Kaprow, "The Artist as a Man of the World?" *Art News* 63 (October 1964): 34–37, 58.

2. Gregory Battcock, *Idea Art* (New York: Dutton, 1973).

3. Leo Steinberg, "Contemporary Art and the Plight of Its Public," *Harper's Magazine* (March 1962). Reprinted in *Other Criteria: Confrontations with Twentieth-Century Art* (New York: Oxford University Press, 1972).

4. Roland Barthes, *A Lover's Discourse* (New York: Hill and Wang, 1978).

5. *Sol LeWitt: Critical Texts*, ed. Adachiara Zevi (Rome: I Libri di A.E.I.O.,U. Incontri Internazionale d'Arte/Edioctrice Inonia, 1994), 78.

6. See Henri Focillon, *The Life of Forms in Art*, trans. George Kubler (New York: Zone Books, 1992).

CHAPTER 8

1. T. S. Eliot, "Tradition and the Individual Talent," *The Sacred Wood: Essays on Poetry and Criticism* (London: Methuen & Co., 1972), 47–59.

2. Michael Haller, *The Past as Future: Jürgen Habermas Interviewed by Michael Haller*, ed. and trans. Max Pensky (Lincoln: University of Nebraska Press, 1994), 119.

3. Theodor Adorno, *Aesthetic Theory*, ed. Gretel Adorno and Rolf Tiedemann, trans. C. Lenhardt (London: Routledge & Kegan Paul, 1970), 121, 123.

4. Gilles Deleuze, *The Logic of Sense*, ed. Constantin V. Boundas, trans. Mark Lester (New York: Columbia University Press, 1990), 4–5.

5. Lewis Hyde, "The Children of John Adams: A Historical View of the Fight over Arts Funding," in *Art Matters: How the Culture Wars Changed America*, ed. Brian Wallis, Marianne Wems, and Philip Yenawine (New York: New York University Press, 1999), 270.

6. In his essay "Circles" (1841), Ralph Waldo Emerson wrote, "People wish to be settled; only as far as they are unsettled is there any hope for them."

CHAPTER 9

1. This section is a substantially rewritten and updated version of my original text entitled "The Proto Academy," in *Education, Information, Entertainment*, ed. Ute Meta Bauer (Vienna: Edition Selene, 2001), 216–224.

2. The collective text was written by Brian Davies, Steve Duval, Luca Frei, Lyn Löwenstein, Shepherd Steiner, and Lesley Young, among others.

CHAPTER 10

1. Here is an extract from *Dwelling Portably*, typical in style and content: "Portable living quarters plus underground storage: I'm enthusiastic about portable dwelling (or maybe just dismayed with the alternatives I see). But, in my experience, the actual living space, be it a tent, dome, camper, or whatever, is only a small part of the total system. Also needed is considerable storage space, and while that may be portable in the sense that everything can be taken apart and backpacked, it's not going to move often (unless you're Paul Bunyon [sic]). I'm talking about portable dwelling that's also comfortable, efficient, and self-reliant—a way a family would want to live for many years. Some guy on the road hitching from hostel to hostel, may be very portable, but is very dependent of people much less portable than himself. I like the system that Hopping Mole wrote about in *Dwelling Portably*, Nos. 19 and No. 20, except that LIVING underground seems to me unnecessarily difficult, requiring more high tech (for illumination, ventilation, and access) than does comparable living space on the surface. And I don't see major advantages in most situations. The system I'm working toward (and already have in part) uses portable living quarters and underground storage. I prefer that STORAGE be underground (or low, at least) for concealment and protection. Storage doesn't need as much illumination, ventilation or access as

does living space. The living quarters may move several times a year, but will remain within an hour's travel of those storage units that are entered frequently. (The actual distances will depend on the means of transportation and difficulty of traverse.) The dwelling system as a whole may become fairly large and complex, but I'd like each component (tent, storage, container, conveyance, etc.) to be relatively small, simple, and easy to replace—which means, either inexpensive and durable so that spares can be stored, or else simple and quick to handcraft. I want enough redundancy and decentralization so that failure or loss of one or a few components will not jeopardize the system as a whole or its users. (Dependency of the whole on parts is something I don't like about live-aboard boats. One serious malfunction or mistake and the entire boat, representing many years of labor, may sink, burn or be seized. Ditto houses. Ditto most other dwellings.)" Dave Drake, Oregon, *Dwelling Portably* 25 (1989).

2. Oscar Tuazon contributed to *Metronome*, no. 9, Paris, 2005, and was a guest artist and faculty member of Future Academy between 2005 and 2007. Together with participants in Edinburgh, Tuazon built an octet truss structure out of steel girders. This structure became the model for a series of new productions created by Future Academy participants and is described in detail in *Metronome*, no. 10, Oregon, 2006, which Tuazon and I coedited for documenta 12. Tuazon has taken part in Future Academy events in Oregon, Edinburgh, Tokyo, and at documenta 12 in Kassel.

3. I would like to acknowledge the enthusiasm and support of Colin Cina, who helped me to set up Future Academy in 2002 while he was still principal of Chelsea College of Art and Design.

4. A philomath seeks awareness, travels to find facts, and loves knowledge. That the Davises' postal box should be in a small Oregon town of this name was a congenial coincidence.

5. Since 1996, *Metronome* has circulated primarily from hand to hand by artists and contributors. There has never been a true commercial incentive or a desire to reach a broad and unidentifiable audience. *Metronome* is inappropriate when it comes to open source or online dissemination. Similarly, *Dwelling Portably* operates without a Web site, and issues can be purchased only through the post office box address in Philomath or occasionally if spotted in a bookshop.

6. I am grateful to Matthew Stadler for his lectures on the Zwischenstadt and settlements in the Northwest.

7. Georg Schöllhammer, "Metronomen: What Is to Be Done?" Tokyo, 2007.

8. "Itinerant Academy or the prototype of an operational mobile art college: a Future Academy lorry, circa 6 meters long, 2 meters wide and 2.5 meters high. A moving lab equipped with audio-visual materials, computers, silent generators, or solar energy captors, all to be used for recording exchanges and communications as well as the presentation of art using projectors on one blank side of the truck. The Itinerant Academy is conceived to create access to the arts, to communicate art professions to students and the underprivileged youth from the rural areas. It dynamizes the transfer of knowledge and skills between urban and rural life." "Future Academy Lorry, Senegal," *Metronome*, no. 10, Oregon, 2006.

9. See the report in http://www.futureacademylab.net (under "Edinburgh").

10. Guest faculty of Studiolab, which operated from 2005 to 2007, included Julius Popp, Oscar Tuazon, Nico Dockx, Jan Mast, Building Transmissions, and numerous scientists and hackers. See http://www.futureacademylab.net.

11. See http://www.cuboid.org.

12. "I speak as a scientist. In trying to become a polymath, you diversify how you measure people's value. You can see value in other activities. Some scientists are really into art and write about it, but the majority are only interested in you if you publish in *Nature!*" Guy Billings, Metronome Think Tank, Tokyo, September 2006.

13. Initiated by Gardar Eide Einarsson together with Kan-Si, the discussion of the interface and differences in approach between Huit Facettes and Superflex was first published in *Metronome*, nos. 4-5-6, 1999, and then reproduced in the catalogue of documenta 11.

14. This paraphrases in English the following lines published in French: "Nous savons en effet que l'explication n'est pas seulement l'arme abrutissante des pedagogues mais le lien même de l'ordre social. Qui dit ordre dit distribution de rangs. La mise en rangs suppose explication; fiction distributrice, justificatrice, d'une inégalité qui n'a d'autre raison que son être." Jacques Rancière, *Le Maître Ignorant* (Paris: Fayard, 1987), 194.

15. This was proposed by Ben Dembrowski, a first-year M.F.A. student from the United States. The M.F.A. group of students agreed that he should coordinate the Future Academy Bank between the college and students. Internal report by the author on Future Academy in Glasgow, March 2003.

16. The Senegalese musician and producer Youssou N'Dour took part in the first Future Academy forum held in Dakar in January 2003. He has recently collaborated with Benetton and established a local Senegalese microcredit association called Birima to support small-scale entrepreneurial initiatives. One of the icons used in the PR campaign is the portrait of a Senegalese hawker. See http://www.birima.org.

17. Discussion between Nalle Auro, Moustapha Mané, Mariama Diallo, Mar N'Diaye, and Awa Diouf at Future Academy's Synchronisations Student Think-Tank hosted by Srishti School of Art, Design and Technology in Bangalore, March 21–April 4, 2004.

18. Gael Raegon, "Greetings Mr Prez," *Chimurenga* 11 (2007): 2–7. http://www.chimurenga.co.za. Published in Cape Town by Ntone Edjabe.

19. Versions of these subtle forms of expression and aesthetic practices can be viewed in Zoe Leonard's photographs of stalls, clothing bundles, and displays of suits taken in Uganda and also in Brooklyn. See Zoe Leonard, *Analogue* (Columbus, Ohio: Wexner Center for the Arts, 2007).

20. Jacques Rancière, *The Politics of Aesthetics*, trans. Gabriel Rockhill (London: Continuum, 2004), 49.

21. "What Is to Be Done?" *Metronome*, no. 11, Tokyo, 2007.

22. See Clémentine Deliss (ed.), *Seven Stories about Modern Art in Africa* (London: Whitechapel Art Gallery and Flammarion, 1995). This catalogue contains detailed information on the first art colleges in African countries and their affiliations to U.K. art schools, including the Slade and the Royal College of Art. A similar relationship can be found in India, and most probably in Latin America. It results from the pre–World War II exportation of colonial European art education to these continents.

23. The Bologna Declaration "aims at the establishment of a European area of higher education by the end of this decade. This area should facilitate mobility of people, transparency and recognition of qualification, quality and European dimension in higher education, as well as attractiveness of European institutions for third country students." The three priorities of the Bologna process are introduction of the three-cycle system (bachelor/master/doctorate), quality assurance, and recognition of qualifications and periods of study. See http://ec.europa.eu/education/policies/educ/bologna/bologna.pdf.

24. It is debatable whether the development of *Metronome* would have been achieved in the mid- to late 1990s if I had worked within museums where the emphasis on public visibility and access may have run contrary to the focus on "conceptual intimacy" that I chose to work with.

25. http://www.metronomepress.com.

26. I am interested in looking back at the controversial discipline of social anthropology, which I studied alongside contemporary art but then denied an affiliation to throughout the 1990s. I want to revisit the maverick methodologies of twentieth-century anthropologists, from Margaret Mead to Michel Leiris, Hubert Fichte, Gregory Bateson, and, more recently, Clifford Geertz.

27. Gregory Bateson, *Steps to an Ecology of Mind: Collected Essays in Anthropology, Psychiatry, Evolution, and Epistemology* (Chicago: University of Chicago Press, 1972), 1.

28. Ibid.

29. See Johannes Raether, "Ten Reasons to Throw an Anchor in All That Motion; Ten Reasons to Float a Utopia on It; Ten Reasons for Opening a Post-Fordist Academy," "What Is to Be Done?" *Metronome*, no. 11, 2007, Tokyo.

CHAPTER 11

1. On the subject of the Ph.D. in art practice, see James Elkins, "Theoretical Remarks on Combined Creative and Scholarly PhD Degrees in the Visual Arts," *Journal of Aesthetic Education* 38, no. 4 (2004): 22–31.

2. So far as we are aware, there exists only one North American implementation of something akin to the vision articulated in this essay: the DX Arts program at the University of Washington, Seattle. Its mission statement reads: "The goal of doctoral education in Digital Arts and

Experimental Media is to create opportunities for artists to discover and document new knowledge and expertise at the most advanced levels higher education can offer. While creating new art is at the center of all activities in the program, the DXARTS PhD is a research-oriented degree requiring a substantial commitment to graduate-level study and reflection. The Ph.D. degree prepares artists to pursue original creative and technical research in Digital Arts and Experimental Media and pioneer lasting innovations on which future artists and scholars can build" (http://www.washington.edu/dxarts/academics_phd.php).

CHAPTER 12

1. Steven Winn, "9/11: Five Years Later: Art and Terror," *San Francisco Chronicle*, September 10, 2006.

2. Gilles Deleuze and Felix Guattari, *A Thousand Plateaus: Capitalism and Schizophrenia*, trans. Brian Massumi (Minneapolis: University of Minnesota Press, 1987).

CHAPTER 14

1. André Breton and Leon Trotsky, "For an Independent Revolutionary Art," in *Manifesto: A Century of Isms*, Mary Ann Caws (Lincoln: University of Nebraska Press, 2001), 472–477.

2. Andrew McClellan, *Inventing the Louvre: Art, Politics, and the Origins of the Modern Museum in Eighteenth-Century Paris* (Berkeley: University of California Press, 1999), 15.

3. Martha Rosler, "Lookers, Buyers, Dealers, and Makers: Thoughts on Audience," *Decoys and Disruptions: Selected Writings, 1975-2001* (Cambridge, Mass.: MIT Press, 2004), 9–52.

4. See http://www.copenhagenfreeuniversity.dk.

5. See http://www.themountainschoolofarts.org.

6. Boris Groys and Anton Vidokle, "Art Beyond the Art Market," *East Art Map*, ed. IRWIN (Cambridge, Mass.: MIT Press, 2006).

CHAPTER 15

1. One way that Spanish colonialism worked during the early stages of domination was to limit the degrees offered by local universities and to force graduation from Spanish universities for the more desirable professions.

2. Requirements were to have elementary school (sixth grade) completed and to pass a drawing exam.

3. The term *concreto* was picked up from the De Stijl tradition and coupled with *invención—arte concreto-invención*—which was later referred to simply as *concretismo*.

4. The manifesto was signed by the most prominent Argentinean artists of the time, but the text appears published in Tomás Maldonado, *Escritos Preulmianos* (Buenos Aires: Ediciones Infinito, 1997), an anthology of essays. It is not clear if Maldonado was the main author or if colleagues in the group, such as Alfredo Hlito and Edgar Bailey, cowrote it with him.

5. Among most distinguished results of this were the designs Hans Gugelot made during that decade for Braun AG.

6. Chile had a tradition of Catholic universities coexisting with public education. It was a hybrid structure inasmuch as public funds financed them, but the ultimate decisions about academic policy stayed with the Vatican. In 1967, a replay of the University Reform of Córdoba took place to put academic control in the hands of students and faculty.

7. In his essay "When Form Has Become Attitude—and Beyond," Thierry de Duve makes a lucid distinction between "talent" and "creativity," favoring the latter term for the changes introduced by the Bauhaus. In the context of this chapter, this distinction would open the discussion to secondary issues. What matters is that the Bauhaus shifted selection from skills to a broader concept that supposedly would help identify the imponderable factor that makes "great" artists as quickly and efficiently as possible. See "When Form Has Become Attitude—and Beyond," in *Theory in Contemporary Art Since 1985*, eds. Zoya Kocur and Simon Leung (Oxford: Blackwell Publishing, 2005), 19–31.

8. Painter Oswaldo Guayasamín, a national glory in Ecuador, had his studio built with glass walls so that visitors could watch him while he was painting. The studio was declared a national landmark.

9. For a more extended discussion of art education in Cuba, see my *New Art of Cuba* (Austin: University of Texas Press, 1994), 138–171.

10. The term *exile* should not be equated here with political exile. Many of the artists who left Cuba during that period did so for economic reasons.

11. Relatorio de Responsabilidade Social, 6a Bienal do Mercosul, Porto Alegre, Brazil, 2007.

CHAPTER 16
This essay does not address the curricula of B.A., M.A., or M.F.A. degrees nor is it a reflection on art education per se. Instead, it is my comment on recent developments that affect artistic education. The original version of this text was written for the conference, "A Certain MA-ness," organized by Henk Slager for the Utrecht Graduate School of Visual Art and Design, in collaboration with the Sint-Lukas Brussels University College of Art and Design, in Amsterdam on March 8, 2008. As well, it addresses a panel debate and workshop, "A New Institutionalism? A Look at the Public Dimension of the Private Art School," organized by Mary Jane Jacob at the School of the Art Institute of Chicago on February 24, 2007.

1. Alex Farquharson, "Bureaux de Change," *Frieze* (September 2006). See http://www.frieze.com/issue/article/bureaux_de_change.

CHAPTER 17

Parts of this dialogue are adapted from my article, "The Art of Education," *Artforum* 45 (Summer 2007), 474–477.

1. Michael Eddy, Hanna Hildenbrand, Sarah Ortmeyer, and Jeronimo Voss, "John Baldessari Talks to Students of the Städelschule," in *Kunst Lehren/Teaching Art*, eds. Heike Belzer and Daniel Birnbaum (Frankfurt: Walther König, 2007), 120–135.

2. Robert Filliou, *Teaching and Learning as Performing Arts* (Cologne: König, 1970).

3. Thierry de Duve, "When Form Has Become Attitude—and Beyond," in *Theory in Contemporary Art Since 1985*, eds. Zoya Kocur and Simon Leung (Oxford: Blackwell Publishing, 2005), 22.

4. Ibid., 26.

5. Jan Verwoert, "Free? We Are Already Free. What We Need Here is a Better Life," *Kunst Lehren*, 97.

6. *Theory in Contemporary Art*, 28.

7. Gerhard Richter quoted in Florian Waldvogel, "Each One Teach One," in *Notes for an Art School*, eds. Mai Abu ElDahab, Anton Vidokle, and Florian Waldvogel (Amsterdam: Manifesta 6 School Books, 2006), 21.

8. Nam June Paik, "Expanded Education for the Paperless Society," *Interfunktionen* (1971).

CHAPTER 19

1. Alain Robbe-Grillet, *For a New Novel* (Evanston, Ill.: Northwestern University Press, 1992).

CHAPTER 20

1. Michel Foucault, "The Means of Correct Training," in *The Foucault Reader*, ed. Paul Rabinow (New York: Pantheon Books, 1984), 194.

2. Giorgio Agamben, "The State of Exception as a Paradigm of Government," in *State of Exception*, trans. Kevin Attell (Chicago: University of Chicago Press, 2005), 28.

3. Edmund Husserl, "Elements of a Science of the Life-World," in *The Essential Husserl: Basic Writings in Transcendental Phenomenology*, ed. Donn Welton (Bloomington: University of Indiana Press, 1999), 375.

4. Nicolas Bourriaud, *Relational Aesthetics*, trans. Simon Pleasance, Fronza Woods, and Mathieu Copeland (Dijon: Les Presses du Réel, 2002); Steven Henry Madoff, "Service Aesthetics," *Artforum* 47 (September 2008): 165–166, 169, 484.

5. Jürgen Habermas, "The Public Sphere," in *Jürgen Habermas on Society and Politics: A Reader,* ed. Steven Seidman (Boston: Beacon Press, 2005), 231–236.

CHAPTER 22

1. Frantz Fanon, *Black Skin, White Masks* (New York: Grove Press, 1967).

2. Michel Foucault *"Society Must Be Defended": Lectures at the Collège de France, 1975–1976,* eds. Mauro Bertani and Alessandro Fontana, trans. David Macy (New York: Picador, 2003), 7.

3. Frank Thomas, *The Conquest of Cool: Business Culture, Counterculture, and the Rise of Hip Consumerism* (Chicago: University of Chicago Press, 1998).

4. Gayatri Spivak, "Can the Subaltern Speak?" in *Marxism and the Interpretation of Culture*, eds. Cary Nelson and Larry Grossberg (Chicago: University of Illinois Press, 1988), 271–313.

Boldface type indicates illustrations.

Abstract Expressionism, 7, 58, 62
Abu El Dahab, Mai, 191
Académie Julian, 205
Académie Royale, 58
Académie Suisse, 19
Adorno, Theodor, 60, 88–89, 190, 240, 245
Agamben, Giorgio, 275
agitprop, 62
Aicher, Otl, 99
AIDS activism, 9
Albers, Anni, 83
Albers, Josef, 59, 83
Allende, Salvador, 211
Allies, Bob, 126
Altamira, 207
Althamer, Pawel, 109
Anaphiel Foundation, xi, 283
anarchic art, 61
Andre, Carl, 266
anti-aestheticism, 61–62
antihierarchy, 107, 109, 112, 154–155
anti-isolation/antiautonomy, 107–108
antispecialization, 107, 112
Antoni, Janine, 316
Appadurai, Arjun, 320
apprenticeship, as educational model or
 means, 17–18, 24, 58, 74, 153, 244
archive, animated, 152–153
Aristotle, 146
art academy, axioms and rules for, 65–67
Art and Architecture Building, Yale
 University, 114, 115
Artaud, Antonin, 58
Art Center College of Design, 228, 229, 312
art colony model, 164
art culture, dissemination and transmission
 of, 17, 19, 21–23, 24, 58–60, 74
Arte de Conducta, 180, 187
arte povera, 182, 226

Artereality, 143, 146, 148–157
art fairs, 30, 173–174
art instruction, general traits of, 36
artist, supposed solitariness of, 145, 164
artistic practice, reflective mode of, 75–80
artists, social status of, 59
art programs, vanguard, shared educational
 philosophies of, 106–109
arts and crafts, 142
art school, temporary, 191, 194, 195–199, 242
art school architecture and design, 34–37,
 160–162, 165–166, 168, 170–175, 249–252,
 255. See also specific projects
art schools. See also university system
 accreditation, 258, 276
 as art-world conscience, 9
 departmental organization of, 294, 296,
 299, 302–303, 305, 308, 312, 315, 319,
 325–326
 as meeting place, 44, 65, 92–93, 198,
 232–233, 240
 mental health services at, 11–12
 as mode of transmission, 24
 moral authority and, 9
 as site-specific entities, 10, 268–269
 state of exception, 274–276, 280–281,
 283–284
arts education, academicization of, 36–37,
 45, 59, 61, 145–146. See also Artereality
arts funding, 9
Art Students League, 57, 195
artworld, 17, 19–21
Asher, Michael, 225
Asociación Arte Concreto-Invención, 207
Auro, Nalla, 130
authenticity, 50, 52, 64, 93, 278–279
avant-garde, historical, 27, 31

Back Dorm Boys, 337
Backstreet Boys, 337
Backwards Translation, 136
Bailey, Edgar, 361n4
Baker, Josephine, 333
Baldessari, John, 60, 232–233, 240, 246
Bangalore, 119, 129, 130, **132**, 133, **135**
Bard College, Milton Avery Graduate School
 of Arts, 90–94, 283
Barney, Matthew, 164
Barthes, Roland, 62, 237
 "The Death of the Author," 279
Basilisco, El, 211
Bastard, The, 136
Bataille, Georges, 32
Bateson, Gregory, *Steps to an Ecology of
 Mind*, 137–138
Battcock, Gregory, 61
Baudelaire, Charles, 32, 61
Bauhaus, 24, 31, 69, 83, 99, 106, 107, 142,
 164, 193, 195, 197, 205, 206, 237–238, 240,
 275, 280, 282
 Vorkurs, 69, 83, 209
Bayrle, Thomas, 240, 246
BBC, 225
Bearden, Romare, 57
Beaux-Arts, 195, 209
Becker, Carol, "The Education of Young
 Artists," 10
Beckett, Samuel, 88
behavioral psychology, 5
Benton, Thomas Hart, 57
Berkel, Ben van, 234, 240
Bernard, Christian, 353n4
Beuys, Joseph, 24, 60–61, 106–107, 206,
 237, 280
Bezalel Academy of Arts and Design, 10
B.F.A. programs, prescriptions for, 6
Bill, Max, 99, 207
Billings, Guy, 119, 128
Black Mountain College, 59, **82**, 83, 164, 197,
 229, 242
blockbuster shows, 242
Bock, John, 234
Bolívar, Simón, 207
Bologna Declaration, 259

Bologna Process, 239, 276
Botstein, Leon, 90
Bourriaud, Nicolas, 235, 280
Bozhkov, Daniel, 317
Brenson, Michael, 11
Breton, André, 191
Broodthaers, Marcel, 29
Brown, Gavin, 307
Bruguera, Tania, 211
Building Transmissions, 358n10
Buren, Daniel, 43, 243
Burroughs, William, 311

Cage, John, 232, 234, 311
 Theater Piece No. 1, 83
CalArts, 24, 42–44, 47, 49–50, 52, 60,
 106–107, 229, 279, 311–312
Caldera, Rafael, 210
California Institute of the Arts. *See* CalArts
Capacete, 211
Caro, Antonio, 211, 334
Carracci family, 58
Casa Daros, 212, 215
Castañeda, Consuelo, 211
Cátedra Arte de Conducta, 187
Catlett, Elizabeth, 57
censorship, 178
Cézanne, Paul, 19
Chaplin, Charles, 88
Chelsea College of Art and Design, 18, 126,
 137
China Art Academy, Hangzhou, 333–334
Chinati Foundation, 217
Chomsky, Noam, 245
Chouinard, 47
City College and Graduate Center, 90
cocreation and collaboration, 154–155, 157
Cohen, John, 298
Cold War, 29, 99, 205
Colección Cisneros, 215
College Art Association, 8
colonial art, 203
colonialism, 333
Columbia University, 58, 279
 School of the Arts, 10
commoditization, 8, 143

Conceptualism/conceptual art, 4, 5, 8, 20, 60–61, 64, 226, 241, 279, 325
concretist movement, 207
Constructivism, 59, 108, 142, 186, 280
consumerism, 29
contemporary art, social conditions of, 17
contemporary art centers, 17
Cook, Peter, 240
Cooper, Paula, 50
Cooper Union, 57, 258–260, 263, 268–269
Copenhagen Free University, 194
Corbusier, Le, 205
Courbet, Gustave, 192
craft, 156–157, 162
creative industry, 73
creativity, cult of, 237
Crime Against Art, A, 198
crit, 37, 273–274
"Critical Confrontation with the Present," 191
Cruz, Alberto, 210
Cuba, 210–211
cult of nature, 164
cultural anthropology, 5
cultural decision makers, 18–19, 21, 23–24
culture industry, 60, 63, 73, 161
culture wars, 96
Cunningham, Merce, 83

Dada, 186, 226, 310
Danto, Arthur, 17, 19–20
David, Catherine, 191
Davis, Bert and Holly, Dwelling Portably, 119
Degas, Edgar, 64
de Kooning, Willem, 46
Deleuze, Gilles, 32, 90, 170
Delfina Studios, 165
Deliss, Clémentine, 112, 123, 282
Dembrowski, Ben, 358n15
democratic society, art's role in, 9, 96–97
Derrida, Jacques, 87, 245
Dessau Bauhaus, 37, 68, 69
Diallo, Mariama, 130–131
Dickie, George, 353n5
digital media, 147–153, 156, 164, 170
Diller, Scofidio + Renfro, 166
Diouf, Awa, 130–131

Dockx, Nico, 358n10
documenta 10, 191
documenta 12, 122, 133
documentation skills, 4–6, 153, 183–185, 317
Dostoyevsky, Fyodor, 32
Duban, Felix, 39
Duchamp, Marcel, ix, 19–20, 27, 60–61, 274, 279
Düsseldorf Academy, 24, 61
Duve, Thierry de, "When Form Has Become Attitude," 237–238, 241, 361n7

Eakins, Thomas, 56, 57
École des Beaux-Arts, 19, 24, 37, 38, 39, 193, 331–332
École Gratuite de Dessin, 19
École Temporaire, 194
Edinburgh College of Art, 106, 111, 119, 126
Edinburgh University, School of Informatics, 126
Einarsson, Gardar Eide, 358n13
Eliasson, Olafur, 164, 243–244
Eliot, T. S., "Tradition and the Individual Talent," 87
Ellwood, Craig, 229
Emerson, Ralph Waldo, 97
employment prospects, 72–73
entertainment culture, 31
Enwezor, Okwui, 354n1
ethics of art, 5, 21, 293, 311
European Economic Community, 108
exhibitions, as pedagogical institution, 191, 194, 195–199, 212–214
Eyebeam, 166, 167, 168, 169, 170, 171, 172

Fabro, Luciano, 182
faculty, 42, 44–46, 52
 celebrity artists, 7, 208, 210, 258
Fanon, Frantz, Black Skin, White Masks, 333
Farquharson, Alex, "Bureaux de Change," 223
Faustino, Didier Fiuza, 126
Feininger, Lionel, 69
feminism, 9, 56
Filliou, Robert, Teaching and Learning as Performing Arts, 234, 243
"Finally," 180

financing school, 57–58
Flanagan, Barry, 241
Flaubert, Gustave, 32
Fleischmann, Dirk, 235
Fluxus, 186, 226, 241
Focillon, Henri, 64
Fontana, Lucio, "Manifiesto blanco," 207
"For an Independent Revolutionary Art," 191
Foucault, Michel, 32, 237, 245, 335
 "The Means of Correct Training," 272–273
foundation curriculum, 3–4, 6
Frankfurt school, 50
Frasconi, Antonio, 298
Free International Universities, 106, 107–109
Fresnoy, Le. *See* National Studio for
 Contemporary Arts
Freud, Sigmund, 55, 244
Future Academy, 112, 119, 121–122, **124**, 126–
 131, 133, 136–139, 282
Futurists, 186

Garciandía, Flavio, 211
Gasthof, 235–236, 283
Geiger, Roger, 355n5
Generator (Price), **254**, 255
genius, 54–55, 65, 276
Gentileschi, Artemisia, 56
George Washington Carver High School, 57
Germany, 182, 259–260, 263
Giangrandi, Humberto, 210
Gibbons, Arthur, 90
GI Bill. *See* military service benefits
Gillick, Liam, 49, 197
Girouard, Tina, 199
Glasgow School of Art, 129
globalism, 4, 11, 17, 32, 103–104, 139, 221, 267,
 284, 337
Goldschmidt, Gertrud, 210
Goldsmiths College, 17, 24, 42–44, 46,
 50–51, 106, 279
Golia, Piero, 194
Golub, Leon, 58
Gonzalez-Foerster, Dominique, 194
Goodden, Caroline, 200

graduate programs, 8, 295–297, 305
 M.F.A., 90–94, 146, 149, 297, 300, 315, 319,
 322
 Ph.D., 45–46, 143, 149–150, 221, 359n2
Gramsci, Antonio, 226
Graw, Isabelle, 240
great man theories, 55–56
Greenberg, Clement, 241
Gropius, Walter, 59, 69, 83, 99, 107, 205
Grosz, George, 57
Groys, Boris, 195, 196
Guangzhou Arts Institute, 337
Guayasamín, Oswaldo, 361n8

Haacke, Hans, 225
Habermas, Jürgen, 87, 282
Haggart, Beth, 316
Haller, Michael, 87
Hamilton, Ann, 95
Hard-Edge Abstraction, 7
Hardy, Saralyn Reece, 11
Harlick, Marjorie, 119
hawker, itinerant, as teaching model, 130,
 133, 139
Hein, Jeppe, 244
Heise, Henriette, 194
Hirsch, Nikolaus, 197
Hirst, Damien, 49–50, 164, 188
Hlito, Alfredo, 361n4
Hochschule für Gestaltung. *See* Institute for
 Design
Houston Museum of Fine Arts, 215
Huang Yixin, 337
Huit Facettes, 127
Hultén, Pontus, 243
humanities. *See* liberal arts and humanities
Hunt, Melinda, 292
Husserl, Edmund, 244, 278
Huyghe, Pierre, 194, 234
Hyde, Lewis, 95

idea art, 61
Illinois Institute of Technology, 59
Immendorff, Jörg, 61
Incubo, 211
Independent Performance Group, 186

industrialism, 4
informatics, 128
INKHUK, 106
installation art, 5, 61
Institut des Hautes Études en Art Plastique,
 243
Institute for Design, **98**, 99
Instituto de Diseño, 210
Instituto Superior de Arte (Havana), 210–211
Interfunktion, 244
International Style, 229
Internet, 89–90, 94, 165, 173
Iommi, Godofredo, 210
Islamic Revolution, 324
isolation, at art school, 27–29
Istanbul Biennial, Third, 191
itinerant teaching and education, 119, 121–
 122, 126–127, 133, 136, 139, 187, 243
Itten, Johannes, 164, 206, 209

Jacolet, Joseph, 128
Jakobsen, Jakob, 194
Jan Van Eyck Academie, 17
Jarzombek, Mark, 37, 355n6
Johns, Jasper, 62
Jones, Gareth, 307
Joyce, James, 244
Judd, Donald, 58, 110, 188, 217
Judd Foundation, 217

Kamin Lertchaiprasert, 200
Kan-Si, 358n13
Kaprow, Allan, 108–109
 "The Artist as a Man of the World?," 58
 "The Education of the Un-Artist, Part 1,"
 108
Kawara, On, 266
Kelley, Mike, 48
Kelly, Ellsworth, 58
Kent, Jane, 316
Kepes, György, 205
Kierkegaard, Søren, 32
kitsch, 27, 203
Klee, Paul, 46
Kocher, Alfred, 83
König, Kasper, 108, 234

Koons, Jeff, 5, 63, 164, 188, 321
Kortun, Vasif, 191
Kozlowski, Jaroslaw, 106
Krebber, Michael, 240
Kubelka, Peter, 327
Kubly, Donald, 229
Kuitca, Guillermo, 210
Kunstakademie, 60
Kunst Lehren/Teaching Art, 232
Kwinter, Sanford, 244

Lambie, Jim, 110
Land, The, 200
land art, 226
Lasker, Jonathan, 307
Latham, John, 241
Latin America, art education in, 203–210,
 301–302
Lawson, Tom, 317
Ledger, Heath, 336
Lee, Pamela M., 234
Léger, Fernand, 205
Leonardo da Vinci, 55, 59
Letterism, 226
Leufert, Gerd, 210
Lewis, Norman, 57
LeWitt, Sol, 46, 61, 63
Lhote, André, 205
liberal arts and humanities, 293, 310, 316,
 319
Libération, 23–24
Lichtenstein, Roy, 49
life-world, 278–280, 283–284
Lindsay, Arto, 234, 236
Lissitzky, El, 108
Lloyd, Hilary, 307
Louvre, 192
Lugar a Dudas, 211
Lyotard, Jean-François, "The Sublime and
 the Avant-Garde," 29

MacDowell Colony, 162, **163**, 164
Magasin, 23
making, as thinking, 64, 75, 156–157, 293
Maldonado, Tomas, 99, 207
 "Manifiesto invencionista," 207

Malevich, Kasimir, 106, 108
 "An Introduction to the Theory of the
 Additional Element in Painting," 28–30
Mallarmé, Stéphane, 64
Malraux, André, 353n2
 Le Musée imaginaire, 284
Mané, Moustapha, 130
Manet, Édouard, 21, 192
 Déjeuner sur l'herbe, 19
Manifesta, 191, 193, 195–197, 243
Manzoni, Piero, Socle du Monde, 317
Manzur, David, 210
Marfa, **216**, 217
Marina Abramović Institute for the
 Preservation of Performance Art, 186
marketplace, academy connections with,
 8–10, 30–32, 50, 145, 165, 221–226, 273,
 275–278, 280–281, 294, 297, 300, 305–
 306, 312–313, 319–320, 322, 326, 328
Martha Rosler Library, 198
mass culture, 29–31
Mast, Jan, 358n10
Matta-Clark, Gordon, 200, 234
McCarthy, Paul, 48
media-specific artistic training/education, 6,
 36, 63–64, 66, 238, 293
media theory, 5
Meese, Jonathan, 237
Mercil, Michael, 95
Mercosur, 212, 283
Merleau-Ponty, Maurice, 244
Metronome, 119, **120**, 121, 133, 136–137
Metzger, Gustav, 111
M.F.A. See under graduate programs
Michelangelo, 55
middle America, 4
Mies van der Rohe, Ludwig, 69
military service benefits, 57–58
Minimalism, 59, 61, 217
mobility, architectonics of, 119, 122, 126–127,
 131, 133, 138
Moderna Museet, 242
modernism, 4, 29, 37, 55–56, 59, 62, 237,
 317, 334
modes of engagement, 148–149, 153, 156
Moholy-Nagy, László, 59, 61, 205

Montessori, Maria, 206
Morris, Robert, 298
Morris, William, 142
Morrison, Graham, 126
Mountain School of Art, 194–195, 283,
 321–322
multidiscliplinary practice, 3–4, 6–8
multimedia art, 61
muralism, Mexican, 206, 211
Musée des Monuments Français, 39
Muybridge, Eadweard, 144
"My Seventies," 178–179
MySpace, 37

N55, 127
National Endowment for the Arts, 57, 280
 Museums and Visual Arts Program, 11
National Studio for Contemporary Arts, **286**,
 287
Natural Press, 121
Nauman, Bruce, 64
N'Diaye, Mar, 130
N'Dour, Youssou, 358n16
Neo-Dada, 62
Nesbit, Molly, 236
Neuman, Hans, 210
Nevarez, Angel, 198
New Bauhaus, 59
New Museum, 191, 242
New School for Social Research, 11
New York City, 5, 7, 10, 48, 95–96
New York University, 267
Niblock, Phil, 111
Nietzsche, Friedrich, 32
Night School, 191, 199, 242
9/11, 168, 170
Nishizawa, Ryue, 341
Nitsch, Hermann, 240
Nochlin, Linda, 56–57
Nova Scotia College of Art and Design, 17,
 60, 106, 108, 243

Obrist, Hans Ulrich, 236
Ohio State University, Wexner Center for
 the Arts, 95
Olson, Charles, 83

Ono, Yoko, 234
Open Circle, 127
originality, 12–13
Other[ness], 21–22, 32
Otis Art Institute, 47

Paik, Nam June, 334
 "Expanded Education for the Paperless
 Society," 244–245
painting, rejection of, 20, 61, 295
Papoulias, Christos, 126
Pardo, Jorge, 110
Parreno, Philippe, 194
participatory art, 267
Partners for Urban Knowledge, Action &
 Research, 127
Pasadena College of Art and Design, 47
Pearlstein, Philip, 58
pedagogical theory, in graduate education, 8
Pennsylvania Academy of Fine Arts, 57
Perez-Barreiro, Gabriel, 212
performance art, 178–188, 234
Permeable Academy, 133
Ph.D. See under graduate programs
phronesis, 146
Picasso, Pablo, 20, 55, 338
Pissarro, Camille, 59
poesis, 148
"Poetry Must Be Made by All!," 242
political science, 5
politics and art, 29–30, 32, 103, 192, 265–
 269, 284, 304
Pollock, Jackson, 55, 57, 334
polymathic educational approach, 127,
 139–140
Pop Art, 274
pop culture, 31
Popp, Julius, 358n10
Portikus, 18, 234–235, 239
postmodernism, 55–56, 58–59, 61
postnationalism, 10
Price, Cedric, 243, 255
Prilidiano Pueyrredón, 214
process-documentation-as-art, 8
"Production of Cultural Difference, The," 191
protoacademy, 109–112

Proust, Marcel, 244, 334–335
public, 21–24, 192, 282
 distinguished from audience, 192–193
 education of, 212–214
 exposure to art, museum control of, 17
 and performance art, 179–180, 185
 role in legitimizing art, 19, 193
public art, 7
publics, 17–19, 21–23
PUKAR. See Partners for Urban Knowledge,
 Action & Research

queer art, 9

Raad, Walid, 197
racism, 57, 333
Ramos, Nelson, 210
Rancière, Jacques, 128, 133, 240
Raum-Konzept, 181–182
Rauschenberg, Robert, 83
Ray, Charlie, 48
Raysse, Martial, 333
Read, Herbert, 206
readymades, 19–21, 60
Reagon, Gael, 130
regionalism, 11
Rehberger, Tobias, 233, 240
Reinhardt, Ad, 58, 64–65, 266
relational aesthetics, 267, 280
Renaissance, 58–59
Restany, Pierre, 333
"retinal" art, 60
Rhythm 0, 179
Rice, John Andrew, 83, 242
Richter, Gerhard, 61–62, 243
Rimbaud, Arthur, 237
Rirkrit Tiravanija, 200, 234–236, 283
risk taking, 93, 154
Rivera, Diego, 191
riyaaz, 76–77, 79
Robbe-Grillet, Alain, For a New Novel, 265
robotics, 5
Rodin, Auguste, 55
Rodríguez, René Francisco, 211
Rodríguez, Simón, 207
Rollins College, 83

Rosler, Martha, 192–193, 197, 240
Royal Army Medical College, 136–137
Rubens, Peter Paul, 63
Rudolph, Paul, 115
Russian Revolution, 203

Saavedra, Lázaro, 211
Salle, David, 43, 334
Salon des Refusés, 19
Samb, Issa, **123**
Saraceno, Tomas, 244
Sarah Doyle Women's Center Gallery, 316
Savage, Augusta, 57
Scholl, Inge, 99
Schöllhammer, Georg, 122, 133
school, meaning of, 75
School of Art, Kassel, 206
School of Design, Ulm, 206–208
School of Fine Arts, Uruguay, 206
Schwartz, Arturo, 19
Second Life, 148
Sejima, Kazuyo, 341
Senegal, 122, **124**, 127, 128, 129–131
Serra, Richard, 164
Serrano, Andres, *Piss Christ*, 280
service aesthetics, 280
sexism, 56
shack studio, 133
Shapiro, Meyer, 58
Shapiro, Miriam, 60
Sillman, Amy, 314
Singerman, Howard, 354n2
Situationism, 226
Skowhegan School, 164
Smith, David, 55, 58
Smith, Tony, 61, 298
social mobility, and the academy, 57
Social Realism, 203
social spaces, in art schools, 174–175
spatialism, 207
specialization, 107
Spencer Museum of Art, 11
Spivak, Gayatri, "Can the Subaltern Speak?," 338
St. Martin's School of Art, 241
Städelschule, 18, 136, 193, 234, 237, 239, 283

Stanford Humanities Lab, 143, 149–152
Stanford University, 143–144
Starling, Simon, 240
Stein, Gertrude, 86–87
Steinberg, Leo, "Contemporary Art and the Plight of Its Public," 62
Stella, Frank, 266
Steve Oliver Ranch, 95
Stijl, De, 360n3
Streeter, Tal, 298
student debt, 3, 8, 274
students, subjugation of, 273–275. *See also* antihierarchy
Studiolab, 126
studio space, 164–165
Stunt and The Queel, The, 137
success, defining, 12–13
Superflux, 127
Suprematism, 28
Surrealism, 310
Synchronisations, 129–130, 133

Tanner, Osawa, 57
Tate Britain, 18, 126
Tate Modern, 215
Tatlin, Vladimir, 242, 263
teachability of art, 208, 232–234
teaching
 and professional activity, 7, 103, 259, 318
 reminiscences of, 48–49, 51, 260–264, 331–339
Tenq, 127
tenure, 6–7
Tevere, Valerie, 197–198
Thatcher, Margaret, 45, 308
Thomas, Frank, *The Conquest of Cool*, 336
Tillmans, Wolfgang, 240
Tisdall, Caroline, 106, 108
Tonti, Lorenzo, 129
Tontine system, 129–130, 139
Torres-García, Joaquín, 206
Toufic, Jalal, 197
Touki Bouki, 333
Trotsky, Leon, 191
Tschumi, Bernard, 287
Tuazon, Oscar, 119, 358n10

Tucumán arde, 211
Tudor, David, 83
Turrell, James, 110, 321

Unitednationsplaza, 190, 197–199, 243, 283
universal immediate access, 3
universalism, 4
Universidad Católica de Valparaíso, School
 of Architecture and Design, 210
Universidad Central, 210
Universidad de los Andes, 209
University of California, Berkeley, 324
University of California, Los Angeles, 47,
 229, 312
University of California, San Diego, 46, 229
University of Michigan, 311–312
University of Southern California, 47
University of Washington, Seattle, 359n2
University Reform of Córdoba, 203, 206,
 209
university system, 36, 39, 45–46, 107, 115,
 128, 143–146, 276, 318
UNOVIS, 106, 108
urban sociology, 5
Utopia Station, 236

Valéry, Paul, 233
Van Dyck, Anthony, 63
van Gogh, Vincent, 55, 58
Velde, Henry van de, 69
Verwoert, Jan, 239
Vidokle, Anton, 242–243, 283
Vietnam War, 204
Villa Arson, 17–19, 21, 24
Villa Médicis, 23
Vitebsk, 106, 108
Vkhutemas, 31
voiceforum.org, 126–127
volunteer service, 9–10
Volz, Jochen, 235

Waldvogel, Florian, 191
Wall, Jeff, 46
Warhol, Andy, 35, 274, 279, 333, 338
 Brillo Box, 19–20
Warsaw Academy of Fine Arts, 106, 109

Weidman, Maurice, 304
Weimar Academy, 59
Weiner, Lawrence, 61
Wei Wei, 337
Wesley, Erik, 194, 321
Western canon, 56–57, 103
White, Charles, 57
Whitehead, Frances, 12
Whitney Museum of American Art,
 Independent Study Program, 193, 237
Wilde, Oscar, 61
Winn, Steven, "Art and Terror," 168
Wittgenstein, Ludwig, 244
women, in art world, 224
women's movement, 56. See also feminism
work ethic, 260–261
Works Progress Administration, 57

Yaddo, 164
Yale University, 59, 267
Yale University School of Art, 90, 95
Yao Ming, 337
YouTube, 187, 245, 336–337

Zen Buddhism, 12, 232
Žižek, Slavoj, 199
Zmijewski, Artur, 109
Zolghadr, Tirdad, 197
Zollverein School of Management and
 Design, **340**, 341

DATE DUE